PARIS AND THE CLICHÉ OF HISTORY

PARIS AND THE CLICHÉ OF HISTORY

The City and Photographs, 1860–1970

Catherine E. Clark

OXFORD
UNIVERSITY PRESS

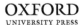

Oxford University Press is a department of the University of Oxford. It furthers
the University's objective of excellence in research, scholarship, and education
by publishing worldwide. Oxford is a registered trade mark of Oxford University
Press in the UK and certain other countries.

Published in the United States of America by Oxford University Press
198 Madison Avenue, New York, NY 10016, United States of America.

CIP data is on file at the Library of Congress
ISBN 978–0–19–068164–7

In memory of Catherine Neill

In this time as well, photography was born, called to revolutionize the reproduction of Paris.

—MARCEL POËTE, *Une vie de cité: Paris de sa naissance à nos jours (1925)*[1]

CONTENTS

ACKNOWLEDGMENTS

Many people and institutions have helped this book along its way. It began at the University of Southern California, where Phil Ethington, Panivong Norindr, and Nancy Troy all provided valuable feedback. Elinor Accampo has been a wonderful reader and mentor. A Provost's Fellowship, a Dissertation Completion Fellowship, and funding from the History Department and the Visual Studies Graduate Certificate Program gave me time to write. I went to USC to work with Vanessa Schwartz, who has been my toughest reader and greatest supporter ever since. She has questioned my ideas, edited my work, and encouraged me time and again. Above all, she has provided a model for combining deep intellectual inquiry with true enjoyment of what we do and become a dearly valued friend.

At MIT, I've benefited from support from the Global Studies and Languages section, the School of Humanities, Arts, and Social Sciences, the French Initiatives Endowment Fund, and the Class of 1947. I particularly thank my mentors Jeff Ravel and Emma Teng, section heads Ian Condry and Jing Wang, and deans Deborah Fitzgerald and Melissa Nobles. The section as a whole, but especially fellow members of the French group—Cathy Culot, Marie-Hélène Huet, Sabine Levet, Bruno Perreau, Jeff Ravel, and Leanna Rezvani—have given me advice, enthusiastically attended countless talks, and welcomed me warmly, as have members of Comparative Media Studies/Writing, History, Literature, and others across the Institute.

Colleagues pushed me to sharpen my ideas at annual meetings of the American Historical Association, Nineteenth-Century French Studies, the Society for French Historical Studies, the Western Society for French History, and the International Association of Word and Image Studies as well at conferences held at the IMT School for Advanced Studies, Chestnut Hill College, and De Montfort University's Photographic History Research Center. I'm also grateful for invitations to share this material at Aoyama Gakuin University; the University of Toronto; the 2015 France in Flux Workshop; Sciences Po; the Bibliothèque historique de la Ville de Paris; the Institut français in London; the University of Chicago; the Ecole des hautes études en sciences sociales; Oklahoma State University; the Université de Paris VII; and the 2012 Paris en

Images Conference. I thank Paul Cohen and the Center for the Study of France and the Francophone World at the University of Toronto for welcoming me during my séjour in Canada. Particular thanks are also due to: Brett Bowles, Laurence Bertrand Dorléac, Maurice Samuels, and Susan Whitney. Editors and reviewers at the *American Historical Review, Contemporary French Civilization*, and *Etudes photographiques* all helped strengthen my work. Those publications have generously allowed portions of those articles to reappear here.

In Paris, I thank the staff at the Bibliothèque nationale de France, the Bibliothèque administrative, the Archives de Paris, the Archives de la Préfecture de Police, the Bibliothèque du film, the Institut national de l'audiovisuel, the Institut mémoires de l'édition contemporaine. Catherine Tambrun and Jean-Baptiste Wolloch at the Musée Carnavalet were particularly helpful. Jean-Christophe Clamaingart at Roger-Viollet responded to countless emails. The staff of the Bibliothèque historique, especially Liza Daum, Carole Gascard, Claire Heudier, and Emmanuelle Toulet, made this project possible. I'm grateful to Yves Chagniot for his friendship in the reading room and to Carole Gascard for hers well beyond it. Sylvie Gabriel welcomed me at the Photothèque Hachette and teaches me something new about the city every time I see her. Britany Salsbury provided research assistance in Paris. On this side of the Atlantic, the staff of the USC and MIT libraries, especially those in scanning and interlibrary borrowing helped tremendously.

This research has taken me beyond the bounds of official archives and collections. Yossi Raviv shared his father's history with me from Tel Aviv. Claude Arthaud talked to me about her father's business practices. Christian Vigne answered my questions about "C'était Paris en 1970." Elizabeth Wallace responded enthusiastically to a random phone call from Cambridge and scanned her father's slides and scrapbooks from his trip to Paris in 1951.

Support from the Bourse Chateaubriand and the Peter E. Palmquist Memorial Fund for Historical Photographic Research allowed me to complete research. It was an honor to receive the 2nd Annual Lawrence Schehr Memorial Award. And the Camargo Foundation provided the sunshine and the silence I needed to complete revisions. It has been a pleasure to work with Nancy Toff, Elda Granata, Elizabeth Vaziri, and the team at Oxford University Press.

Many colleagues and friends have made this book better. In Paris, François Brunet and Christian Delage provided support and encouragement. Christina Gonzalez and Natalie Adamson affirmed that my interests had legs. Ken Garner, Laura Kalba, Sarah Easterby-Smith, and Bettina Stoetzer read portions at key moments. Jeff Ravel, Mary Louise Roberts, Priscilla Ferguson, Abigail Solomon-Godeau, Pete Soppelsa, and Courtney Traub all read the whole thing—Jeff more than once. My graduate school friends made me smarter and made me laugh: Mark Braude, Matthew Fox-Amato, Laura Kalba, Ryan Linkof, Raphaelle

Steinzig, Erin Sullivan, Sam Solomon, Virginia Solomon, Kris Tanton, and Amy Von Lintel. My Paris cohort commiserated over stumbling blocks and celebrated successes: Andrew Ross, Jessica Fripp, Ken Garner, Carolyn Purnell, and Tyson Leuchter. Since then, I've been lucky to count Nadya Bair, Emma Chubb, Sarah Easterby-Smith, Lauren Jacobi, Kim Timby, and Elsje Van Kessel as friends and interlocutors. Others housed me and fed me as I worked: Anne Aghion and Wilfrid Rouff, Carole Gascard, Véronique Goupil and Sébastien Antunes (now Lana too!), Saphir Grici, Manuela Jessel, CCKL, and Heather Lee.

That I have become a historian of France is in part thanks to great teachers, especially Doug Wortham and Carina Yervasi. This book is dedicated to the memory of my godmother, Catherine Neill, a brilliant pediatric cardiologist, a lover of the arts, and later in life, a medical archivist. I wish she could see it. My parents, Carleen and Ed, have encouraged and supported my love of books and interest in the past since I was old enough to beg for stories about "the olden days." Ed and Mer have provided many a meal and a stateside base. Brian Jacobson has read every word here more times than even he will admit. He is my sounding board and my partner in adventures of all stripes. We've been up and down mountains, across oceans, and over continents together. I can't wait to see where we go next.

INTRODUCTION

PARIS, PHOTOGRAPHY, AND HISTORY: 1860 TO 1970

In the fall of 1970, 100,000 photographs of Paris arrived at the Bibliothèque historique de la Ville de Paris.[1] This unprecedented donation was the largest set of photos the city's historical library had ever received. They were the results of an amateur photo contest called "C'était Paris en 1970," or "This was Paris in 1970," organized the previous spring by city officials, the ORTF (Office de radiodiffusion, télévision française), and the FNAC (Fédération nationale d'achats des cadres). At the time, the French chain of multimedia stores, which had opened in the 1950s as a members-only camera club, had already become a major player on the cultural scene. But the idea for the competition had originated with Henry de Surirey de Saint-Remy, the director of the Bibliothèque historique, who viewed amateur photographers as the ideal solution to a pressing problem: how to document Paris at the height of its twentieth-century renovations. The amateur submissions would enter a collection largely composed of nineteenth- and early-twentieth-century photographs by professionals including Charles Marville, Pierre Emonts, and Eugène Atget. While the earlier photos have circulated widely, becoming both iconic images of the city of Paris and the measure of an essential link between urban history and the history of photography, the contest photos have, until recently, been almost entirely forgotten. They were deemed uninteresting because they were "bad," because they were taken by amateurs, and because there were simply too many of them to make sense of.[2]

The fate of the "C'était Paris en 1970" photo contest entries inspired a larger question: what is the history of Paris's photographic history? Put another way, what is the history of preserving, writing, exhibiting, theorizing, and imagining the history of Paris photographically? How, when, and to what end did photographs become interesting as

historical evidence—and more specifically, evidence of the history of Paris—and to whom? I consider this last question by looking at accounts from and actions of city officials, archivists, librarians, curators, amateur and popular historians, journalists, editors, and even photographers themselves. I ask how photographs came to function in the mind's eye, shaping modes of seeing and acting in the world beyond the frame. I first answer these questions via an institutional history of how photos were collected and used at the Bibliothèque historique and the Musée Carnavalet.[3] The latter was first proposed in 1860 as part of the city's mid-nineteenth-century renovation. In 1898, its library moved into a separate building and gained administrative independence as the Bibliothèque historique. These institutions' collecting policies and exhibition histories demonstrate how major municipal officials imagined the photograph functioning as historical evidence. But while their ideas are of key importance, they were by no means singular. Indeed, amateur and popular historians, private collectors, journalists, and photographers themselves also developed their own interpretations of the photograph's historical possibilities. Their stories lead to the history of public festivals, photographic histories (published as books and pamphlets as well as in the press), photo contests, and watershed moments, such as the 1944 Liberation of Paris, when history seemed to come alive in the streets. The content and reception of these events and documents offer access to another set of explicit and implicit theorizations of how photographs functioned as historical documents. For collecting practices influenced the lives and uses of photographs within, on, and beyond the walls of municipal historical institutions and vice versa.

The story begins with the proposal to create a public history museum, the Musée Carnavalet, during the Second Empire. Preserving and disseminating the city's history was a key, if rarely acknowledged, aspect of the Parisian modernization project led by Napoléon III and Georges-Eugène Haussmann. The museum's founding established a consistent pattern traceable over the course of the next century: traumatic and disruptive events in Paris, from war to urban renovations, inspired Parisians to collect pictures as a means of preserving the changing city.[4] The Musée Carnavalet thus first acquired photos as one-to-one copies of objects and buildings that might soon be gone. In the museum's study rooms, such photos provided documentation for researchers who could use them to produce texts and reconstruct pictures of lost historical spaces and places. Their early users recognized that photos had an important analytic value as versions of the past in the present. Other potential uses, however, could not yet be imagined. Indeed, for historians and curators in the nineteenth century photos lacked the trace of a maker that might provide emotional access to the past. The museum thus kept photos out of its public galleries, leaving it to oil paintings, engravings, and historical objects to activate the public's historical imagination.[5] By the turn of the century, these uses would begin to change as shifting notions

around the documentary and the recognition of photography's increasing role in documenting contemporary life recast its place in these institutions, especially at the Bibliothèque historique under the direction of Marcel Poëte.

In the first decades of the twentieth century, photographs of Parisian buildings, streets, and people became increasingly important as a default mode of representation on the pages of illustrated histories, or what I term photohistories.[6] The history of these books reveals a new mode of interpreting older photographs as a haunting slice of lost time and as a way of accessing the emotional trace of the past that the Carnavalet had left to other kinds of images and objects. This mode emerged in the wake of World War I and marks the materialization of another pattern: the disruption and trauma of social, cultural, and physical change in the city also shaped what Parisians saw in existing pictures and how they imagined new photos to both capture the world and operate in the viewer's mind.

Photographs would continue to be used in these ways in the decades that followed, until the experience of the German Occupation of Paris (1940–1944). This event once again changed meanings and understandings of the act of photography itself, influencing a third mode of reading the photo, which I term repicturing. First taught in a series of photohistories produced during the Occupation, this mode deployed the contemporary snapshot as a mental gateway to remembered, often nonphotographic, pictures of the past. During the city's Liberation in August 1944, such pictures reappeared in physical form in the barricades that traditionally symbolized revolution. After the Liberation, the Musée Carnavalet collected and exhibited photos of the recent events, thus ensuring their preservation, promoting an emotional connection to them, and promising that they might inspire future political action. Photos of the Liberation also circulated in books and pamphlets as simultaneously the most objective *and* the most emotionally resonant evidence of the recent past: a past that photos helped to mythologize.

After the war, Parisians' interest in the medium's historical potential gained increasing public traction, as evidenced in such major commemorative events as the 1951 celebrations of the capital's 2,000th birthday, the Bimillénaire de Paris. Exhibitions, press coverage, and books published for the occasion reveal how writers, magazine editors, and local officials sold photography to the world as the future of documenting the present and studying the past. Amid the specter of Parisian global decline, they nonetheless simultaneously leaned heavily on old prints and paintings and their historical styles in order to call forth better times from the city's venerated past. They contributed to the creation of what I designate as Paris's "visual vocabulary," a set of standard image subjects and styles that knit the past into the present, both on the printed page and in the mind's eye. Even though other visual forms continued to play an important role in the historical imagination, by the mid-twentieth century, photography

became the dominant means of capturing change and historical events for future generations.[7]

It is little wonder then that Henry de Surirey de Saint-Remy proposed an amateur photo contest to document Paris's twentieth-century renovations. The history of the organization of "C'était Paris en 1970" brings to light how a later generation of municipal officials, critics, photographers, historians, and key players in photography's private sector conceived of photography's pervasiveness as both an impediment to— and the only possibility for—forging a comprehensive record of the capital. The contest submissions provide remarkable insight into how their makers had come to see older photographs as documents of the city's past, how they imagined photography could visualize the passage of time, and how they in turn imagined that their own photos might one day be seen. As this multifaceted view of photographs suggests, tracing photography's shifting place in the historical imagination over the course of a century reveals it as much more than a medium of representation. Photography threw the city itself, its changing place in the world, and its role on the historical stage into greater relief. The history of Paris since the mid-nineteenth century is incomplete without a careful consideration of photography's role in its making.

Paris as Image, the Past as Image

Scholars writing the history of Paris since the mid-nineteenth century have repeatedly understood physical, social, and cultural change as a story about the city as an image. Guy Debord first theorized contemporary society's reduction to spectacle in 1967.[8] While Debord wrote in part about the effects of actual images consumed en masse by increasingly passive spectators, the spectacle functioned primarily as a metaphor, shorthand for changing relationships structured by capital. Urban space was a key element of this argument, and Paris its case study.[9] Scholars have since responded to this notion. Some have charted the lives and social bonds of working-class Parisians during the late 1940s and 1950s in order to prove their disintegration. Rosemary Wakeman's history of working-class Paris, for example, argues that in the immediate postwar period, the capital became nothing but an image, "a picture book of the past."[10] Others have historicized the very idea of the city as spectacle. Studies by T. J. Clark, Christine Boyer, Vanessa Schwartz, Naomi Schor, and Anne Friedberg have explained how Paris's nineteenth-century renovations encouraged residents and visitors to consume the city as an image, as a visual spectacle on the boulevards, at the Universal Expositions and the wax museum, in picture postcards, and on screen at the cinema.[11] Simultaneously, Shelley Rice has argued that photographs prefigured and produced "the new sense perceptions and defin[ed] the new visual spaces

that mark this period in Parisian history."[12] We thus know how Paris gave rise to visual forms of entertainment and a new visual urban regime as well as how these shifts helped shape a particular mode of detached, mobile urban spectatorship: *flânerie*.[13] While the literature on nineteenth-century Paris both considers the idea of the city as an image and discusses actual images, scholarship about twentieth-century Paris too often deploys the idea of the city as image in purely metaphorical terms.

The image also appears in a similar manner in scholarly work about history and memory. This body of scholarship distinguishes history—which it treats as an abstraction, a critical analysis of the past—and memory, which is imperfect, personal or collective, but above all lived.[14] The image, such scholars argue, is best understood in relation to the latter.[15] But the very same work rarely considers actual images. It uses the term "image" as shorthand for interpretations or representations that are not necessarily visual: the "image" of the countryside, for example.[16] Or this work reduces the analysis of images to plot descriptions of films.[17] In contrast, I investigate the particular messages embedded in and produced through the use of actual photographs. At the same time, however, I also ask whether "memory" may have outlived its usefulness as a category of analysis. After all, "memory" now seems to encompass just about any reading of any cultural object dealing with the past.[18] Instead of "memory," then, the term "historical imagination" helps us historicize ideas about how exactly pictures worked to conjure the past.

Ideas about the importance of the image for historical thinking can be placed in conversation with histories and theories of photography as a tool of history. Indeed, photography's relationship to history and memory has long captivated theorists of the medium. For Susan Sontag, for instance, memory itself was photographic: "[it] freeze-frames; its basic unit is the single image."[19] For Roland Barthes, the photograph was a poignant provocateur. Photographs allowed for the positivistic study of the past through scrutinizing details within the frame. At the same time, a photo might provoke a deeply personal jolt of recognition, an emotional connection to the past.[20] Writing a generation earlier, Walter Benjamin understood the photograph's ability to freeze time, to abstract it from its context, to hold multiple temporal moments at once, as the very stuff of historical analysis.[21] For all three aforementioned theorists, the medium makes the distance of time and the alienation of death itself apparent: the photographic past is tantalizingly close and irreparably distant.[22] As important as Sontag, Barthes, and Benjamin have become to histories of photography and history, or photography and memory, they were not the only ones thinking through the problem of what photographs do within the collective historical consciousness and how they both forge and thwart an individual's relationship to the past. Rather than relying on these much-cited critics, I have sought out other ideas about photography,

memory, the mind's eye, and historical method in the overlooked work of a network of critics and practitioners.[23] Their ideas helped shape the body of photographs available for the study of the past today.

Studying the material and social history of how Parisian history was preserved and consumed in images, framed through the concept that Parisian history is *itself* a spectacle, reveals three things. First, it shows that what happened in Paris—from urban transformations to historic events as well as perceived social and cultural shifts—did not merely produce a metaphoric relationship between the city and images. Rather, it influenced interest in and policies for preserving and consuming the capital in physical pictures. Redesigning Paris for the future, first in the nineteenth century and again in the late twentieth, involved making pictures of the city available to the public at large. Importantly, photographs—with their promise of a one-to-one copy of what lay in front of the lens—became the default means of doing so. That story, which to a photo-mad society now seems self-evident, was not always so.

Secondly, photography, photographs, and modes of understanding them changed how people understood, saw, and acted in the world. Photographs and the access to history they promised became political tools. Those on the left sought to deploy the images that haunted Parisian spaces in order to call up a collective revolutionary consciousness.[24] In the case of the Liberation, photographs worked to prove that it had been activated.[25] But the very idea of preserving the city in photographs came in part from the political right: notably from Haussmann and the trio of city officials who initially sponsored the FNAC contest.[26] Their actions seem to support Debord and subsequent scholars' interpretation of the image as reactionary. The range of photography's uses over the course of a century, however, underscores that the photo bears no inherent political meaning. Rather it is both tool and agent, whose role is best illuminated by the specific and careful consideration of context, rather than by ontological or theoretical concerns.

Finally, a relationship emerges between photographic modes of viewing, changes in Paris's standing in the world, and the city's physical transformations in the latter half of the twentieth century. The heyday of Parisian photographic history—of old photographs not just nervously accepted or troubled over, but exuberantly sold as the future of studying the past—coincided with an era marked by the capital's declining global importance.[27] In the last decades of the nineteenth century, the city had seemed to be the "capital of the world," leading innovations in science, architecture, industry, and art.[28] But by the end of the twentieth, its standing appeared more rooted in its cultural heritage and perceived importance as a world tourist destination.[29] Recent historical studies have confronted the notion of Paris's decline by examining modernization and preservation projects since the 1970s (and how Parisians have perceived them).[30] Others, more akin to Debord's 1967 work, trace changing patterns of commerce,

traffic, and housing—as well as the rising cost of living—to debate Paris's status as a "museum city" or chart the emergence of a new Paris, as one recent book describes it, "without its people."[31] The notion of the museum city, of course, is a paradox. The museum cultivates a certain type of relationship, of reverence and distance, toward its objects, its fragments of the past. But cities—as lived places in which people and objects constantly interact—are supposed to resist such distancing and reverence. Paris's contradictory status as a museum city thus owes something not just to the ideals of urbanism but also to modes of urban perception, to ways of identifying and abstracting the past from the present: ones learned through photographs and the powerful presence of the Parisian past, disseminated heavily in photographic form.

The Social History of Photography and the Cliché

In one of the most visited and thus most photographed cities in the world, history has come down through the generations as the history of photography. Looking *through* these pictures reveals a familiar narrative of urban renovations—the World's Fairs, revolution, war, and street life—in short, the myriad aspects of urban life for over a century. But photographs are not just representations of the city's past: the production, collection, and circulation of photographs are part and parcel of Paris's history.[32] Looking *at* and *around* photographs helps us to write a social history of photography.

This approach investigates three levels of meaning held within the photograph. Photographs, first, offer us access to the historical events they depict. Second, and inseparable from the first, they capture "the history of photography" or the history of the making of the photograph.[33] The photo always records the act of photography itself, the social interaction between the photographer and the subject. Photographers are just as much players on the scene as those they photograph. Historians of photography and historians who use photographs often focus on these two levels of meaning, reading photographs as images that tell us about the events that occurred in front of the lens and about how photographers captured them.[34] Their focus on the immediacy of the photograph, however, can cause them to overlook its history as a material object that acts in the world.[35] Because they are objects, rather than mere disembodied images, photos are traces of the history of their preservation and use. We must accordingly account for a third level of historicity rooted in the photograph's materiality: "the history of photographs."[36] Although they may not reveal their own provenance, to borrow a term more often applied to art objects, by virtue of their existence in an archive, on a printed page, or on the wall of an exhibition, they bear witness to the actions that brought them there and reveal histories of acting in the world.

How, though, does one read this context, when all that is available is the object in the archive or on the page? Such analysis involves the sort of careful detective work borrowed from the methods of the social and material history of ideas: notably histories of printing, publication, and circulation, studies of reception, or the history of narrative structures, footnotes, and timelines.[37] The physical details of the cards—from the age of their paper to whether or not they are handwritten or typed—in the catalog of photographs at the Bibliothèque historique tell the history of the archive's growth, purview, and organization.[38] The photographs themselves, which may be glued to backings, bear stamps, have notes about loans, or even original and then revised captions, also tell of the archive's uses.[39] In illustrated books, captions and surrounding texts reveal how authors, editors, and designers conceived of the function of their illustrations.[40] At other times close attention to the composition of a photograph uncovers something about the influence of past images of Paris. After all, images dialogue with other images as much as with the world outside the frame. But one must also take texts seriously in order to look at pictures, and the discourses about photographs at the time of their making and in their long subsequent lives help us understand why photos show up in some places and not in others.

There are two main types of photographs at work in the history of Paris's photographic history. First are photographs created expressly for the future: the photos commissioned from Charles Marville, Charles Lansiaux, or the contestants in "C'était Paris en 1970." These "picture now, use later" images may have held short-term purposes of illustrating preservation discussions, supporting mapping projects, or being sold to the press, but they were also intended to one day serve as historical documents of the moment of their making. The second are photographs taken and circulated for numerous reasons that have subsequently been reinterpreted as pictures of the past. Not all photographs fall into the first category, but any can join the second.

Because time itself seemed to speed up over the course of the twentieth century, that "one day" when photographs might serve as fragments of the past seemed to grow closer and closer.[41] In the first decades of the twentieth century, it appeared that photographs of the present would be pictures of the past within two generations. In 1944, it was just a matter of weeks. By 1951, critics described pictures of the present as images of the past in the same breath. The use of the past imperfect tense—c'était, this was, Paris—in the very name of the 1970 contest suggests that the camera's products were part of history even before the shutter opened.

With so many pictures available, what of the risk that looking at photohistories of the capital or the use of photographs in historical celebrations might just open up onto a history of the tired circulation of clichés? After all, even the most

cursory browse through the kiosks that line the quays of the Seine, the tables of half-price books at stores such as the Mona Lisait, or the gleaming aisles of today's FNACs turns up generic Paris picture books: ones published, vaunted, and sold ad nauseam at discount. Don't these books and their seemingly endless, identical photos enable the stale recycling of history that epitomizes the "museum-city?" If so, how do we get beyond the idea of such photos and their ubiquitous presence as clichés, and worse, is there any service the photo can provide the city other than to reproduce it as a cliché?

We must start by rethinking the very term "cliché."[42] Since the late nineteenth century, in both English and its original French, "cliché" has denoted an idea or image, repeated so often that it has become tired, unremarkable, and ultimately meaningless.[43] Before that, however, it had two other meanings, each of which originated in the material culture of mass print and image production. First, cliché meant a metal printing plate cast from set movable type or a combination of type and images on metal plates or wooden blocks. Secondly, after the invention of photography, the term used to denote the sensitized glass plates on which the camera captured images: in other words, the photographic negative. While these two meanings are technical or historical in English, they have endured in French.[44] "Cliché" also later assumed a third French sense, now a bit dated, as a generic umbrella for any sort of photographic image.[45] In both languages, the cliché as a trite idea thus only appeared on the heels of these other denotations, as the product of mass print culture, of reproduced and reproducible ways of thinking about the world.[46]

We need to recuperate those older meanings: to read photographs as clichés, in other words, invokes a methodology that conceives of them as mass-produced objects functioning in close relationships to other types of images and texts.[47] To do so means considering the material conditions of the photograph's production and circulation in the world before understanding it as hackneyed or trite. The multiple meanings of "cliché" also make it essential to explore photography's relationship to other pictures and texts.[48] "All media," after all, "are mixed media."[49] In this story, photographs appear on the page with text or prints. Paintings haunt their edges. Historians write about them, and contest participants scribble captions on their backs. If photography became a dominant means of preserving the city, this does not mean that Parisians lost interest in the rich visual record of the city's past that survives in paintings and prints. Individuals worked out their ideas about how photographs captured and evoked the past in relationship to these other types of pictures. By employing the word "cliché," this book obliges us to also bear these nonphotographic antecedents and influences in mind when looking at their photographic counterparts.

History and the Visual Turn

In 1988, as part of a forum entitled "History in Images/History in Words" in the *American Historical Review*, Hayden White called for historians to distinguish between images and words as primary sources and as means of communicating historical analysis. He underlined historians' tendency to read images as texts and to deploy them as the "complement of [. . .] written discourse," as "'illustrations' of the predictions made in our verbally written discourse."[50] White called for historians to understand "imagistic evidence" as "a discourse in its own right and one capable of telling us things about its referents that are both different from what can be told in verbal discourse and also of a kind that can only be told by means of visual images."[51] He proposed the term "historiophoty"—the practice of writing history with and in images—as distinct from "historiography."[52] Looking at academic historical practices, White saw history's visual turn as still largely a work in progress. But approaching the social history of photography—of seeing where photos went and how they were used in historical circles well beyond the university, reveals a different story.[53]

Indeed, for all its importance, White's manifesto—and those historians it addressed— ignored a century of work that had already asked this question and was deeply engaged with images as sources and narrative tools of Parisian history.[54] The historical reconstructionists Fedor Hoffbauer and Georges Cain, who subsequently became director of the Musée Carnavalet, used old pictures to produce imagined historical scenes. Marcel Poëte, a trained archivist and director of the Bibliothèque historique, articulated the image's place among historical sources and purchased thousands of photographs of contemporary Paris for the library. The critic and collector Louis Chéronnet authored books that posited the camera's products as haunting fragments of lost time. A later director of the Carnavalet, François Boucher, acquired photos of the Liberation of Paris, while one of his employees, Jacques Wilhelm, taught repicturing in a multivolume book series. Another critic and collector, Yvan Christ, posited photography as a means of measuring and protesting against urban change. He commissioned the first rephotography projects: new photos taken from the same vantage point as older ones and printed alongside them.[55] The idea for the "C'était Paris en 1970" contest came from a subsequent director of the Bibliothèque historique: Henry de Surirey de Saint-Remy.

Thanks to these figures, by the last decades of the twentieth century there was already a rich visual archive and more than a century of practice among historical professionals (if not academic historians) sitting in Paris. Twentieth-century academic historians have been drawing on this archive for illustrations for decades, without seeing it as the result of a project of historical methodology. To study this archive and the practices in which it was embedded reveals that the "visual turn"

was staring us in the face all along in an archive that we simply needed to identify more clearly.[56] In order to understand how this came to be, we must look back to the nineteenth century: to see how, as Marcel Poëte explained, photography was "called to revolutionize the reproduction of Paris"—and to forever shape how we see its past.

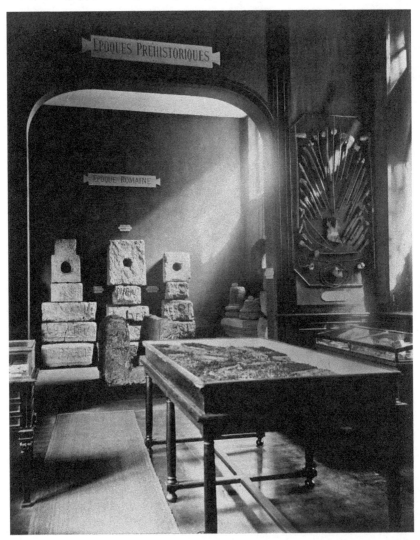

FIGURE 1.1 Pierre Emonts, *The Gallo-Roman and Stone Age Museum*, in *Le Musée Carnavalet: Hommage des conservateurs à M. Félix Grélot, Secrétaire Général de la Préfecture de la Seine*, 1892. Bibliothèque nationale de France.

1

IMAGINATION AND EVIDENCE

VISUAL HISTORY AT PARIS'S MUNICIPAL HISTORICAL INSTITUTIONS

In 1925, Marcel Poëte, librarian, historian, and director of the Bibliothèque historique de la Ville de Paris, declared that photography's dominant status in the twentieth century would change how future scholars wrote the history of Paris. In the contemporary world "photographic reproduction, in all its diverse forms, reigns supreme," he explained.[1] But although photographs made "perfect documentary precision" possible, he lamented that they "lack[ed] that particular note of life that the artistic figuration of yesteryear added."[2] Poëte's reservations underline the major concerns that had animated discussions of visual historical methodology for fifty years. He weighed the desire for documents and images—one that would bring the past to life, which had marked the Romantics' pursuit of history and underlay the nineteenth-century popularity of plays, paintings, and *tableaux vivants*—against contemporary historical methodologies that called for precise, factual documentation and analysis. The Parisian policies and practices of visual history that emerged in the 1860s and took shape at the Musée Carnavalet and the Bibliothèque historique in the following decades navigated this fundamental shift in the study and appreciation of history by contemplating what it meant to collect and use images as historical evidence. Even before photographs appeared on the walls and in the display cases of Paris's historical museum, they had changed how Parisians conceived of history and its visual documentation.

An interest in photographs developed amid an explosion of interest in Parisian history: one that was itself fueled by the city's renovations, initiated in the 1850s. While Haussmannization destroyed large swaths of Paris, it also helped produce the very idea of "*vieux Paris*" or "old Paris," which needed to be saved from imminent demolition, and groups of Parisians who identified as its *amateurs*.[3] The label draws

on the French word's double meaning as both a nonprofessional and an aficio-
nado. The avid history buffs that came out of this movement were not run-of-
the-mill nonprofessionals. They founded a host of historical societies organized
by neighborhood, including la Montagne-Ste.-Geneviève, le Vieux Montmartre,
and la Société historique d'Auteuil et de Passy. Their members gathered for
lectures and guided tours, collected documentation, and published newsletters.[4]
They often mixed scholarship with activism. Like members of the association
the Société des amis des monuments parisiens (Society of the Friends of Parisian
Monuments), founded in 1884, they mobilized their historical knowledge in the
fight to preserve examples of sixteenth-, seventeenth-, and eighteenth-century
architecture. Haussmann himself recognized the public's increased interest in
recreating, studying, and preserving the past as part and parcel of urban reno-
vation. In an 1860 speech, the prefect had declared that "the City of Paris must
disregard nothing, forget nothing, neglect nothing of its past."[5] To that end
he announced the creation of a municipal history museum and five years later
created the Service des travaux historiques.[6] The preservation of Paris's past and
its dissemination among scholars and the mass public thus became a fundamental
part of the capital's modern identity.

At the same time that the city invested in images as a means of documenting
the past and reaching audiences of varying levels of literacy, the use of visual
sources of all sorts—not just photographs—emerged as a marker of the growing
divide between professional and amateur historians. University-affiliated
historians rejected whimsical romantic imaginings and reconstructions of the
past that had dominated nineteenth-century historical practices from Salon
painting to lectures at the Sorbonne. Instead they placed an increasing em-
phasis on scientific evidence, proof, and rigor in historical research. This often
meant no longer using paintings, prints, coins, and medals, since these sources
presented subjective representations of the past whose ties to romantic forms of
history made them unreliable. Collectors, municipal officials, and nonuniversity
historians, on the other hand, embraced images as never before. Jules Cousin and
Georges Cain collected and displayed everything from paintings to porcelains at
the Musée Carnavalet, while the members of Paris's amateur historical societies
scoured bookstores, print shops, flea markets, estate sales, and painters' studios
for Parisian iconography. By the first years of the twentieth century, however,
curators, librarians, and even amateur historians had become interested in devel-
oping discussions of scientific rigor. Recognizing the wealth of historical infor-
mation that paintings, prints, and objects offered, they sought to define methods
of visual historical study and display that respected the romantic pull of pictures
while applying scientific methods.

Photographs and photography did not fit easily on either side of the binary
of fodder for the historical imagination and scientific evidence. Photographs

seemed neither to foster poetic or subjective connections to the past nor necessarily to satisfy the rigor demanded of the impartial scientific observation of historical evidence. Yet photography is integral to this story. It made the critical mass of interest in Parisian history possible, for it rendered reproducing and circulating iconography easier and cheaper than ever before. Photography also increasingly became the method by which municipal officials preserved the city in the face of urban change. But many collectors and historians rejected photographs of Parisian buildings and streets taken since the 1840s as too scientific to function as proper historical documents. And yet with the passage of time, as the scenes these old photographs showed began to fade from memory and acquire the smoky haze of the past, photographs increasingly occupied both roles, straddling the line between imagination and evidence.

Haussmann's Plans for Parisian History

Paris's municipal governments had preserved documents and sponsored historical accounts since the Middle Ages, but the Second Empire saw the creation of a separate administrative service charged with these tasks. City officials had long purchased paintings of significant events and statues of historical figures and cast medals to commemorate anniversaries. Librarians at the Hôtel de Ville maintained the archives of city governance and bought relevant books and prints. But by the 1850s, the city had run out of room for new acquisitions. According to Charles Poisson, municipal councilor and member of the Commission des travaux historiques, paintings, manuscripts, prints, archaeological artifacts, and architectural fragments cluttered offices and the library. They took up space needed for administrative documents or languished in suboptimal conservation conditions in the building's attics, closets, and basements.[7] These collections were accessible to the researchers and employees who knew where to look for them, although one can imagine that most bureaucrats would have balked at the prospect of rooting around in the attic for a rolled up canvas. Just as the 1793 opening of the Musée du Louvre during the French Revolution reframed the monarchy's collections as national property, Haussmann's creation of the Commission des travaux historiques and announcement that the city would invest in a public museum of Parisian history sought to make the city's collections accessible to all Parisians.[8] The study, preservation, and public dissemination of the city's past became an essential part of its modern makeover.

The idea of urban transformation was not new under the Second Empire, but its scale was.[9] Louis-Napoléon's plan to make the capital the worthy seat of a modern empire involved overhauling the city's center, building new infrastructure, and annexing adjacent suburbs to make way for future growth.[10] Haussmann

worked closely with Napoléon III as he ordered the destruction of large swaths of the city in order to make way for new boulevards, parks, market pavilions, train stations, and cemeteries as well as to encourage the privately financed projects such as hotel and apartment buildings that rebranded the city as the capital of modern pleasures.[11] Workers constructed a much-needed sewer system and another set of pipelines to bring clean drinking water to the city. Paris grew from twelve arrondissements to twenty with the 1860 annexation of surrounding towns including Montmartre, Belleville, and Passy.[12] But transforming Paris into a sparkling imperial capital also went hand in hand with preserving its rich historical legacy. Although historians and critics have charged that Haussmann destroyed the city's medieval neighborhoods with no regard for their historical importance, his efforts in fact guaranteed that the selective preservation, documentation, and transmission of the city's past became a modern municipal imperative.

And indeed, the enlargement and unification of Paris demanded the creation of a new historical narrative. The art historian T. J. Clark has argued that Haussmannization "homogenized" Paris, integrating independent neighborhood economies into the greater fabric of the city and absorbing private businesses (such as the omnibus companies) into large, generic, public ventures.[13] Similarly, the Commission des travaux historiques would work to integrate local histories of neighborhoods and former communes into a larger history of the city. The Sous-commission or Service des travaux historiques, created in 1865, would oversee the day-to-day activities in service of a triple mission to produce high-level scholarship; collect relevant documents, artifacts, and art; and make "material history" accessible to all Parisians in a free public museum. In 1866, the Service also took control of the Archives de la Bibliothèque de l'Hôtel de Ville, a move that concentrated municipal history in the hands of the Prefecture of the Seine (and its appointed prefect) rather than the municipal council (with its elected officials).[14] Since the 1860s, the Service has produced the *Histoire générale de Paris* alongside series of monographs and primary document collections. Throughout the nineteenth century it also worked on volumes of the *Topographie historique du vieux Paris*, which in recounting the history of all the arrondissements helped knit the newly annexed areas into the city's core. Haussmann hoped that this written history would one day constitute "a veritable monument" on par with the physical city he had rebuilt.[15]

These books were to look as impressive as the new city itself. Haussmann had criticized previous histories of the city for rarely "answer[ing] to the grandeur and importance of the subject."[16] Imperial support would guarantee high production values. For the first few years of the project, the Commission des travaux historiques outsourced illustration work, but in 1868, the Service des travaux historiques opened its own studio and hired Ernest Lacan, a well-known photography expert to run it. Lacan had founded *La lumière*, Europe's first photography

journal, in 1851. The Atelier iconographique specialized in the production and printing of chromolithographs, photographs, and photolithographs.[17] Lacan estimated that the Atelier saved the city half of what it would have cost to hire independent contractors.[18] His appointment suggests the importance of photography to the reproduction of images in scholarly works.

Much like the Atelier iconographique, the museum of Parisian history addressed the need to present a new historical narrative alongside a series of practical concerns—in this case, the material consequences of urban renovation. As workers tore into buildings and opened up the ground, they uncovered a veritable treasure trove of the past: Roman artifacts, elaborate paneling, ironwork, wooden beams, and gothic carvings. For the most part, new construction moved forward rapidly, covering over the remains of previous centuries, but in certain cases it allowed for sustained digs, led by the archaeologist Théodore Vacquer. He and his teams unearthed and identified the Arènes de Lutèce, a Roman amphitheater found at the site of a proposed bus depot near the rue Monge. They also discovered traces of the city's first walls beneath the Parvis de Notre-Dame and two Roman cemeteries on the Left Bank, among other sites.[19] The Commission helped solve the problem of what to do with the bones and stones turned up by these excavations.

The museum promised to integrate such finds with debris from the more recent past and centuries of visual representations into a vast historical narrative. Haussmann insisted on the social value of this free public display. As "a simple mode of instruction within the reach of those who do not read," he explained, the museum would bring Parisian history to a wider audience.[20] The city purchased the Hôtel Carnavalet, a *hôtel particulier* built in 1548 where the noted seventeenth-century epistolary figure Madame de Sévigné had briefly lived, so that the collection's home would be "already in and of itself a page from Parisian history."[21] Its displays would begin in the city's distant past with Roman and medieval artifacts as well as maps and reconstructions. Paintings, drawings, etchings, maps, books, manuscripts, medals, and architectural fragments and artifacts would teach visitors about subsequent centuries. Its rooms would culminate with objects and artifacts from buildings destroyed during Haussmannization. According to Charles Poisson, the museum would thus show visitors "in the most striking and easiest to understand form, what existed on the site of the boulevards, the promenades and the squares that [the municipality] had gifted to the Parisian population."[22] In other words, they would help justify the upheaval of the city's reconstruction to the public.

The museum's narrative would conclude with the flourish of the imperial city, drawing on the wealth of documentation commissioned as part of its renovation. The city administration had consistently ordered visual documentation of a changing Paris. Today, the photographs of Charles Marville are the best-known

of these documents. Working as the city's official photographer, Marville recorded the swath of neighborhoods threatened by demolition. But given the absence of photographs in Poisson's descriptions—and what contemporaries knew about how quickly photographs faded when exposed to light—these photographs were most likely never intended for public display. Moreover, well before Marville—and before Haussmann—the architect Gabriel Davioud was already on the scene. Davioud is perhaps best known today for having designed key sites and ornamentation for the new Paris including the Parc Monceau, the Buttes-Chaumont, the Trocadéro, the Place Saint-Michel and its fountain, and the Place du Châtelet and its theaters. But the city of Paris had first hired the architect in 1852 to produce drawings of the buildings destroyed to make way for new market pavilions at Les Halles.[23] Haussmann later commissioned him to produce similar documents of the areas affected by the construction of the rue de Rivoli.[24] In 1865, the city called on another architect and artist, Fedor Hoffbauer, to produce four paintings depicting before and after views of the city's transformations.[25] This date coincides with the elaboration of more precise plans for the museum, suggesting that the paintings were intended for public display there. Meanwhile the drawings and photographs—which were stored at the Hôtel de Ville and burned in the fire of 1871—would have been reference documents for planners, mapmakers, and city officials.

It is impossible to determine the exact form that the Musée Carnavalet's rooms would have taken under Haussmann and Napoléon III, since both were forced out of office before the completion of the building's renovations. Succumbing to (quite justified) accusations of Haussmann's extralegal dealings and a growing distaste for his authoritarian regime, Louis-Napoléon fired him in January 1870.[26] The emperor barely outlasted the prefect. Defeated at the Battle of Sedan by the Prussians in September, Louis-Napoléon never returned to power. Later that month the Third Republic took over the war effort, and the Prussians laid siege to Paris. In the spring of 1871, after the siege was over and the peace treaty with the Prussians signed, the people of Paris seized control of the capital. The subsequent suppression of the Paris Commune had dire consequences for the city's written historical record and the burgeoning collections of its future historical museum. As the Communards resisted the soldiers, they set fire to the Tuileries palace, the Hôtel de Ville, and countless private residences. At the Hôtel de Ville, the city's administrative archives, its library, and the vast majority of the paintings, prints, medals, scale models, and other objects destined for the Musée Carnavalet went up in flames.[27] The Communards never took possession of the Hôtel Carnavalet (which they had hoped to turn into a museum of the Commune), so the building itself survived undamaged.[28]

The Commission des travaux historiques and the project to build a city history museum would nonetheless emerge intact from the ashes of the Commune.

In fact, the Third Republic would continue most of Haussmann's projects: finishing the Opéra Garnier, cutting new streets, and building the pavilions at Les Halles. Under the Third Republic, however, the museum's focus would shift away from the history of everyday life and the working classes that it had emphasized under the Second Empire. The original project had made provisions for multiple rooms devoted to the history of daily life in Paris. Charles Poisson had described how "interior views of houses, specimens of furniture and domestic utensils, will reveal a host of intimate details, dear to historians as well as artists, and useful to all by the precise ideas that they give about the existence of old."[29] The architectural historian Jules Gailhabaud, who directed the acquisition of this part of the future museum's collections, had amassed objects from fire starters and corkscrews to meat hooks.[30] These were made available to the public during the Second Empire at the Musée de l'ustensillage, opened in a provisional space at the Maison communale du quai de Béthune (the same address housed storage for archaeological finds). The museum enjoyed particular popularity during the Commune, for, as the art historian Peggy Rodriguez has argued, its subject and its approach to providing public art education aligned with the social ambitions of the Communards.[31]

When the Musée Carnavalet finally opened in 1881, however, it did so without what had become known as the Gailhabaud collections. They had been sold over the course of two successive auctions at the Hotel Drouot in January 1875. The 1874 *arrêté préfectorial* that authorized their sale declared that these objects "present no interest from the point of view of the history of Paris."[32] The museum's director Jules Cousin dismissed them as a "heap of Italian, Flemish, German, and even French knickknacks, [acquired] haphazardly."[33] Subsequent histories of the museum have similarly rejected their possible historical value by describing them as mostly ironwork sold for scrap. But the auction catalog lists much more than just iron knickknacks. Porcelains, clocks, wooden tools, musical instruments, doorknockers, delftware, bronze works, buttons, nutcrackers, needlepoint tapestries, and "a lot of eighteenth-century clothing" all ended up on the block.[34] The art critic Paul Marmottan, who covered the opening of new rooms at the Carnavalet in 1886, lamented the loss of the iron objects, evidence of "one of the most interesting aspects of industrial art from the sixteenth century until the end of the eighteenth."[35] In their place, the Musée Carnavalet would display objects devoted to the history of Parisian revolution.

Why did the city get rid of the Gailhabaud collection? In the first place, it would have represented an easy source of money with which to replace those items lost in 1871. After the fire, the future collections still included 10,000 historical objects, but many of its prized possessions had been lost.[36] Members of the Service des travaux historiques established long lists of these documents—both archival and artistic—with the intention of purchasing existing copies, where

possible. The Gailhabaud sale raised 40,799 francs.[37] Although this represented a
relatively large sum at the time, it hardly would have permitted the wholesale re-
constitution of books and objects collected over the course of centuries. The de-
cision to sell off these objects must also have stemmed from a desire to break with
the intentions of both Haussmann and the Communards. The auction aligns
with the subsequent denial of Gailhabaud's involvement in the museum that
emerges from the Carnavalet's administrative archives. In 1906, the Service des
Beaux-arts denied that Gailhabaud had ever been "invested with an official post,"
declared that he had certainly never been the museum's director, and dismissed
him as an over-avid collector.[38] Already in 1870, Gailhabaud himself had written
to the Prefect insisting that he alone had been charged with the production of the
museum's "scientific plan."[39] The whole business reeks (as do many of the bureau-
cratic archives of Paris) of personal rancor.

But this move also came out of differing political visions for the Carnavalet.
Critics of the Gailhabaud collection repeatedly disparaged its pan-European
origins. While the Louvre's pan-European collection represented the richness
of France during the Revolutionary period, late nineteenth-century Europe's na-
tional consolidation restrained such international interpretations of heritage.[40]
Even though Parisians had long been European consumers, the Commission
des travaux historiques now rejected the idea that objects from neighboring and
even rival nations could represent the history of the capital. Because Parisian
craftspeople specialized in luxury goods sold to the crown and nobility, it may
not even have been possible to produce exhibits of everyday life with only locally
produced objects. The collection thus did not fit into the developing borders of
the French nation and Paris's place within it.

The collection also stemmed from a now politically passé, magnanimous pop-
ulism that defined the Second Empire. The historian Erika Vause has argued that
through the display of these objects "the Carnavalet was meant to serve as a ped-
agogic inculcation of the shiftless urbanite into the quiet, apolitical, domestic
patterns condoned by the bourgeois ideology of the Second Empire."[41] Had this
collection made it into the museum, the working-class Parisian (had he or she
found the time) would have encountered the quite humble history of his or her
ancestors' increasingly bourgeois patterns of consumption among portraits of
monarchs and officials, commemorative medals, and commissioned paintings.
On the heels of the Commune, this idea must have made city officials nervous.
After all, the republican government had just wrested control of the capital back
from the hands of a truly populist uprising and must have been loath to celebrate
the people of Paris—even if these objects would have told the story of their bour-
geois conversion. Placing previous revolutions at the heart of the museum offered
a way to enshrine Parisian radicalism at the safe distance of a hundred years. By
highlighting Paris's role as the revolution's stage, bureaucrats shifted the museum's

discourse from Paris as the worthy seat of the Second Empire to the birthplace of the Republic and the nation.

The newly conceived museum's curators would also attempt to define their version of history by distinguishing it from earlier history museums that reconstructed and staged the past. Haussmann may have cast the mold for a new model of urbanization, but the idea of a museum that would house the wreckage of historical upheaval was hardly new in 1860. This type of museum first opened during the French Revolution when Alexandre Lenoir, charged with overseeing the storage of artworks confiscated from aristocrats and the Church at the Petits-Augustins convent, organized the storerooms into a public museum: the Musée des monuments français. Starting in 1793, visitors could stroll through rooms organized by period that combined architectural fragments and sculpture with reconstructed decors to evoke the religious and political history of France.[42] In other words, the Musée des monuments français pioneered the idea of displaying historical artifacts in a setting that would help evoke what the art historian Michael Marrinan terms "a specific historical 'feeling.'"[43] Lenoir even led guided visits by torchlight to help bring the ghosts of the past back to life.[44] Lenoir's museum closed in 1815 and its collections were dispersed (many were returned to their original homes). But Paris quickly welcomed another version of these display practices in the Musée Cluny, which opened in 1834.[45] The Musée Carnavalet would be shaped in its early years by the tension between this more romantic idea of history and its scientific mission to document Parisian evolution.

Science, Reverie, and Art in the Musée Carnavalet

Writing in the nationalist daily *Le Gaulois* in 1885, a journalist and self-proclaimed "antiquarian" described two modes of approaching objects from the past. One was embodied by "the historian–collector," the other, "the sensual [*voluptueux*] collector."[46] The first inspected objects "detail by detail, interpreting them without fuss, without commentary, in precise words, as a historian rather than a dilettante."[47] He nonetheless took pleasure in his treasures; he was "completely happy and entirely at ease" only when surrounded by them. But the passion of the second collector burned brighter. Before his display cases, his eyes glittered, he almost swooned with emotion: "he needed to take the piece in his hands, to turn it over and over, to caress it."[48] Rather than two abstract models, the subjects of this article were two equally respected pillars of Paris's artistic and historical circles who had recently died just three days apart: Alfred de Liesville, director of the Musée Carnavalet, and Edmond du Sommerard, head (and son of the founder of) the Musée Cluny. Both were also avid collectors. De Liesville had accumulated the detritus of the revolutionary past, while du Sommerard pursued

his father's passion for medieval history. Their differences could almost stand in for the divisions between the emerging rationalized and primary source-based methods of university-trained historians and the private world of impassioned collectors. But such a reading would polarize nineteenth-century historical practices: ones that in fact existed along a more fluid continuum between the scientific and the romantic. It would fail to understand the prevalent mode of approaching historical objects, which combined an almost scientific attention to detail and method with a passion for resurrecting the past through a direct connection to its artifacts. This approach defined the collections and organization of the Musée Carnavalet as it opened, setting it apart from previous historical museums, and shaped popular practices of research-based and authentic object-based historical reconstruction during the late nineteenth century.

New standards of professional historical research and training emerged in Europe in the last decades of the nineteenth century, but they did so alongside a thriving and publically influential culture of antiquarianism. Beginning in 1870, a generation of young French historians, trained in Germany, would formulate a positivist model of historical study.[49] Their ranks included Gabriel Monod, Gaston Paris, Charles Seignobos, and Charles-Victor Langlois. They rejected a previous model of teaching and publishing, open and accessible to the public, that privileged "style over content, speculative imagination over patient research, and political efficacy over scholarly objectivity."[50] These historians staked out a professional niche within a handful of institutions including the newly established Ecole pratique des hautes études. Their efforts did not, however, undermine the importance of private collectors and untrained historians in the world of public history. Private collectors, as the historian Tom Stammers has argued, "had a direct impact on publications and learned societies, museums, and exhibitions."[51] Those interested in Paris organized the nation's presence at the World's Fairs, ran the spate of historical societies that emerged in these decades, campaigned to preserve the past, and directed public historical collections. In all of these activities, they continued to imagine and reconstruct the past (with various degrees of accuracy), revere its artifacts, and approach the study of history as leisured entertainment.

The successful opening of Paris's historical museum and library depended on the civic engagement of such private collectors. Jules Cousin, who was named director of the Hôtel de Ville library under the Commune, helped rebuild it after the fire. First, in order to end the library's pilfering at the hands of municipal councilors, he argued for the creation of two institutions: an administrative one in the restored city hall and a separate historical library open to the public.[52] He took charge of the latter, housed at the Hôtel Carnavalet. To it, he donated his own collection of some six thousand books and six thousand prints and called on other collectors to do the same.[53] The library opened to the public in 1875. Five

years later, the wealthy aristocrat Alfred de Liesville ceded his own collection of engravings, ceramics, coins, medals, books, and other assorted objects relating to the revolutions of 1789, 1830, and 1848 to the Carnavalet.[54] When the museum opened the following year, Cousin and de Liesville were named cocurators. The museum and library would remain in the hands of private collectors—Lucien Faucou, Paul Le Vayer, and Georges Cain—rather than scientifically trained curators, librarians, or archivists until the first decade of the twentieth century.[55] Their interests and priorities as collectors, including a belief in the historical animism of artifacts, shaped the staging of Parisian history for the public during these decades and beyond.

The museum's objects and organization combined scientific and romantic approaches to the past. Its rooms progressed in chronological sequence from the ground floor to the second floor, which also housed the library and reading rooms. Upon entering, visitors would have moved through displays of prehistoric, Gallo-Roman, and medieval artifacts and fragments of buildings. Ancient tombs filled what had been the building's kitchens. Stacks of large architectural fragments stood along the room's edges, while smaller finds crowded glass cases or hung in intricate wall displays.[56] At the center of the Gallo-Roman and Stone Age room sat a scale model of Roman Paris and its surrounding land (fig. 1.1). More bits of buildings and statues lined the stairs that led to the first floor, where stone floors and exposed beams gave way to parquet floors and elaborate paneling. There, visitors encountered Paris from the Renaissance through to the contemporary period. A wood-paneled cabinet displayed printed and painted views of the capital, while in the Salon Dangeau, they could admire mirrors and gilded paneling alongside oil paintings and artist sketches. This floor contained a reclaimed room from a Place des Vosges townhouse with ceilings painted by Charles Le Brun as well as the revolutionary collections (fig. 1.2).[57] Here, artifacts were displayed alongside the former possessions of revolutionaries: "the walls are hung with paintings representing the different phases of the siege of the Bastille, bundles of weapons, phrygien caps, fans, the painter David's last palette donated by one of his students, a decimal clock, etc." (fig. 1.3).[58]

By placing artifacts within an authentic decorative cadre, organizers hoped to forge the visitor's own relationship with the past on the model of the collector's. This mode of historical reverie would set the museum apart from other more popular contemporary entertainments such as the diorama and the wax museum, which tangibly reconstructed past scenes for the visitor. Indeed the Musée Carnavalet opened as these competing spectacular visual depictions of historical and contemporary events were at the height of their popularity. Parisians flocked to the Musée Grévin, which opened in 1882, and to the series of dioramas and panoramas whose revived popularity marked the decade.[59] But while these dynamic forms of entertainment drew Parisians to the newly constructed

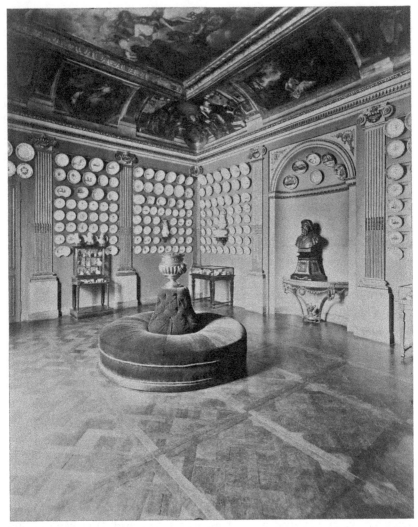

FIGURE 1.2 Pierre Emonts, *The Liesville Room*, in *Le Musée Carnavalet*, 1892. Bibliothèque nationale de France.

boulevards—themselves sites of a form of urban spectacle—the Musée Carnavalet brought visitors to a distinctly unpopular, almost backwater, neighborhood and put their imaginations to work.[60] The streets of the Marais, according to one art critic, "exuded" the past, but they "no longer offered the picturesque spectacle of carriages, and gentlemen with capes and swords."[61] Inside the museum, architectural and interior design elements from the sixteenth, seventeenth, and eighteenth centuries similarly telescoped the past into the present. While some of these were original to the building, others were scavenged from recent demolitions and

FIGURE 1.3 Pierre Emonts, *The Great Room of the Revolution,* in *Le Musée Carnavalet,* 1892. Bibliothèque nationale de France.

used to decorate the newly added wing of the museum. The Englishman Frederic Harrison commented that the visitor "can almost cease to believe that two hundred years have passed since the greatest of letter-writers [Madame de Sévigné] used to sit in the same room with the same ornaments, labouring at her daily task of love, or receiving the brilliant literary society of her age."[62] This mode of encounter with the past relied on visitors' preexisting knowledge of Parisian history. It depended on their ability to date architectural elements and call to mind

the lives of historical figures. The Musée Carnavalet would have been opaque to visitors—be they foreign or working class—who lacked this rich understanding of the city's past.

Despite the fact that the museum so heavily relied on the invisible historical knowledge of its visitors, it did present a visual narrative of Parisian history through city views, maps, and scale models. The same critics who praised the museum's ability to engage the visitor's imagination also commended its presentation of city history as the science of observation. Paul Marmottan explained how these images of the city were "intended to so keenly strike the eyes," the privileged organ of Enlightenment science.[63] These displays replaced the vagaries of imagination with precise documentation. Marmottan unwittingly parroted Charles Poisson's proposition that the topography room would "present to the eyes the growth of the City's boundaries during its different eras."[64] Indeed, Frederic Harrison dubbed the museum a foremost global model for "scientific history of the city."[65] Although there was much in Paris "which no sensible Englishman would desire to imitate," he conceded that institutions such as the Musée Carnavalet represented "a model for the civilised world to follow [. . .] which must fill Londoners with wonder and envy."[66] Visual reconstructions of urban forms—not events—thus formed the basis for the museum's claim to scientific history.

While the Musée Carnavalet's displays certainly seem more rigorous than the historical scenes on display at the Musée Grévin, the newly professionalizing historical community still would have rejected labeling them as scientific. In their 1898 manual of historical methodology, the historians Charles-Victor Langlois and Charles Seignobos insisted that history "is not at all, whatever one might say of it, a science of observation."[67] They counseled that "in history, *one sees nothing* of the real but writing on paper—and occasionally monuments or the products of manufacture."[68] This method, then, which helped university professors train generations of students, decreed that the historian must always work with documents of a secondary order and study the past through analysis and interpretation.[69] The historian did not directly commune with the past through images and artifacts. The historical profession thus distanced itself from scientific visual history as practiced in museums.

The successful implementation of the museum's expository mode of history, which allowed visitors to compare the city during different periods, also conflicted with the Musée Carnavalet's aesthetic prerogatives. The museum's curators, who themselves found not only scientific but also aesthetic pleasure in the objects they collected, sought to transmit taste and beauty to the public. They were limited, however, by the materials at their disposal. Critics praised the work of engravers, who had produced detailed views of major events as well as streetscapes.[70] But they pointed out the dubious aesthetic value of the paintings

hanging near them. Harrison, for example, declared the latter lacked "any artistic merit."[71] Unfortunately, the restrictive hierarchy of genres espoused by the French Academy, which privileged monumental history painting over genre scenes and limited the acceptable subjects within those categories, meant that many of the best painters of each generation never thought to touch Parisian subjects. Artists had only very recently embraced such scenes as acceptable subjects of a new mixed genre of history painting. Nonetheless, belief in the scientific value of city depictions pushed curators to display previous works in the topography rooms. Curators and visitors had to look past their poor quality, reminding themselves that, as Charles Poisson had explained in the 1860s, "a painting that is mediocre from the point of view of art deserves sometimes to be classed as a first-rate historical document."[72] Even second-rate paintings could provide first-rate perspectives on Paris's transformations.

The tension between historical accuracy and artistic merit had troubled organizers even before the museum's opening. Throughout the 1860s, the Commission des Beaux-arts commented on both aspects when acquiring works for the city's collections. In 1861, for example, the body refused to purchase two paintings depicting old Paris because "they d[id] not offer sufficient historical authenticity."[73] Similarly, in 1864, its members declined an artist's offer of eighty views of vieux Paris because they lacked historical accuracy and were poorly executed.[74] They did, however, decide to purchase an album of etchings, despite "regretting that the artist had sometimes overlooked, in his picturesque and thoughtful drawings, the exactitude that would have given them the value of historical documents."[75] In other words, the artistic value of the latter series made up for its lack of verifiable detail, but it seemed difficult to justify the purchase of aesthetically impoverished work. As they discussed the acquisition of an album comprising photographic reproductions of sepia drawings of the "principal views" of the Bois de Boulogne, the Bois de Vincennes, and the Parc Monceau, members of the commission hesitated to purchase a large collection of works in such a technical medium. They suggested that the artist reproduce his drawings as etchings (and cull half of the one hundred proposed). Or, better yet, they asked why they could not simply purchase the original drawings, thus ensuring that "the city would become the owner of a work of art with real value."[76] Photographic copies would not suffice.

The still relatively new medium of photography held a vexed place within the creation and organization of the historical museum and library. The Commission des travaux historiques certainly embraced photography's potential. Photographs facilitated deliberations in all manner of city commissions, whenever preservation or acquisitions were discussed. Photographing Paris was also part and parcel of the Commission's work. It funded the creation of Lacan's Atelier iconographique and its production of photographic views. Even after the dissolution of the Atelier,

the Commission continued to debate the relative value of various types of image reproduction technologies, including carbon prints, chromolithography, and heliogravure, both in terms of cost and the benefits for readers.[77] Once the museum and library had opened, their staff continued to conceive of photographs as tools. The institutions purchased and received donations of photos for their study collections.[78] Many depicted paintings and engravings, which allowed researchers access to materials the library did not own.[79] They would also serve to document the history of the museum itself: in 1892 the Musée Carnavalet hired Pierre Emonts, a photographer—not an engraver or a watercolorist—to capture its exterior, rooms, and displays.

Photographs thus played a technical role in supporting historical activities at the library and museum. By the 1890s the library boasted an impressive collection of prints, maps, and photos separated into boxes by subject matter, with separate files for topography, history, portraits, and customs. In the museum, then, photos might help a researcher verify some detail of Parisian history, but they did not serve to evoke the past in its public rooms. In 1903, only two photos figured among the nearly one thousand objects that displayed the history of Paris since the sixteenth century.[80] That photography should play a behind-the-scenes role in supporting the museum's activities should come as no surprise. After all, even the most outspoken nineteenth-century critics of the new medium admitted that it presented unparalleled technical support for researchers and artists.[81] In the delicate balance between historical accuracy, romance, and the artistic value of the museum's displays, photography's very utility as a technical aid must have cast it too far on the side of science to fit into the romantic and aesthetic displays of the museum. Its ties to the mass culture of the boulevards, where Parisians and visitors alike sat for portraits and purchased likenesses of the era's celebrities, may have created a further incentive—one of maintaining respectability—that guaranteed photography's relegation to the study rooms.

When Jules Cousin retired in 1895, the museum and library split. Paul Le Vayer took over as director of the library, and the artist and collector Georges Cain became the museum's new chief curator. Le Vayer managed the library's 1898 move to the adjacent Hôtel Le Peletier de Saint-Fargeau and the division of the museum's collections: the library took the books, periodicals, and all of the bound volumes of images, while the museum retained the rest, including the loose topography files. This split should have differentiated the two institutions' missions and publics between a mandate for public history and a responsibility to cater to the needs of specialized researchers—or at least the literate and leisured portion of the public who had the time to frequent reading rooms. After all, museums and libraries have distinct identities. The separation of the Carnavalet and the Bibliothèque historique, however, did not effectively do so. The museum would maintain a small library and study rooms catering to researchers, while

the library would, beginning in the first years of the twentieth century, stage public exhibitions and undertake the historical education of the wider populace. Separated at first by only a wall and then, after 1969, a narrow street, the two institutions would collaborate but also often compete for the same audience interested in the city's past.

Under Cain's direction, the museum would increasingly focus on the mission of the public's aesthetic education. First, he extended its opening hours. In 1889 it only welcomed visitors on Thursdays and Sundays from 10 am until 3:30 pm.[82] In 1903, they could stay until 4 or 5 and also visit on Tuesdays.[83] By 1912, the museum was open six days a week.[84] They could also see more, for Cain reshuffled existing rooms and added new ones devoted to politics (the revolutions of 1830 and 1848; Paris during the Commune), topography (rooms consecrated to the Palais Royal and Hôtel de Ville included scale models), and culture (the theater; Parisian fashion).[85]

Upon the Carnavalet's reopening in 1898, contemporaries declared it an artistic success. The critic and collector Jules Claretie suggested that Georges Cain had achieved his goal of creating an "artistic dwelling where the crowd could, with its eyes, take in simultaneous lessons in history and art."[86] Almost ten years later, the praise continued. Cain had started with a "rich mess," wrote Arsène Alexandre, left by those who "did not care so much for artistic taste as for documentation."[87] The director had turned the museum "into one of the prettiest to be seen."[88] Alexandre predicted that the recently opened new rooms would appeal to an educated but not necessarily specialized public: they would be visited "by artists, by enthusiasts of beautiful and refined coziness [intimité], by women even, searching for an idea for an arrangement or for a place to dream about the past."[89] While one might be wary of taking these men's word for the success of the museum—or even the words of socialist John Labusquière, who reported that the Carnavalet had finally taken its place among the world's best museums—a 1912 American guidebook offers more substantial proof.[90] It warned to avoid the Carnavalet's biweekly free afternoons when its "tiny rooms render it insufferably crowded."[91]

Romantic Reconstruction and Visual Historiography

Cain's selection and success as the museum's chief curator speak to the scientific rigor, historical animism, and artistic appreciation operating within the same institution. As an artist, Cain had produced the epitome of this type of historical work for decades. Recent scholarship usually remembers Cain as the director of the Carnavalet or as a popular author—a role he took up later—but he began his career as a visual artist specializing in historical reconstruction. Cain the painter drew inspiration from the romantic pull of past artifacts. He also studied

documents to depict them as part of historically accurate scenes. He was hardly alone in his interest in developing a method for producing scientific historical reconstructions of Paris: he joined Fedor Hoffbauer and Albert Robida as the celebrated practitioners of their day. Robida worked as an illustrator, journalist, and novelist, publishing both histories and clever visions of the future. He designed the immensely popular "Vieux Paris" display, complete with medieval drinking halls and Renaissance shops, for the 1900 Exposition universelle. He has also received much attention from scholars.[92] But Hoffbauer and Cain's contributions have largely been forgotten.

Their activities spanned a range of artistic production. Cain regularly exhibited oil paintings at the Salon. Like many works presented at the biannual competition-cum-marketplace, these also circulated as engraved and photographed copies. Hoffbauer produced drawings and watercolors of reconstructed historical scenes for scholarly publications and created a diorama of historical Paris. All three combined the pull of the artifact with the rigor of documentary research. As they channeled the object's direct connection with the past into visual representations, they improved on evidence in order to better engage the viewer's imagination. And yet even in doing so, they fell in different places on the continuum between the scientific and the romantic. The rejection of their historical modes would play a critical role in structuring the scientific method of visual history that emerged at the Bibliothèque historique in the early decades of the twentieth century and lived on in subsequent practices of photographic history.

Born into Paris's artistic elite in 1850, Georges Cain possessed both the fervor of the collector and the technical abilities of the artist. His father, the sculptor Auguste Cain, had gained renown for his dramatic scenes of animals. According to his friend the critic Jules Claretie, Cain grew up in a particularly cultured Parisian milieu: "They loved the theater, meals with friends, chats in their *home* [sic] covered with artworks, with mementos of old friends, the drawings of Charlet, Raffet, [and] views of Paestum by Gérôme."[93] Cain's interest in the city's history dated from such childhood experiences. As an adult, he would describe, for instance, the thrill of perusing Charles Meryon's Paris prints.[94] He trained as a painter and worked successfully as an illustrator, curator, journalist/critic, and author/historian. Paris provided the unifying thread for all of these activities. As one of his obituaries elegized in 1919, Cain, "Parisian at heart, loved his city with a fervent passion."[95] That passion also extended to art. The obituary mentioned him in the same breath as the Goncourt brothers, contemporary collectors who mourned the loss of the Old Regime by avidly accumulating eighteenth-century, rococo objects.[96] Cain's collection, sold at auction after his wife's death in 1939, with its sixteenth- and seventeenth-century furniture, sculpture, and decorative pieces, as well as ivories, jades, and art from Asia, would have been the envy of many nineteenth-century collectors.[97]

Cain's collections did not just inspire him to historical reverie; he transcribed that imagined world into his works. For example, his painting *Le sculpteur Pajou faisant le buste de Mme du Barry* (1884) was likely inspired by the Pajou terracotta bust of the king's mistress in his possession (fig. 1.4). The painting, which was exhibited at the 1894 Salon, presents the sumptuously dressed Madame du Barry seated in front of the artist, while a crowd of eager courtiers look on and chat among themselves.[98] The statue is hardly a work in progress, though, which supports the idea that Cain worked directly from the completed object. An 1896 report of a visit to his studio describes an abundance of historical artifacts that doubled as costumes and set pieces for his models. These included furniture as well as "wonderful fabrics, historical clothing (such as this skirt of the [Countess of] Dubarry, a background of blue of France, embroidered with a D in forget-me-nots and the L of Louis XV in oleander)."[99] In his composition, the King's favorite indeed wears an embroidered floral skirt. The ghosts of the past it contained helped turn the studio models into historical actors. Critics credited Cain's use of historical objects and dress with giving his work authenticity.

Unlike many of his contemporaries, Cain favored the relatively recent past. Although his choice of subjects suggests a weakness for the Directory, he also depicted the revolutions of 1789 and 1830 and nineteenth-century bourgeois

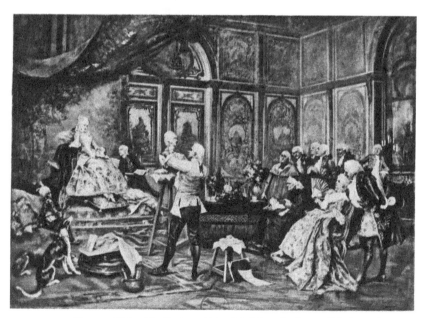

FIGURE 1.4 Georges Cain, *The Sculptor Pajou Modeling the Bust of Madame du Barry*, 1884. Reproduction by Jules Hautecoeur; Imprimerie Chardon et Lormani. Bibliothèque nationale de France, Cabinet des estampes.

set pieces. This range set him apart from contemporary painters and collectors. Historical genre painting first exploded in popularity in the early nineteenth century, alongside renewed interest in the medieval period. Painters of the so-called troubadour style meditated on the fragments of the lost monarchy with scenes of royal and aristocratic drama and piety.[100] Over half a century later, historical and political nostalgia still motivated Cain's fellow collectors. De Liesville, for example, collected Revolutionary objects, while the Goncourts and others mourned the loss of the monarchy, Catholic France, and all its lifestyle had to offer the upper classes.[101]

Cain's oeuvre coheres around an investigation of personal and political turning points, rather than any single lost regime. Three of his revolutionary scenes, all shown at the Salon, portray Marie-Antoinette leaving the Conciergerie on the day of her execution, the suicide of the last Montagnards, and a revolutionary tribunal during the Terror (*Marie-Antoinette quitte la Conciergerie pour l'échafaud* [1885], *Le suicide des derniers Montagnards* [1897], and *Un tribunal sous la terreur* [1881]). These works display a clear sympathy for the fallen aristocracy: Marie Antoinette's straight-backed ascent of the prison stairs lends her much more dignity than Jacques-Louis David's sketch made that day (fig. 1.5).

FIGURE 1.5 Georges Cain, *Marie-Antoinette Leaving the Conciergerie for the Scaffold*, 1881. Reproduction by Jules Hautecoeur; Imprimerie Chardon et Lormani. Bibliothèque nationale de France, Cabinet des estampes.

David's Marie-Antoinette is haggard. Her wispy hair sticks out straight from beneath her bonnet. Cain's fallen queen is still dressed in snowy white lace, her hair neatly gathered at her neck. Her hands may be bound, but she walks on her own, in control of her own destiny. There is much menace and little room for order in the slouching suspicious judges, the violently pointing crowd, and the paper-strewn makeshift courtroom in *Un tribunal sous la terreur*. The paintings, however, do not condemn the revolutionaries. Rather they highlight the contingency of history, the banality of life, death, and change on the national stage.

A similar taste for drama animates Cain's depictions of the Directory, be they quotidian scenes such as the celebration of a marriage or events of more political import, such as his 1895 Salon entry of street celebrations after the news of Napoléon's 1797 victory in Italy and his 1893 entry of the pathos of Napoléon's abdication. In the latter, the lone figure with his characteristic bicornered hat descends a monumental staircase at Fontainebleau (fig. 1.6). And yet Napoléon's move from darkness into the light of the courtyard hints at his thoughts of a comeback. Cain's quotidian scenes of Parisian life lit on smaller dramas, such as the day's news read from *Le petit journal* by a concierge to her building's residents or the arrival of a new maid in a bourgeois drawing room. Throughout the range of times and places he depicted, Cain betrays a penchant for the cusp of historical change: the meetings, news, and actions that shifted the destiny of their participants and, often, the nation.

As a painter, Cain explored the boundary between accuracy and drama. Critics commended his attention to both. A review of his *Le buste de Marat aux piliers des Halles* (1880) declared, "the ceremony is perfectly reconstructed in its historical and picturesque truth."[102] This authenticity thus hinged not only on the characters and events he depicted but also on how he did so. Cain's paintings bristle with details—silver serving sets, wallpaper, curtains, hats—each of which adds another layer of "historical truth," another layer of research into the objects and habits that animated the past. The "picturesque truth" consisted of improving on these details, of setting them in an idealized scene to make them most compelling to viewers. Another critic described this combination when he referred to Cain as "a storyteller who relives the past with delight, who tastefully restages its spirit, humor, and costume."[103] Cain would bring the art of the anecdote to the museum, where he encouraged visitors to appreciate the story or historical scene to which each object gave access.

Although Fedor Hoffbauer fell distinctly on the scholarly end of the historical continuum, he too worked to create the same sort of intimate relationship with the past by translating documents into detailed historical reconstructions. Born in Germany and naturalized French in 1873, Hoffbauer began his career as an archaeologist and architect.[104] His drawings, for example, appeared in Viollet-le-Duc and Félix Narjoux's 1874–1875 *Habitations modernes*, a compendium

FIGURE 1.6 Georges Cain, *Napoleon I at Fontainebleau, After His Abdication, 1814,* 1893. Photo by Daniel Arnaudet. Musée national du Chateaux de Malmaison et Bois-Préau, Rueil Malmaison, France. ©RMNGrand Palais/Art Resource, NY.

of modern architecture across Europe.[105] Their meticulous attention to detail conforms to the contemporary genre of pen and ink architectural drawings that graced architectural publications such as César Daly's *Revue générale de l'architecture.* In 1867, the city of Paris commissioned Hoffbauer to produce a series of watercolors showing its streets and neighborhoods before the transformations of Haussmannization. Given that, in some areas, demolition was already underway, Hoffbauer likely turned to older views of Paris in order to aid this work.

Upon his death, one of his fellow members of the Commission municipale du Vieux Paris credited this commission with showing Hoffbauer his true calling.[106]

From this point forward, he focused his energies on meticulous reconstructions of historical views. The first major output of this work was the dozens of illustrations published in *Paris à travers les âges*.[107] The book's large expensive format and dense text targeted erudite and wealthy audiences. But Hoffbauer was also keenly aware of the pull of boulevard culture and its particular visual spectacles. He transformed these drawings into a more widely accessible form, a diorama, which might bring Parisian history to a mass audience.[108] Unlike a panorama, which provided one continuous scene, the diorama offered windows onto separate—in this case eight—views. The "Diorama of Paris Through the Ages" opened at the Carré Marigny on the Champs-Elysées in 1885 and ran for two years. After it closed, Hoffbauer became active in the Salon, exhibiting works in 1887, 1890, 1891, and 1892. Around the turn of the century, his interests shifted again, this time toward Italy. Hoffbauer drew successive views of ancient Rome and Pompei and published *Rome à travers les âges* in 1905.[109] At the end of his career, however, he returned to Paris, constructing a series of scale models of the city in successive periods, one of which is still on view at the Musée Carnavalet today.

In contrast to Cain's more romantic approach, Hoffbauer's reconstruction practices aligned him more with the scientific practices of "historian-collectors." He mined libraries and archives. Jules Cousin's preface to the first volume of *Paris à travers les âges* explained the breadth of sources that Hoffbauer consulted over a decade of research. This list of only the "principal" documents, which includes maps, drawings, and prints dating back to the sixteenth century as well as photographs from the nineteenth, takes up almost four folio-sized pages. Cousin credited the city's historical library and museum with making this research possible and dubbed the book their "first suckling-child."[110] Its texts, authored by experts such as Cousin, Edouard Fournier, and Paul Lacroix, were the product of the community that had sprung up around Parisian history in the previous decades. Even so, Hoffbauer had hoped to publish his images without these lengthy chapters, in order, Cousin explained, to allow his reconstructions to form "a series of scenes, passing rapidly before the reader's eyes."[111]

The plates of *Paris à travers les âges* compiled disparate information and vistas into a rational succession of views taken from exactly the same point in the city. Cousin dubbed them a "chronorama," a view of the city across time:

> where the most picturesque perspectives of vieux Paris appear successively, aging or rather becoming younger from era to era in the same rigorously fixed frame. As if the spectator, placed at a window opened onto a chosen point in the city, saw unfurling before his eyes the various aspects of this same perspective presented from century to century.[112]

Cousin describes watching a time lapse of the capital, in which buildings appear and disappear, streets grow wider and brighter, and, in every view, the charms of medieval Paris succumb to the ugliness of its modern form.[113] The book and its images received glowing reviews. One explained that the latter allowed readers, "book in hand, to take themselves to exactly the same view point and mentally turn back the clock through the centuries."[114] The images functioned as a "diorama. . . where the effect of day, night, snow follow one another on the same painting, except here it's a matter of variations in time not optics."[115] The opening of *Paris à travers les âges* on the Champs-Elysées thus represented a logical (and successful) extension of the book. A journalist writing in *Le Correspondant* criticized the diorama for skipping from the fourth to the sixteenth century.[116] He nonetheless praised the paintings for their "admirable exactness."[117] Taken together, they offered a "living voyage through the past" which proved better than any existing textual account.[118] One of Hoffbauer's fellow members of la Société de l'histoire de Paris et de l'Ile-de-France suggested mandatory visits for Parisian children, since "it's through the eyes that object lessons are best learned."[119]

Critics credited the success of Hoffbauer's images to his detailed historical research, artistic prowess, and use of new visual technologies. The same journalist who lauded the book as a diorama also declared that "until now not a single work of this importance and merit has been published on this same subject."[120] A report presented to the Municipal Council dubbed it "the most extraordinary and interesting book to be published about the history of Paris in a long time."[121] Hoffbauer's work made the "historian-painter" a darling of Parisian historical circles. After the diorama closed, the Musée Carnavalet acquired and displayed its paintings, and his career culminated with his 1912 nomination as a member of the Commission municipale du Vieux Paris.[122]

The pictures of *Paris à travers les âges* themselves argue for the advantages of reconstructions over original documents, indeed even over photographs of the same scenes. Hoffbauer, like today's historians of nineteenth-century Paris, used Charles Marville's photographs as documents of the city before Haussmannization. Hand-copied prints of several appear set within the chapters' text, and Hoffbauer's reconstruction of the marché des Innocents in 1855 is nearly an exact copy of Marville's photo of the same scene (figs. 1.7 and 1.8).

His depiction faithfully transcribed some details, such as the arrangement of cloth awnings, umbrellas, and figures. But he also corrected the photograph's limitations. He pulled the camera's perspective back away from the central fountain in order to keep the same view as his other images (fig. 1.9). This larger field depicts more of the square's activity. Hoffbauer also transformed the photograph's blurred figures into distinct portraits of market sellers, identifiable by their wares and dress. The watercolor (and its chromolithographic reproduction) becomes the snapshot, freezing the motion of the square into legibility. Only the cascading

FIGURE 1.7 Fedor Hoffbauer, *Le marché des Innocents (1855)* in *Paris à travers les âges*, 1875–1882. Courtesy MIT Libraries.

FIGURE 1.8 Charles Marville, *Le marché des Innocents*, 1855. Musée Carnavalet/ Roger-Viollet.

FIGURE 1.9 Fedor Hoffbauer, *Le cimetière des Innocents (1550)* in *Paris à travers les âges.* Courtesy MIT Libraries.

water retains its photographic blur. It also adds color to the scene: shades of red, blue, and green to the vendors' umbrellas, a warm rich brown to the roofs of the pavilions lining the square, and a lighter version of the same color to the fountain itself. Hoffbauer thus used his imagination to animate what a photograph could only suggest. In doing so, this image proposes the limitations of not just the photograph but of the primary document in general—which could only capture certain details and not a total view.

By the twentieth century, however, visual historical reconstructions no longer held the same appeal for erudite and amateur audiences. Parisian history buffs and staff at the Musée Carnavalet and the Bibliothèque historique still sought out artists' depictions, but now they preferred views that the artist might actually have seen. In 1899, the Société de l'histoire de Paris et de l'Ile-de-France published an inventory of works depicting Paris on display at the Salon. Its author noted that "the list only includes documentary works, those for which the author had truly had the represented subject before his eyes."[123] He went on to say that readers might thus notice the absence of both of Albert Robida's entries (*Aumônes à la recluse du cimetière des Innocents* and *Le Pont aux changeurs*).[124] Georges Cain must have foreseen this shift in taste, for he submitted his last Salon entry in 1900. As curator of the Carnavalet, he remained an important figure in Parisian history, but from this point forward, Cain wrote history instead, reconstructing scenes and anecdotes in print rather than on canvas.

Although Fedor Hoffbauer remained personally influential in the capital's historical circles, his work too fell out of favor. In 1906, concerned about the lack of space in the storage rooms at the Musée Carnavalet, the curator Charles Sellier wrote to the Inspecteur en chef des Beaux-arts suggesting that they get rid of "several other objects, which have long been in temporary storage, and which, devoid of any documentary character, have no utility for the Musée Carnavalet."[125] The useless things taking up space were none other than "the old dioramas of Mr. Hoffbauer" as well as "the panoramas of Mr. Ch[arles] Normand," which had been exhibited at the second Congrès international d'art public, held in Paris in 1900.[126] The paintings were ultimately transferred to the museum's warehouses on the quai Saint-Bernard and left to deteriorate.[127]

The decision to all but discard this work reveals the changing meaning of the term "documentary" and with it a shifting conception of the continuum between scientific and romantic historical practices. While "documentary" had referred to objects produced in consultation with historical documents, it now indicated something produced as part of an act of direct witnessing. The scientific nature of the document's relationship to the past had been rooted in the collector's approach to it. Now it depended on the nature of the document itself, and only certain types of objects and images could bear accurate witness to the past. The shift in this definition narrowed the possibilities of the categories of texts, images, and objects that fell within scientific historical practices. In the first decades of the twentieth century, it formed the basis for the elaboration of a method of scientific visual history—and fundamentally altered the role of photographs in historical research.

Visual History's Scientific Method and the Role of Photography

In 1906, the same year that the Musée Carnavalet curator suggested putting Hoffbauer's diorama out with the trash, Marcel Poëte took over as director of the Bibliothèque historique.[128] Poëte's selection likely came as no surprise, for since being hired in 1903, he had demonstrated an ambition to expand the library's public mission. Over the course of the next decades, Poëte would organize lectures, seminars, and exhibitions to bring the newest methods and results of scientific history to the Parisian public. As he ranked historical documents according to their usefulness, Poëte outlined a new method for visual history. While Poëte may have best articulated this method, he did so in response to a general movement among Parisian historical circles to determine how the wealth of images amassed in municipal collections would serve to write the city's history. Poëte and these Parisian collectors and

historians defined visual hierarchies, placing images along a new continuum between the evocative or romantic and the factual. In the process, Poëte's would be the first Parisian institution to articulate the historical importance of photography.

Unlike the founders of the Musée Carnavalet and the Bibliothèque historique, Poëte was not a collector but a trained archivist. He graduated from the Ecole des chartes, which was one of the first institutions to teach a positivistic scientific approach to the past through documents.[129] *Chartistes*, as they are still called, trained in the technical methods of history, which included paleography, numismatics, epigraphy, and comparative philology. They learned to conceive of history as the process of tracing events through the detailed study of documents rather than the colorful resurrection of the past through rhetoric, flowery prose, or visual and material reconstructions. In other words, they received very similar training to the newly professionalizing university historians. Poëte would attempt to bring these methods to the greater public, making the Bibliothèque historique a widely inclusive yet scientifically grounded institution for the study of Parisian history.

Under Poëte's direction, the library attracted a much wider audience. He sought to increase scholarly traffic in the reading room by inviting the city's historical societies to use the library as a meeting space. He even suggested that their members might work as volunteers on the institution's projects.[130] But the library did not limit its appeal to those already interested in Parisian history. Between 1903 and 1913 the Bibliothèque historique organized a series of exhibitions whose themes included "Paris during the Romantic Age," "Paris in 1848," and "The Transformation of Paris under the Second Empire." These exhibitions provided an opportunity for "visual teaching" (reminiscent of the Musée Carnavalet's aims) achieved through the combination of "a limited selection of items grouped as methodically as possible, each one accompanied by an explanatory label and presented by the means of a free leaflet."[131] While such displays targeted a literate audience, the emphasis on explicative text would have made them more accessible to nonspecialists.

The library's exhibitions were, by all measures, successful. Between four and six thousand visitors attended each, with the most—6,180—turning out for the 1908 "Paris during the Romantic Age."[132] Critics and journalists across the political spectrum praised Poëte for making good history available to the masses.[133] Word of them carried across the Atlantic: a journalist writing in the *New-York Tribune* deemed the 1908 exhibition "well worth a visit."[134] While the critic Arsène Alexandre had praised the artistic quality of the Musée Carnavalet, he credited the Bibliothèque historique with didactic success, declaring that Parisians had to see the 1910 exhibition about Haussmannization in order to better understand contemporary urban renovation projects.[135]

The Bibliothèque historique's new pedagogical mission extended beyond the stuff of Parisian history to teaching those who frequented it—from members of historical societies to the larger public—a scientific method for producing their own historical studies. With this goal in mind, Poëte began a series of public lectures in 1903. In their second year, these focused on methodology and sources, a topic to which Poëte returned again and again in public talks as well as in the first pages of his books. In that year's opening session, he reminded his audience that even "if history is not, properly speaking, a science, it must at least benefit from scientific methods."[136] The latter involved identifying and ranking different categories of documents and the approaches they demanded.

Archival documents came first. They offered the "impersonal element of history, [its] raw materials" and were thus the most reliable.[137] Published chronicles, accounts, and histories, whose "knowledge of facts come through an intermediary," came next.[138] Poëte listed literary sources last, admitting that although much less transparent, the study of "certain works" could "give us a more accurate idea of past society than . . . the examination of archival documents or the reading of chronicles."[139] Objects and images, which helped evoke a reverie of the past, fell into the same category as literature, for as Poëte explained, "out of the feeling that they provoke in us emerges a fully formed impression of the past."[140] The librarian Etienne Charles reformulated this idea in 1907, writing that "graphic documents . . . often inform us better and more exactly about life and habits than books and . . . in any case have a power of evocation that books hardly possess."[141] Poëte and his staff continued to believe in the image's almost magical connection to the viewer's imagination.

But while Poëte was content, in 1903 and 1904, to define the image's relationship to the past just as vaguely as his predecessors had, only a few years later, a group of Parisian history buffs—including Georges Cain and other employees of municipal institutions—identified a need to hone this methodology. To that end, they established the Société d'iconographie parisienne in 1908. The Société's charter lays out three main goals: to bring together like-minded iconophiles, to catalog pictures of Paris available in public and private collections, and to "contribute to the establishment of a critical method to determine the representation's correspondence to the reality of things."[142] Its members did not intend to compete with existing groups—such as the Commission municipale du Vieux Paris and the Société d'histoire de Paris et de l'Ile-de-France—but rather to build on their efforts. In large part this work involved defining and promoting the use-value of existing archives.[143] A later history of the society explained that up until this point historical research had relegated the image to a "modest, humbled, almost even childish, role."[144] But they were also responding to the problem of eyewitnessing. In a world in which Hoffbauer's work was no longer rigorous, which images could be deployed scientifically?

Photographs would seem one logical answer. But the Société d'iconographie parisienne resisted their ubiquitous presence. Its educated bibliophiles were interested in works of art. And photographs were not considered art. After the disastrous winter of 1910, when the Seine rose more than twenty-eight feet and submerged much of Paris, the society printed a series of paintings and watercolors that might serve as documents for future historians. Despite the accompanying flood of photographic views, often sold as postcards, the compendium did not include a single one. The group had chosen not to publish them, for "no matter their precision or the ingenuity of their operators, it was more interesting, above all more lively, to search for painted works by artists intrigued by current events; one cannot compare the photographic *objectif* [meaning lens but also objectivity] and the talent of the painter taken with the story."[145] There are two sets of values at work here. First, the Société d'iconographie parisienne judged the photograph too objective. Paintings and drawings were infinitely more interesting, for they offered up artistic interpretations of the scene.[146] Second, the group's members were collectors, for whom the hunt was as important as its results. Just about anyone could buy a mass-produced photographic postcard on the street. Tracking down the unique object demanded social networks, time, and money. Photography held no appeal in this rarified world.

At the same time, however, Marcel Poëte and the staff of the Bibliothèque historique began to prize photographs. The library's exhibitions included them instead of prints or paintings whenever possible. The 1910 show about the Second Empire's renovations of Paris, for example, displayed then lesser-known photos taken by Marville and Richebourg instead of Hoffbauer's well-respected reconstructions. In part, Poëte's use of photographs must have stemmed from a desire to promote the library's collections. In a 1908 speech to the members of the Société d'iconographie parisienne, he had vaunted the institution's "exceptional collection of several thousand photographs of which the oldest date back to the nineteenth century and which have neither been put up for sale nor distributed."[147] But Poëte's prioritization of photographs also demonstrates an emerging interest in the medium as an objective eyewitness to history. During a public lecture that same year, Poëte described the inconsistency of historical memory and imagination. He marveled at how many times he had noticed that "this or that visitor's memories, in the presence of our exhibited objects, hardly matches another's."[148] While the historical object might evoke the ghost of the past in the mind of the visitor, the curator had no control over the shape, size, or behavior of that ghost—and no way of verifying what it looked like. It was thus nearly impossible to make the experience of historical reverie consistent and reproducible for the public. Photography, however, could help solve this problem. The photograph, Poëte proclaimed, was "the veritable document in the rigorous sense of the word!"[149] There was no need to worry about the historical

imagination with the photograph, for it showed viewers the city exactly as it had been.

By the early twentieth century, photographs had also simply become the default medium for urban documentation. The concurrent work of the Commission municipale du Vieux Paris to compile traces of buildings and streets slated for destruction had, out of practical concerns, largely been reduced to acquiring photographs. Oil paintings and watercolors were both too hard to store and much more expensive than photographs. Marcel Poëte and Edmond Beaurepaire, who oversaw the library's photo collection, followed this model, buying photos of old streets, buildings, and architectural details. In 1907, Poëte also obtained Georges Cain's agreement to send the library a copy of each photograph deposited at the museum by the Commission municipale du Vieux Paris.[150] With these purchases and donations, the Bibliothèque historique accumulated a vast photographic archive of the traces of sixteenth-, seventeenth-, and eighteenth-century Paris. Poëte, after all, believed that these traces of the past allowed for the direct observation of previous eras that lay at the heart of rigorous urban historical inquiry.[151]

The Bibliothèque historique's collections also grew thanks to Poëte's belief in the future usefulness of photos of contemporary Paris. While around him, other institutions and amateur societies sought to document traces of the past before they disappeared, Poëte mobilized the Bibliothèque historique to capture history as it was happening.[152] After the 1910 flood, the library purchased thousands of photographic prints and postcards of the city under water.[153] The journalist and collector Henri Lavergne commended Poëte's purchase. "Photography is the history of the future," he wrote.[154] Thanks to the Bibliothèque historique and its "museum of photographs," he continued, "we can say that our successors, nephews, great-nephews, and great-great-nephews will be all the more knowledgeable about the life that Parisians led in the lamentable year 1910."[155]

In 1912, Poëte also promised to help the municipal councilor Victor Perrot realize an ambitious project to preserve history on film.[156] As president of the Société du vieux Montmartre, Perrot had firsthand knowledge of the popularity of Parisian history and municipal and private preservation efforts. Why though, he began to ask in 1911, did these not include film?[157] After all, he explained, after a decade of fruitless campaigning, "it's on film, in photographic letters, that the real, impartial, living history of the great City, writes and etches itself, automatically as it were, without effort, to be at long last resurrected for future generations."[158] Historians, painters, and even reconstructionists such as Hoffbauer could only try to approximate what film recorded automatically.[159]

Creating such an archive, however, posed a major practical challenge. At that time film was printed on highly flammable nitrate stock, responsible for a number of disastrous fires in exhibition spaces (most notoriously at the Bazar de la Charité in 1897). Although concerned about the fire risk, Poëte nonetheless

proposed the Bibliothèque historique as an obvious home for such an archive.[160] The outbreak of war in 1914 disrupted the project, and Perrot's vision would ultimately take a different form—of cinematic pedagogy rather than the preservation of history—when it opened as the Cinémathèque de la Ville de Paris in 1926.[161] But Poëte's interest in the project testifies to his belief that the history of his moment would be told through the products of the most up-to-date image-making technologies. His conviction was shared by the likes of Perrot and Albert Kahn, a French banker who, in 1909, launched the Archives de la planète project to document the entire world in photographs (stereograms and color photos) and on film.

While waiting to find a solution to the problem of archiving Paris on film, Poëte continued to collect photographs documenting the contemporary city. During the First World War, the library purchased more than one thousand photos from the photographer Charles Lansiaux.[162] These included two series: the first of industry along the city's northern canals and the second, a series of views and scenes of contemporary Paris. The latter depicts a city at war: families seeing young men off at train stations, the posters that disseminated news around the city, the arrival of refugees by the thousands, the looting of German-owned businesses, Parisians fleeing to the relative safety of the provinces, and the closing of the city's gates in preparation for a possible siege. To today's viewers, Lansiaux's photographs, especially those taken in 1914 that express the excitement of war, are obviously capable of sparking the emotional reaction that Poëte believed lay at the heart of the image's power as a historical document.

The Future of Photographic History

By the outbreak of World War I, the photographic age was firmly upon Paris. Contemporary history would be documented through the lens of the camera, not the brushes of watercolorists. In the same 1910 article that commended Marcel Poëte for purchasing four thousand photographs of the recent flood, journalist Henri Lavergne declared the photograph "the most perfect witness, the one that does not lie, that cannot lie."[163] With this statement he neatly articulated the idea that photographs provided mechanical and objective traces of the present. He also spoke to the idea that the practices of Parisian photographic history grew out of Marcel Poëte's exhibition and collecting efforts at the Bibliothèque historique. Historians, of course, have long credited Haussmann with spawning photographic history by hiring Marville to document Paris during its destruction. Haussmann deserves credit not just for hiring the photographer but also for creating the need for a new historical narrative of the capital and a set of public institutions to write it. But while Marcel Poëte and the Bibliothèque

historique seemed to barrel into the future with investments in photographic and cinematic documentation of the city, they did so alongside a growing sense that photography's triumph foretold romantic history's decline.

At times, even the leaders of the photographic revolution in the preservation of Paris seemed skeptical of the medium's advantages. In his 1925 history of Paris in images, Poëte reflected on the tradition of visual history in the capital. His judgment that "photography had brought about perfect documentary precision [but] lacks the particular trace of life that the artistic representation of yester-year added" articulates a fundamental contradiction in the photograph's utility for history.[164] Photographs were almost too objective. Their transparency helped the historian see the past but deprived him of the romantic detail that the artist's hand brought to the image. In a 1905 watercolor, Fedor Hoffbauer, whose legacy fell victim to the changing definition of "documentary" in the late nineteenth century, also foretold photography's influence on the recording of the present (fig. 1.10). The image shows a wedding party leaving a photographer's studio lodged in a fine stone turret. The bride and groom do not so much as glance at the shuttered wooden shack labeled "painting" that occupies the courtyard. Hoffbauer's scene suggests that photography would document the future, while painting struggled to get by in its shadow.

And yet, even before the creation of this image, Hoffbauer unwittingly bore witness to the new medium's influence on his craft. Although the artist had added color to his scenes of the past in *Paris à travers les âges*, he executed almost every view of contemporary Paris in the near monochrome of a faded sepia (fig. 1.11). In doing so, Hoffbauer seemed to borrow the camera's documentary authority for his own images. Even before photographs appeared on the walls and in the display cases of Paris's historical museum, then, they had changed how Parisians conceived of history and its visual documentation.

Beginning in the 1920s, historians, curators, and critics nonetheless came to understand photographs as evocative historical documents in their own right. In the same 1925 history, Poëte described how even precise photographs of architecture could bring the past to life. Poëte offered a romantic description of what he saw in Charles Marville and Pierre-Ambroise Richebourg's Second Empire photographs:

> the streets seem hoary with age, offer corners conducive to open-air chats and seem to harmonize themselves to the rhythm of an old city that keeps slow time: among the jumble of age-laden dwellings, architectural gems sparkle brightly here and there; then, the deep grave of the past is dug, the ground heaves up; in the midst of demolition, parts of houses rise like skeletons.[165]

FIGURE 1.10 Fedor Hoffbauer, *Tour de l'ancien moulin d'Amour, 26 av. d'Orléans; La sortie d'un mariage,* c. 1901–1905. Musée Carnavalet/Roger-Viollet.

He describes photographs populated by ghosts and skeletons, traces into which the reader could project life. Photographs finally had joined prints and paintings in allowing Poëte to imagine Paris as it used to be. And yet even before this point, photography's profound influence on other image-making

FIGURE I.II Fedor Hoffbauer, *Le square des Innocents (1878)*, in *Paris à travers les âges.*
Courtesy MIT Libraries.

technologies had ensured that it already shaped how Poëte and others saw the
Parisian past in images.

By the time Poëte wrote these words, photography had become essential to
the production of all types of historical pictures. Because of its technological and
industrial nature, photography seemed to many contemporaries to operate in a
register apart. Its precision and ability to capture a scene in a single instant, how-
ever, had already ensured that photos played a fundamental role in the creation
of the types of hand-drawn images that contemporaries believed sparked the his-
torical imagination. Late nineteenth-century Parisians may not have consumed
large numbers of photographs in exhibitions or books about the history of Paris,
but they did look at copies of these images made by artists such as Fortuné Louis
Méaulle and Fedor Hoffbauer. Moreover, the aesthetic style of photographs
influenced how artists rendered scenes of contemporary Paris.

In the decades that followed, even though historians started to prefer
photographs to other types of documents depicting the same places and scenes,
the Bibliothèque historique and the Musée Carnavalet slowly stopped collecting
them. This change in collecting practices does not, however, indicate the end of
curators, archivists, and historians' investment in the value of photographs as his-
torical documents.[166] Even as Poëte's interests shifted to a wider study of the city
and the Bibliothèque historique de la Ville de Paris became the Institut d'histoire,
de géographie et d'économie urbaines de la Ville de Paris, its budgets continued
to include a line for the acquisition of photographs.[167] Rather, it indicates that

photographs of Paris had become so common in published sources that libraries and archives no longer had to purchase prints directly from photographers. The library's acquisition of photographic prints tapered off in the 1920s because photographically illustrated books offered a cheap and easy means of acquiring pictures of the city.[168] As curators and librarians purchased illustrated books, publishers' ideas about the function and purpose of photographs for history came to shape the content of the collections at the Bibliothèque historique and the Musée Carnavalet. And, as they combined views of the contemporary city with old snapshots, a new generation of authors, publishers, and critics began to find not only objective documentation of the city but also subjective connections to the past in photographs.

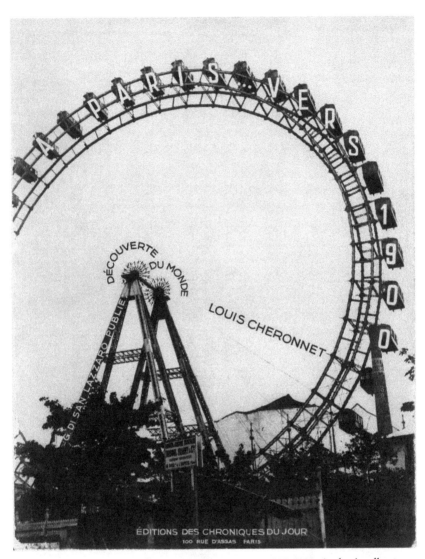

FIGURE 2.1 Cover, Louis Chéronnet, *A Paris . . . vers 1900*, 1932. Author's collection.

2 INDEX AND TIME

NEW FORMS AND THEORIES IN PHOTOHISTORIES

In the first decades of the twentieth century, photographs of Paris left archives and study collections en masse, coming into public focus in numerous new books on Parisian history. While some of these books were produced with specialists—vieux Paris amateurs or book collectors—in mind, others were meant for a broader range of readers. On the pages of photographically illustrated histories— or photohistories—where lithographers and engravers had once copied photographs, new technical processes from photogravure to halftone and photolithography now gave photographers the role of reproducing prints for publication.[1] In books as well as in libraries then, rather than simply pointing to "the history of the future," photographs already denoted the history of the present.[2] These books also retrospectively function as records of negotiations—between networks of publishers, authors, photographers, archivists and collectors, picture editors, and designers, many of whom had experience in the rapidly changing world of the illustrated press— that went into the production of historical narratives. These actors' assumptions about the utility of the image—and in particular of the photograph—to the study of the past shaped what sorts of pictures they included and how they chose to put them on the page. So too did, of course, the types of photographs available to them either in external institutions or within publishers' rapidly expanding in-house photo archives. The latter tended to privilege buildings and objects that could be photographed in the present. The conventions of these books and their emerging preference for photographs responded not only to technological developments in image printing and industry practices that privileged photographic reproduction but also—and more importantly—to changing ideas about what Paris was losing and how the past should best be preserved.

Parisians' shifting sense of the city's disappearing past would shape assumptions about what was historically important and about how the photograph might provide access to it. During the 1900s and 1910s, authors and editors published books about Paris that were still very much preoccupied with the question of the city's physical changes. They operated under the logic of Haussmannization, new definitions of documentary rigor that privileged the eyewitness, and a taste for *flânerie*. Their books embody the hunt for traces of the old city that remained despite the renovations. These authors, who included Marcel Poëte and Georges Cain, and their editors came to privilege photographic illustrations because photographs could provide direct, unmediated access to city artifacts from the past. In their books, the photograph functions as an index. It maintains a physical tie to the object it pictures, and the object itself holds the power to evoke the past in the reader's imagination.

In the aftermath of World War I, however, Parisians' understanding of the photograph's power shifted amid mourning for the world before 1914. The losses, hardships, and upheaval of the war had been social and cultural as well as physical and political: it affected gender relations, the visual arts, and literature.[3] When it finally reached France, the global financial crisis of the 1930s only compounded the feeling of rupture and distance from the past felt throughout the 1920s.[4] Paris too changed in these years. Between 1919 and 1930, the city's system of fortifications was destroyed. The capital reached its demographic peak in 1931, while its surrounding suburbs seemed to grow unchecked.[5] For many bourgeois Parisians, who feared the spread of these urban "tentacles" and worried about the influx of everything from immigrants to automobiles, it seemed that a way of life had been lost.[6] Marcel Poëte noted that the physical changes created by increased traffic and industrial expansion came alongside "a shift in values" that further cut ties to the city of just thirty years before.[7] During these years Paris itself— what it was and what it would be—was called into question.[8] In fact, the Great War seemed to have transformed the fabric of urban life in Paris. Marcel Poëte compared it to the French Revolution, noting, "The war marks, in all regards, a turning point in urban evolution."[9]

It also marked a juncture with regards to the role and presence of photography in French society and culture. The writer and critic André Beucler pinpointed several sudden shifts in 1918. Almost overnight, photography had joined the "beaux-arts." Everyone was now an amateur photographer: "we fell upon the world, took aim everywhere, at every hour of the day, with more and more sophisticated, more and more clear-sighted [*clairvoyante*] cameras, cameras that no longer feared neither shade, nor rain, nor sun."[10] Everyone became a photo collector too. Beucler's was one of several similar reflections published in *Photographie*, a yearly publication by *Arts et métiers graphiques* that analyzed the state of the medium. These essays described its role in the press, the museum, and the book and called

for new approaches to photography: ones that would define it neither as art, nor as technique (the standard historical narrative attributed to the medium), but as a visual form critically engaged in the culture of its present moment and the past. The collector and critic Louis Chéronnet's contribution called for the creation of a museum of photography.[11] The surrealist author Philippe Soupault denounced photographers intent on turning the medium into a version of painting. Instead, he insisted that the photograph's artistic capacity should never take precedent over its ability to represent its subject nor over "its *usefulness*."[12]

Both of these developments influenced books about Paris. First, photographs arrived on their pages—mainly at the behest of publishers—as a means of satiating a growing desire for photography. Throughout the 1920s, publishers' increasing reliance on contemporary photos of the city drove the growth of useable archives of standard illustrations within publishing houses themselves. Second, a new generation of photo collectors and Paris experts, driven by a sense of loss in the wake of World War I, turned to photographs as emotionally laden snapshots of a bygone era in order to produce books about "Paris 1900," as the fin-de-siècle was called in the early 1930s (fig. 2.1). Photographs became frozen moments, uncannily passed down through the generations. They no longer functioned as simple material traces of the thing they pictured but became frozen instants, documents of the unpicturable: time itself.

The Musée Carnavalet and the Bibliothèque Historique Take to the Book

By 1905, photographic processes had largely infiltrated book illustration. A review essay in the *revue des deux mondes* about books that might make good holiday gifts identified photography as the year's most noteworthy trend:

> The current fashion is photography, which with its rapidity of execution and variety of manner, lends itself to the character of contemporary illustration, [and] responds to tastes for instant and increasingly generalized information, which the agitated and dispersed life of our era demands.[13]

Photography was not simply more efficient. It more closely corresponded to the fast-paced needs and desires of early twentieth-century society, lending its abilities to topics and genres as varied as travel, natural history, art and architecture, history, biography, and the novel. Publishers deemed "the talent of almost perfect imitation" useful for reproducing nearly any type of image: from quotidian scenes to paintings, engravings, tapestries, and other objects.[14] This general taste for photography would, when combined with the value placed on images at

Paris's municipal historical institutions and changing beliefs in the importance of the capital's past, help drive the increasing production of photographically illustrated books about Paris.

Photography had caught on as a practice long before it infiltrated mass-produced publications. Inventors and photographers had experimented with the mechanical reproduction of printed materials since the invention of photography. Viable techniques, grouped under the term "photogravure," existed since the 1850s.[15] French newspapers and magazines, however, did not include photographic illustrations until after the development of the dot-matrix technique and halftone process in the 1870s and 1880s.[16] These made it possible to transfer photographic images onto flat metal plates and translate the photograph's gray tones into printable dots of black ink. By 1900, most large book publishers had adopted some form of the photogravure process.[17] While wood-block prints would continue to illustrate literature into the 1930s, photogravure (without halftone) became the norm for "travel, archaeology, architecture, and popular science and technology books."[18] The introduction of rotogravure, which translated the flat plates of photogravure onto rolling cylinders, in France in 1912 allowed for more efficient production of higher quality images. French newspapers bought rotogravure presses throughout the 1910s, and by 1918 most book printers had done so as well.[19] Publishers would continue to prefer photogravure (*héliogravure*) to the newer halftone process into the 1940s, since the older process, which used variations in ink thickness to produce black and gray tones, offered better quality images.[20]

The possibility of photomechanical illustration allowed curators and librarians from the Musée Carnavalet and the Bibliothèque historique as well as vieux Paris amateurs to reach a larger audience—to disseminate their collections in the pages of books. Many photohistories of Paris from the early part of the century drew on and replicated these institutions' and groups' existing uses of images, combining historical prints with practices that privileged the physical city as the most faithful document of its past. Marcel Poëte, Georges Cain, and Edmond Beaurepaire, to name only a few authors, all wrote illustrated books or articles about Paris that used the collections of prints and photographs held by the Musée Carnavalet, the Bibliothèque historique, and a vast network of private collectors.

When Cain, Poëte, and others authored these books, they did so with the keen awareness that illustrated histories of Paris had been published for centuries. Photomechanical processes may have made the production of illustrations easier, but they did not invent them. In Poëte's lectures, he dated the first legitimate illustrated history of the city to the 1550 edition of Gilles Corrozet's *Les antiquitez de Paris*.[21] Its wood-block prints depicted the churches, abbeys, and statues that constituted Corrozet's principal sources. For Poëte, these images were not

decorative but scientific: they proved the rigor of Corrozet's method.[22] The prints show statues with hands and forearms broken off, as the sixteenth-century historian would have seen them. They were evidence of his having consulted the artifacts, studying traces of the past rather than imagining or idealizing it. Throughout the seventeenth and eighteenth centuries, illustrated histories continued to reproduce objects and iconography such as portraits, coins, or clothing from the period at hand. And, of course, the nineteenth century saw the explosive popularity of historical narratives printed alongside retrospectively imagined reconstructions of historical events.[23] The popularity of this genre, however, did not prevent the continuing production of volumes that reproduced period engravings and views of the city. Fedor Hoffbauer's volumes on Paris had included such images. During the same years, the art historian Armand Dayot authored a series of albums designed to teach children history "through images."[24] In the early twentieth century, photographic illustration joined these existing modes of depicting the city's past.

Georges Cain's books used primarily nonphotographic images from the museum's collections (as well as others) to illustrate walking tours through the city similar to those given by amateur historical associations at the turn of the century. Since changing tastes in painting had diminished appreciation for Cain's talent for reviving historical scenes via the brush, he switched to the pen and spent the last decades of his life putting them into words. Between 1900 and the years following his death in 1919, Cain published over two-dozen books about Paris and its history. These included often-copious illustrations—reproductions of engravings, etchings, drawings, and paintings—which featured prominently in their titles.[25] While he initially published limited-edition books for collectors, for example the 1904 *Croquis du vieux Paris*, with wood-block prints by Tony Beltrand, by 1905 Cain was churning out books for a wider audience at the rate of almost one a year.[26] In what must have been a profitable collaboration with the publisher Ernest Flammarion, the most popular of these sold tens of thousands of copies, had multiple printings, were translated into English, and arrived in bookstores on both sides of the Atlantic.[27]

These volumes brought the historical method and knowledge of the upper-class collector, who accessed the past through intimate relationships with objects and artifacts, to a wider public. Cain painted a portrait of Parisian history sparked by images in private collections, municipal institutions, and on the streets, privileging the city as "the living document" of its own past.[28] In *Coins de Paris*, Cain asked his reader to imagine him or herself on a walking tour of the city (similar to those popular with vieux Paris amateurs), with suggestions such as "let's cross the Parvis de Notre-Dame" and "let's stop at the Place des Vosges."[29] With the reader in tow, Cain moved quickly from the contemporary city to its past. Passing in front of Notre-Dame, for example, he described the cathedral and

the buildings of the hospital l'Hôtel-Dieu that once stood there, which he knew from old pictures: "this old place of debauchery, of which Meryon left us such impressive etchings, and before which, as children, we stopped in fright, following with our eyes the enormous rats that lived and walked about there in full daylight, eating piled-up garbage."[30] Cain thus narrated his own engagement with Parisian history, describing the images that flitted through his mind. A reviewer for the *New York Times* praised Cain as "a delver into old archives, a peeper into mansions . . . ; an explorer of fearsome and narrow ways," in short applauding him for balancing the archive and the city, the past and the present.[31] These books gave the public access to Paris and to Cain's own vast historical imagination, allowing readers to tour the city with all the multilayered cultural references proper to a certain upper-class education.

For Marcel Poëte, the illustrated book similarly provided a means of bringing his narrative of Parisian history and ideas about scientific methods to a wider audience. Although he produced only a handful of books, Poëte churned out articles, lecture offprints, and catalog texts.[32] His books were more scholarly than Cain's, the result of years of research and thought. The centerpiece of these was *Une vie de cité: Paris de sa naissance à nos jours*, a multivolume biography of the capital. The publisher Auguste Picard released the first volume, *La jeunesse, des origines aux temps modernes* in 1924 and the album containing six hundred illustrations the following year.[33] Poëte finished the album before the third and fourth volumes because images were so central to his intellectual project.[34] Between 1907 and the 1920s, Poëte had amassed a collection of over eighteen thousand glass lanternslides featuring prints, objects, paintings, documents, and photographs that he projected as gateways into the past.[35] The best of these went into this album to animate the city's transformations, its changes in style and size. In it, Poëte argued that prints, maps, and photographs—"the exact reflection of life"—could make real the evolution of a small settlement on the Ile de la Cité into a modern metropolis.[36] They did not, however, work alone. The illustrations needed words to bring them to life. The album thus contains essays that directly addressed the images, explaining what they picture and how they contribute to the history of Paris. It is didactic, constantly telling the reader not just what to see but also how Poëte is using it as a historical source.

Illustrated, and particularly photographically illustrated, books would also complement the historical practices of vieux Paris amateurs. In large part, their explorations of the city's past were carried out in its streets. In the preface to the publisher and vieux Paris amateur Charles Eggimann's photographically illustrated series, *Le vieux Paris: Souvenirs et vieilles demeures*, the popular historian of Paris G. Lenotre described his fellow history buffs as a veritable army of colonial pillagers:

Thus, just as the explorers do for Assyrian palaces or the Khmers of Cambodia, enthusiastic investigators travel all over Paris, penetrate into the courtyards of its oldest buildings, brave concierges, climb staircases, tour the building, noting all that makes it unique; a door knocker, wood-paneling, a sculpted door or window frame, a painted ceiling, a Bacchus head at a cellar entrance, a wrought-iron balcony, a wooden banister, a trumeau mirror.[37]

Lenotre himself headed this charge, taking pride in his persistent and wide-ranging hunt for the past's traces. According to his daughter, he liked to brag, "I've been kicked out [of buildings] more than any other man in France!"[38] He and his compatriots noted their finds on paper, of course, but also, thanks to photography, in images, accumulating photographic documentation about the city in order to preserve elements slated for destruction and map out the contours of historic Paris.

Georges Cain, for one, became a keen amateur photographer. He assumed that many of his readers too would carry new, cheaper, and lighter cameras on their walks through the city and gave them advice for producing picturesque views.[39] His suggestions range from the general—to choose a foreground to highlight the background—to the minutely detailed—"Install yourself at the intersection of rues Broca and Mouffetard, in front of 144 rue Mouffetard, on the road, about 5 meters from the gaslight (3 to 4 o'clock)."[40] Certain subjects, such as the "shady lanes" of the Jardin des Plantes, would require the use of a tripod, while the bears, goats, monkeys, and elephant of the garden's zoo were best caught in a "series of 'snapshots.'"[41] Cain even warns against using complicated cameras requiring a long set-up, for "the crowd quickly gathers around the operator, the picturesque pedestrians become curious idlers and one only gathers frozen images of individuals, turning their wide eyes towards the same point."[42] The photographer needed to act quickly or risk taking portraits of these Parisians marveling at the camera. For that reason, he recommended that "one's habitual [camera] is the best."[43] If the photographer wasted time fiddling with an unfamiliar object, he would never stay ahead of the crowd. Cain himself used a Richard Vérascope, a lightweight camera that used glass plates to produce stereograms.

Cain's enthusiasm for the city's photographic possibilities and the lengthy list of shots (complete with hours for the best light) he proposes together suggest that at the same time that he was overseeing the acquisition of photographs at the Musée Carnavalet, he was also creating his own collection of images to be enjoyed via the stereoscopic viewer in the comfort of his living room.[44] Like other vieux Paris history buffs, Cain found the same pairing of pleasure and scholarship in photographs—"fun to look at, fascinating to study!"—as he did in the city itself.[45]

Photographs became key documents for the official arm of the vieux Paris movement as well. The iconography section of the Commission municipale du Vieux Paris, the body founded in 1898 by the city to study questions of urban destruction and preservation, had initially proposed collecting paintings and drawings as well as photographs featuring buildings slated for destruction and picturesque views. The former, however, were expensive and often difficult to store properly.[46] Photography quickly became their default method of documenting the city. The group commissioned photos from professionals, many of whom wrote offering their services.[47] Starting in 1903, the group also held a series of amateur photo contests to take advantage of the zeal for photography displayed by Parisian history buffs. But photography's nature as a process of mechanical reproduction also drove this preference, for it gave the viewer direct access to the city, which was itself a living document of the past.

The publication of photohistories brought vieux Paris amateurs' photographic forays into the city in search of the past to a wider audience. The publisher Charles Eggimann, for example, an avid amateur historian of Paris, used his own collection of photographs, taken by many operators, in the three-volume *Le vieux Paris: Souvenirs et vieilles demeures.*[48] The books featured copious photos and essays about monuments and landmarks such as the Tour Saint-Jacques, Romanesque churches, and entire neighborhoods. Their authors, including Georges Cain, Edmund Beaurepaire, and Lucien Lambeau, form a veritable "who's who" of the vieux Paris world. The photographs were not brought in, however, to illustrate the texts, but rather, the other way around. G. Lenotre describes how Eggimann knew how to deploy "this army of snoops" in order to gather "the richest collection of documents on the architecture and ornamentation of Paris's old houses."[49] This collection inspired the very idea for the volumes, and Eggimann commissioned essays to "illustrate so many artistic photographic reproductions."[50] The practice of taking and collecting photographs of the city's historical sites helped stimulate the publication of photographically illustrated books about the city and its history. One can imagine that such a book would have supplemented, rather than replaced, individual amateurs' collections of photographs.

Illustrated histories of Paris that mapped out the traces of the city's past also would have functioned as guides for these amateur photographers. In *Nouvelles promenades dans Paris*, Georges Cain explained that readers often asked him how to "create on one's own, a collection of Parisian scenes, without reproducing the tired clichés that clutter every card and stationary shop window?"[51] He strongly discouraged them from focusing on photographing modern life and society. Instead, he advised them to capture sites and places at risk of disappearing.[52] Cain's public could follow his detailed instructions, but he also encouraged them to think for themselves. They could consult illustrated books in order to identify

remaining traces of the old city.[53] These would develop their sense of the pictur-esque, so that they could recognize a good scene when it presented itself. Cain's advice to the *vieux Paris* amateur reveals the mutual influence and exchange that occurred between amateur photographic practices and photographically illustrated books.

The books demonstrate this shared sensibility of the city and photographs of it as a time machine, ready to transport visitors and viewers not only through their texts but also through the ways in which their editors and designers placed photographs on the page. Their selection, cropping, and layout suggest a concep-tion of the photograph as something allowing direct access to the objects—the tangible traces of the past—that it pictures. In a letter written during his first years in Paris, G. Lenotre described discovering this miraculous effect (felt by collectors of objects as well): "every old residence keeps something of those who lived in it [...]. An old stone that has *seen* things, that a certain dress once brushed, and on which paused eyes now forever shut, creates an intense emotion."[54]

Touching up the photographs in *Le vieux Paris: Souvenirs et vieilles demeures* so as to erase their frames worked to give the reader transparent access to these stones so that he or she might feel an emotional connection with the past. When the photographs in question depict artifacts, such as a gargoyle gutter spout, a tympanum, a wrought-iron balcony, and a doorknocker, the object itself, rather than a picture of it, sits on the page (fig. 2.2). Photographs in the journal of the Commission municipale du Vieux Paris were often similarly manipulated to iso-late the historical fragment. But at the same time that this manipulation removed the surrounding building or neighborhood, allowing the viewer to see the artifact in an almost museum-like setting, it also negated the presence of the mediating machine: the camera. The pictures are no longer framed photographs; they are doubles for the objects themselves.

The erasure of the photos' frame drew readers into buildings and neighborhoods, reproducing vieux-Paris rambles through the city. Georges Cain characterized his essay about the St. Lazare women's prison, which would be closed in 1937, as a "flânerie."[55] The essay opens with a shot of the building's courtyard, whose left and top edges are smooth, straight lines (fig. 2.3). Thanks to the retoucher's brush, its right side blurs into the page, while the bottom extends down the page and seemingly toward the viewer. The photograph seems almost three-dimensional, inviting the reader to follow the small nuns entering an open door in the background. The same manipulation comes into play in another view of one of the prison's entrances (fig. 2.4). Here again the foreground stretches to-ward the reader, while a cutout picket fence frames the right side of the door. To the left, the overhanging roof reaches out into the blank space of the page. These elements funnel the reader into the prison. The image above it of a large dormi-tory presents what awaits the reader once inside.

FIGURE 2.2 G. Lenotre, *Le vieux Paris: Souvenirs et vieilles demeures*, vol. 2. Courtesy University of Southern California Libraries.

Finally, the reader winds up in a prison cell containing only a chamber pot, a stool, and a blanket-covered bed (fig. 2.5). The cell's tiled floor juts out from the photograph's frame. The photo's right edge bulges to include a hanging smock, but instead of leading the viewer through a door or into a hallway, the photo dead-ends at the locked door with its shuttered and barred window. This is the claustrophobia of life in the St. Lazare. Similar transformations of photographs feature in layouts throughout these volumes, making them the very spaces they depict.

In the case of *Le vieux Paris: Souvenirs et vieilles demeures,* the book's design made explicit the function of photographs in the pursuits of historians, be they amateurs or employees of the city's historical institutions. It also foreshadowed developments in ideas about the possibility of the cropping, positioning, and manipulation of pictures on the page. Two decades later, Alfred Tolmer, a Parisian publisher specialized in elaborate illustrated advertising and other materials,

COUR D'ENTRÉE.

UN COIN
DE COUR.

ʟ y a vingt ans, Paris possé-
dait encore — presque intacts
— trois des plus importants
décors ayant abrité les pires
tragédies de la Révolution :
la Conciergerie, la Prison des
Carmes, Saint-Lazare.
Avec une inlassable ténacité, nos modernes
architectes, irrespectueux des reliques du passé,
sont parvenus à maquiller à ce point la Concier-
gerie, qu'il ne reste plus rien — ou presque
rien — de cette antichambre de la mort où,
successivement, vinrent agoniser tous les partis.
La prison des Carmes, qui vit les mas-
sacres de septembre 1792, est à son tour menacée.
Déjà, en 1867, les percements de la rue de
Rennes et de la rue d'Assas lui avaient enlevé

7

FIGURE 2.3 G. Lenotre, *Le vieux Paris: Souvenirs et vieilles demeures,* vol. 3. Courtesy
University of Southern California Libraries.

reiterated this idea in his influential treatise on the art of the layout. In the section
about printing processes, a cutout photo of the view down the Champs-Elysées
toward the Arc de Triomphe appears pasted onto a purple page. The scene is lit-
erally "a window onto Paris!": gauzy curtains tied back with bows and a table
complete with flower vase, pen, paper, and envelope have been printed onto and
around the photo (fig. 2.6). The photographic window onto "Paris, the capital of
gaiety and pretty things," Tolmer promised, will bring readers "an emotion unlike
any other."[56] Eggimann's book had already made this utility explicit. The photo
offered transparent access to the physical space of the city, which itself triggered
the reader's imagination.

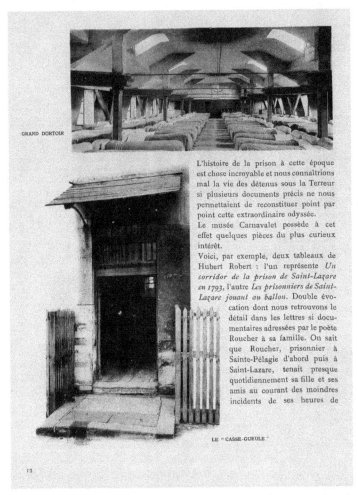

GRAND DORTOIR

L'histoire de la prison à cette époque
est chose incroyable et nous connaîtrions
mal la vie des détenus sous la Terreur
si plusieurs documents précis ne nous
permettaient de reconstituer point par
point cette extraordinaire odyssée.
Le musée Carnavalet possède à cet
effet quelques pièces du plus curieux
intérêt.
Voici, par exemple, deux tableaux de
Hubert Robert : l'un représente *Un
corridor de la prison de Saint-Lazare
en 1793*, l'autre *Les prisonniers de Saint-
Lazare jouant au ballon*. Double évo-
cation dont nous retrouvons le
détail dans les lettres si docu-
mentaires adressées par le poète
Roucher à sa famille. On sait
que Roucher, prisonnier à
Sainte-Pélagie d'abord puis à
Saint-Lazare, tenait presque
quotidiennement sa fille et ses
amis au courant des moindres
incidents de ses heures de

LE " CASSE-GUEULE "

12

FIGURE 2.4 G. Lenotre, *Le vieux Paris: Souvenirs et vieilles demeures*, vol. 3. Courtesy University of Southern California Libraries.

Illustrated Publishing and the Photothèque Hachette

Explicit explanations, such as the one that appears in *Le vieux Paris: Souvenirs et vieilles demeures*, of publishers' roles in shaping the conventions of illustrating Parisian history are rare. But their traces nonetheless remain in the books they produced and the images they used to do so. From them, it becomes clear that Eggimann was not the only publisher who would play an important role in shaping what Parisian history books looked like and how they used photographs. From the 1920s onward, publishers' roles became even more pronounced as they responded to public demand by increasing the photograph's presence in their

captivité. Grâce à ces lettres évocatrices, nous les suivons — lui et ses co-détenus — dans les préaux, dans les corridors, dans les cachots et les réfectoires, dans les cours encore intactes aujourd'hui, et nous les voyons jouer, causer, coudre, lire, dessiner et surtout rêver sous l'œil inquisitorial des gardiens, escortés de chiens féroces. Les prisonniers, en attendant la mort, s'ingéniaient à adoucir leurs heures de captivité : les dames avaient « clavecins et harpes » ; la société possédait même un singe qui servait au divertissement de tous. On trompait la vigilance des gardiens en emplissant UNE CELLULE. de malaga de grosses bouteilles portant l'étiquette « tisane » ; on rem-

plissait de café prohibé un bocal étiqueté « tabac en poudre ». Plusieurs détenus élevaient des fleurs sur les rebords des fenêtres de leurs cellules : n'en accuse-t-on pas quelques-uns de cultiver des lys... Ce n'était heureu- sement que des tubéreuses ! Pauvres distractions que troublaient sans cesse les visites domiciliaires, les fouilles, les interrogatoires, les appels, les menaces, les insultes, les dénonciations !

Hubert Robert conso- lait de son mieux ses infor- tunés compagnons. Pour ce peintre amoureux de son art, pour cet acharné tra- vailleur, tout sujet était bon : tantôt il dessinait des portraits de détenus, tantôt des dessins allégoriques, dans lesquels il se plaisait à évoquer la liberté perdue ; tantôt, enfin, sa provision de panneaux, de toiles, de

15

FIGURE 2.5 G. Lenotre, *Le vieux Paris: Souvenirs et vieilles demeures*, vol. 3. Courtesy University of Southern California Libraries.

books.[57] Photographs became the default means of illustration across a range of books about Paris. They replaced prints even in the work of those, such as Georges Cain and Marcel Poëte, who preferred the latter as both an artistic docu- ment and one that created a tangible connection to the past for the viewer.

Publishers had the power to push even the most reticent Parisian historians to use photographs as evocative historical documents. Eggimann's volumes testify to their ability to shape the conception of a book, obliging authors to produce their work alongside and in response to the photographs, sometimes against their desires. After all, some were members of the Société d'iconographie parisienne, the body that had just dismissed photographs as uninteresting. Eggimann forced

A window opening on to Paris ! Those who have known the bustle of the great capitals of the Old and New Worlds— Broadway, the Strand, Friedrichstrasse and the Prado—those who have lived in the grey atmosphere of Belgium, the white glare of Canada or the golden warmth of the countries of the sun, will be given an emotion unlike any other by the window which opens on to Paris, the capital of gaiety and pretty things.

FIGURE 2.6 Alfred Tolmer, *Mise en Page: The Theory and Practise of Lay-Out*, 1931. Courtesy Rhode Island School of Design Library, Special Collections.

them to work within the framework of the amateur photographer's investigation into the traces of the city's past. The publishing house Nilsson (sometimes also referred to as Nilsson per Lamm), developed as one of the first to publish photographically illustrated novels in the 1890s, would similarly bring a photographic aesthetic to city history. Nilsson's photographic novels featured as many as one hundred photographs produced specifically for each. It too had at first sought

to take advantage of amateur photographers, running open contests for them to submit pictures for any novel, rather than simply hiring professionals.[58] Although Nilsson only produced photographically illustrated novels for a scant decade, it adapted this infrastructure and experience with a series of urban and architectural histories in the 1920s.

Photography would become the norm for illustrating books about places at the most innovative publishers and beyond. Nilsson's "Les cités d'art," edited by Armand Dayot, updated a familiar mode: photographic illustrations alongside texts penned by experts. It is a small collection, covering only Paris, Rouen, Bruges, and Venice. It nonetheless testifies to the desire to bring leading experts in the field of city history into conversation with the cutting edge of illustration: photography. Marcel Poëte, for example, penned the texts for three volumes about Paris: *L'art à Paris à travers les âges* (1924), *Les thermes et les arènes, le palais et Notre-Dame, anciennes églises* (1925), and *Palais et hôtels, places et avenues, nouvelles églises* (1925). The illustrations for all three came from the archives of the Neurdein brothers, major postcard producers whose images were held at the Monuments historiques and at the Bibliothèque historique. The photos for Robert Hénard's 1925 volume *Rouen* were drawn from the same institutions.[59] For his own history of Paris in six hundred images, published at roughly the same time, Poëte would include a mere handful of photographs. Nilsson, however, could construct these histories as photographic narratives and succeed—where the early project to produce photographically illustrated novels had not—in changing the genre's conventions.

Hachette, founded by Louis Hachette in 1826 and best known for its pioneering railway bookstores, would similarly transition to photographic illustration in its books during the first decades of the twentieth century.[60] At Hachette, images came to drive the very production of its texts. As its editors explained on the title plate of the first volume of its pictorial encyclopedia: "the image is queen: we're living in photography's century."[61] It was no longer appropriate to deploy images as afterthoughts; now images would lead and "the text only follows."[62] This move shaped a range of publications dealing with Paris, starting with guidebooks. Between the 1870s and the 1900s, these books phased out engravings and woodcuts of monuments in favor of a combination of maps, building plans, and photographs.[63] Photographs invaded architectural guides slightly later. Hachette's 1918 *Pour comprendre les monuments de la France* by Jean-Auguste Brutail contained pen and ink drawings, but by 1925, another book in the same series, Georges Huisman's *Pour comprendre les monuments de Paris*, almost exclusively used contemporary photos of the city.[64] Nearly every page contains a small square photograph of the structure in question. While readers could bring this book with them as they toured the city, they could also tour Paris's architecture through the photographs it contained. Another Hachette

series, "Pour connaître Paris," published between 1925 and 1929, created even more explicit walking tours, to be carried out in the streets or enjoyed by the fire. Its books mixed photos with prints, maps, and texts penned by Paris experts such as Marcel Poëte, François Boucher, and Léon Gosset. Produced with the collaboration of the Société des promenades-conférences, the seventeen volumes all measure approximately 11 by 13.5 cm: just the right size to carry alongside one's camera on jaunts around the city.[65]

Other publishers followed suit. The Grenoble-based publisher Arthaud hired a handful of photographers to produce the pictures for over one hundred volumes of the almost exclusively photographically illustrated series "Les beaux pays." These were dedicated to the cities and regions of Europe and its colonies. Production on them began in 1924.[66] In *Paris*, the historian and art critic Pierre Gauthiez, writing in the manner of Georges Cain, used these photos to lead readers on a historical tour of the city from its origins on the Ile de la Cité to celebrations of the French victory in World War I.[67]

This switch to photographic illustration had several larger effects on both the publishing industry and on how Parisian history could and would be written. Just as the creation of the illustrated series by the Commission des travaux historiques had instigated the establishment of an in-house image production unit run by Ernest Lacan, publishers would establish their own photo archives. While many publishers made this move, the history of the development of Hachette's archive is the most accessible, since its collection of over 730,000 photographs, postcards, and drawings is still housed at the Hachette Livre headquarters in Paris and watched over by a very helpful archivist.[68] The presence of glass plates and silver gelatin prints alongside the results of numerous color processes attests to the slow accretion of images over the production of thousands of books. Hachette's contracts, such as the ones signed by a group of authors writing for the Pierre Lafitte series "Visages de Paris," published in 1927 and 1928, stipulated that while the authors owned their texts, the images belonged to Hachette, who could sell or reproduce them at will.[69] Hachette started collecting photographs around the turn of the century and its iconographic service expanded and made use of the archive until the 1980s.[70] At its peak, in the 1950s, the service employed "researchers, artists, photographers, technicians of all sorts, archivists, and secretaries" and housed dark room and lab space.[71] Even in the 1920s, the Bureau des illustrations et photographie, as it was then called, was a hive of activity.

In the 1920s, the archive acquired two types of photographs. The first was commissioned from in-house photographers. Their identities have been subsumed by that of the archive they worked for, their photographs credited "photothèque Hachette." The six hundred photographs in Huisman's *Pour comprendre les monuments de Paris*, for example, are almost all credited to the publisher. The second type was purchased from photo agencies, which usually let

Hachette keep copies of these images, marked with the name of the photographer to be credited. Although photographers, increasingly worried about maintaining the rights to their photos, put a stop to this practice in the 1980s, many of these non-Hachette photographs remain. These two types of photos are stored in separate series of alphabetically ordered subject folders including, for example, India, Insects, Napoléon, and Paris (Libération).[72] Other purchased collections are also kept apart. They include: a private collector's photographs of Algeria; the glass stereographs of Richard Vérascope (the manufacturer of Georges Cain's camera); and a separate collection of theater iconography that once belonged to the theater expert Eugène Rigal. For the glass slides, which are challenging to flip through, the archive contains a browsable series of bound volumes of printed copies. Separate files and boxes hold images produced for particular publications, including the magazine *Annales* and the series "Connaissances d'histoire." Throughout the century, Hachette would also function as a photo agency, opening its collections to researchers and charging fees for the use of Hachette-owned images.

The existence and logic of this archive did not just help streamline the process of choosing and selecting illustrations; in the case of the history of Paris, it also worked to create a self-referential canon of illustrations. This canon was largely codified in the 1920s and 1930s by these initial photographically illustrated publications. Alongside photographic negatives and prints, the Bureau des illustrations et photographie kept an extensive library of Hachette illustrated books and magazines, as well as a complete run of the weekly *L'Illustration* and a wide selection of exhibition catalogs and books about historical and scientific subjects.[73] The bureau's copies of Hachette volumes that pushed photographs wholesale into narratives of Parisian history—Huisman's *Pour comprendre les monuments de Paris*, the seventeen books in "Pour connaître Paris," and Léon Gosset's 1937 *Tout Paris par l'image*—show signs of heavy use. Each illustration is annotated with the name of the folder that housed a photo of it. In turn, each print bears on its back a record of its use—often publication title and page number— which would help researchers who came across the print to identify other relevant pictures. Researchers could also have referred to the handwritten lists pasted into each volume that recorded which new publications had reused some of the same illustrations. What had already been published became just as important—if not more so—than what might be available in the archive. The process of illustrating Parisian history thus became a sort of closed loop, controlled by publishers who relied on their own images to accompany new narratives.

The practices of publishers would, moreover, influence the types of illustrations that became part of this canon. Because photo agencies and publishers assembled their archives by purchasing pictures from currently active photographers, the historical landscape they would create with photographs privileged what was photographable in the city at the moment of a commission

or sale. This presentism becomes apparent in Huisman's *Pour comprendre les monuments de Paris*. The photograph that accompanies the description of the Tuileries palace depicts one of the building's few remains: a decorative doorway left standing in its eponymous gardens. There are multiple extant photographs of the Tuileries before it was burned by the Communards in 1871 and demolished by the state in 1883. The predominance of photographic illustration in books about Paris's history in the 1920s worked to shift historical consciousness away from an image record stored in archives and museums and toward an understanding of the past either as existing in agency or publisher archives or as photographable at the moment of publication. Such photographic practices reduced the past from a rich imagined and reconstructed world to the sum of its physical remains in the present.

This shift toward photographic illustration also affected the practices of Parisian historical communities. First, the acquisition of illustrated books replaced that of photographs at the Musée Carnavalet and the Bibliothèque historique. Whereas, in the 1910s, photographers such as Atget and Charles Lansiaux charged the library 2 to 2.5 francs per print, by the 1920s, the library could purchase as many as six hundred pictures in a photographically illustrated book for as little as 20 francs.[74] In the mid-twentieth century, the Bibliothèque historique would catalog these books separately under the classification "ICONO," short for iconography, distinguishing them for researchers in search of pictures of the city.[75] This organizational strategy acknowledged illustrated books as the logical extension of the image collection. Here the books would become fodder for the research of the countless scholars enrolled at the Bibliothèque—from the next generation of historians such as Pierre Lavedan to the scores of urban planners who trained at the Institut d'histoire, de géographie, et d'economie urbaines de la Ville de Paris, the former Bibliothèque historique. There, the latter learned to "imagin[e] Paris as a timeless web of vernacular streetscapes, historic buildings, and monumental stage sets."[76] In the next decades they deployed this knowledge to modernize while preserving its historical heritage and form.[77]

This shift thus affected the landscape of the Parisian historical imagination. Books, which placed an emphasis on the historical artifacts that could still be seen in the city, shaped planners' desires to preserve these objects and buildings. They also helped ensure that other histories disappeared from collective consciousness. At least one advocate for historical preservation lamented in 1941, "the Bastille, the Hôtel Saint-Pol, the Tournelles, the Tuileries have disappeared into the fog of the past."[78] Certainly Parisians forgot these places because they no longer existed, but their absence from the canon of photographic illustrations established in the 1920s must have helped this erasure. The centralization of sources shaped what histories of the city could be told. At the same time, it made it easier for authors and publishers to use one of these archives to find illustrations rather than cobble

together collections of images from different municipal historical institutions, individual photographers, and private collections.

Photographs may have entered histories of Paris en masse in the 1920s as part of an industry-wide drive toward photographic illustration, but within a few years they would come to be the focus of theoretical discussions of the value of the photograph as historical document. While such conversations about photography's uses did occur during this decade within photo clubs and at the Société de la photographie française, they held little resonance among the wider public. In 1924, the photographer Claude de Santeul lamented, "in France—only in France—in the milieu when one calls the public at large, the idea still reigns that photography is an essentially mechanical and impersonal process."[79] With the exception of Marcel Poëte, most of the authors whose texts appeared alongside photographs did not address their specificity as photographs. Their silence seemed to hide a simple appreciation for photography's one-to-one transcription of objects. It betrays the assumption, as de Santeul continued, that "[the photographic print] is only, in the end, the geometric projection of an object on a plane."[80] In the 1930s, the transparency of photography, however, gave way to the recognition of photographs as objects with histories of their own; this both came out of and influenced the place of photographs on the page of illustrated books about Paris. The new hunger for photography demanded efforts to think about and theorize photography's role in contemporary culture as well as the study of the past.

Theorizing the Past in the Photograph

New perceptions of the role of photography emerged, in part, thanks to concurrent shifts within the other voracious market for photography: that of the illustrated press. Magazines such as *Berliner Illustrierte Zeitung* and *Arbeiter-Illustrierte-Zeitung* in Germany and *Vu*, founded by Lucien Vogel in 1928 in France, hired young and innovative photographers and published avant-garde photos and photomontages.[81] They covered world events, fashion, culture, and sports but also published articles about photomechanical processes and the role of the photo agency. Such pieces instructed *Vu*'s readers in the workings of photography and photographic illustration.[82] In multipage photographically illustrated articles as well as rubrics such as "Everything in Images," "Seen in the World," and "Photographic Echoes," photographs became the basis for experimentations in storytelling. Such magazines taught readers to think about the photograph as well as to differentiate it from other types of images.

Two new trends in books about Parisian history would develop out of collaborations between publishers, authors, and photographers from the illustrated press. The first was a new type of history—epitomized by books such as

André Warnod's 1930 *Visages de Paris* and Louis Chéronnet's 1932 *A Paris . . . vers 1900*—that used photographs as uncanny snapshots of the past. Warnod and Chéronnet were members of a new generation of Parisian historians who brought a sensibility developed in press and art criticism circles to the study of the capital. Channeling nostalgia for prewar society, which influenced thinkers throughout Europe at the time, Warnod and Chéronnet used photographs as means of accessing the long-lost past. The second were books about contemporary Paris that featured the work of photographers active in both the press and avant-garde art circles. Brassaï, André Kertész, Germaine Krull, Roger Schall, and René-Jacques all produced photo books about the city. Contemporary critics interpreted and embraced these volumes as the future of historical documents—the equivalent of the images presented in the work of Warnod and Chéronnet. These books in turn entered Paris's municipal historical institutions as historical documents for future generations. The illustrated press thus affected not only photographically conscious ideas of Parisian history but also its photographic record.

Warnod and Chéronnet brought storytelling skills honed in the press and long-standing interest in the capital to their books. Warnod, born in 1885, spent his early adulthood frequenting artists in Montmartre and Montparnasse. He trained at the Ecole des Beaux-arts and afterward found work as an illustrator and art critic—sketching and writing for *Comoedia*.[83] Over the course of his career, he defended the work of the "School of Paris"—a group of young, foreign-born painters living in the capital—and befriended some of the city's best-known artists and intellectuals. Chéronnet, on the other hand, had Parisian history in his blood. His great-grandfather Dominique-Jean-François Chéronnet, wrote the first history of Montmartre.[84] His father owned a vieux Paris bookshop, which also sold pictures and small collectibles, on the rue des Grands Augustins. Born in 1899, Chéronnet must have spent countless hours there, cultivating the family interest. During the interwar period, he made a living writing articles and criticism for publications of the political left: *Photographies, L'art vivant, Art et décoration, Le Crapouillot, Beaux-arts*, and *Vu*. From 1937, he worked as the film critic for the communist newspaper *L'Humanité*, but he remained taken with photography.[85] He wrote about it, befriended the most important collectors of his day, and for years championed the idea of a museum of photography.[86] Under Vichy, Chéronnet focused on folklore and promoted the reform of artistic education. Afterward, he was denounced as a collaborator.[87]

Both Warnod and Chéronnet's books intervened in a much larger discourse, which first emerged in the 1930s, about the prewar period or "1900," as it became called.[88] These discussions began in print in the late 1920s and crystallized around Paul Morand's book of that name, published in 1931.[89] Like the French Revolution, World War I produced an acute sense that a way of life had been lost.[90]

The question at hand was whether or not to feel nostalgic for it. For Warnod and Chéronnet, the war represented a veritable fissure. "We are going faster, we are living faster," Warnod wrote.[91] Paris itself was also changing. The city was filled with new sounds, new pictures. It had been, Warnod explained, "a city where the past remained alive, but which harmoniously welcomed new eras and evolved gently."[92] No more. The war had interrupted this rhythm, and the new seemed out of step.[93] One might say Warnod himself was out of step. Even though he defended the work of immigrant artists, he complained about nearly everything else new in Paris: rising rent costs, the ever-present automobile, American bankers, jazz and the African-Americans who played it, and eastern European Jews.[94] But he was not alone in his aversion to these new people and forms.

Louis Chéronnet agreed that life could never be the same: "in 1914, one tremendous ax blow divided the first third of the century into equal parts: depriving one of its flowering, the other of its roots."[95] He argued that this trauma was most acute for members of his generation, born between 1898 and 1902, who had reached adolescence expecting one way of life and found, at age eighteen, an entirely different one. Their reaction was an almost pathological need to feel connected to the past. They were the victims of a new disease: "a tragedy of the century, a torture of the past, a need to bind oneself to past eras, to no longer be alone in time."[96] Warnod and Chéronnet's books often figure into contemporary historians' analyses of these sentiments, shared by other articles and books published at the time. But how these ideas were intimately bound up with the photograph's capacity to make this past present sets them apart and demands the reconsideration of both *Visages de Paris* and *A Paris . . . vers 1900*.

Photographs became privileged evidence with which to judge "1900" and to bring it, if only briefly, back to life. When nineteenth-century Europeans too had mourned the world of the eighteenth century, they had consumed Michelet's histories and Sir Walter Scott's novels and flocked to see history and genre paintings at the Salons.[97] Critics, memoirists, and historians of 1930, however, did not need to imagine or resurrect the past. The world of 1900 remained tangibly present for them in period photographs. The photographs themselves could take the stand. Chéronnet deployed them in order to "objectively, historically, provide the discussion with arguments, to add authentic documents to the trial."[98] And the book is essentially composed of photographs: just under one hundred of them spread over sixty pages of plates. Chéronnet's text, which occupies not even half as many pages, situated these images as part of the ongoing "trial" of 1900 and draws some preliminary conclusions from them.

But the photographs, for however much Chéronnet described them as objective, were not simply transparent documents. They reanimated the past. Chéronnet described the magic of stories that brought "an entire Paris back to life, little by little, from the ashes of the prewar period."[99] He did the same thing

with photos, wandering through this world, commenting on its architecture and boulevards, its art, women, scandals, and habits. He imagined that photographs provided a more direct and emotionally resonant access to the past. "Our fathers," he wrote, "who only had miniatures or paintings, just 'works of art,' to reconstruct the past did not know the photographic or cinematographic document's painful intensity. The sheer number of them, their relentlessness, changes the quality of our dreams, terrifies our mind."[100] Chéronnet characterized the photograph as haunting and emotionally powerful, more so than other types of images. He posited that there were simply more photographs available of the recent past, photographs whose very quantities seemed to promise the ability to reconstruct the past, to bring it back to life. Their promise was a vexed one, however, for they could not fully resurrect the past. Unlike Fedor Hoffbauer, who had been able to reconstruct a totality from pieces of the past, Chéronnet could only sift through them to see the past as a fleeting dreamscape.

And yet, Chéronnet was troubled by the idea that even the great quantities of photographs did nothing to prevent their disappearance. *A Paris . . . vers 1900* represents just one of his many attempts to ensure the preservation of the photographic past, threatened by inexcusable "systematic destruction."[101] This contradiction lay at the heart of his calls for an institution dedicated to their preservation. A museum of the history of photography would bring together pictures scattered in archives, museums, and private collections and save those that might be otherwise thrown out.[102] Its collections would be available to researchers, but like the Musée Carnavalet, it would also have a public vocation to make photographic history—the history of techniques and aesthetics, as well as photographers, machines, and subjects—available to the masses. The institution would have a permanent exhibition and space for temporary shows. In short, such a museum would provide a much broader and more flexible narrative of the history of photography than any current repository. Chéronnet's proposal never came to fruition, although he did lay out quite detailed plans.[103]

The failure of Chéronnet's museum project as well as the mixed reception of *A Paris . . . vers 1900* suggest that his perspectives were not shared by most of French society. In a review published in *La nouvelle revue française*, the critic Pierre Lièvre rejected the idea that the rupture felt by Chéronnet's generation was anything new. "We always feel the same emotions," he wrote, "and find ourselves always given over to the same astonishments."[104] In 1800 an older generation had looked back to 1770 with a similar mix of nostalgia and fondness. Lièvre dismissed Chéronnet's trauma: "thirty years creates the same gulf between two dates, and 1930 is no further removed from 1900 than 1800 was from 1770."[105] But more importantly for our purposes, Lièvre was unmoved by the photographic nature of the book's evidence. "The documents exhumed from a still recent past work on all sensibilities in the same way," he declared, thus flattening any differences between

types of documents.[106] In drawing parallels between 1800 and 1900, he cast aside Chéronnet's argument that the photograph and cinema (the latter of which, of course, was impossible to reproduce in the book), changed the relationship to this past. The idea of this gulf and the particularity of the photograph, Lièvre intimated, were both delusions of a younger generation.

And indeed, in composing his own history of Paris just two years earlier, André Warnod had also articulated a particular relationship between the photograph and the past. *Visages de Paris*, published by Firmin Didot, recounted the history of Paris from Julius Caesar to the present day. While Chéronnet's book is an album—what we might today call a coffee table book—Warnod's is the same size as Marcel Poëte's *Une vie de cité*. It seems to update Poëte's project to tell the history of Paris through images for the photographic age. It too contains 600 illustrations spread over 374 pages. Warnod explained that the image is "among the surest documents that we have of that which no longer exists."[107] And he attributed this power both the ability to testify to "what was" and "how people of other times conceived of what surrounded them."[108] In light of the latter function, Warnod rejected retrospective reconstructions, which told the historian more about the period in which they were produced than the one they depict. And, like Chéronnet, he preferred photographs above all. "As soon as possible," he wrote, "we have privileged photographs above all other types of documents. A snapshot is for us, provided that it is not altered, of course, a first-rate document because the lens is cruelly unblinking and impartial."[109] The photographs—ready with their objective information about the past—thus become a key tool in the book that Warnod, evoking H. G. Wells's 1895 novel, dubbed a "time machine."[110]

The cover of *Visages de Paris* embodies this preference for photographs. It features a printed portion, rendered in a blue reminiscent of eighteenth-century porcelain, of the same century's Plan de Turgot, showing the Louvre, the Tuileries, and the Seine (fig. 2.7). A black-and-white photograph—an aerial view of the Place de l'Etoile and Arc de Triomphe—bursts through the center of the map. The powerful photograph has literally torn through the print, leaving a gaping hole with ragged edges. It is as if the photograph's objectivity has obliterated previous representations of the city. Furthermore, the fact that the Arc de Triomphe is not actually located in the area depicted on the map emphasizes a rejection of the way in which photographs had, until now, largely been used as documents of physical spaces. According to this reading, the cover provides a visual metaphor for a new generation's ideas about the power of photography. An alternative interpretation of it might suggest that the book will excavate through images of the past to arrive at a true picture of Paris today—which it does in its last chapters about the contemporary city, illustrated with photographs by Germaine Krull.[111] In yet another reading, this collage or photomontage, designed in all likelihood by a Firmin Didot employee, might be his or her own clever commentary on the

FIGURE 2.7 Cover, André Warnod, *Visages de Paris,* 1930. Author's collection.

shifting landscape of illustration—as photographs blow competing images out of the water. All three interpretations reveal the negotiation between photographs and other types of images as integral to the very process of picturing the "faces of Paris."

Both Warnod and Chéronnet placed as much value on the books' images as they did on the texts and personally selected the former from multiple public and private collections.[112] Although Warnod's book did not focus exclusively on

"Paris 1900," he too looked back romantically on this period. According to its preface by Jean de Castellane, president of the Conseil municipal de Paris, "before these scenes of pre-war Paris [...] before this forever-gone setting, the impression of nostalgia grasps us."[113] Both published snapshots that seemed to present the prewar past as the daily news. Despite the differences between Warnod's *Visages de Paris* and Chéronnet's *A Paris . . . vers 1900*, their shared characterization of the photograph as objective, tangible proof of what the past looked like demands that they be treated as part of the developing sense that photographs could provide posthumous "reportages" of the past.

The past becomes a series of images that might have been—and often were—pulled straight from the contemporary press. *Visages de Paris* includes photographs that captured current events such as the 1885 "boeuf gras," or carnival celebration, Victor Hugo's funeral procession from the same year, the 1910 flood, and the 1918 victory parades. It presents the history of Paris as the history of what had already been photographed, which now included daily life and events, not solely monuments. Similarly, Chéronnet's *A Paris . . . vers 1900* features the familiar staple images of society, arts, and fashion coverage. We see women's dresses, jewelry, and hats, interior design, theater productions, the arts, and posters. Fads and fashions—such as the widescale adoption of the bicycle by women in bloomers—appear in both books (fig. 2.8). So too do the *faits divers* of the time; Chéronnet included a photograph of Madame Steinheil (the mistress in whose arms President Felix Faure died in 1899), while Warnod tells her tale and others' of murder, deception, and betrayal.

The photographic documents in the two books not only shared subjects with press and snapshot photography but also echoed formal characteristics of these genres. While many of the photos in *A Paris . . . vers 1900* are portraits, views of interiors, or staged theater stills, there are a handful of pictures with a more informal aesthetic. There are pictures of carriages, omnibuses, and automobiles by press photographer Maurice-Louis Branger. One, blurred and overexposed at the edges, depicts the early aviator Albert Santos Dumont and his dirigible (fig. 2.9). Chéronnet likely overlooked its aesthetic faults in favor of the fact that the photo presents a tangible view of this exciting early-twentieth-century spectacle. Warnod must have made the same calculation when he chose a blurry photograph of women at the races (fig. 2.10). Another reviewer, writing in the moderate, center-right literary review, *Le jardin des lettres*, described the book as "a series of retrospective reportages" whose images were "worthy of the text [...] all curious, amusing or touching."[114]

In using photographs as fragments of the past, Chéronnet and Warnod drew on the historical power of the photograph: one rooted in its status as a material object. Both authors had hunted for pictures in state and municipal collections, including the Monuments historiques, the Société française de

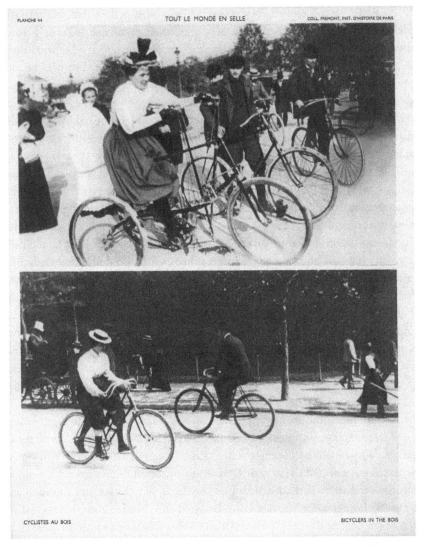

PLANCHE 44 TOUT LE MONDE EN SELLE COLL. FREMONT, INST. D'HISTOIRE DE PARIS

CYCLISTES AU BOIS BICYCLERS IN THE BOIS

FIGURE 2.8 "Everyone on Bikes," in Louis Chéronnet, *A Paris . . . vers 1900*, 1932. Author's collection.

la photographie, and the collection of the Institut d'histoire, de géographie et d'économie urbaines.[115] At the same time, they had selected the types of photos collected by French people across the social spectrum in 1900. *A Paris . . . vers 1900* included reproductions of Richard Vérascope's photographic slides, whose archive, alongside those of newspaper and press agencies, Chéronnet explained, held "riches of unexpected images that step out of Time like miraculous spirits."[116] Both Chéronnet and Warnod selected portraits of actresses,

FIGURE 2.9 Maurice-Louis Branger, "Taking to the Sky," in Louis Chéronnet, *A Paris ... vers 1900*, 1932. ©Maurice-Louis Branger/Roger-Viollet; Author's collection.

politicians, and society figures by well-known photographers such as Nadar, Lucien Walery, and Léopold Reutlinger, all popular inclusions in private albums and scrapbooks.[117] *Visages de Paris* contains a host of photographic postcards produced by the Neurdein brothers. Georges Huisman, who reviewed *Visages de Paris* in *La quinzaine critique*, likened reading it to flipping through "an album of family photographs."[118] He was right: the book contained the types of photographs that the French middle classes avidly consumed alongside pictures of their own family members. By including popular forms of turn-of-the-century photography, Warnod and Chéronnet evoked the photograph's potential not just as an image but also as an artifact of the past.

Rather than using photographs to picture how the physical city had changed, the new approach epitomized by *Visages de Paris* and *A Paris ... vers 1900* suggested the idea of photographic history as that of the city's people and their changing habits. One of these habits was, of course, the production and consumption of photographs. Both books also testify to the importance of the practices of photography itself to the previous century of Parisian history. But their photographs of events, fashion, and everyday life pictured a sense of distance from the past even as they held it close. They made visible the isolation

FIGURE 2.10 "At the Races," in André Warnod, *Visages de Paris,* 1930. Author's collection.

of the present. Paris in 1900 no longer remained just hidden in the outline of a doorway or lamppost; it only existed in an inaccessible photographic dreamscape. This new sense of the photograph's historical capacity did not just open up reinterpretations of old pictures but also changed critics and historians' understandings of contemporary photographs of Paris. They became the future of an uncanny access to the past.

This shift becomes apparent in critics' responses to the other new genre of photographically illustrated books that took off after World War I: the photographer-authored photo book. The latter was often more album than book, even though it usually contained a text by a well-known author, who received full billing on the cover. The photographers were given full or co-credit, and their pictures enjoyed pride of place. Rarely shrunk or cropped to fit with text, they appear in full plates.

These books were a way for photographers to repurpose pictures that often had already been published in the press. Because they all lived in Paris, beginning in the late 1920s with Germaine Krull's *100x Paris* (published in Berlin), the French capital became a privileged subject as well as a site for the production of these volumes, a trend that continues to this day.[119]

These contemporary photo books about Paris presented a new view of the city, deploying the meticulous observation and exploration of the amateur history buff with an eye for the new. As the art historian Kim Sichel has described, instead of trading in views of Paris's great monuments, they tended to "present Paris as a collection of building fragments and personally observed individuals."[120] Germaine Krull's *100x Paris*, for example, mixes views of traffic jams, movie palaces, and traffic cops with those of monuments. The pictures in the Lithuanian-born and Bauhaus-trained painter turned photographer Moï Ver's *Paris* (1931) juxtapose past and present, privilege and poverty in collage-inspired layouts.[121] Its cover image of factory smokestacks superimposed on a façade with classical columns renders Paris through the combined lens of heritage and industry (fig. 2.11). Brassaï's 1933 *Paris de nuit*, with its photos of seedy nightlife and the city after dark, challenges Paris's identity as the "city of lights." André Kertész too, in *Paris vu par . . .* (1934), with his photos of prosaic street scenes and lone pedestrians, showed a less glamorous side of the city. His views of the Eiffel Tower foregrounded by train tracks or the Sacré Coeur framed by decrepit buildings suggest that monumental aspects of the city could not be isolated from the industry and poverty that also shaped Paris (fig. 2.12). Roger Schall's photographs in *Paris de jour* (1937) similarly present the city's familiar monuments in playful and mocking fragments: a decapitated obelisk or the rear ends of equestrian statues. René-Jacques, who took the photographs in Francis Carco's *Envoûtement de Paris* (1938), presented a more intimate portrait of Paris, depicting its back courtyards, empty quays, quiet streets, and sleeping homeless.

Although these books focused on the present moment, they too engaged with debates about the city's past. By criticizing poverty, modernization, industry, and even the nostalgic gaze itself through both prosaic and contemporary lenses, they reacted to the burden of nostalgia for Paris 1900. With their interest in the everyday, they suggested that there is too much life or too much work to be done in the contemporary city to trouble over the past—and perhaps even, that nostalgia for Paris's past prevented it from moving forward. Moreover, participants in these debates recognized this type of contemporary photography as the constitution of a new archive of photographic evidence of the city.

Warnod's book straddled the divide between the use of old photographs as snapshots of the past and the prediction that today's would serve the same purpose in the near future. A series of photos by Germaine Krull accompany his

FIGURE 2.11 Cover, Moï Ver, *Paris,* 1931. Reproduced with permission from Moï Ver's family and estate, his son Yossi Raviv, Israel; Courtesy Rhode Island School of Design Library, Special Collections.

chapters about the contemporary city. In his foreword Warnod predicted, "before [these photos] too, our grandchildren will say: 'what a unique period that was!' "[122] He thus imagined a future generation using them as he did old photos. In a front-page review in *Le Temps*, the journalist and literary critic Emile Henriot foretold the same future for Brassaï's *Paris de Nuit*: "One readily imagines one of our

FIGURE 2.12 André Kertész, *Montmartre*, 1925. Ministère de la Culture, Médiathèque du Patrimoine ©André Kertész/RMN-Grand Palais/Art Resource, NY.

grandsons later taking his turn flipping through this collection of precise images and being moved by its poetry. It's the reality of the most quotidian things that has, over time, the strange charm of the past."[123] He predicted not that *Paris de nuit* would become an art book—displayed in museums—but rather its future as a beloved historical object, thumbed through in living rooms by children who had exhausted the family's photo albums. For these children he foretold (à la Chéronnet), the "new surroundings where we live will seem the setting of a dream."[124] Henriot addressed himself to photographers of the present moment, urging them to think about this duty to future generations—to the fact that their work in the contemporary moment would be the most direct link to the past for generations to come. He concluded, "photographers of 1933, it's for the year 2000 that you are working."[125]

In the 1930s, ideas about the importance of photographs for the future of Parisian history thus left the relatively narrow world of Paris history buffs to become part of more mainstream discussions. A wider variety of voices—from collectors to critics—weighed in on the utility of photographs for the present and the future. This was in part thanks to the illustrated press and the market for photography that it encouraged. The role of the illustrated press, as we shall see, would only grow in the decades to come.

Objectivity and Imagination

While in 1905 a review of illustrated publications could marvel at the very existence and growth of contemporary photographically illustrated publishing, by 1932, such reviews focused on how effectively illustrated books about Paris used photographs. A full-page review essay in the March 1932 issue of *Le jardin des lettres* brought its anonymous author's opinions to bear on a series of books published over the course of the last seven years, including Poëte's *Une vie de cité*, Warnod's *Visages de Paris*, Huisman's *Pour comprendre les monuments de Paris*, and a handful of others.[126] The article explains that they had been selected for review because they were all excellent "as much from the point of view of their texts as their illustrations."[127] The journalist held historical illustration to the same standards as other archival sources; he praised one book's authors for using a broad assortment of national archives and libraries to find their plentiful images.[128] This review reveals a shifting attention to the function and purpose of illustrations in books about Paris beyond their ability to ornament the text.

The story of illustrated histories of Paris brings to light histories of both the photograph in print and the photograph's changing theoretical status. The evolution of these books first of all bears witness to the functional relationships that developed at the beginning of the twentieth century between the publication of photographs and the strong archival impulse to document the past and the present through photographs that scholars have almost exclusively associated with municipal and not-for-profit archives and projects. The development of new norms of photographic illustration in books of all stripes affected photography's place in a hierarchy of historical images. They became the means of reproduction through which other types of images entered the written page and the default means for picturing the city. Books thus pushed the formation of new types of photographic archives and a canon of pictures. But the printed page also became a venue for the negotiation of photography's potential role as a document of history. In books such as Louis Chéronnet's *A Paris . . . vers 1900* and André Warnod's *Visages de Paris*, photographs came to weigh in as objective documents in the trials of the past. And yet, unlike a previous generation of historians, Chéronnet and Warnod found the photograph anything but cold. They saw it as a document of unparalleled emotional power. Their perceptions of the photograph represent a marked shift from thinking about photographs as the least emotionally resonant document of the past to embracing them as the most.

Importantly, this transformation occurred within illustrated histories of the city, helping to spread new ideas and theories about the relationship between the past, the present, and the image throughout the world. Turn-of-the-century photo archives, museum exhibitions, and lectures could only reach the viewers who came to them; photohistories wound up in foreign libraries, personal collections,

and even the research divisions of Hollywood film studios. Paramount, the studio responsible for such Paris-themed films as *Love Me Tonight* (1932), *I Met Him in Paris* (1937), *Midnight* (1939), *Sabrina* (1954), and *Funny Face* (1957), owned copies of Warnod's *Visages de Paris* and Pierre Gauthiez's *Paris*.[129] Illustrated books thus facilitated the global circulation of images used to picture Paris's lost past romantically and photographs whose popularity demonstrated a sort of "prenostalgia" for contemporary everyday life. Collected in archives and libraries, these books created palliative myths about the city's historic greatness. At the same time, they disseminated ideas about the photograph's very utility for the study of the past.

Just a few years later, during the 1939 celebrations of photography's centenary, the French poet Paul Valéry would address the dual role of photographs as objective documents and fodder for the subjective reconstruction of past scenes. Speaking to members of the Société française de photographie about the influence of photography on humanistic scholarship, Valéry divided historians according to their understanding of the discipline's relationship to objectivity:

> For some, History is summed up in image albums, in operatic storylines, in spectacles and generally in critical moments. Among these scenes that our minds create and receive, there are some that offer us fairytale worlds, beautiful or incredible theatrical effects, which we interpret at times as symbols, poetic transpositions of real events. For others, more abstractly interested in History, it is a register of human experiences that one must consult like meteorological logs, with the same concern to discover in the past some indication of the future.[130]

One group understood the study of history as the task of reviving the past through the combination of physical and imagined images until it existed in a state akin to Chéronnet's dreamscape. For the other, historical scholarship entailed the positivistic accumulation of events and facts. And yet the photograph appealed to both schools. The former turned to photographs as tools for reconstructing the foreign drama of the past, while the latter deployed them as details, slices of objectivity that could be studied and added to the accumulation of evidence. In describing this divide, Valéry addressed much of what separated amateur and professional history and the duality that made photographs the illustration of choice in books of Parisian history during the 1930s.

The history of these illustrated books of Paris speaks to changing notions of what past was worth studying, for they both developed out of and helped nurture a changing sense of what the capital, rushing headlong into a future of neon lights, jazz, suburbanization, the invasion of the automobile, radical politics, and eventually another war, stood to lose. Authors and critics no longer devoted the same energy

to mourning the destruction of medieval streets and crumbling buildings. Now it seemed that less tangible elements of urban life—styles, customs, habits—were in just as much danger. And they increasingly recognized that their own way of life, even as it seemed shockingly new and modern, was also slipping away and in need of preservation. Photography, capturing the world in fractions of a second, seemed just the tool to do so and would be pressed into action when history came to life in the streets during the German Occupation of Paris.

FIGURE 3.1 Jacques Wilhelm, *Visages de Paris: Anciens et modernes*, 1943. Photo (bottom, far right) by Marcel Bovis. ©Marcel Bovis/RMN-Grand Palais/Art Resource, NY; Author's collection.

3 PAST AND PRESENT

"REPICTURING" DURING THE OCCUPATION AND LIBERATION OF PARIS

In 1943, the Musée Carnavalet curator Jacques Wilhelm explained how contemporary photographs called on the historical imagination of his contemporaries:

> For the Parisian worthy of the name, the images of the past superimpose themselves, slightly blurry, over the clarity of the modern photo [*cliché*], doubling and tripling each street, each square, each monument with the successive incarnations they offer, the historical events of which they were the setting.[1]

Contemporary snapshots of the city evoked older images in viewers' minds to create composite pictures of Paris's past. Scenes known from prints or paintings emerged from the deepest recesses of memory to complement the one shown in the contemporary photograph. Wilhelm was not alone in promoting this dual way of seeing photographs of the city as both snapshots in their own right and as windows onto a past imagined in other types of images. The book in which this description appeared—*Visages de Paris: Anciens et modernes*—is the first of many that explicitly taught readers a mode of reading photographs that I term "repicturing." It did so through layouts that placed contemporary photographs alongside prints or old photos of historical scenes featuring the same locations (fig. 3.1). Unlike historians and curators in the early twentieth century, who also used the photograph as a gateway to the imagined past, these mid-twentieth-century historians and critics no longer assumed that readers would automatically employ photos in such a way. Now they operated as if this mode of understanding photographs needed to be taught. Repicturing, however, became much more than simply a layout used in a handful of histories of Paris. It emerged as a visual

epistemology that framed the use and understanding of photos in general. This logic of reading contemporary photographs as if they contained meaning drawn from the long history of images of the Parisian past shaped their use in books and exhibitions as well as discussions of photography's documentary value.

Just as the Germans' presence changed what Paris looked like, their photographic practices and the restrictions placed on French photography during these years affected what it meant to take—and look at—photographs of the city. Repicturing developed in response to these shifts, frequently reappearing in Parisian photo books, photo histories, and public historical exhibitions from roughly 1940 until 1945.[2] Its logic shaped a wide swath of productions of pictures and helped give meaning to one of the most defining events of the period: the Liberation of Paris from the German Occupation in 1944. The photograph came to function as both a picture of the present and of the past.

France had declared war on Germany at the beginning of September 1939, but fighting between the two countries did not actually start until the following spring. The German army launched the offensive into France on May 10, advancing rapidly toward Paris. The government chose not to defend the capital, declared it an open city on June 10, and retreated south to the spa town of Vichy, which became the capital of Free, or Vichy, France. On June 14 the Germans entered Paris. Just over a week later, the French signed an armistice with Germany.[3] Many Parisians had fled before the invading Germans in what became known as the *débâcle*.[4] Some would stay in self-imposed exile—making their way to the south of France, the colonies, or abroad—while most returned to continue their lives as best they could. Cultural and intellectual life continued in Paris. It also remained an important place of entertainment, but its clientele changed. Paris became the culture and leisure capital of Nazi Europe, promoted by programs such as *Jeder einmal in Paris* (Everyone in Paris Once), which sought to offer leave time in the city to every German soldier.[5] Tourism materials boasted that by May 1941 alone over one million Germans, mostly such men, had already visited it.[6]

Plans for German Paris began to crumble in the summer of 1944, when Allied troops landed in Normandy. In August, Parisians looked on gleefully as nonnecessary German personnel organized their departure. The American and British command had no interest in diverting manpower from the push to the German border to help remove the remaining Occupation forces; by arguing for Paris's symbolic, if not tactical, importance, however, the Free French leader Charles de Gaulle convinced the Allies to send a handful of units toward the city on the Seine. Their acquiescence made the French victory of the Liberation of Paris possible. Anticipating the Allies' arrival, Parisians rose up against the remaining Germans. Groups of workers went on strike on August 18. Starting the next day, members of the French Resistance forces (Forces françaises de l'intérieur [FFI]),

the police, and the Garde mobile (a reserve branch of the armed forces), as well as many people without official affiliations, took over key administrative buildings, fought German tanks, and built barricades in the streets. Allied troops, led by General Philippe Leclerc de Hauteclocque's 2nd Armored Division, entered the city on August 24 to root out what remained of the German strongholds. The 4th US Infantry Division joined them on the 25th. On the 26th, General de Gaulle triumphantly paraded down the Champs-Elysées.[7] Despite its secondary status in military terms, in the weeks and months that followed, the Liberation of Paris was sold across France as the iconic battle of the war, the founding myth of the postwar nation.[8]

What does war, and the experiences of the Occupation and Liberation, have to do with the history of how photographs were used as historical documents of Paris? First of all, both inspired the copious production of photographs that have their own place in a much longer history of the tradition of visual documentation, including photography, of war, battle, and revolution.[9] Photographing Paris—picturing the city, its people, clichés, and events—became an imperative for both the Germans and the Allied forces. After all, pictures help create meaning for national and personal experiences. We might look at these photos, as many historians do, as windows onto the scenes they represent. Or we might ask how this copious photographic production shaped the meaning of the act of photography as well as contemporary understandings of the limits of photographic representation itself. The experience of war and occupation threw the politics of picture taking into sharp relief, shaping how Parisians saw photographs of the city in general. The logic of repicturing, as it was first laid out in photo books of the city, became a way of rejecting the often rosy interpretations of Paris produced by three distinct groups: German soldiers, who arrived armed with cameras; French and German publishers, who sold photo books of the occupied city; and the French photographers authorized to work in the former capital.

Paris's image, not simply its physical existence, was in danger during the war. The city suffered some damage from Allied bombs but survived largely intact compared to other European cities such as Warsaw or even London. In general, Parisians experienced better living conditions during the Occupation than most other residents of occupied territories.[10] But even as Paris's buildings, streets, and monuments survived, its losses were great. German signage sprung up at every corner. Soldiers paraded down the boulevards. And Parisian history and culture were deployed in service of an imperial project that many, if not most, French people did not support. Looking through the contemporary photograph—past all the details that spoke of the Occupation—to images of the city's history came to function as a way of denying Paris's contemporary reality. Doubling the contemporary view supported the argument that the true meaning of Paris was not so easily coopted by the Germans. It was not visible in the contemporary snapshot,

whether or not it showed the image of Occupied Paris, but rather depended on a deep familiarity with Parisian history that only a legitimate resident could have. Although photographs may have become the privileged document to preserve twentieth-century Paris, during World War II prints remained integral to how Parisians would understand those photographs as historical documents. Once established during the Occupation, this mode would reinforce the meaning of the photographs of the Liberation as collected and displayed at the Musée Carnavalet and published in popular books. The logic of repicturing would help create a visual consensus around the difficult politics of 1944 and 1945.

Photography during the Occupation

Both the act of photography and photographs of Paris took on new meanings under the Occupation. Photography became a way for German soldiers to frame their experiences as occupiers as well as tourists and to take possession of the city, starting with Hitler's visit on June 28, 1940. During his one-day tour, Hitler posed for his personal photographer, Heinrich Hoffmann, at the former capital's iconic sites.[11] A photo taken in front of the Eiffel Tower became the cover image for *Mit Hitler im Westen* (*With Hitler on the Western Front*), one of Hoffman's popular photo books.[12] The picture functioned as proof of a particular event—Hitler's visit—and a symbolic claim: the City of Lights now belonged to Germany.[13] It transformed the Eiffel Tower from symbol of French industrial modernity into shorthand for German victory on the whole of the Western Front.

Photography was not limited to Nazi elites but widespread among the ranks. In Paris soldiers purchased picture postcards to send home. Others arrived with cameras, prepared to take their own pictures of sites promoted in photographically illustrated books and guides.[14] Soldier-amateur photographers blurred the line between combatant and tourist: many were even billeted in the city's finest hotels. Even the very first to arrive wielded cameras. An American journalist noted on June 18, "It seems funny, but every German soldier carries a camera. I saw them by the thousands today, photographing Notre-Dame, the Arc de Triomphe, the Invalides."[15] Taking pictures was itself an act of occupation. A French photo history of these years noted under a photograph of a German soldier snapping away at the Assemblée nationale, "Only they had the right to take pictures. It is thus—and only thus—that they were able to make off with a little bit of Paris."[16] While this caption, written from the vantage point of liberated Paris, made light of the appropriation, it suggests just how pervasive the influx of amateur photographers had been.

Even as photography became a means of possessing Paris, it also served to publically deny the severity of the Occupation. Professional photographers, photojournalists, and photo agencies continued to operate in Paris. Both the

German illustrated magazine *Signal,* which was modeled on the American *Life,* and the Lyon-based Vichy French magazine *7 jours* maintained Paris correspondents.[17] Freelancers such as Pierre Vals and Roger Schall also sold to dailies and weeklies including *La Semaine, L'Illustration, Paris-Midi,* and *Paris-Soir.* These magazines and newspapers distracted the public with fiction, human-interest stories, arts reviews, and *faits divers* all the while selling them anti-Semitic and pro-German propaganda.[18] The occupying forces strictly regulated all of this press photography. Each photographer needed German permission to work in the streets, and those who sold to the French press also needed Vichy press accreditation. The pictures of Paris that appeared in print during the war thus presented a tightly controlled vision of the city endorsed by two censuring regimes.

The photographs of Paris taken by *Signal's* correspondent, the French photographer André Zucca, depict it as a pleasure-capital rather than as a city at war.[19] Shot in color on German-furnished Agfa stock, these pictures capture fashionably dressed Parisians strolling through streets and parks. At a time when shortages made buying film difficult or even impossible, Zucca showcased, in brilliant color, Germans soldiers enjoying Paris's pleasurable offerings: its flea markets, cinemas, racetracks, and zoo. The same image of Paris as a tourist's paradise emerges from what Roger Schall sold to the Vichy press. His photos provide a mixture of carefree street scenes and official German visits, such as tours of Napoléon's tomb and the Louvre, which ground the current occupiers in the tradition of educated Germans, fluent in French as well as the nation's art and history. The photographs of Paris disseminated both in German- and in Vichy-controlled territory presented the German Occupation as peaceful and Paris as the enduring site of culture and prewar pleasures.

At the same time that German soldiers descended on the city with cameras, and as cheery pictures of Paris went out to major news outlets, ordinary Parisians saw their own access to photography restricted. On April 26, 1940, the Third Republic had made unauthorized photography illegal in the territory—then along the nation's eastern border—under direct military control.[20] When this zone was expanded to include the Paris region on May 16, civilian photography became technically illegal there as well and remained so throughout the war.[21] Functionally, these laws restricted rather than forbade photography: it does not appear that the French police, who were charged with enforcing the civil code, arrested photographers in large numbers.[22] Civilians continued to take family snapshots, although shortages of film, developing chemicals, and cameras meant they did so more rarely. Those with means still visited the portrait photographers whose studios remained open. Photographing military installations or possessing photographs of them, however, was a punishable offense.[23] So photography took on a range of meanings as a restricted and controlled—as well as potentially subversive—activity after 1940.

The Development of Repicturing

At the same time that photographic production encountered new limitations, so too did French book production. After the German invasion, many writers and editors fled Paris for the South of France or abroad. Shortages affected all industries, and for publishers they meant restricted access to paper and ink. New censorship laws curtailed books' subject matter. The German "Otto List" published in September 1940, for example, pulled a large number of existing books from circulation.[24] As one American professor wrote in 1942, this list had "strictly controlled, if not entirely stifled" French presses for the past two years. But while he advised his readers that "what has not been published is in all likelihood much greater than what has," the range of books dedicated to Paris are nonetheless interesting.[25] They reveal something of how Parisians understood the act of photography during the Occupation and how they learned to look past the contemporary photograph to a longer tradition of the city's history. This new mode of viewing photographs rejected the meanings generated by the parameters placed on photography after 1940.

There was no shortage of books, with or without illustrations, about Paris published during this period. These often continued the same genres familiar from the 1920s and 1930s. Self-exiled Parisians such as the journalist Elliot Paul and the poet and novelist Francis Carco wrote nostalgic memoirs about prewar Paris.[26] Publishers continued to produce albums of contemporary photography, while amateur and municipal historians churned out illustrated histories. Guidebooks, too, sold well during this period. In short, familiar prewar genres continued to find an audience.

Louis Chéronnet also remained active, expanding on his argument about the particularity of photographs as historical documents. Once again, he contributed a series of old photographs as evidence—"documents for the file"—to a public debate about the value of the past.[27] This time, it centered on what to do with the so-called *îlots insalubres*, some of the poorest and also oldest neighborhoods of the city, which had been flagged for renovation after World War I.[28] Chéronnet was following up on a series of books by urbanists and historians, including Georges Pillement and René Héron de Villefosse, denouncing plans for demolition. But while these often used contemporary photographs, Chéronnet proposed the historical photo as essential evidence, a document without par.[29] His 1943 *Paris tel qu'il fut* brought together 104 photos, for the most part taken by Charles Marville, of nineteenth-century Paris before Haussmannization. Chéronnet was even more insistent than he had been eleven years earlier on the specificity of this documentation. The photograph's power, he remarked, only grew with the passage of time.[30] And in a sense his statement proves correct, for this particular book marks one of the first major instances in what would grow

into prolific scholarly and popular interest in the Marville photos as unique and uncanny documents of nineteenth-century Paris.

In terms of new developments, both French and German publishers sought to appeal to an expanded European readership by adding German text to multilingual editions or simply producing German-language editions of photo books about Parisian monuments and surrounding attractions. Prior to 1940, such multilingual editions were usually only in French and English. But in 1941 Editions Tel, which specialized in illustrated history and art books, reissued *Notre-Dame de Paris* with photographs by Emmanuel Sougez and captions in English, German, and French.[31] A year later, it published *La cathédrale d' Amiens* with texts in German, Spanish, and French.[32] The publisher Braun similarly issued many of the volumes in its "The Masters" series dedicated to the visual arts with German, English, and French texts.[33] French as well as German houses also catered to the German-speaking population's interest in the city and heritage with single-language books.[34] Their production was often likely driven just as much by editors and authors' need to make money as by their politics. But the political and imperial dimensions of guidebooks and photo books would not have been lost on contemporaries. After all, since 1933, Heinrich Hoffmann had sold Hitler's conquest to the public in the form of mass-produced photo books.

The use of contemporary photos of Paris as German propaganda posed a problem for the publishers, authors, curators, and historians who traded in pictures of the city. Many of the books about it published during the Occupation (Chéronnet's for example) employed now conventional modes of representing the past in photographs. But others seem the product of a real attempt to come to terms with the question of how to picture Paris when who could take photos was restricted and the photos one could take did not show it as many wished to see it. The fact that Paris was not heavily bombed compounded this problem, for its outline remained largely the same. And yet it seemed almost impossible to believe that the city still existed. The illustrator and songwriter Maurice Van Moppès, writing in England, saw Paris as a long-suffering loved one: "its features are transformed, however, and if one recognizes them as one does those of an invalid, one cannot stop oneself from seeing the results, the ravages of pain."[35] Just as photographs from before World War I had given Parisians an uncanny sense of a tangible yet unreachable past, the fact that the city remained physically intact yet inaccessible haunted them throughout the Occupation.

Among the books on Paris published during this period, two stand out for how they responded to the problem of representing the contemporary city. The authors of the books' texts both offered their illustrations as a means of time travel to Paris before 1940. To counteract the disfigured image of Paris, Van Moppès, in his 1941 *Images de Paris*, drew it from memory. His illustrations show bustling streets, prosperous businesses, and the typically Parisian pleasures of cafés,

booksellers, flea markets, open-air balls, and gardens. These are the same scenes, minus the Germans, that appear in André Zucca or Roger Schall's photos of the city. *Voyage dans Paris*, published the same year by Les éditions de la nouvelle France, used photographs to offer the same sense of escape. Its 112 pictures by Marcel Arthaud, Marcel Bovis, Albert Durand, Grono, Pierre Jahan, René-Jacques, and Jean Roubier, many of which were likely taken before 1940, show places oddly emptied of people. Lone pedestrians and cars rattle through vacant streets, squares, and gardens.[36] The book's preface, written by Pierre Mac Orlan, proposed that readers should view these photographs not as windows onto a particular place, but as a sort of meander through time itself. Neither this text nor the captions provide a sense of when the photographs might have been taken. They include no dates, and Mac Orlan's text, while it evokes multiple different historical eras, steers clear of the present. Instead he instructed readers to use their imaginations to animate the photos. Like Van Moppès, he explains that even when not in the city, "we carry Paris with us" in the form of memories and mental images of it.[37] "While flipping through the collection of these images," Mac Orlan wrote, "each [reader] can choose one and furnish it according to his creative powers."[38] The photos were only gateways to the rich world of images stored in the reader's mind.

While *Voyage dans Paris* hints at the logic of repicturing, the Musée Carnavalet curator Jacques Wilhelm produced the first Paris book to explicitly teach it. The pages of his 1943 *Visages de Paris: Anciens et modernes* combine contemporary photographs with prints or older photographs of the same sites throughout the centuries (fig. 3.1). The layout, Wilhelm explained, "was necessary in order to make readers understand Paris's soul."[39] A mental image bank of the city's history, the ability to see ghosts of the past in each contemporary photograph, he went on, differentiated "the Parisian worthy of the name" from "travelers, those who are only passing through [who] see of Paris only its contemporary and external appearance."[40] This layout reaffirms the now as photographic and photographable and the past as the realm of artistic representations, an idea that Alfred Tolmer had put forth in his 1931 treatise on layout. Tolmer had reminded designers that "simple things, landscapes and monuments, as seen externally by the eye, create also an inner vision" and that the layout could evoke this mix of present and past as powerfully as the cinema or the arts.[41] He had illustrated this idea with his own creative page composition: photographs of Versailles and, printed over the top of them, sketches of fireworks, royal crests, and a woman clad in an eighteenth-century gown with paniers (fig. 3.2). The historical was laid over the photographic present.

But while other publishers, designers, and authors had been content to allow the reader to bring his or her own historical scenes to the contemporary photo, Wilhelm put them directly on the page. Instead of progressing toward the

The thoughts, dreams and memories suggested and awoken in us by simple things, landscapes and monuments, as seen externally by the eye, create also an inner vision, which verges to some extent on the literary plane.

The mingling of real life and imaginary life, of present and past, of probability and improbability, could only be expressed hitherto in Surrealist poetry and by the technique of the cinema. To-day it is one of the most powerful devices of the art of lay-out.

FIGURE 3.2 Alfred Tolmer, *Mise en Page: The Theory and Practise of Lay-Out*, 1931. Courtesy Rhode Island School of Design Library, Special Collections.

present in a linear fashion, repicturing proposed a montage of pictures from all eras flickering at the edges of the present view. While Wilhelm, like Mac Orlan, ventured the idea that all Parisians carried images of their city's history in their minds, the book's format suggests that they needed to learn these scenes. After all, the ability to resurrect Parisian history belonged only to "the Parisian who loves his city, [and] *studies its history*."[42]

Why publish this particular book in 1943? *Visages de Paris*, like the many books produced by other Carnavalet curators, helped to promote the museum's

collections, which provided the illustrations. But the book also hints at subtle resistance to the German Occupation. Wilhelm's insistence on the difference between those who are just "passing through" and the real Parisian distinguishes the recently arrived occupying forces from the city's residents. None of the contemporary photographs show any traces of the former. The book encompasses historical episodes from urbanization to war but erases its most recent defeat. It also draws heavily on Paris's revolutionary iconography—including scenes of the revolutions of 1789, 1830, and 1848 as well as the Commune and its aftermath—in the layouts devoted to the Hôtel de Ville, the Bastille, the Madeleine, the Place Vendôme, the Palais-Royal, the Tuileries, the Louvre, the Place de la Concorde, and St-Germain-des-Prés (fig. 3.3). Such pictures taught readers that the history of resistance to tyranny and oppression lay beneath much of Paris, doubling and tripling contemporary scenes of the Occupation. This technique of seeing the city's history in the pictures of its present became a way to resist the totality of the Occupation—to see a richer history that the Germans could never access.

The German presence thus encouraged contemporaries to question the documentary sufficiency of the contemporary photograph. After all, it could only capture moments of the Occupation, leaving centuries of prestige and revolutionary

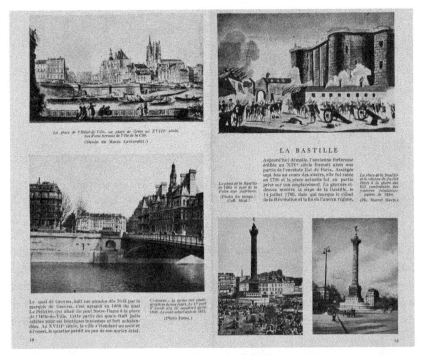

FIGURE 3.3 Jacques Wilhelm, *Visages de Paris*, 1943. Photo (bottom, far right) by Marcel Bovis. ©Marcel Bovis/RMN-Grand Palais/Art Resource, NY; Author's collection.

heritage unpictured. The repicturing book marked a shift from the imagined past as a series of indeterminate mental images and the photo as a document of a particular moment, to the photograph as a gateway to a succession of discrete scenes remembered from prints and paintings. This mode of picturing or repicturing Paris would become even more significant toward the end of the war and in its aftermath.

Picturing and Repicturing the Liberation

The content and meanings of photographs and photography during and after the Liberation built on the meanings and uses formed since 1940. Throughout that August week, its participants—photographers included—helped produce an event whose sense was rooted in the fact that it overturned the laws of the previous four years. They took part in a range of defiant activities. Some brought out hidden weapons to fire on the Germans; others organized new governmental structures and printed newspapers. For many, though, resistance was smaller in scale. They donned patriotic armbands and rosettes and flew the tricolor flag. People gathered in the streets in defiance of restrictions on mass assembly. Edmond Dubois described "an almost Sunday-sized crowd, wandering in search of spectacle."[43] Photographers captured them, adding to the mix their own transgressions of the restrictions placed on photography.

Most of these photographers had no prior experience capturing combat. War-hardened photojournalists such as Robert Capa only arrived in Paris with the Allies. Amateurs as well as some well-known fashion, portrait, and press photographers, including Robert Doisneau, Pierre Jahan, and Jean Séeberger were first on the scene. Interviewed in the 1990s, these photographers explained that they took photos to sell to the press, to add to personal or family albums, or to collect evidence of German crimes or French heroism.[44] Many had saved film throughout the war with an eventual liberation in mind. And they ran great risks to get their shots. The journalist, author, and avid amateur photographer Roger Grenier told of how German soldiers held him at gunpoint and confiscated his camera on August 19.[45] Jean-Marie Marcel also put his life in danger when he stood up during sniper fire in order to capture the cowering crowd at the Place de la Concorde. The thought "this is a historic moment, I'm a witness, I can't miss this" forced him to his feet.[46]

As members of the political left, the photographers participated in the battle by documenting it. Roger Schall and André Zucca, whose photographs had helped produce a whitewashed picture of occupied Paris, took few Liberation photos.[47] Zucca, for example, seems to have taken few photos before the victory parade on August 26th.[48] Even though they would have had cameras and film, they likely did not feel safe on the streets now run by the FFI. Photographs of

FIGURE 3.4 Portrait of a photographer. André Gandner, August 1944. Musée du Général Leclerc de Hauteclocque et de la Libération de Paris—Musée Jean Moulin, Paris-Musées. Coll. André Gandner.

the Liberation, thus, are not mere windows onto these events, as many historians often view them. They are the work of those with an investment in the particular interpretation of the Liberation as a week of heroism and in its continued postwar resonance. These photographs, just as much as the photos by Zucca and Schall of the Occupation, helped produce and circulate a particular interpretation of the historical significance of Paris during that August week.

The parallel between the heroism of the soldier—both amateur and professional—and that of the photographer becomes apparent in a pair of photographs taken by the professional photographer André Gandner. Among his six hundred pictures held at the Musée du Général Leclerc de Hauteclocque et de la Libération de Paris–Musée Jean Moulin in Paris are two images of fighters aiming their machines at his lens. The first is a photographer in civilian clothes and a helmet emblazoned with the Cross of Lorraine, symbol of the Free French Forces, the second an unidentified machine gun operator (figs. 3.4 and 3.5).[49] Both men adopt the same pose, staring at Gandner through their respective weapons, ready to "shoot."[50] Their helmets signal the dangers they face. The gunner, holding wilted flowers and flanked by grinning civilians, must have been hamming it up for the photographer during the celebrations of the Liberation's final days. The other man was either photographing Gandner or simply looking through his viewfinder. Regardless of whether Gandner asked the photographer

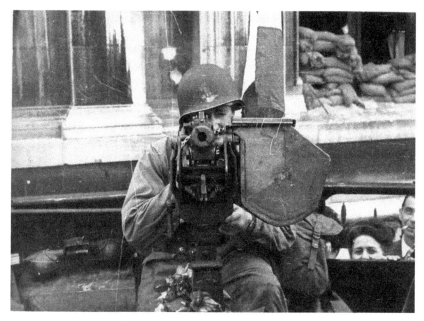

FIGURE 3.5 Portrait of a machine gunner. André Gandner, August 1944. Musée du Général Leclerc de Hauteclocque et de la Libération de Paris—Musée Jean Moulin, Paris-Musées. Coll. André Gandner.

and the soldier to adopt the same pose or simply caught them in it, his pictures imply that both were warriors in the battle to liberate Paris and France.

After spending more time with the Liberation photos, it becomes evident that some such scenes were staged for the camera.[51] There was certainly real fighting that took place during the week, and photographs capture hand-to-hand combat, the launching of Molotov cocktails, and the tank battles that occurred once the Allies arrived.[52] However, the scene in the photograph by Serge de Sazo, of three men clustered around a window at the Hôtel de Ville—one points a rifle over the sill while two others throw hand grenades over his shoulder—could not have been taken in the midst of a firefight (fig. 3.6).[53] These men, and certainly the photographer, are exposing too much of themselves through the open window to have remained safe during a siege. Furthermore, the photo has often been flipped around in its subsequent reproductions, so that (unlike here) its action reads from left to right, making it more aesthetically compelling.[54] What the photos look like matter as much as their function as proof of real actions.

Repicturing came to life on the streets as photographers captured what they and the Liberation's other participants thought history should look like. Photographs of the barricades epitomize this confluence of photographic aesthetics and the appearance of actions on the ground. They would, for many,

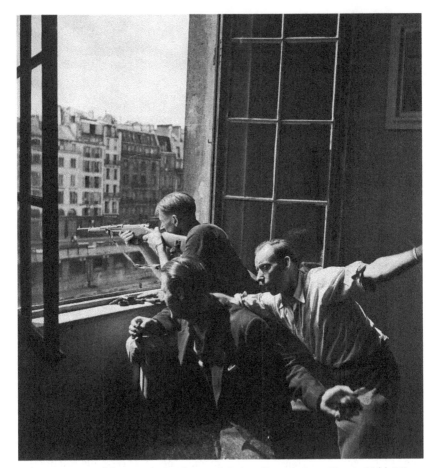

FIGURE 3.6 FFI fighters at the Préfecture de Police. Serge de Sazo, 21 août 1944. ©Serge de Sazo/Rapho.

come to define the Liberation as a populist uprising against the tyranny of the Germans. They are the materialization of the latent history—the possibility for revolution—that Jacques Wilhelm suggested lay beneath every street and square in Paris. And yet, much as the liberation of the city itself served little purpose in the larger push to free the continent, the barricades had little strategic value.

Photographs reveal just how poorly these structures would have withstood the machines of modern warfare. A photo taken by Jean Séeberger shows an American tank rolling over a barricade with an ease confirmed by an eyewitness's judgment that "if the Germans had wanted, . . . with six of their tanks, they could have smashed through every one of these barricades."[55] In another photo, Séeberger captured the German defenses: steel rails planted vertically in the streets.[56] Nor had the barricades been particularly effective in earlier revolutions.

The revolutions of 1848 and 1871, after all, had incited bloody reprisals. Barricades were erected only once during the 1789 Revolution (in 1795).[57] The barricades of the Commune, eight decades later, did not constitute an effective system of defense.[58] Those of 1944 certainly seem flimsy compared to the latest in military technology. So Parisians must have known, even as they built and defended barricades, that these structures offered little in the way of protection. Nonetheless, they persisted in playing out what they had spent four years imagining the liberation from the Germans might look like.

The barricades mattered, then, as sites of social engagement and the realization of a collection of historical images. The activist and artist Jean-Jacques Lebel has identified barricades as sites of social performance rather than strategic objects, or even objects at all.[59] Barricades became sites not only associated with the assertion of popular sovereignty but also with the construction of communal solidarity during a joyous yet uncertain time. Those who manned them were served drinks from their local café and received food passed out by the FFI.[60] Combatants at the barricades lounged in the sun, smoked cigarettes, and socialized with sundress-clad young women (fig. 3.7).

An October 1944 cartoon published in the daily *Le Parisien libéré*—showing an annoyed housewife asking her husband "are you going to keep pulling this barricade trick on me?" as he walks out the door with his FFI armband and hunting cap—gently mocked the fraternal camaraderie men found there (fig. 3.8).[61] The barricades also drew curious onlookers. The writer and historian Adrien Dansette noted that they "offer[ed] a permanent spectacle that one [could] admire at one's leisure."[62] Such was not the case for the real fighting of the Liberation, which resembled "an American movie: shots ring out from who-knows-where, a car races by, men run with shotguns or grenades in their hands, stop to crane their necks around the corner, and take off again with no apparent reason, as if they were following the secret rules of a baffling game."[63] Barricades gave a point of observation to the crowd. People were drawn, as an eyewitness recounted, by "curiosity without thought for danger, [by] passion for gawking" and by a sense of duty "to watch with fervor, to forever remember this astonishing spectacle."[64] As it turns out, the barricades also became easy fodder for the camera.

Almost every photographer active during that August week captured at least one barricade. Many, as their photos show, returned again and again to particular fortifications. Although one map shows dozens that photographers could have chosen from, the historical record contains a concentration of photographic representations from the Latin Quarter.[65] The neighborhood's small streets facilitated the barricades' construction, while its revolutionary past made their presence there significant. The one that barred the entrance to the rue de la Huchette where it met the Place du Petit Pont caught the eye of several photographers.[66] They captured its transformation from a modest sandbag

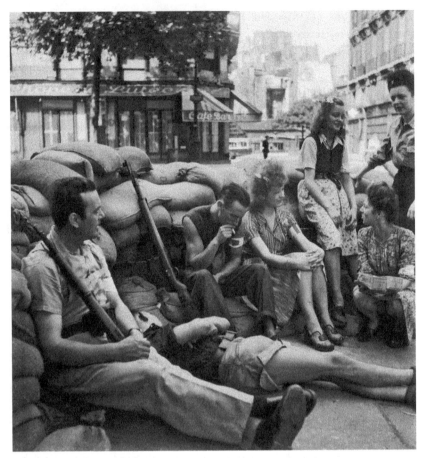

FIGURE 3.7 Liberation participants relaxing at the barricade. Robert Doisneau, August 1944. ©Robert Doisneau/Rapho.

structure on August 21 to a large earthen mound two days later. They must have been drawn to the classic figures of Parisian visual culture who manned this fortification: the bourgeois gentleman; the militant housewife, the concierge, or the market woman; the gangster-inspired rough-and-tumble hero of the working classes; and the one-legged veteran of World War I (figs. 3.9 and 3.10).

Just as these participants were guided by the idea of restaging the Parisian past in response to posters that quoted from the Marseillaise to order "aux armes, citoyens!," photographers were guided by the logic of repicturing. As Parisians restaged what they thought a righteous and just uprising should look like, photographers captured its visual legacy in ways learned from generations of images. The pictures taken at the Huchette barricade echo older compositions. They bear the legacy of both the dramatic paintings of the

— *Tu vas continuer à me le faire longtemps, le coup des barricades ?...*

FIGURE 3.8 WN Grove, *Le Parisien libéré*, October 14, 1944. Bibliothèque nationale de France.

nineteenth century—which often featured heroic groupings going over the tops of the barricades—and the posed photographic portraits taken at the barricades in 1871.[67] The 1944 photographers produced portraits of the barricades themselves, often taken from high windows, which evoke one of the very first barricade photographs, Thiébault's June 25, 1848, view down the rue Saint Maur (fig. 3.11). The length of Thiébault's exposure erased the people who stood behind and atop these structures, but so does the distance from which Doisneau framed the barricade at the rue de la Huchette (fig. 3.12).[68]

The composition of René Zuber's group portrait taken at the barricade (fig. 3.9) recalls paintings such as Jean-Victor Schnetz's *Combat devant l'Hôtel de Ville* of the revolution of 1830 (fig. 3.13). Schnetz's central figure, clad in white trousers and brandishing a rifle, emerges from a scene of combat and chaos, and Zuber's is still, posing with his pistol. But both become the focal point of each picture by virtue of the fact that they sit at the center of crossing diagonals of light and shadow that endow them with a clarity of purpose and set them apart from the figures aligned behind them.

Several photographers produced portraits of the bakerwoman Béatrice Briand in her spotted house dress (fig. 3.10), which seem to restage the multiple depictions of the female figure of Liberty at the barricades—from Delacroix's 1830 *Liberty Leading the People* to Nicolas Edward Gabé's 1849 *The Barricade*

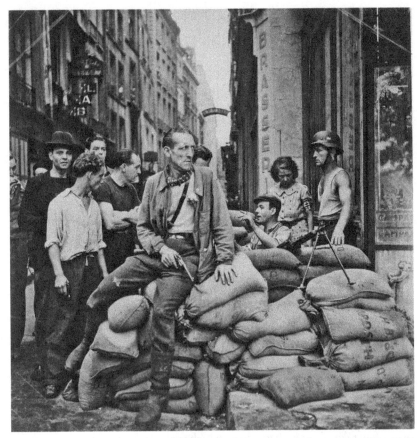

FIGURE 3.9 Barricade at the rue de la Huchette. René Zuber, August 22, 1944.
©René Zuber/Pierre Zuber/Roger-Viollet.

at Porte St Denis, Paris 1848—or even the *pétroleuses*, the women said to have thrown fuel on the fires lit by the Communards in 1871.[69] The photographer Pierre Roughol froze Briand in midthrow: the photo gives her an active role in the charge for freedom (fig. 3.14).[70]

Rather than repicturing functioning here to erase the details of the present in favor of a comforting image of the past, the doubling of past and present in these photographs helped construct the Liberation's historical significance. One journalist writing at the end of August described it as "a week-long dream during which the most glorious scenes from [Paris's] past reappeared in its streets."[71] By echoing familiar images of revolution, photographers added historical depth to the present. They helped ensure that the record of the dreamlike replay that happened in the streets looked like snippets of past dreams of rebellion and revolution.

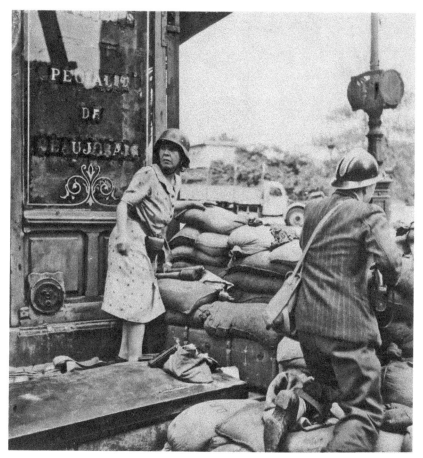

FIGURE 3.10 Barricade at the rue de la Huchette. Pierre Roughol, August 1944. ©Pierre Roughol/Collection Roger Schall/Musée Carnavalet/Roger-Viollet.

Collecting and Exhibiting the Liberation

Even before the dust and smoke had settled around the city, archivists, librarians, and publishers began making plans for the Liberation photographs. The Liberation, one might say, kicked the French documentary impulse into over-drive. These efforts overwhelmingly originated with former members of the Resistance: they sought to ensure that the movement's clandestine activities, which often left no paper trail, would enter the historical record. The trans-lator Suzanne Campaux and historian Adrien Dansette were among those who conducted interviews with participants throughout 1944 and 1945, and publishers such as Payot began producing series of documents.[72]

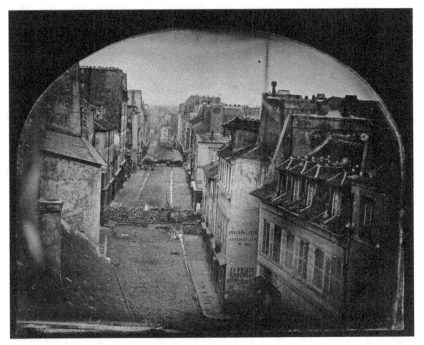

FIGURE 3.11 Eugène Thiébault, *Barricades on the rue Saint Maur, Before the Attack, June 25, 1848*. Photo by Hervé Lewandowski ©RMN-Grand Palais/Art Resource, NY.

At the Musée Carnavalet, the institution's director, François Boucher, sought to amass extensive photographic documentation. Starting in September, he solicited donations of posters and photos from individuals, photo agencies, and French and American government offices. He joined forces with officials from the Archives de France and the Direction des bibliothèques to launch a public contest for the best testimonies and ephemera.[73] Radio reports and articles in the press spread the word, specifying that Parisians should submit written accounts of what they had seen and done that August week. "If possible," they were asked, include "a map of your neighborhood's barricades, noting the construction date of each." The sponsors called for "photographs, sketches, tracings of graffiti, collected posters, [and] pamphlets."[74]

By October, those behind the contest had become an official body—the Comité d'histoire de la Libération—thus institutionalizing the study of the history of the present in France.[75] The French responded enthusiastically. One of the organizers reported that "an abundance of accounts and photographs immediately began to arrive."[76] Parisians donated "underground newspapers, the archives of resistance movements, [and] private correspondence."[77] These combined activities were just the first of the many developments that shaped the uses and effects of Liberation photographs in the post-Liberation period.

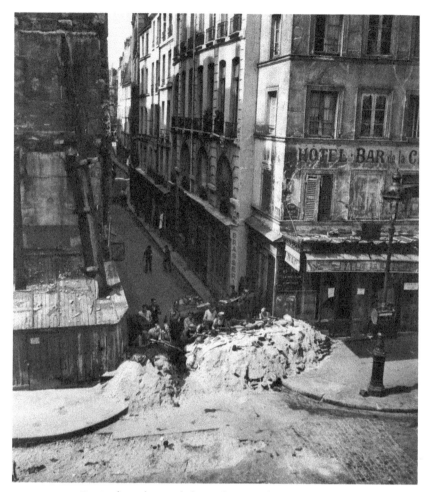

FIGURE 3.12 Barricade at the rue de la Huchette. Robert Doisneau, August 23, 1944.
©Robert Doisneau/Rapho.

At the Musée Carnavalet, Boucher's participation in the Resistance influenced his drive to collect Liberation documents, but these efforts were rooted in his larger campaign to modernize France's history museums. In a pair of articles published in 1941, the curator had criticized such institutions for their willy-nilly acquisition practices. He argued that staff should outline rational plans for acquiring systematic documentation about the present.[78] In a letter written shortly after the close of the 1944–1945 exhibition, Boucher declared, "for the first time, in very short order, we have been able to gather substantial documentation on contemporary events in Parisian history."[79] Moreover, the museum had acquired the very types of documents that did not usually enter traditional archives. Boucher emphasized the novelty of collecting posters, which otherwise were often "not

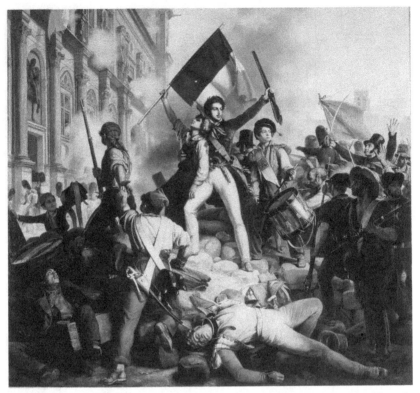

FIGURE 3.13 Victor Schnetz, *Combat before the Hôtel, July 28th, 1830,* 1833. Photo by Bulloz ©RMN-Grand Palais/Art Resource, NY.

even kept by the issuing services [*services émetteurs*]," and photographs, which "will be quickly neglected, scattered, or destroyed!"[80] If one waited even a few years to collect these documents, they might no longer exist. Boucher's project thus helped prevent the loss and dispersal of some fifteen hundred photographs of the Liberation.

But while Boucher undoubtedly collected pictures to ensure the preservation of ephemeral materials, his focus on photographs was also motivated by a belief in their particular utility as material proof of what they pictured. He and others who issued similar calls believed that they needed more than just official documents to tell the history of the Liberation, but they were wary of other types of testimony and records. Even as archivists and commentators collected and republished eye-witness accounts and newspaper articles written in the heat of the battle, they warned against lending them wholesale credibility.[81] Photographs seemed to offer direct and objective access to the events of the Liberation: a counterpoint to the slipperiness of these other sources. The photographic record ensured, in

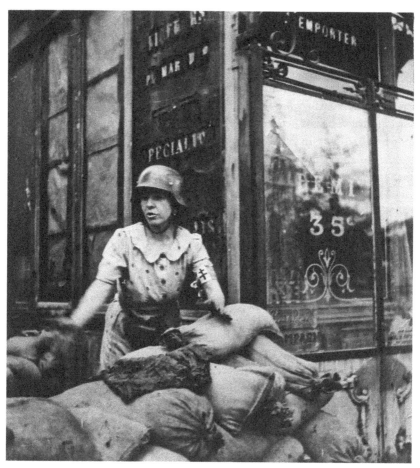

FIGURE 3.14 Barricade at the rue de la Huchette. Pierre Roughol, August 1944. ©Pierre Roughol/Collection Roger Schall/Musée Carnavalet/Roger-Viollet.

the words of François Boucher, that "from now on history will benefit from the progress of science."[82] Photographs had become what Marcel Poëte had imagined them to be: the ultimate scientific document of the city.

Contemporaries thus lauded the impartiality of photographs, while also crediting them with the ability to evoke strong emotional reactions in the viewer. Boucher averred that the photos at the Carnavalet "have a trace of truth that will move visitors."[83] In fact, archivists and historians' warnings against writing the history of the Occupation and its end too soon simply paid lip service to an ideal of objectivity. The accounts and documents collected in the fall of 1944 and the winter of 1945 became fodder for a series of histories of the most recent past.[84] And photographs, instead of sitting in archives and collections waiting to be used,

would play a key role in bringing to the French public not just what happened, but the emotional intensity of it—seen through a particular political lens.

Boucher's collection of photographs became fodder for an exhibition about the Liberation, which opened on November 11, 1944, and ran, following a prolongation due to public demand, through January 14, 1945.[85] This exhibition was just one of many throughout Europe that interpreted the tumult of the previous five years and started to stake out national narratives of responsibility and victimization.[86] In Paris alone, curious crowds could choose from a series of exhibitions about the war on subjects as varied as the conditions of prisoner of war camps, the production of the underground press, and the role of the French navy.[87] The largest exhibition about war crimes, "Les crimes hitlériens," organized by the Ministère de l'information's Service des crimes de guerre, opened at the Grand Palais on June 10, 1945 and ran until July 31. Its displays about Nazi atrocities highlighted the torture, execution, and deportation of members of the Resistance, economic spoliation, and the massacre of the town of Oradour-sur-Glane.[88] They drew what one reviewer described as "a silent and horrified crowd" who "slowly shuffle[d] along in front of the charts, maps, and huge photos of the Nazi atrocities."[89] This exhibition would travel throughout France and Western Europe helping to create a national narrative for the war. The exhibition at the Musée Carnavalet featured a very different story, simultaneously both more local, focused on one week in Paris, and more universalizing in celebrating the triumph and heroism of Parisians and inscribing them in a longer history of the city as the capital of revolution.

The displays, which occupied four rooms in the museum's ground-floor temporary exhibition space, included photographs, posters, written documents, and objects.[90] The first room presented the Liberation's "general physiognomy" via panels and display tables with information about the victims, as well as a reconstruction of a barricade behind which hung panels devoted to great men—among them de Gaulle, Leclerc, and Eisenhower—and anonymous citizen-heroes (fig. 3.15). Panels bearing photographs of posters framed this ensemble. The second room contained panels and cases devoted to the takeover of the Préfecture de Police and the Hôtel de Ville, as well as a large map of insurrectional activities throughout the city. In the third, panels hung under wooden cutouts of the Gallic rooster and a Resistance fighter at the barricades. These, alongside a series of glass-topped display cases, presented key events and sites: the barricades and fighting on the Left and Right Banks, the entry of the Allies, the parade. This room also contained a large back-lit installation of the Cross of Lorraine, framed by Allied flags (fig. 3.16).

The final room was consecrated to the objects produced before and during the Liberation: the "thousand badges, handkerchiefs," "the trinkets and the

FIGURE 3.15 Anonymous, Musée Carnavalet, 1944. ©Musée Carnavalet/Parisienne de la Photo/Roger-Viollet.

jewelry that the Parisienne wore: dresses, hats, parasols, shoes, brooches, clips, belts, earthenware, glassware, scarves, etc." (fig. 3.16).[91] It also contained "artists' works, inspired by the theme of the Liberation of Paris, watercolors, paintings, engravings or ceramics, book illustrations, and children's picture books."[92]

Although Boucher claimed in a press release that the Carnavalet exhibit was of "a principally documentary nature," its displays presented a specific and heroic interpretation of the Liberation.[93] Here, photographs were key to the construction of meaning. Their presumed objectivity masked their interpretive work; what they pictured concealed what they did not. In his press release, Boucher wrote, "photography offered the most considerable contribution" to the exhibition.[94] He discussed the importance of showing written documents alongside the photographs, which might "make real events that had not been the object of figural representations or uphold and reinforce the interest of those that were represented by this photographic documentation."[95] Thus he relied on written documents to exhibit some of the unphotographed actions of the Resistance groups. But he also chose not to include events that were photographed. There were no images in the exhibition of Franco–French violence on the part of the Milice, the French paramilitary group that fought with the Germans; or of those who participated in the abuse and shaming of the *femmes tondues*, women accused of sleeping with the enemy.[96]

FIGURE 3.16 Anonymous, Musée Carnavalet, 1944. ©Musée Carnavalet/Parisienne de la Photo/Roger-Viollet.

At other times the interpretation was wrought from combinations of photographs. On the wall behind the recreated barricade, for example, Charles de Gaulle's portrait practically rubbed shoulders with Pierre Roughol's snapshot of Béatrice Briand defending the barricade at the rue de la Huchette (fig. 3.14). This pairing placed the two on the same side of the barricade, when at the time the largely communist internal Resistance was at odds with the authoritarian power that de Gaulle represented. And yet Boucher's narrative maintained the illusion of transparency. One reviewer opined that to visit the exhibition was to "believ[e] oneself brought four months back in time."[97] The displays gave visitors seemingly direct access to some of the strong emotions of that week.[98]

For Boucher and critics alike, the exhibition would aid in reinterpreting the rich and varied images and objects left behind by other revolutions and also housed at the Carnavalet. The mode of repicturing, seeing past and present side-by-side, after all, did not just allow viewers to interpret the present moment. It also changed how they saw the past. Boucher was keenly aware of these parallels, explaining to the press that the museum might keep a certain number of the material objects from 1944, "as today the Carnavalet itself conserves analogous [objects] from the revolutionary period."[99] The parasols and glassware of 1944 updated the swords, flags, and Phrygian bonnets of 1789. And as one reviewer noted, "the stones of the barricades of the month of August 44 have joined the stones torn in 89 from the Bastille."[100] This association gave the Liberation a

longer history, but it also worked to reinterpret the previous revolutions. The Parisians of 1944 built barricades in the streets, but a representation of a previous revolution could never have depicted a prominent right-wing general next to a militant Parisian woman at a barricade. During any other uprising, a high-ranking military officer would have been much more likely to have ordered his troops to attack such a woman than to stand at her side.

While François Boucher would report to the press that the exhibition drew sixty thousand visitors, documents held at the Carnavalet indicate that only 32,638 people attended.[101] This is still, however, an impressive number for a paying exhibition held during a period of worse shortages than the French had suffered under the Occupation. The high attendance suggests that memories of the Liberation, as pictured in sun-drenched photographs, became a form of solace to Parisians. Those who wanted to see it again or who had not made it the first time around could purchase the book version: a richly illustrated tome published in 1945.[102] In fact many more people throughout the nation witnessed that August week neither in person nor on the walls of this exhibition, but rather on the pages of photographically illustrated books.

The Liberation Photohistory

Accounts of the war enjoyed great popularity in its aftermath, but according to Howard Rice, an American then based in Paris, books about the Liberation were by far the most popular, rivaled only by biographies of Charles de Gaulle.[103] By the end of 1944, publishers had produced at least a dozen such books and pamphlets. In 1945 they produced at least sixteen more and reissued several from the previous year. Production slowed to a dozen in 1946. Of these more than three-dozen accounts, only a handful lack illustrations.[104] Some had a few images inserted between pages of dense text, while roughly half were true albums of photographs accompanied only by captions and a short preface.[105] Several publications whose first editions had not included illustrations were reprinted with photos months later.[106] Prices ranged from 300 francs for a bound book printed in color to 10 francs (or about five times the price of a daily newspaper) for a pamphlet of stapled newsprint, ensuring that almost any French person could afford to bring home such a keepsake.[107] During a period in which paper, ink, and photographic materials were in short supply, it would have cost more—in terms of both money and effort—to produce such illustrated books. That publishers did so speaks to their savviness in capitalizing on the resonance of the Liberation and to the public's desire to own a material slice of the history of that iconic week.

Photographs did not merely ornament texts in these books; they played a key role in providing readers access to the events of the Liberation. With titles such as *Seen during the Liberation of Paris: Journal of a Witness, Illustrated with 21*

Photographs; The Liberation of Paris: The Historic Days from August 19 to August 26, 1944 as Seen by Photographers; The Liberation of Paris as Seen from a Police Station, and *Ever Watchful in Insurgent Paris*—books and pamphlets presented the battle as a carnival of spectacles.[108] In the preface to one such album, the journalist and Académie française member François Mauriac captured the duality of scientific proof and mysticism embedded within the photo: he described it as "an irrecusable testimony to the miracle."[109] A review of the book promised that its 120 photographs would, "better even than the—albeit excellent—commentary that accompanies them, evoke these indescribable and blessed hours for the future."[110] The photograph must indeed have had magical powers if it could upstage the prose of a member of the Académie française! According to Marcel Flouret, prefect of the Seine, only photos might convey "the living, breathing image of spectacular hours in all their variety, in their racing speed, almost in their disorder, . . . the atmosphere at once tragic and joyful, just as it was breathed by all those who [participated in the battle]."[111] Similarly, the author Louis Gratias explained that the 150 photographs in his book *Barricades* would "rapidly evoke the atmosphere of this battle for Paris."[112] Like a sort of cinematic montage, photographs would transmit the Liberation in all its enthusiastic glory, as if the reader were right there in the streets.

Photographs also made for better propaganda. One critic, responding to the exhibition "Les crimes hitlériens" had asked, "Why has the government not yet turned [these images] into an illustrated pamphlet printed in millions of copies and that would be distributed not only in France, but also to our Allies, and, why not, even to Germany?"[113] The question illuminates an assumption that drove the production of these types of documents: that illustrated books and pamphlets could reach much larger audiences and have an effect on people's understandings of events of the recent past for much longer. The evocation of propaganda underlines, too, just how sensitive audiences would have been to the fact that the wartime reinterpretation of French values under Vichy had passed through its own iconography celebrating the rural and the pious, the peasant and the artisan.[114] France's national iconography had been purged of representations of Paris, factory workers (who were likely to be Communist), and secular symbols of the Republic such as the Marianne. The dissemination of photographs of the Liberation of Paris replaced Vichy images with pictures of the capital, the Parisian revolutionary, the victorious Communist worker crouched behind sand bags and paving stones. These photos, which repictured one type of national visual tradition, also worked to unpicture another.

The transparency of the photography hid all of this political maneuvering. In 1945 Howard Rice recognized that the Liberation books were not just distracting pulp that might help the French through a hard winter but the very stuff by which historical myth was manufactured. "In France, more than in any other

country," he explained, "the popular imagination transforms the present into history with extraordinary rapidity. Events and collective experiences are miraculously crystallized into symbolic dates and emotion-laden myths. Already 'La Libération' is such a myth."[115] The photographic narratives that emerge in these books offered a cleaned-up version of the events. They promoted an iconography of the revolutionary tradition and erased the internal divisions and violence of the *Epuration* or purge that began during the Liberation and continued for several years.[116] A survey of the illustrated books, which include hundreds of photographs, turns up no more than four photographs of the Milice, only three of the public shaming of the *femmes tondues*. The seeds of an alternate interpretation were there: the photos that show the tactical insignificance of the barricades were all published in books or pamphlets at the time, and yet the books foreclosed readings of these images as anything but evidence of Parisian heroics.

With their photographs, these books constructed the interpretation of the heroic Parisian as part of a community united across divisions of age, class, and gender. They included copious photos of the barricades' construction, for example, showing men, women, and children ripping up paving stones and cutting down trees. Page layouts brought this to life by placing photos of construction alongside the finished product (fig. 3.17). Photographs of battle project a similar image of social solidarity as bourgeois and working-class men, young boys, and even women took up arms. Others show how the city itself participated, contributing cast-iron tree grates, newspaper kiosks, and even its iconic Morris columns for barricade construction.[117] As François Mauriac enthused, "for the first time, it was not a question of fratricidal struggle; for the first time, all of the French found themselves on the same side of the barricade."[118] These books thus provided narratives into which a wide range of readers could project themselves, becoming part of the battle to liberate the capital. The photographs became historical documents twice over, freezing moments from August 19 to 26 and inserting them in a much longer past, evoked in the viewer's mind.

By all measures the French eagerly consumed these images and narratives and imagined preserving them for years to come. In November 1944, a journalist exulted, "bookstores are running out of their stacks of [*Libération de Paris du 19 au 26 août 1944*]. Bravo!"[119] That such books would sell well is not surprising. After all, newspapers sold out within a few hours during the Liberation, and at the opening of the film *La Libération de Paris*, six thousand people packed into a theater with seats for two thousand.[120] The journalist and literary critic Robert Coiplet recounted the anecdote of a Resistance fighter who had fought at the barricades at the place Saint-Michel. As he left to join the front lines, the man "asked his wife to take great care, among the objects he left behind, with [a book about the neighborhood's liberation], which reminded him of the best hours of his life."[121]

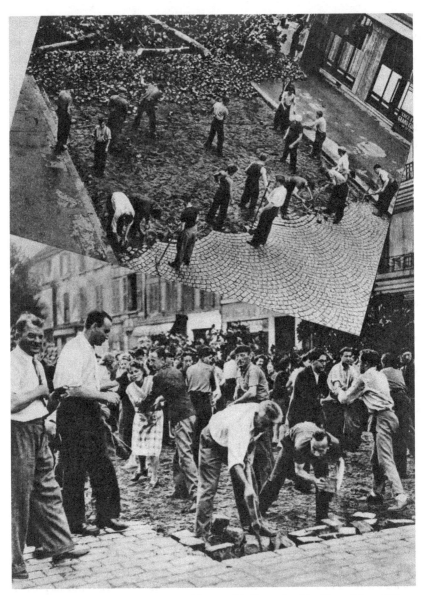

FIGURE 3.17 François Mauriac, *Paris libéré*, 1944. Photo (top) by Pierre Jahan. ©Pierre Jahan/Roger-Viollet; Photo (bottom) by Robert Doisneau. ©Robert Doisneau/Rapho; Author's collection.

Beneath the homogeneity of Liberation narratives, however, lay vicious conflicts and the serious settling of scores. The unified interpretation of the Liberation presented in books and pamphlets did not just hide efforts to define the war's legacy, and the work they performed did not merely shape how their readers understood what had happened in Paris at the end of August 1944. Their production also became a way for photographers, authors, and publishers to justify and excuse their wartime actions while claiming allegiance to the Resistance during the postwar *Epuration*. While publishers and authors certainly published accounts of the Liberation of Paris because they thought people would buy them, they also relied on the presumed transparency and objectivity of the photograph in order to make claims about their own roles in the previous four years. Photographs here could mask events that they did not picture.

Some of the printers and publishers behind books and pamphlets about the Liberation had also catered to a German-speaking public and printed official Vichy publications during the Occupation. Unlike French newspapers and magazines, which the new government had forcibly dissolved if they had operated legally after 1940, most publishing houses and printers remained open.[122] While many had avoided politics, others produced works that were intimately tied up with the Vichy and German regimes. Throughout the war, the printers Draeger frères, for example, who specialized in illustrated books and advertisements, printed Vichy propaganda.[123] In the postwar period they would produce four photo books glorifying the Liberation, among them a commemorative book put together by the city of Paris.[124] The publisher Fasquelle published a volume of Pétain's speeches in 1941 and a photo book about the Liberation in 1945.[125] Similarly, the Parisian publisher Braun atoned for a photographically illustrated German-language guide to Versailles with a series of accounts of liberations throughout France.[126] While these particular editors were not arrested for collaboration, Bernard Grasset was. A journalist writing in *Le Parisien libéré* under the tagline "the Parisians" accused "this notorious collaborator" of "preparing in all haste a grand work whose title has already been decided: Vigil for Liberty."[127] He too sought to hide unsavory wartime projects behind a newfound embrace of Paris's favorite muse.

The authors and sponsors of accounts of the Liberation of Paris also used them to mask their sometimes-questionable wartime activities. After the war, the author and journalist Jacques de Lacretelle wrote the introduction to *La Libération de Paris: 150 photographies* and helped start the newspaper *Le Figaro*. But in the 1930s he had worked as the editor of *Croix-de-Feu*, the newspaper of the nationalist (and arguably fascist) political party of the same name. When the provisional government sent him on an official mission to the United States in 1945, a journalist in *Les Lettres françaises* protested, reminding readers about a particularly eloquent anti-American and pro-German ode that de Lacretelle

had penned in 1941.[128] De Lacretelle might have feared the same fate as another prominent prewar author turned fascist, Robert Brasillach, who faced a firing squad in February 1945.[129] Likewise, members of the French police preferred that the public remember their call to strike, which had sparked the Liberation, as it was laid out in the pamphlet *La Libération de Paris vue d'un commissariat de Police*, rather than their cooperation in enforcing the laws of the Occupation.[130]

The most obvious example of such an attempt to rewrite the history of the Occupation occurred with the photo book *A Paris sous la botte des Nazis*. Written by Jean Eparvier and published by Raymond Schall in 1944, it reinterpreted the material history of wartime photographs taken by Roger Schall (the publisher's cousin), Joublin, Pierre Vals, Roger Parry, Maurice Jarnoux, and André Papillon as heroic acts of documentation.[131] Their pictures show the German Occupation of Paris. Some, of bread lines and signs declaring food shortages, document the city's difficult conditions, but others present scenes of leisure and peaceful coexistence—rather than violence or oppression—between German soldiers and French civilians. Many of these photos could not have been taken without German permission. Although the book does contain some photos of Nazi atrocities, they are all credited to anonymous photographers. Nevertheless, the preface provides an unambiguous reinterpretation of all the book's photos, explaining that they were in fact the products of acts of resistance:

> In the hope of one day publishing it for all to see, [this book's creators] wanted to make it a record of the winds of insubordination, which never stopped blowing through Paris and France. Thanks to various ploys, the photographic documents were produced behind the enemy's back, quite often at the risk of the photographers' liberty—if not their lives.[132]

Typeset in the shape of a Phrygian bonnet, symbol of the 1789 revolutionaries, this preface elides the very fact, so visible in their pictures, that these photographers had worked with German approbation. *A Paris sous la botte des Nazis* sought to preclude retribution by recasting photographs that had been taken to be sold to the press. It reinterpreted them as historical documents taken as proof of the enduring spirit of French resistance.

Jean Galtier-Boissière, founder of the satirical magazine *Le Crapouillot*, recorded the publication of this book in his journal, which he later published. He dubbed it a "remarkable book" but also described the conditions of the production of some of its images.[133] Otto Abetz, the German ambassador to Vichy, he claimed, had negotiated the photographer Roger Schall's release from a POW camp in 1940 and "accorded him exclusive photographic rights for the whole occupation."[134] Knowing this, Galtier-Boissière declared that the preface, and in particular its lines about subterfuge and the risking of bodily harm, "takes us for

fools."[135] His judgment resonates all the more if one looks closely at the people to whom the book's many photographs are attributed. The photographers who get top billing in the album took neither the chilling pictures of Nazi atrocities nor the handful of barricade photos. The absence of their names from those pages suggests that they either may not have felt welcome at Paris's barricades in 1944 or they did not want to be there at all (not even to snap the picture). Yet the inclusion of their photographs in a book that glorified the Resistance was an attempt to give them a place in this movement.

In much the same way that writers sympathetic to the Nazis had sought to become the new literary elite of the Occupation, those who authored the texts for or sponsored books about the Liberation did so as they jockeyed for position in the cultural hierarchies of the new regime. Most acted as verifiable long-term opponents of Vichy and the Occupation. They included journalists (Georges Duhamel), Free French officials (Alexandre Parodi), and active Resistance fighters (Claude Roy), each working to emphasize his own group's importance in the Liberation. The French Communist Party, for example, which had organized and planned the uprisings of August 1944, published a pamphlet about the Liberation that celebrated it as a solely homegrown insurrection rather than the intervention of the Free French.[136] For these actors, publishing books about the Liberation of Paris helped lay claim to national contributions as they maneuvered through postwar politics.

The publication history of the books that so heavily employed photos of the Liberation provides another way in which the logic of repicturing served to recast the history of the present. Publishers, writers, and photographers built on the meanings produced by what the photos pictured to delineate their own positions within postwar conflicts. How these photos were used gave them meaning. At the same time, the photographs constituted proof of claims to heroic action, political allegiance, and solidarity precisely because their meanings seemed so self-evident. To publish photographs of the Liberation was—much the same as taking photos of it had been—to lay claim to acting in its name.

Repicturing Lives on

The specific genre of Liberation books with their celebratory photographic deployment and redeployment did not survive the decade. Such books must have started to seem naïve as the French grappled with the reality of postwar reconstruction. Howard Rice had claimed in 1945 that the Liberation "books and photographs [. . .] already have a certain nostalgic quality."[137] Read alongside the venomous accusations of collaboration that appeared in newspapers at the time, they do indeed. They were nostalgic for a national unity that never existed, not in August 1944, and certainly not in the months that followed. Writing in

1946, the communist director of *Les Lettres françaises*, Claude Morgan, criticized this almost reactionary genre. Singling out François Mauriac as one of the worst offenders, Morgan declared that accounts of the war and Liberation needed to "stop considering events as a succession of Epinal prints [*images d'Epinal*]" and instead account for "the three-dimensional space in which we live."[138] He equated the facile interpretation of the war's many internal conflicts with cheap, popular, and mass-produced pictures. And indeed, the Epinal prints of the day—photographs—had facilitated the erasure of many actions in those years. As if responding to Morgan's call, by 1947 the production of Liberation books had slowed to a trickle. Books about the previously repressed tensions and conflicts of the Liberation (Georges Duhamel's experiences, an anonymous collaborator's memoir, or the Swedish ambassador's account of negotiating the August cease-fire) as well as democracy, France, and its relations with the United States, took their place in bookstores.[139] Even the significance of the Liberation of Paris as a major moment in the history of the barricades seemed to disappear: a 1948 children's book about Parisians at the barricades included just one sentence about those of 1944.[140]

However, the waning of the production of enthusiastic tributes to the Liberation does not mean that this event completely lost purchase after 1947. Contemporaries expressed faith in the idea that the books—like the photobooks of Paris from the 1930s—would continue to teach future generations. The wording on a red paper band wrapped around the cover of *La semaine héroïque* declared, "May your grandchildren one day find in your library this lasting testimony of the Liberation."[141] André Tollet echoed this sentiment: "Let us hope that, later, young French people will often turn the pages of this book and many others [like it]. They will learn, via the image, what the People of Paris are worth."[142] And indeed, the children who pulled these books off bookshelves would know nothing of their production histories. The volumes would simply offer these young readers the transparent testimony of the photograph, and through it the value of the Parisian people.[143]

They also perpetuated the new mode of repicturing. Perhaps no image better illuminates this new mode than a photographic montage included in *Un micro dans la bataille de Paris,* a four-disc set put out shortly after the Liberation by the Société de radioproductions (fig. 3.18).[144] Each disc's paper folder features a montage of photos and prints. The first combines three photographs of the defense of Paris. In the upper left, French police patrol the rooftops, rifles at the ready, while just below, a policeman and a civilian defend a barricade made of sandbags. The right-hand sides of these two images fade into a picture of two young men throwing Molotov cocktails from a window overlooking Notre-Dame. Over these three scenes floats a snippet of an engraving of National Guards defending Paris in 1871, printed in rust-colored ink. They too are armed and dug-in behind

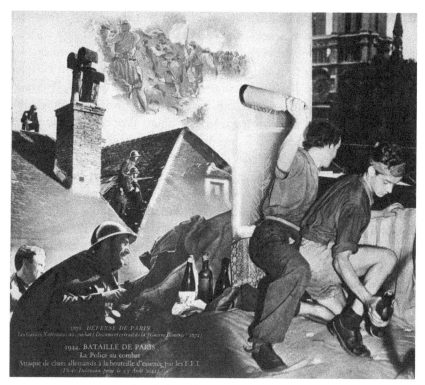

FIGURE 3.18 *Un micro dans la bataille de Paris*, 20–26 août 1944. Photo by Robert Doisneau. ©Robert Doisneau/Rapho; Cambridge University Library.

a barricade. The print's edges are soft, blurring into the surrounding sky: it is as if the ghosts of past battles hover over Paris in August 1944. While the page layouts in Jacques Wilhelm's *Visages de Paris* had simply hinted at the revolutionary potential dormant behind the contemporary photo, this image declares it a *fait accompli*. It makes visible how the French understood the Liberation and pictures of it refracted through older pictures of Parisian revolution. One contemporary, writing shortly after the Liberation, had described how "We still have, stuck to our retinas, the images of that Paris [of the Liberation] which join the thousands of other images of Paris that a man of the century stores in his memory: the living mixed with the dead, fresh colorful images mixed with old prints."[145] This image provides the shape of how the scenes of August 1944 might join the other pictures of history carried in the mind's eye.

Just as the content and technologies of photography are always shifting, so too are ways of viewing photographs. The logic of repicturing built temporal depth into the picture of the present. It made the vision of occupied Paris more palatable and helped boost the historical meaning of the Liberation. It was the fruit of the intersection of two currents in understandings of photographs' utility

to interpretations of the recent past in the first half of the 1940s. On the one hand, publishers, archivists, and curators believed in the photograph's superior abilities as both more objective and more emotionally powerful than other sorts of documents, be they texts or images. And this conviction drove their efforts to collect, exhibit, and disseminate photos of the Liberation in 1944, 1945, and 1946. On the other hand, however, they were deeply aware of the photograph's insufficiencies. As transparent as it seemed, the photo often could not function on its own. Rather it needed techniques of historical montage, either on the page or in the viewer's mind, to accurately picture both the present and the past.

Thus even though the production of Liberation books tapered off, both repicturing and an increased reliance on photographs to testify to the greatness of Parisian history would continue in popular historical productions after the war. The uses of photographs as history took on a new vein in the 1950s as the illustrated press, museum exhibitions, and a spate of books put Parisian history—and especially photographic history—front and center for the nation's future. At the same time contemporary photos of the everyday knit ties to the past much in the same way those from the Liberation had done. Both trends would come to the fore in 1951 during the public celebrations of Paris's two thousandth birthday—the Bimillénaire de Paris.

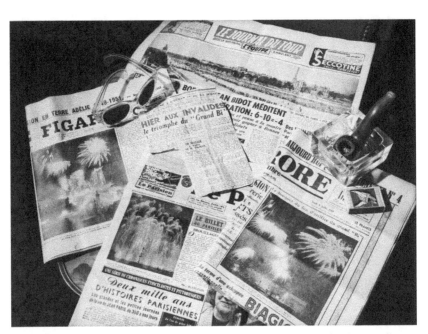

FIGURE 4.1 François Kollar, *Press Reports Related to the Fireworks for the Bi-millénaire Celebration of Paris*, July 1951. ©François Kollar/Ministère de la Culture/Médiathèque du Patrimoine; Dist. RMN-Grand Palais/Art Resource, NY.

4 STYLE AND SUBJECTIVITY

THE BIMILLÉNAIRE DE PARIS AND
THE PARISIAN CLICHÉ

In 1954, the poet Pierre Mac Orlan described the photos in Willy Ronis's *Belleville-Ménilmontant* as already belonging to the realm of history. Taken over the course of the previous few years, the photos show everyday life and architecture—buildings, gardens, small passageways, children at play, and craftsmen at work—in two northeastern Parisian neighborhoods. Nothing much happens in these pictures, and they were fairly recent shots. They are not the photographs of vieux Paris architecture, which were touted as historical documents in the 1910s and 1920s; nor do they attempt the spectacular restaging of history that the Liberation photographs had. Rather these are quiet images of daily life in two predominantly working-class areas. They most resemble those of Paris photo books published in the 1930s. When critics and commentators had written about these earlier volumes, however, they had only praised their historical value for the future. Books such as Brassaï's *Paris de nuit*, the critic Emile Henriot had written, would serve as history lessons not for contemporary readers or even their children, but for their children's children. Henriot had reminded photographers that they worked for readers of the year 2000.[1] Mac Orlan, though, did not assume that these photos would need the distance of time. Already, he wrote, "the images of contemporary life in peaceful Belleville-Ménilmontant allow for resurrections."[2] How, just decades after Henriot looked at Brassaï's Paris photos and saw the present, did Mac Orlan understand Ronis's photos as instant historical documents?

His judgment makes sense when understood within the context of two major shifts in the valorization of, and discourses around, photographs and history that emerged after 1945. These discourses particularly focused on the history of the capital leading up to and during 1951, the year that this history was brought into the streets

and sold all over the world as part of celebrations of the city's two thousandth birthday: the Bimillénaire de Paris. Two new developments, which were influenced by the specter of global decline and the push for modernization that defined the decade, shaped popular understandings of photography. Interest in the value of old photos as historical documents left the purview of a handful of collectors to enter the wider landscape of the popular historical imagination. Exhibitions, photohistories, and the illustrated press all taught the public about the particular pull of these old pictures. And building on the logic of repicturing, contemporaries increasingly read history into images of the present in which nothing much happened. They saw these as historical documents not necessarily because they depicted iconic architecture or world-altering events but because they captured people or elements of everyday life that seemed to embody the city's centuries-old historical strata. History, in such pictures, became a set of visual clichés: elegant Paris, intellectual Paris, popular Paris, all set in relief by visions—or a lack of vision, as it were—of what Paris might become in the decades to come.

Both trends incorporated shifting valuations of the photo: not as an objective and transparent document of what it pictured but increasingly as evidence of visual style, form, and the subjective viewpoint of the photographer. Journalists, popular historians, and curators—as well as city promoters—praised both new and old photos for what they looked like as well as what they pictured. For Mac Orlan, Ronis's photographs captured the neighborhood and the photographer's perspective. Photographs were "Rolleiflex poetry" revealed verse by verse in the darkroom.[3] For such critics the vision of history became bound to the aesthetics of the picture. Photographs thus entered the public consciousness—the popular historical imagination—not just as documents of the city, but as what thirty years earlier Marcel Poëte had lamented they were not: documents of how the artist had seen it. These interests in style, in naming and tracing the particularity of the photographer's gaze, developed alongside the importance of visual clichés of Paris.

On the one hand, old photographs gained in public exposure and importance because enough time had passed to make their scenes strange and compelling. On the other, they were simply one piece of the role that French, and particularly Parisian, history played in the tensions shaping the nation's post-1945 identity. France had been both an Ally and a collaborating nation. While the other Allies could celebrate victory, France was wracked by the internal turmoil of the *Epuration* and the beginnings of armed conflict in its colonies. France's linguistic empire, too, was in decline as English gained ground as the lingua franca of international commerce and diplomacy.[4] American commercial influence (and the Marshall Plan funds that France needed for reconstruction) also seemed to threaten fundamental aspects of the French way of life.[5] By the late 1940s, Simone

de Beauvoir opined, "having become a second-class power, France defended it-self by glorifying, for purposes of exportation, its home-grown products: fashion and literature."[6] One might well add history to the list. At the same time, these years marked the beginning of three decades later dubbed "les trente glorieuses," or thirty glorious years of growth and prosperity that modernized the nation.[7] Being French meant adopting technological innovation, and modernization projects themselves were sold as both forward-looking and deeply grounded in past traditions.[8]

The specter of global decline most tangibly haunted the capital itself. Although Paris survived the war intact, it seemed to be losing its status as capital of the Western world, beacon of culture.[9] Even Paris's physical survival had its downsides: most money for reconstruction went elsewhere, while Parisians lived in increasingly decrepit conditions.[10] Scarcities of materials and money meant that many buildings and neighborhoods had gone so long without necessary maintenance that they were literally "rotting."[11] In part Mac Orlan saw history in Ronis's photos because time did seem to stand still in neighborhoods such as Belleville and Ménilmontant.[12] And yet, as postwar tourism ramped up and Americans brought dollars to spend, city officials sold the idea of Paris as a global cultural destination—a must-see stop on the latest iteration of the European tour—in part because city residents maintained strong ties to the past. Parisians in this period looked with nostalgia to the height of the capital's modern glory, renaming "Paris 1900" the "Belle Epoque."[13] Janet Flanner, the *New Yorker*'s Paris correspondent who used the pen name Genêt, commented in 1946, "in the midst of the new, Paris [was] also certainly leaning heavily on its past."[14] By its very na-ture, photography was poised to become an integral part of the heady cocktail of past and future shaping Paris for the decades to come. Representing the accretion of past city history and the future of tourism (the new tourist was, de rigueur, an amateur photographer), photographs had never played a greater role in both exacerbating the sense of Paris's decline and providing a means to alleviate it.

The Bimillénaire de Paris

During the summer of 1951, foreign tourists and locals alike had their choice be-tween two major festivals in Europe. The first, and better known, was the Festival of Britain.[15] With a main hub of activity at South Bank in London and displays and events throughout the British Isles, the Festival drew foreign tourists to fete the nation's postwar recovery. It was, according to historian Raphel Samuels, "determinedly modernist in bias, substituting, for the moth-eaten and the tradi-tional, vistas of progressive advance."[16] The festival's main South Bank site, which featured the rocket-shaped Skylon tower and concrete and aluminum Dome of Discovery, demonstrated what that innovation might look like. Throughout the

city on the Seine, the Bimillénaire de Paris offered something very different: a celebration of past, not future, greatness. Conceived of as the commemoration of Julius Caesar's arrival in Paris in 51 B.C., this festival had no dedicated site. Instead it played out throughout the city as a series of loosely affiliated celebrations of any and all periods of Parisian history.

The Bimillénaire's highlight was a fireworks display depicting key historical episodes, staged on July 8, 1951, in front of the Invalides for an audience of Parisians, world leaders, and the mayors of the twenty-three other towns and cities named Paris. Many photographers attended, capturing the explosions in the sky for the press. François Kollar, best known today for his work documenting industry, was among them. In the following days, he produced one more photo of the Bimillénaire's fireworks, this time reinterpreted as a media event.[17] His photo depicts the headlines and photos of the fireworks display that appeared on July 9 in *Aurore, Le Parisien libéré, Le Figaro*, and the sports paper *L'Equipe* (fig. 4.1). Spread out on a round café table, the papers adopt the form of the flowering explosions. A pair of clear-framed dark-lensed glasses, a box of Gaulois matches, and a pipe in a square glass ashtray both hold the papers in place and evoke a combination of fire, light, flame, and smoke—and perhaps even some of the spectacle's dazzle. This photo presents the celebratory press coverage as part of the entertainment. After all, as we know from the Liberation photographs, these press photos would circulate and shape understandings of the celebrations, of Parisian history, and—in the process—of photography itself well outside the city limits.

Although the Bimillénaire as a celebration had the potential for global reach, it did not entirely live up to its organizers' ambitions. Boosters and some members of the press clung to the Bimillénaire as an unmitigated success: a front-page headline in *Combat* on July 4, 1951, proudly declared, "The English [are] fleeing their 'Festival' for our 'Bimillénaire.'"[18] The sense of the celebrations as a failure is best framed through another Kollar photograph, this one ostensibly of the façade of the Printemps department store decorated with a several-story-high version of the boat referenced in Paris's Latin motto: *Fluctuat nec mergitur*, or "She is tossed by waves but does not sink" (fig. 4.2). But the building's front is hardly the subject here. Partially obscured by a tree, the store occupies only a small portion of the image's upper right-hand corner. Seen from the side, the boat reveals itself as nothing but a wooden cutout. Look at it sideways and it disappears. A view down the boulevard Haussmann occupies most of the picture's surface. In the busy foreground, dozens of pedestrians cross the street. Several look into the camera. In another version of this view, taken from the same spot, a woman has stopped between the lens and the store, almost entirely obscuring the decorations. Kollar's photograph of the fireworks themselves similarly relegates the Paris-themed decorations at the Invalides to an obliquely angled spot on the right-hand side

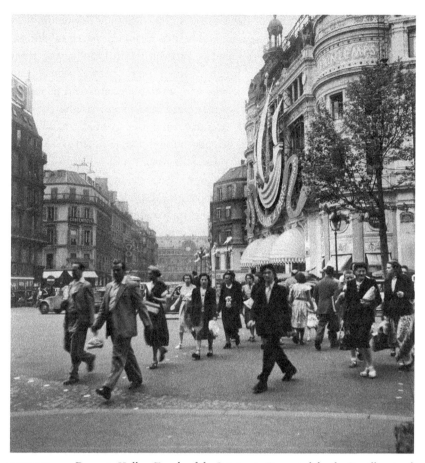

FIGURE 4.2 François Kollar, *Façade of the Printemps Decorated for the Bimillénaire de Paris*, 1951. ©François Kollar/Ministère de la Culture/Médiathèque du Patrimoine; Dist. RMN-Grand Palais/Art Resource, NY.

of the pictorial plane. All of these photos document the Bimillénaire, but they seem to be looking at it askance.[19] Why would Kollar view this celebration out of the corner of his lens? Why photograph it as a media spectacle, its decorations as two-dimensional, throwaway embellishments? I propose that we understand Kollar's framing as the transcription of Parisian history in 1951 as a sort of false front. This event produced by and for pictures reveals the relationship between Parisian history and its reconstruction in and reduction to images.

The Bimillénaire was a flawed and controversial celebration. The product of cooperation between the city's Municipal Council and its Chamber of Commerce, it featured a veritable hodgepodge of hundreds of celebrations and events.[20] Individuals and storeowners competed to decorate balconies and

vitrines. All of the city's major department stores, including Printemps, were bedecked for the occasion. Museums and libraries organized special exhibitions of illustrated books, tapestries, and medals. Parisians donned top hats, morning jackets, and crinolines to parade through the streets on foot as well as in old cars and carriages. They participated in bike and automobile races and danced at *bals publics*. Musical and theatrical groups performed in and around the city's oldest buildings. The Bimillénaire's executive committee planned small historically themed events and sponsored neighborhood initiatives, such as a Second-Empire themed celebration at the Buttes-Chaumont and a Carnival parade that crossed Paris during the spring.[21] Crowds gathered in Saint-Germain-des-Prés to watch costumed Parisians play and dance to traditional music.[22] At the Moulin Rouge, dancers kicked up layers of petticoats during performances of the "French Can Can."[23] The official day of celebrations on July 8 featured military music, an homage from the provinces, and more *bals publics* in addition to the fireworks.[24] Drawn by advertisements and promotions—such as an essay contest for American college students and Paris-themed *Lil' Abner* comic strips that ran for months in American newspapers—more foreign tourists visited the capital than ever before during the summer of 1951.[25]

As the closest thing to an Exposition universelle celebrated in the capital since 1937, the Bimillénaire marked a culmination in shifting understandings of Paris's continued global importance. Less than a century earlier, at the 1867 Exposition universelle, Victor Hugo had famously imagined Paris as the future capital of Europe and humanity itself. While Hugo recognized the importance of Paris's (particularly revolutionary) past, he described the city's universal role as waxing, not waning.[26]

But by the early twentieth century, critics began to suspect that Paris's greatest moments might lie behind it. At the 1900 World's Fair, Albert Robida's "Vieux Paris," which featured architectural reconstructions and themed shops, restaurants, and taverns, was the third highest-grossing display.[27] The texts of illustrated books published throughout the twentieth century often argued that the physical remains of Paris's past distinguished it from other European capitals, in particular London. In 1912, the historian G. Lenotre claimed that vieux Paris, rather than the modernized city on display at the World's Fairs, made Paris different and better.[28] The popular Parisian historian Léon Gosset described London as a huge city devoid of history and Rome as a city with nothing but a past, while Paris, he claimed, combined both.[29] In 1930, the illustrator, painter, and engraver Robert Bonfils even recast Hugo's enthusiasm for the present into an appreciation of the past: "it is [Paris], after Athens and Rome, which for centuries has shaped the ideas of men; 'Paris, Victor Hugo was able to say, works for the world community.' "[30] By the time of the Bimillénaire de Paris, this shifting rhetoric, promoted by city promoters and at Parisian World's Fair exhibitions,

had reached a crescendo: rather than focusing on the endless possibilities of the French capital's future, the emphasis was now firmly placed on the glories of its past as the major attraction for foreign tourists.

Although the Bimillénaire also marked the beginning of a veritable Paris fever among American tourists, many of its festivities, which took place during the spring and fall, were staged by and for Parisians. The fireworks display, for example, drew more visitors than any other Bimillénaire event. According to the police 80,000 people gathered to watch on the Esplanade des Invalides alone, with an additional 100,000 elsewhere in the city.[31] The newspaper *Combat* reported 400,000 total spectators.[32] The Bimillénaire, like the Liberation of Paris, thus drew great numbers of people into the streets but without the political divides inherent in 1944. Even Kollar's photo of press coverage of the fireworks, with the inclusion of the most Parisian of accessories—the café table and the Gaulois matches—places its consumption as a media spectacle squarely at home.

The rhetoric surrounding the Bimillénaire celebrated the festivities as a way to transcend politics. It feted what the organizing committee's official president, the poet and Académie française member Jules Romains, declaimed as the "incredible happiness . . . [of] the miracle . . . Paris has good reason to never cease marveling at being all at once so tested and so intact, so old and so alive."[33] The Bimillénaire, however, was hardly without politics. It was officially sponsored by a politically mixed but right-leaning group composed of the city's governing trifecta—the Prefecture of the Seine, the Prefecture of Police, and the Municipal Council—as well as the Chamber of Commerce.[34] The Gaullist majority that had maintained control of the Municipal Council since 1947 under the leadership of Pierre de Gaulle, Charles's brother, was fracturing in 1951, although the most decisive split occurred around the legislative elections in June, after the Bimillénaire had already kicked off.[35] The council's representation on the Bimillénaire organizing committee would split across political lines.[36] On the one hand, the committee as a whole included a member each from the Communists, Socialists, and the centrist Mouvement républicain populaire. But no one from the political left sat on the executive committee, conceived of as the group that would really make things happen. The committee's vice president, Jean Marin, who had been one of the voices of *France libre* on the BBC, was still a Gaullist in the spring, as was its deputy vice president Janine Alexandre-Debray. It also included five members of the Chamber of Commerce, two independent auditors [*commissaires des comptes*], and the president of the Syndicat générale de l'industrie hôtelière. For the members of the Chamber of Commerce, the Bimillénaire provided an opportunity to further an agenda of increasing their political influence in order to liberalize the economy.[37]

The Bimillénaire was thus a decidedly right-wing affair, and as such it provides a different perspective on the creation of the "image" of the city from

the Liberation. Although the festivities drew on traditionally popular forms such as song and dance, and seemed to represent a wide swath of historical periods, they shied away from the history of revolution and the political left so etched into the city's landscape. The executive committee gave neighborhoods agency to organize their own festivities, but most often these served to throw into relief the commercial offerings of each. These smaller events helped revive commerce and tourism, which, after all, along with cultural production had made Paris the capital of the nineteenth century. The organizing committee did not want to sell Paris as the capital of revolution, a place where street uprisings might occur at any moment. The locations of the Bimillénaire's celebrations help make this clear. To map these would produce a topography of the monarchist, imperial, commercial city—its military spaces, such as the Arc de Triomphe, its hotels, its boulevards, and its shopping districts. Only smaller events such as *bals publics*, which drew local audiences (and much less press coverage), occurred in working-class neighborhoods in the north and east. Were one to lay this map on one of the 1944 barricades, the Bimillénaire's festivities would seem not to restage the recent Communist and populist history of the city but to reclaim the areas that had housed German strongholds in 1944. Thus when the novelist, poet, and prominent Communist Louis Aragon refused to attend the celebrations and declared on the front page of *Les Lettres françaises*, "This Paris [of the Bimillénaire] is not mine," he was right.[38] His Bimillénaire would have celebrated the Communards, the members of the left killed in the streets in 1934, Victor Hugo's Gavroche, and other heroes of popular Paris. The Bimillénaire that took place appealed to those who sought to promote Paris as the commercial capital of Europe, backed by centuries of culture and history, not as an intellectual capital of revolutionary political thought.

Indeed, many of the Bimillénaire's festivities had only tenuous historical themes. The garden party for officials and visiting dignitaries in July, for example—as well as the musical spectacle featuring Edith Piaf, Frank Sinatra, and Maurice Chevalier held at the Palais de la Porte Dorée the following December—were simply excuses to draw press coverage and allow wealthy Parisians to mingle with foreign dignitaries and celebrities.[39] Chevalier recorded a song, "Paris a ses 2.000 ans," for the occasion, which repeated festive platitudes: "Paris is 2,000 years old, and is singing its way to 3,000 . . . 5,000 . . . 100,000!"[40] The Bimillénaire became a common theme in everything from advertisements for department store sales to promotional newsreels for Metro-Goldwyn-Mayer's 1951 Technicolor musical *An American in Paris*.[41]

Even so, such sponsorship did have its limits. The organizing committee rejected, for instance, the proposition from the Printemps department store to sponsor multiple events, including an "Artistic fortnight," on the basis that it was "essentially of a commercial nature."[42] It also refused to sponsor Julien Duvivier's

1951 film *Sous le ciel de Paris*, a fictional portrait of the intersecting lives of numerous Parisians over the course of one day, after the Chamber of Commerce officially declared its opposition.[43] It is unclear why its members objected to Duvivier's film; it might have been a question of aesthetic taste rather than politics.

What was staged nonetheless drew criticism for multiple historical inaccuracies. Theater critics panned one of the Bimillénaire's supposed highlights: the medieval play "Le vray mystère de la passion," staged in July on the Parvis de Notre-Dame.[44] They had no problems with the acting or script but derided the quality of the play's historically reconstructed set. Marc Beigbeder fumed in *Le Parisien libéré* that he blamed the directors for ruining the play.[45] They "threw up cardboard sets—some of which represent stained-glass windows!—instead of quite simply using the set offered up—if one knows how to use spotlights—[by] the magnificent and varied façade of Notre-Dame."[46] The honorary vice president of the Société préhistorique wrote to *Le Monde* to complain that the Bimillénaire would spread "false ideas . . . that the creation of Paris dates back to only 2,000 years ago." Paris, he insisted, "was already several centuries old" when the Romans arrived.[47] Similarly, an article styled as breaking news on the front page of *L'Aube magazine* declared, "Bimillénaire paradox: Lutèce [the city's Gallo-Roman name] was already inhabited by . . . Parisians!"[48] A journalist writing in the left-wing *Le Parisien libéré* echoed a common theme of such criticism with the lament that "history holds such a small place in the festivities which are supposed to commemorate the city's life history."[49] Because it lacked the rigor of specific historical engagement, the Bimillénaire came to seem at best, a set of generic clichés—and at worst, the sum of their commercial celebration.

The Bimillénaire largely became a commercial event because it suffered from disorganization and diminishing funds. It was so troubled that it nearly did not take place. Citing lack of support and poor organization of the festivities, Jules Romains resigned from his position as president of the executive committee in December 1950. He feared the events would be an embarrassment.[50] By February, the president of the Municipal Council and the president of the Chamber of Commerce had agreed to suspend the powers of the executive committee and consolidate the Bimillénaire's organization in the hands of Romains's replacement, the dramaturge and novelist Jacques Chabannes.[51] Chabannes would be watched over by a new four-person executive committee. They hoped the new leader could quickly move forward and save the Bimillénaire from disaster. Ultimately, the Bimillénaire did take place, but without some of the largest, more historically focused celebrations, such as a series of parades/reenactments that the committee had planned throughout the previous summer and fall.[52]

Despite its failures, or perhaps thanks to them, the Bimillénaire points to two important ideas: the reduction of history, in Paris, to a set of visual clichés and

to history as style and visual aesthetics rather than content. Although this reduction was enacted in part through photography, this was not exclusively the case. The 1951 festivities seemed stripped of history to contemporaries because they privileged the representation of historical style over content. This is not meant dismissively, for an attention to style was, and is, in and of itself a vision of history. Because viewers recognize and identify elements of color, perspective, or line, for example, with particular periods, an image's aesthetics can trigger a form of repicturing, where an image becomes imbued with multiple layers of historical significance. This effect was at work in much of the Bimillénaire's festivities—from the street festivals featuring costumed Parisians to the newsreels and television coverage of Bimillénaire-themed entertainment.[53]

The effect is most clear, however, in the posters produced to advertise the Bimillénaire. The committee commissioned these from Raymond Savignac and Roger Chapelain-Midy and shipped them all over the world.[54] Both riffed on the city's iconic buildings, the tricolored flag, and the boat from its Latin motto, but by using the clean-lined style that prevailed in advertising during the late 1940s and early 1950s, worked them into a vision of the present. Savignac's offers a whimsical portrait of a man and woman holding red and blue flowers, hanging from an Eiffel Tower hardly taller than they are (fig. 4.3). Its composition evokes romance and beauty all while reducing Paris's monumental modernity to an approachable size. Chapelain-Midy's features a ship containing the city's monuments (fig. 4.4). The Sacré Coeur, Notre-Dame, and the Eiffel Tower dominate the grouping, while the tricolor flag flying from the top of the tower seems to stand in for the ship's sail. A woman's profile, rendered in gray with streaming hair and upturned eyes, emerges from behind the vessel. Like a bowsprit, she is the spirit of Paris, tossed by the gray waves but sailing resolutely, hopefully—and even gloriously—into the future. These posters operate as visual clichés of the capital.

A separate genre of poster forged the link between past and present through the mimicking of historical styles. The artist who designed Montmartre's 1951 poster, for example, drew on the conventions of picturesque landscape, often used to depict the neighborhood of a hundred years earlier (fig. 4.5). The poster features framing elements, or staffage, in the form of decorative scrollwork and trees that surround four figures in simple, country-style dress posed at the top of the hill's monumental staircase. The presence of the staircase suggests the outlines of contemporary Montmartre, for it was built as an approach to the Sacré Coeur, completed in 1914. But its style firmly situates the image, and by extension the neighborhood, in a nineteenth-century ideal of the pastoral. Similarly, the poster for an exhibition about the history of the Compagnons du Tour de France, the artisans' organization active since the Middle Ages, mimics conventions of medieval art.[55] The image does not employ the rules of perspective, by which the largest figures inhabit the foreground and recede in size toward the background

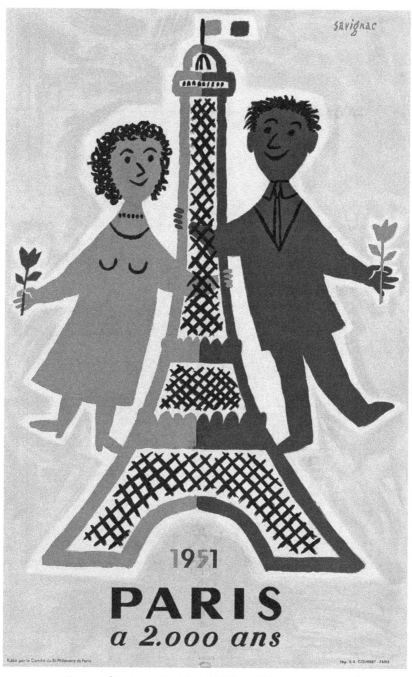

FIGURE 4.3 Raymond Savignac, *Paris Is 2,000 Years Old* ©2017 Artists Rights Society, New York/ADAGP, Paris; Courtesy Bibliothèque Forney/Roger-Viollet.

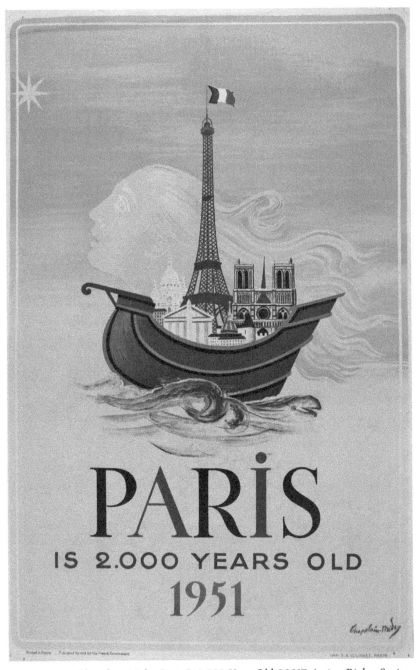

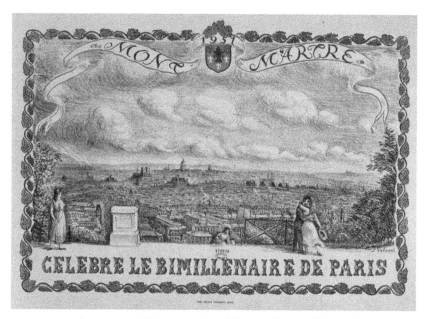

FIGURE 4.5 Anonymous, *Montmartre Is Celebrating the Bimillénaire de Paris*, 1951.
Bibliothèque Forney/Roger-Viollet.

(fig. 4.6). Rather, it uses size to indicate relative importance: the compagnons dwarf everything else in the image. So while the poster may depict carriages and men in top hats that did not populate thirteenth-century Paris, it still evokes the illuminations of medieval manuscripts. In doing so, the poster roots the more recent history of the compagnons in the medieval period, advertising the historical tradition of superior French craftsmanship.

In addition to trading in visual clichés, the posters demonstrate how the Bimillénaire brought a version of the mode of repicturing to life, overlaying multiple visions of the city's past into its streets and onto the images produced for it. It did not necessarily matter if these visions were rooted in detailed research and held up to criticism by professional historians; they inhabited and came to inhabit the historical imaginations of those who produced and witnessed them. The composite image of Paris welcoming the world to celebrate its long history certainly helped elide some of the unpleasant realities of the late 1940s and early 1950s in Paris, but it also worked to create an image of the city that would carry forward into the next few decades: Paris as a star on the world's stage thanks to its role in the past.

FIGURE 4.6 Anonymous, *Bimillénaire de Paris: Paris and the Compagnons du tour de France*, 1951. Bibliothèque Forney/Roger-Viollet.

Photographs and the Authenticity of Form

Photography would play a minor but important role in the Bimillénaire festivities; the medium, after all, had captured only a century of the two previous millennia. The year, however, was a key one in the history of photography, for it marked a century since the death of Daguerre. The tensions that emerged around the commemoration of this anniversary, combined with a series of exhibitions, books, and articles in the illustrated press, nonetheless all helped to promote photography as the future of looking at the past. This self-consciously innovative trend within amateur and popular history helped bring the idea of purely photographic history—which had begun with a handful of private collectors— into mainstream view. It celebrated photographs for what Louis Chéronnet had recognized in them two decades earlier: their seemingly objective precision and the uncanny emotional reaction they produced in the viewer.

Institutional and popular interest in old photographs had been on the rise even before the celebrations of the summer of 1951. The Musée Carnavalet held its first temporary photo exhibition in 1941, three years before François Boucher's about the Liberation. This earlier show featured some two hundred pictures by Charles Marville, Eugène Atget, and Louis Vert. Like Atget, Vert, a printer by trade and freelance photographer who sold to the press, had taken a series of photos of Paris's street trades and homeless residents around the turn of the century.[56] At the time, the Carnavalet staff knew very little about these photos. The show's curator, Max Terrier, had to appeal to Marcel Pouzin, who had donated Vert's photos to the museum, and Vert's family for more information.[57] He asked the private collector Georges Sirot to instruct him in the history of photography and its link to Paris.[58] Terrier was thus branching out, hoping that the exhibition would draw new visitors: "those interested in the history of photography and even all lovers [amateurs] of photos."[59] Some might already know Atget and possibly Marville, but they would discover Vert for the first time.[60] Some sixty years after the Carnavalet's opening, its curators were beginning to realize the potentially wider appeal of the documents that had long populated its study rooms. On the one hand, Terrier's initiative must have fit in well with François Boucher's desires to innovate the museum. On the other, the ability to stage such a show during the Occupation suggests the continued secondary value of photos, for they had been left behind when the museum's most valuable pieces were removed for safekeeping in 1940.

According to the press, the Carnavalet show enjoyed great success.[61] A particularly glowing endorsement by the Belgian poet José Bruyr in the weekly German-controlled *Tout et tout* urged readers to see it. These photographs, he wrote, were the art of the mechanical age: "everywhere here the vibrations of life are geared to the click of the shutter."[62] But Bruyr did not automatically assume the public

would share his interest. He sought to draw them in with a demonstration of the exhibition's potential appeal. He described a "test" document: a photograph of "the former Château de la reine blanche (in the Gobelins neighborhood) whose clock marks 10:05."[63] If readers found themselves seduced by "the enchantment of this document's precise time," they would enjoy the show.[64] If not, they were immune to the power of old photographs and need not bother even finishing the article. Old photographs were not yet the clichéd objects of nostalgia they would eventually become.

Louis Chéronnet's *Paris tel qu'il fut* tapped into and helped cultivate an interest in photos of the past. As it contributed to debates about the decaying neighborhoods dubbed *îlots insalubres*, this book traced the work of time on the photograph and its effect on the viewer. While his comment about the haunting nature of the photo had appeared as a footnote in *A Paris . . . vers 1900*, here exploring its draw was woven throughout the text, front and center to the book's purpose. Writing a decade after his first such book appeared, Chéronnet did not see the stuff of dreams (or even nightmares) in these photos, perhaps because they were no longer the stuff of his own memories. Rather their power lay in the fact that they no longer belonged to the living past: "By their very nature, the images that [photography] offers us so cling to life and to reality that one must wait for this life, this reality, to retreat, so that they can appear to us in a new light."[65] Paintings of the same scenes did not have the same effect; they were not a fragment of past time captured on "glossy, yellowed paper."[66] Although no one else had yet excavated the photos Chéronnet published here, he was not alone in his hunger for these documents. Already, he wrote, "numerous 'retrospectives' had revealed to us more than the charm in the facile sense of the word, but rather all of the magic of old photos."[67] One reviewer echoed this wonder: "[the photos] give us an image of our fathers and grandfathers' Paris, all the more moving because it is real, without interpretation."[68] The art critic, photo collector, and popular historian Yvan Christ later credited *Paris tel qu'il fut* with shaping not just his—but his whole generation's—interest in old photographs. It had given "early photography eminent value—at once scientific and poetic, scholarly and sentimental."[69] Chéronnet must have had some sense of the interest his work sparked, for two years later he expanded into book form his 1933 essay calling for a museum of the history of photography.[70] Amid growing public interest in old photographs, perhaps this project's time had come.

The idea that one could use old photographs to produce a simultaneously faithful and poignant account of the past gained purchase with more such books published in the years that followed. In his 1948 book *La vie à Paris sous le Second Empire et la Troisième République*, Jacques Wilhelm compiled old photos, paintings, and prints alongside excerpts from primary source documents in order to bring the period to life.[71] Instead of choosing the images of the period

privileged by contemporary tastes, he selected those that accurately reflected the style of the times.[72] Photography, he judged, was particularly effective: "thanks to these small yellowed images, the reality of vanished time imposes itself more intensely on our eyes."[73]

The 1950 photo history, *Dans les rues de Paris au temps des fiacres*, showed a similar preference for old photographs.[74] Assembled by the collector René Coursaget, the book reprised *Paris tel qu'il fut* with photographs from roughly 1850 to 1910. But while Chéronnet let the photographs speak for themselves— they occupied full pages, their descriptions and credits appearing separately before and after—this book is an erudite composition with accompanying essays by Léon-Paul Fargue and copious captions penned by Coursaget and the vieux Paris defender Georges Pillement. The text meanders through photos set four or five to a page; it is as lively as the pictures. The latter are full of people of all classes, crowds, and images relating to commerce, fashion, and entertainment. Chéronnet's shots are still, empty, and mostly of architecture. These were the type that appealed to vieux Paris amateurs decades earlier; the photos here are those they eschewed, photos that showed the people who crowded sidewalks and gathered to gawk at the camera.[75]

If in the 1920s and 1930s the illustrated press influenced photohistories, in the 1950s the relationship was decidedly reciprocal. The illustrated magazine *Paris Match* helped sell the idea of photographic history to the wider public throughout 1950. Launched the previous year as a French equivalent to the American *Life*, just two years later *Paris Match* already sold upward of 400,000 copies each week.[76] On March 3, 1950, the magazine added its voice to the Paris 1900 nostalgia with a "half century special issue" featuring dozens of old photographs alongside cartoons, drawings, posters, and advertisements. Its pages celebrated French inventions, fashion, love, and humor. A full-page spread featured words that had entered the French language over the last fifty years. Another lauded French valor during war. Even though old photographs were plentiful in this issue, its layouts slotted them into standard treatments of news illustrations. The surrounding texts described what was happening in the photo, identified people, or pointed out the length of a skirt. They did not broach the concept of photography's specificity.

Just five months later, however, *Paris Match* introduced a reoccurring feature dedicated to the idea that photography had fundamentally altered the historical record. "A Century of History in Photographs" ran for ten weeks. Its first article declared, "with the first appearance of photography, an entire world began at least for historians if not for contemporaries."[77] In capturing a hundred years of history, photography had created a new world for historians to look back on. It was now possible to "retrace the history of France in photography."[78] The series addressed the questions of photographs as historical documents glossed over

in the midcentury special issue and taught readers about the history of the medium. The first article introduced three founders of photography: Nicéphore Niépce, Daguerre, and Henry Fox Talbot. Subsequent pieces presented other great names including Nadar, Roger Fenton, and Olympe Agnado, identified as Louis-Napoléon's official court photographer.[79] They explained the anonymous photographer's contribution, via the figure of the ambulant operator, alongside the amateur's, with a full page about Victor Hugo's passionate pursuit of photography during his Second Empire exile.[80] The series offered up details about the technical constraints, such as long exposure times, that shaped the look of old photos and their subjects. While it certainly might have begun as a way to fill pages during the slow news month of August, the series continued to promote the idea of photographs as different—and superior—documents for history throughout the fall. "A Century of History in Photographs" marked a major moment of popularization of this idea, disseminating it on a scale unseen since 1944.

The Bimillénaire allowed publishers, collectors, and critics to hope for a similar vehicle of popularization. Les éditions Tel, which published Louis Chéronnet's *Paris tel qu'il fut*, reprinted it in 1951, evidently hoping to capitalize on the summer's piqued interest in old pictures of Paris.[81] The Cultural Services of the French Embassy in New York organized an exhibition of pictures depicting Parisian history. There, visitors saw daguerreotypes alongside images of the Commune and nineteenth-century streets.[82] Eugène Atget's photographs also enjoyed an increase in popularity in 1951. In December, the New School for Social Research hosted an exhibition of roughly two hundred photographs by Atget—part of his archive that Berenice Abbott had preserved and which would end up at the Museum of Modern Art.[83] This was one of his first solo shows in the United States.[84]

A few months later the Comité de la quinzaine de Saint-Germain-des-Prés, which organized the neighborhood's annual summer festival, published a small book containing over seventy-five Atget photos. These feature the buildings, courtyards, and shopfronts of Saint-Germain-des-Prés as well as its advertisements, *petits métiers*, and crowds in the Luxembourg Gardens. Although a handful of photographs came from the Bibliothèque nationale and other public archives, the vast majority belonged to Yvan Christ's private collection. Christ penned the book's essay about the photographs, in which he asked, "how could one not love old photography if one also loves lost time?"[85]

Christ, however, did not love all old photos. He derided those by other turn-of-the-century photographers as "any old 'slice of life.'"[86] Atget, on the other hand, was an artist—"a 'primitive,'" "a 'realist,'" and an "'impressionist'"—a poet and historian in his own right who froze time with "his precious tawny or golden prints."[87] These photographs were valuable not simply because they showed Saint-Germain as it used to be, before it became a hotbed of jazz and youth

culture, but because they showed it as an artist saw it, with all the constraints and beauty of an outdated form of image capture. Christ's language is important here, for it suggests that when faced with the problem of choosing which of the many photographs from decades past should serve history in the present, he based his selection on aesthetic criteria. Photographs had fully entered the types of discourses about the need for both documentary and aesthetic value that had initially excluded them from public displays at the Musée Carnavalet. Moreover, by 1951, ideas about the objective, emotional, and aesthetic value of old photos had become familiar to a wide swath of the public.

Just because the interest in old photographs appeared in a handful of venues throughout 1951 does not mean that an appreciation of the artistic value of photography had conquered Paris's cultural institutions. At the Musée Carnavalet's exhibition about the major stages of Paris's urban development organized for the Bimillénaire, photographs served as documents of last resort, much as they had during the museum's first decades. The museum's curators, working with the help of staff from the Bibliothèque historique, privileged maps, paintings, and prints. The catalog lamented, "for the contemporary period, [they had] resort[ed] to simple photographs, modern artists having hardly, or at least with hardly any precision, devoted themselves to representing new structures."[88] Marcel Poëte was right: the nature of modern urban documentation made the use of photographs obligatory, even at the Musée Carnavalet. And yet, the curators' resentment toward photos in this case undermines the embrace of historical photographs on display in 1941 and 1944.

Contemporaries' reluctance toward photography emerged in another paradox of the 1951 celebrations. The year coincided with the hundred-year anniversary of Daguerre's death, but this commemoration did not figure among the Bimillénaire's official events. From today's point of view, this absence seems odd. It would have been very easy to incorporate the invention of photography in a narrative of two millennia of Paris's contributions to the modern world. There was certainly a historical precedent for it: the fifty-year anniversary of photography's announcement to the world had been celebrated at the 1889 World's Fair as one of France's contributions to art, industry, and commerce. In 1951, such an embrace would have helped shift the celebration's rhetoric from pleasure and consumption to one of technological innovation, the very thing on which much of France's postwar identity was forged. Members of the executive committee of the Bimillénaire, however, do not appear to have fielded any propositions to incorporate this anniversary in the celebrations. Nor did they discuss the possibility on their own. They may simply not have been aware of this other anniversary, which would suggest what little importance photography had for them. But even if they were aware, they may have shied away from what turned out to be a controversial event.

The Daguerre anniversary inspired two major commemorations in Paris.[89] In June the Centre national des arts et métiers hosted a series of public lectures about the medium's history. Later that month, the Muséum d'histoire naturelle presented an exhibition dedicated to the last hundred years of photographic (and by extension cinematographic) technologies. The Société française de la photographie loaned a large part of its collections for the show.[90] The exhibition did not just celebrate the past. In keeping with the tenor of forward-looking innovation that defined the period, it also showcased aerial, submarine, and even astrophotography. Press coverage of the anniversary capitalized on the sensational aspects of Daguerre's rise. All of the principle daily newspapers reported that Daguerre had "stolen" the idea of photography from his deceased former business partner Niépce.[91] *Le Monde*, for instance, declared, "Daguerre died on July 10, 1851, but he had not invented photography."[92] By the time this scandal hit the press, the Bimillénaire committee would have been even less likely to want to associate a thief with celebrations of the glory of Paris.

Even though the coverage of the Daguerre celebrations contributed little to a heroic interpretation of the French invention of photography, it still helped bring the medium—and its century of applications—into the public eye. A well-known corpus of Parisian photographic history—one that included pictures by the likes of Marville and Atget—was in the makings in these years for audiences from visitors to specialized exhibitions to those who might only encounter them on the pages of *Paris Match*. Amateur photographers, too, were gaining an education in nineteenth-century photographs (by Daguerre, Niépce, Nadar, and Roger Fenton) and criteria by which to judge them, thanks to magazines such as *Photo-France*, which launched in 1950 and regularly ran articles about photographers, illustrated books, and photo archives. By 1951, the accumulation of old photographs, and the perspective on them that the distance of time allowed, offered up new and exciting ways of looking at the past.

Contemporary Photography and Parisian Visual Vocabulary

Contemporary photography was everywhere during 1951. This was the golden age of the illustrated press, when "the public had an insatiable thirst for images, and, for several years, photography for the printed page saw a period of great fertility."[93] During the Bimillénaire these publications played an important role in defining Paris's identity—in the present and for the future. Magazine coverage of the Bimillénaire used new photos to vaunt Parisians as the living inscription of history in the city. These photographs, alongside those produced by members of the photo collective the Groupe des XV that summer, helped to construct a

visual vocabulary of Paris: a series of subjects as well as compositions and styles that came to represent the city's twentieth-century identity while outlining the conventions of the genre of postwar French humanist photography.[94] These photographs employed a form of repicturing—projecting the past and future onto images of the present.

Major French and American periodicals—from *Paris Match; France-Illustration, le Monde illustré; Réalités*; and French *Vogue*, to *Life* and even the *National Geographic Magazine*—dedicated lengthy articles and special issues to Paris during the spring and summer of 1951.[95] Despite all of the interest in old photographs leading up to and during the Bimillénaire, they included very few. What they did publish falls into two camps. First are photos of the festivities themselves. The *New York Times Magazine* featured a spread that included pictures of the signs reading "Paris is 2,000 years old" that lit up façades around the Place de l'Opéra, dances, and parades held in the city's honor.[96] *Paris Match* published photos of the July 8 fireworks display.[97] And daily newspapers printed similar pictures of the goings-on in the streets that summer.

Second are the photos that promoted Paris and all it had to offer rather than depicting the specifics of the Bimillénaire. Because they went to press on an extended schedule, it would have been difficult and costly for monthly magazines to include photos taken that summer in their June or July issues. Instead, such publications printed photos of Paris that seemed liberated from the constraints of indexing a particular day or event in the city. *France-Illustration, le Monde illustré*, for example, included views of famous monuments and buildings—including the Pont Neuf, the Palais de l'institut, the Louvre and the Tuileries gardens, and the Pont des Arts—as well as shots of people fishing along the Seine and browsing at the flower market.

The July 28 issue of *Paris Match* devoted a color cover and seven pages to Izis's photographs of the city at night: its monuments and partygoers.[98] The use of color both on the cover and on two of the internal pages allowed Izis to play with the sinuous red and white lines created by long exposures of automobile head and taillights. Set off by the luminescent blue of the almost-night sky, the cars themselves seem to carve the colors of France into the streets of Paris. The popular American magazine *Coronet* devoted sixteen pages to the same subject: "Paris after Dark."[99] *Life* mixed photographs of monuments and buildings—Notre-Dame and the column at the Bastille—with more poetic and evocative offerings such as cyclists on a cobblestone street, a lone nun, and young women avoiding puddles after a recent rain.[100] Even *Touring*, a French magazine devoted to cars and travel, featured views of the Seine, the Eiffel Tower, Notre-Dame, and a small street in Montmartre.

The similarities between the types of photos published in these magazines become no more apparent than in the covers of the monthlies *Réalités* and *Touring*

FIGURE 4.7 Cover, *Réalités*, June 1951. Author's collection.

that accompanied Bimillénaire coverage (figs. 4.7 and 4.8). Both show the Place de la Concorde from different angles, populated only by a lone figure targeted at the magazines' respective readerships. The *Réalités* cover features a young woman in red, and *Touring*, a shiny black 1951 Renault Frégate. The woman and car's respective styles help depict Paris as a city that was embracing modern trends and even producing them, for both fashion and Renault cars were still manufactured in and around the capital. However, they did so while respecting the city's

FIGURE 4.8 Cover, *Touring*, June 1951. Author's collection.

rich historical heritage. The absence of dates and events helped these publications produce an image of the city unmoored from a particular time and constructed the idea of a Paris embodying both the latest styles and the inherited past. This Paris awaited visitors whether they made it there in the summer of 1951, later that fall, or even several years hence.

Photographs in the press drew on and contributed to the idea of Parisians as the living embodiment of the past through the use of historical—and visual—types

familiar from old prints as well as the old photographs that were being newly valued at midcentury. In *France-Illustration, le Monde illustré*, photographs of the banks of the Seine populated by river barges and fishermen, as well as the city's bustling flower market on the Ile de la Cité, pictured instantly recognizable figures and activities—not unlike photos of Parisians building barricades in 1944. These appeared on the page alongside engravings of *cris de Paris*, or popular portraits of street sellers, that usually include a snippet of the lilting calls that described their wares. The June issue of French *Vogue* featured a series of studio portraits titled "Faces and Trades of Paris" meant to reprise such images for the contemporary moment.[101] The magazine had originally asked the quintessentially Parisian photographer Robert Doisneau to take these pictures. He turned down the commission because he disliked shooting in the studio.[102] It then went to the American photographer and *Vogue* staff member Irving Penn, who Doisneau helped with identifying and hiring suitable subjects.[103]

At first glance, Penn's photos provide continuity with centuries of Parisian representations. They are the *cris de Paris* of his day, the same genre that Atget, Vert, and Marville had refashioned photographically and had been displayed at the Musée Carnavalet not even a decade earlier. But to look closely at these photos reveals differences. Penn's predecessors—and even the earlier engravers—had depicted the tradespeople in the streets, framed by buildings, shopfronts, and even crowds. Penn's pictures remove them from the city. His subjects appear against the uniform mottled paper of the studio backdrop, still carrying the tools of their trades—the twig broom, the copper pot, or the easel—and often ill at ease in front of the camera. The layout of the photos on the page reinforces this sense of extraction and decontextualization. The *Vogue* article opens with a full-page portrait of a chef, but the subsequent page brings together six smaller portraits arranged in sets of three above and below descriptive text on a white page (fig. 4.9). They hang here like pictures on a wall. Their captions attempt to resituate these people in a social context, by naming them (although only by first name) and describing where they live and work, but the layout resists that work. They have been cropped and enlarged so that not just each photo, but each subject is also the same size. This equalizing, read in conjunction with the uniform backgrounds, extracts them from their social contexts and makes them exchangeable in their place on the page. They are reduced to visual clichés of the living embodiment of Parisian history.

Although Penn would go on to take photographs of "small trades" in London and New York, the series started as a part of the homage to the living presence of Parisian history during the Bimillénaire—and as part and parcel of the representational work that could abstract a picture of history from even the most flesh-and-blood, individual elements of the city. Paradoxically, Penn's portraits depict the working classes as an integral part of the city's identity at the same time

FIGURE 4.9 Irving Penn, "Faces and Trades of Paris," *Vogue*, June 1951. ©Irving Penn Foundation/Condé Naste; Bibliothèque nationale de France.

that they foreshadow the disappearance of tradespeople from the streets in the decades to come.

In their Bimillénaire coverage the editors of *Réalités* sought to replace the old *petits métiers* with new Parisian types. The magazine's issue included a photo essay designed to portray what they termed the city's soul, its "seven essential characteristics."[104] It too worked to link the contemporary city to the past. Rather than commissioning new work, however, the editorial team spent six months sifting through some thirty thousand pictures (or so they claimed) available in their own archive and at commercial photo agencies. They settled on seven photographs representing a typology of Parisians: "the human beings, the child, the worker, the student, the tourist, the elegant woman, who bestow on a monument or a site its true appearance."[105] The photographs show these figures in front of a series of recognizable, even iconic, settings: the Notre-Dame, the Eiffel Tower, the Seine, the Luxembourg Gardens. Insisting that the people impart on these monuments their true meaning was a way of asking readers to look past the buildings' often-dilapidated states to celebrate the vitality of the city's residents. Altar boys process in front of Notre-Dame; children play in the Jardin de Luxembourg; a young woman sits for her portrait along the banks of the Seine; a woman gazes in the window of Hermès; scantily clad dancers perform at the "Nouvelle Eve" cabaret (fig. 4.10). Fittingly, the only identifiably working-class subjects in these photographs are laying asphalt, which began to replace the paving stones so

FIGURE 4.10 Johnson, "The Banks of the Seine: Lovers and Bohemians' Paris," *Réalités*, June 1951. Author's collection.

useful to generations of revolutionaries (fig. 4.11). This is a vision of a different Paris from that of 1944.

Contemporaries' choice of perspectives and styles inscribed the new in traditions of representing the city. The cover of French *Vogue* featured a Robert Doisneau photo of a fashionably dressed female model perched high above a familiar cityscape (fig. 4.12). Behind her lies a gray expanse: the Seine, its many

FIGURE 4.11 Anonymous, "Asphalt on the Grands Boulevards: Workers' Paris," *Réalités*, June 1951. Author's collection.

bridges, and, in the distant background, the Eiffel Tower. Her nipped-in waist and pleated dress give her the most up-to-date silhouette—although the gauze streaming off her hat makes her look a little like the pigeons who normally perch so high above the city. The scene behind her, however, evokes not only Parisian history, visible in the accumulation of buildings, quays, streets, squares, and monuments, but also a long history of aerial views of the city—from the 1739 Plan de Turgot to the aerial photos popular since the 1930s.[106] *France-Illustration,*

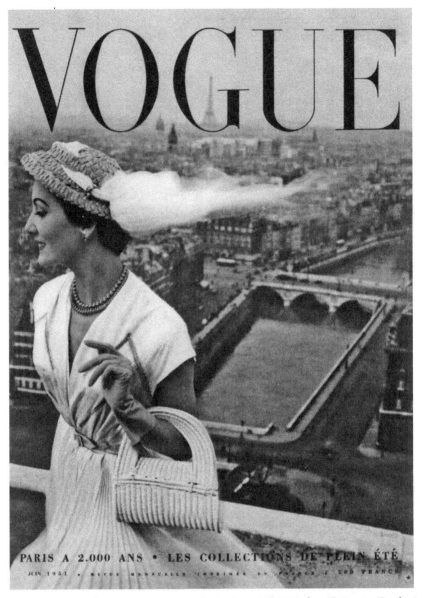

FIGURE 4.12 Robert Doisneau, cover, *Vogue*, June 1951. ©Robert Doisneau/Rapho/ Vogue Paris.

le Monde illustré made this connection explicit by publishing contemporary aerial photographs and Merian's 1620 bird's-eye-view of the city within the same article.[107] Just as with publicity materials created for the Bimillénaire, the significance of these photographs lay in what they pictured and in how they pictured it.

A similar evocation of style was at work in nonphotographic pictures of the city published during the summer of 1951. *France-Illustration, le Monde illustré*'s Bimillénaire special issue, for example, included an article that used reproductions of old maps, caricatures, and paintings as historical documents.[108] Like the Bimillénaire posters, it incorporated contemporary illustrations that drew on past artistic styles. A small illustration of the church of Saint-Germain-des-Prés, for example, included modern details such as cars and the awning of the Deux Magots café, but also reproduced the distinctive bold, curved lines of etchings, suggesting the past that contemporary Saint-Germain evoked.

The illustrated press was not alone in tying the past to the present through the use of contemporary photography; photographers would do so themselves when they took advantage of the interest in Parisian history roused by the Bimillénaire to promote their work. The largest and most active group of professional photographers in France at the time, Le Groupe des XV, used Paris and its history as the theme for its annual exhibition in 1951.[109] Dubbed "the Académie française of photography" by the amateur photo magazine *Photo-France*, the group consisted of fourteen professional photographers who largely sold illustrations for publishing, advertising, and the press.[110] They excelled in producing what Marcel Bovis described as "illustrated stories about the life of everyday people."[111] Although they sometimes covered events, they were not reporters per se. As Izis, who worked for *Paris Match* for twenty years, described his career, " 'I became the photographer of the non-event, the one who was sent to where nothing much was happening."[112] Founded in 1946 and disbanded in 1957, the Groupe des XV came together in order to show their work, to promote the idea of photography as more than just a commercial art form, and to prove the relevance of French photography on the international stage.[113] Many of these photographers produced the images printed elsewhere in the summer of 1951, but they also worked through the idea of Parisian history—of how best to represent the city—on their own time.

The photographs that the Groupe des XV exhibited in 1951, a selection of which were reprinted in the July 1951 issue of *Photo-France*, demonstrate the wide range of work eligible for promotion as art under the rubric of Parisian history. The group divided the printed photographs into three thematic categories: "[the] landscape of Paris," "[the] faces of Paris," and "[the] prestige of Paris." Some of these, in particular Philippe Pottier and Jean Séeberger's photos of fashion plates in front of Parisian monuments, appeared that year in magazines. Others, such as Doisneau's photo of an American soldier posing for his portrait atop the Maillol statue "Monument à Cézanne" in the Tuileries gardens, just look like they could have appeared in print. Other photos resist the conventions of contemporary magazine coverage of the Bimillénaire. Those published under the rubric "landscape," for example, are largely devoid of human figures. These empty photos

shy away from monuments too, only showing them backlit, reflected in puddles or windows, or in the background of expansive views. René-Jacques's photo of the Sacré Coeur reflected in the vitrine of a shop selling religious kitsch made the monument even less grand than André Kertész's had (figs. 4.13 and 2.12). Most of the portraits, on the other hand, would have been quite at home on the pages of magazines alongside the slightly humorous but still compassionate pictures of people and trades published during the Bimillénaire.

FIGURE 4.13 René-Jacques, *Paris, Montmartre, rue Saint-Eleuthère, the Storefront of a Shop Selling Religious Objects, 18th Arrondissement*, 1947. ©René-Jacques/BHVP/Roger-Viollet.

The essays—by Jean-Louis Vaudoyer of the Académie française and René Coursaget, editor of *Dans les rues de Paris au temps des fiacres*—that accompanied these photos lauded them as equal parts art and future historical documents. Vaudoyer predicted that to the photograph's artistic value would be added "a value of witnessing, of a power of evocation" that one would find in photographs regardless of their aesthetic merit.[114] Coursaget's essay held them up as heirs to the long history of photography's role in documenting the city, a history marked both by technological innovations and the contributions of particular photographers.[115] The Bimillénaire provided the opportunity for the Groupe des XV to reach a larger audience and to draw on the cultural capital of these essayists in order to do so. At the same time, the photographs that they produced reinforced the visual vocabulary of Paris seen in other photographs published in the illustrated press: a vocabulary of individuals and monuments that worked to imbue contemporary Paris with the prestige of its past. This was not because these photographers were engaged in the systematic production of propaganda, but because when they looked at the city around them, they saw this relation to the past at work. These photographers would play a much larger role in preserving the historical record than they might have imagined, for owing to the lack of photo collecting at Parisian institutions during these years, much of the major documentation of Paris at midcentury happened through private efforts and the dictates of the market for illustration of the types encouraged by the Bimillénaire.

Tourism and the Amateur Photographer

Photography did not just herald the future of understanding the past in Paris; it was also an integral part of the contemporary experience of the city. The major push to reinforce Paris's historical identity was caught up in photography's importance for tourism. Photographs sold (and continue to sell) Paris and France to a global audience; when visitors arrived in Paris they, like the German occupiers a decade before, were armed with cameras. Parisians too were avid amateur photographers. Amateurs and professionals ended up in a complicated dialogue. The prevalence of amateurs made professionals uneasy. Their attempts to differentiate themselves gave voice to a new discourse about technical expertise.[116] Amateur photographers, of course, parroted the techniques, styles, and subjects they saw in magazines and exhibitions. But they also brought their own subjectivity to the viewfinder. City boosters in the early 1950s, moreover, developed an appreciation for the amateur photographer, for the Parisian not just in front of but also behind the camera's lens.

The emphasis on a link between photography and consuming the history on offer during the Bimillénaire appeared in some likely places. Kodak, for example, produced a Bimillénaire-themed ad that promised: "You will have marvelous

memories of the fêtes du Bimillénaire if you choose a camera by . . . Kodak."[117] Voyagers crossing the Atlantic on the ocean liner Liberté late that summer and through the fall could admire photographic displays of the French capital purchased from the Galerie Kodak in Paris. When the sale was reported in the amateur photo press, Paul Sonthonnax, editor of *Photo-France*, predicted that the photographs would bookend visitors' experience of the capital as "a prelude to their stay in Paris or a nostalgic memory of what they have left behind."[118]

Photography was integral to official tourism efforts in 1951. The Commissariat général au tourisme often purchased work from professionals for advertising campaigns to promote Paris and France abroad. But around the time of the Bimillénaire it bid for and received Marshall Plan funds to produce a new campaign with amateurs. The Commissariat did so, because as Paul Sonthonnax reported, the professional photos of monuments and major sites seemed too cold and sterile. They lacked the human element of contemporary life, the quotidian figure or aspect (cited by the editors of *Réalités*) that placed these historical traces in the context of a living culture.[119] The administration of the Commissariat decided that amateurs, photographing the places they knew, were best positioned to show France as more than a mere museum of monuments.

The Commissariat thus launched an amateur photography and film contest in June 1951. It called for submissions of color and/or black-and-white photographs and films, designs for brochures and posters, or photographic albums on particular themes such as regional hotels. Participants competed for some 2.7 million francs in prize money.[120] Giving prizes to amateurs certainly cost less than hiring professionals, but the choice also speaks to the perceived value of amateur photography. Dispensing advice to participants later that fall, Lucien Lorelle reminded them "to photograph animated scenes."[121] Amateur photography was called on to ensure that the modern appeared along with the historical in promoting France and Paris to the world. The choice also guaranteed that the subjectivity of ordinary people would become part of a larger vision of the nation.

The contest received further promotion that fall at the sixth Salon national de la photographie. The Salon had received a large sum of money from the Commissariat général de tourisme, which likely influenced the year's theme: "Discovery of France: Things and People of France." The annual event, held at the Bibliothèque nationale, had cultural rather than commercial aims.[122] In 1951, it featured photographs taken throughout the nation by professionals, mostly *photographe-illustrateurs* including René-Jacques, Emeric Feher, and Pierre Auradon. According to a reviewer writing for *Le Monde*, the theme provided an opportunity for the regurgitation of a visual vocabulary so familiar as to be cliché: "lots of Basque dances, Breton *coiffes* and Biarritz beaches."[123] The reviewer nonetheless conceded that there were several very good photographs on display—good because of composition, artistry, or because the

photographer simply found himself in the right place at the right time. The Salon proved an opportunity to question the role of touristic images in photography's elite cultural spheres. In an essay for the catalog, Yvan Christ redefined early photographers such as Charles Marville, Auguste Bartholdi, or Adolphe Braun as camera-wielding tourists. Such illustrious ancestors had been replaced by the "tourist of our century:" "a young man, or a young woman, whose camera, glued to his or her chest, seems to have become a third eye."[124] This "third eye," Christ declared, "is perhaps the essential discovery of an era rich with less delightful inventions."[125] The world that invented the atom bomb had at the very least also produced the affordable camera.

William Wallace, one of the four American college students who won trips to Paris as part of the Bimillénaire, was among the camera-wielding tourists to arrive in the French capital during the summer of 1951. Wallace loaded his camera with color slide film for the months-long adventure, which took him from the West Coast, where he was a student at the University of Oregon to New York City, Paris, Florence, and London (and the Festival of Britain).[126] His photographs display an eye for composition and an appreciation for the combination of human and architectural history on offer in the capital. They range from the monumental (the Eiffel Tower and the Arc de Triomphe) to the personal (a desk and window with accompanying view of what must have been his lodgings). But among all of these views of gardens and architecture, Wallace also focused in on Parisians: the policeman directing traffic, a woman painting across the river from the Notre-Dame, and a crowd of young men in bathing suits about to take a dip in the shadow of the Eiffel Tower (figs. 4.14 and 4.15).

Wallace gazed on these people with the detached interest of the tourist, the student of French culture, seeing for the first time images of Paris he knew only from books, movies, and the press. He might also have wished he too was surrounded by friends and about to enjoy a summer swim. Other photos that combine the human and the monumental suggest that Wallace may simply have opened his camera shutter in the right place at the right time. A car whizzes through the foreground of a nicely framed view down the rue Soufflot to the Pantheon. In a picture of the Trocadero, a woman in a mint-green dress leads a little boy with one hand while shielding her eyes against the bright summer sun with the other (fig. 4.16).

Despite tourism promoters' fears, it turns out that it was nearly impossible to capture Paris as anything other than a mixture of the historical and the modern. Driven by the desire to observe and appreciate French history and culture, tourists such as William Wallace would help put France back on its feet. The French needed to be nice to these tourists, or so the head of the Commissariat général au tourisme insisted. Writing in to the magazine *Photo-France*, he reminded readers that the attitude of the people he or she encountered (and photographed) would be just as important and memorable for the tourist as the monuments she visited.[127]

FIGURE 4.14 William Wallace, Paris, summer 1951. ©Elizabeth Wallace.

The interest in promoting amateur photography in the form of tourist snapshots in Paris in 1951 helps to round out a veritable confluence of interests regarding the possibilities of photographic representations of the city. These amateurs, the illustrated press, and the professional photographers working on their own time converged on the idea that documenting and promoting Paris and its past was best achieved through photographs. While Paris was not the sole focus of these activities, as the capital and the most important destination for tourists, it certainly played a starring role. Attracted by the city's reputation for pleasure, luxury goods, and history, tourists would encounter all three in part through photography. Because Parisians themselves in the postwar period were seen as

FIGURE 4.15 William Wallace, Paris, summer 1951. ©Elizabeth Wallace.

the living embodiment of the past, contemporary street photographs emerged as another way of capturing the past in the city. But they also functioned—as the Liberation photographs had—thanks to the doubling of these contemporary images with mental ones. As the editors of *Coronet* explained, the camera could only represent the city so well:

> [Paris] is so overlaid with the longings of those who have never been there, so wrapped in the nostalgia of those who have, that the reality, as pictured in these pages, is only half the whole. The rest lies beyond the reach of any camera lens, in the imaginations of pleasure-hungry men and women, scattered across the world.[128]

All photographs would thus be completed by the scenes and memories that emerged from the viewer's mind. But in the 1950s, the gateway to these was indisputably photography.

From Old Photographs and Styles to Rephotography

The celebrations and promotions of Parisian history during 1951 did not so much inspire the creation of a new archive of photographs of the city as encourage the dissemination of those already in existence, be they the photographs of Atget tucked away in museum collections, pictures of recent buildings that the Musée

FIGURE 4.16 William Wallace, Paris, summer 1951. ©Elizabeth Wallace.

Carnavalet had to exhibit if it wanted to include twentieth-century urbanism, or those of the contemporary city on offer in press agencies and the archives of *Réalités*. At the same time, fears of postwar decline and efforts to promote Paris as not just a once, but also a future, capital of the Western world helped imbue new and old photographs with new meanings. Photographs give us access to the celebration of Paris's past as both an event and a media event. As a practice, photography seemed to offer up the future of modern tourism in Paris, shaping the city's identity as a place of modern life, potential innovation, and deep historical roots. Contemporary photographs also captured all that made Paris unique at the time, namely the inscription of new and old—via their subjects or even their forms—in the same spaces. Old photographs provided tangible access to the height of the city's reputation as a modern capital around 1900. They also gained in value as charming documents layered with curious shades of blue, yellow, and rust and for the subjective gaze they seemed to offer up.

Many of the photographic trends present during the Bimillénaire would continue and grow in subsequent years. Illustrated books increasingly incorporated old photographs as pictures of the eras in which they were taken. Amateur photo magazines as well as the yearly Salon national would continue to educate the public about techniques and the history of the medium. Even the interest in the style and form of images, not just their content, became a staple of illustrated books: when the author and journalist Jean Pastreau penned the introduction to René-Jacques's 1964 book of color photographs of Paris by night, he described how the book might "pass images of the history of Paris through time's magic lantern."[129] By the second half of the twentieth century, the idea that the Parisian past was contained in a flood of pictures was nothing new. That these pictures should appear before the reader as a sort of magic lantern show put on by time itself, however, speaks to this new attention to the historicity embedded in the forms themselves. It confirms the developing theorization of the relationship between history and photography that marked the decades that followed the Liberation of Paris: an investment not only in the content of historical images but also in the authenticity of their very forms.

The use of contemporary photographs during the Bimillénaire also speaks to a shifting sense of time itself during this period. It did not seem contradictory to magazine editors, photographers, and city boosters that pictures of everyday life in the present might also contain something of the past. Parisians themselves, not just buildings, functioned as traces of history. In part this was because the pace of time itself seemed to pick up, but also because of the contradictions embedded in the capital and the nation after World War II. This was a city marked by innovation and modernization as well as a desire to protect and valorize a rich and long historical tradition. Photography seemed both innovative and itself an act of historical preservation.

One final and particularly telling development came out of the post-1945 investment in the historical value of photographs: the rephotography project. The pace of historical change in the city would only accelerate in the years to come, as Paris finally became the target of modernization projects, which destroyed and reconstructed wide swaths of it. By the end of the 1960s, this destruction and reconstruction had inspired a new use of photographs. Now they were not just a way of freezing urban change or looking nostalgically to the past, but a reliable means of measuring—and denouncing—the pace of historical transformation. Rephotography refers to the practice of returning to the scenes of old photographs and capturing them from the same place, as closely reproducing the originals' perspectives as possible.

Although photographers and scholars tend to credit projects based in the American West with producing this form, it appeared years earlier in Paris, as a means of taking stock of a century of urban change, with Yvan Christ's 1967 book *Les métamorphoses de Paris*.[130] Working with his publisher Balland, Christ commissioned two contemporary photographers, Charles Ciccione and Jaqueline Guillot, to take new views of the old photographs in his own collection. The contrasts present in the resulting images, he hoped, would inspire people to act to help stop the ravages of modernization. With its layouts of these views side-by-side, this book was both an updated form of Jacques Wilhelm's repicturing layout and the closest thing to a "chronorama" since Fedor Hoffbauer's *Paris à travers les âges* (fig. 4.17). Like Hoffbauer's reconstructions, the photos here offered readers a series of fixed perspectives from which they could observe change unfold in the city. The rephotography project also anticipated the future. Christ predicted that, "one day sooner or later," the new photographs would be just as "gut-wrenching" as the old photographs that stood next to them on the pages of this book. They were valuable because the present they inscribed was, in some cases, already past.

The idea of rephotography tapped into collectives desire to delve into pictures of the past, measure the ravages of modernization, and document the present before it was too late. By all measures *Les métamorphoses de Paris* was quite successful. Christ reprised the idea with photographs of the suburbs in a book published two years later, raging against the destruction of nearly everything that had surrounded Paris just one hundred years earlier.[131] He counseled his readers to feel anger, rather than sadness, before the photos of what remained. This project led to others about both Normandy and the Riviera.[132] The metamorphosis of the capital, however, seems to have been the most popular, for Balland produced three separate editions of it. The last was revised and substantially expanded.[133] The interest that this book raised suggests photography's importance to the modernization of Paris in the late 1960s. Producing and consuming photographs emerged as more than a nostalgic pastime or a means of

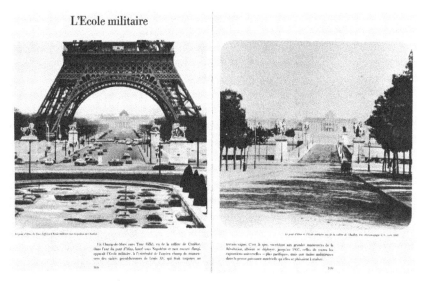

FIGURE 4.17 Yvan Christ, *Les métamorphoses de Paris*, 1967. Photo (left) by Michel Ciccione. ©Michel Ciccione/Rapho; Author's collection.

escaping from the reality of the urban changes that rocked the postwar city; instead, it constituted an important reaction to or even resistance to the modernization of Paris. The interest in the historical value of old photographs and faith in the transformative power of the new would motivate the fifteen thousand amateur photographers who signed up to document the city through the lens during the photo contest "C'était Paris en 1970."

FIGURE 5.1 Anonymous, "Opening for a Defunct Pavilion," submission to "C'était Paris en 1970," square 789. BHVP/Roger-Viollet.

5

"C'ÉTAIT PARIS EN 1970"

AMATEUR PHOTOGRAPHY AND THE
ASSASSINATION OF PARIS

On April 25, 1970, a veritable army of amateur photographers gathered under one of the iron-and-glass Baltard pavilions at Les Halles. Until just a year earlier, these nineteenth-century umbrellas, commissioned during Haussmannization, had housed the city's central food markets, active at this site since the twelfth century. Now, under the watchful eye of the Paris police and crowd control specialists from the Garde mobile, Les Halles welcomed streams of amateur photographers pouring out of the metro and surrounding streets. These more than fifteen thousand people had converged on the center of Paris to embark on a massive "operation" to document the city in photographs: "C'était Paris en 1970."[1] Like the Bimillénaire de Paris, this amateur photo contest was both a commercial and public venture and an unstable cooperation between the left and the right: it was organized by the FNAC, a cooperative electronics and camera store, and sponsored by the Prefect of Paris, the Prefect of Police, the Municipal Council, and the Office de la radiodiffusion-télévision française (ORTF). Instead of disseminating Parisian history to the world, however, "C'était Paris en 1970" was launched in order to prevent its disappearance. In 1970, the French capital seemed desperately in need of some form of preservation. A series of radical urbanization projects begun more than a decade earlier—Paris's first major overhaul since the nineteenth century—was updating old infrastructure, building anew, and razing entire neighborhoods in the process. These projects reworked the city's social and physical landscape. The very pavilions at Les Halles, which sheltered contestants from the rain that day in April, would themselves come under the wrecking ball just over a year later (fig. 5.1).[2] Photography—and particularly amateur photography—was called on to document these changes as they were happening. In the process, it ensured that

participants' perspectives on Paris that spring and what they thought about the city's transformations also entered the archive.

We should understand the history and the results of this photo contest against the backdrop of the changing capital. The urbanization projects of the previous decades drove the desire for a photographic record of Paris in 1970, but these were not the only forces at work here. The history of the past 100 years of photo collecting and use in Paris also helped produce the contest and its some 100,000 entries. "C'était Paris en 1970" was driven by the same desire for a comprehensive record and totalizing view of Paris that was at work in the reconstructions of Fedor Hoffbauer. At the same time, its results reveal how thousands of nonprofessionals saw the city and its changes. Each picture, after all, captures both what was in front of the camera's lens when the shutter opened and something of the person who wielded it. Rather than just reading submissions as pictures of Paris, we can understand them as evidence of modes of understanding how photos operate. The photographs produced during May 1970 bear witness to individual photographers' ideas about what was historical in the city and how their own photos might function as traces of history in the future. The photograph functions as a document both of the changes that the historian Louis Chevalier later condemned as "the assassination of Paris" and of its amateur author's perspective on photographic history itself.[3] These amateur photographers, after all, were heirs to the history-buff-cum-photographers of the early twentieth century.

The photo contest responded to a growing sense that the radical reconstruction of Paris in the 1950s and 1960s was speeding up time itself.[4] Postwar industrial recovery drove redevelopment and expansion, which began at the city's edges with the construction of housing for new workers.[5] Infrastructure also got a major overhaul. In 1958, work began on the *boulevard périphérique*, a ring highway, built to facilitate the speed of automobile-based urban living.[6] The "périph'," as it became known, replaced la Zone, the shantytown built on the former site of Paris's fortifications. Cars took the place of fishermen, strollers, swimmers, and sunbathers along the river when the Seine expressways opened in 1966 and 1967. In neighborhoods all over the city, workers destroyed buildings and dug down to build underground parking structures. Efforts to create more and higher-standard housing breached the city's walls in the 1960s: a series of slum-clearance projects (the likes of which Georges Pillement and Louis Chéronnet had protested twenty years earlier) razed working-class neighborhoods in the 13th, 15th, 19th, and 20th arrondissements and replaced them with modern apartment blocks. New zoning regulations removed industrial activity from the city's core.[7] In 1958, the wine markets left their centuries-old location along the quai Saint-Bernard in the 5th arrondissement. Eleven years later, the central markets at Les Halles were moved to the suburb of Rungis in order to facilitate the flow of goods arriving via highway and the Orly airport. The result of all this change, according to the journalist and art critic André Fermigier, was "Paris III," a radical new cityscape

of modern skyscrapers and highways that rose up alongside and over the remains of vieux Paris and Haussmann's Paris.[8]

By 1970, commentators no longer needed to imagine or resurrect the past from contemporary photographs of the city. The pace of change in Paris ensured that yesterday's photograph—as the use of the past tense in the contest's title makes clear—was already today's historical document. The camera might none-theless help contemporaries make sense of this headlong sprint. The contest's rhetoric promised that "from this moment, Paris [would] examine its present by the hundredth of a second," scrutinizing itself in photographic increments of time.[9] Amateur photographers, influenced by the popularization of the value of the photograph as a historical document of previous decades, were well primed to understand photography in this way. Its powers and possibilities, however, were not without contradiction. Photography, and in particular amateur photography, seemed to the organizers just as much the reason to launch the contest as urban destruction itself. They argued that by rendering image-making so easy, photog-raphy had paradoxically put an end to the type of rich, detailed transcription of the city ensured by prints, paintings, and sketches over the course of previous centuries. At the same time, it seemed the obvious solution to a growing need to document all that was going on in the capital.

"C'était Paris en 1970" would, ironically, produce its own unwieldy flood of not just hundreds or thousands but tens of thousands of pictures. There are too many photographs to describe them adequately here, just as there were too many to catalog after their donation to the Bibliothèque historique de la Ville de Paris. So unlike the nineteenth-century photos at the library, the contest photos—excepting those included in an exhibition put on by the FNAC and a special issue of the magazine *La galerie: Arts, spectacles et modernité*—have neither been widely exhibited nor studied.[10] Even after the addition of a librarian specifically charged with photography, the staff of the Bibliothèque historique only managed to catalog a handful of black-and-white photos (no more than three hundred). The rest of the prints were relegated to the basement, stored in paper folders or-ganized by numbered squares. The slides were similarly placed in plastic sleeves. The lack of cataloging means that researchers must request photographs by loca-tion rather than by subject, theme, style, or even photographer.[11]

The arguments in what follows are based on a survey of some 11,000 black-and-white photographs of roughly 120 squares selected according to the histor-ical identity of their neighborhoods and the pace of modernization within them. This selection includes a range of areas identified by five main characteristics: the presence of the Parisian working classes or new immigrants, their position within or exclusion from the city's network of architectural icons and tourist sites, the historical periods with which Parisians identified them, the industries (from au-tomobile manufacturing to leisure) the areas housed, and how they had fared during modernization and renovation projects since the 1950s. An in-depth

investigation of the four thousand photographs of the twenty-seven squares that contain some part of the Marais complemented this sampled survey. Combined with a set of specific questions for the images, this approach helped me to identify reoccurring patterns within the photos. These patterns shed light on how amateur photographers conceived of Paris and its past as photographable commodities and on what they thought about its future.

As they documented the city that May, the contestants selected their subjects, framed them, and commented on them in ways that ensured their own ideas about the changing city entered the archive. Unfortunately, photographs of the squares containing some of the most controversial projects transforming the capital, such as Les Halles, are not among those preserved at the Bibliothèque historique.[12] Only a handful of photos from adjacent squares show the pavilions in their last months. But participants' engagement with destruction and construction throughout the city is perhaps more valuable than these photographs of the Baltard pavilions would have been. They captured their own critiques of the changes at work in the capital and documented on-the-ground protests against modernization occurring far from the city center. Scholars often turn to the destruction of the market structures at Les Halles in order to understand mass public concern over and objection to the city's reconstruction, but the 1970 photos suggest a more diffuse and earlier history of public resistance, frustration, and mourning set in action by demolition and construction throughout the city.

"C'était Paris en 1970" adapted the rich visual tradition of Parisian transformation for an era of mass photography. The FNAC contest embraced the idea that everyone could be a photographer and, by extension, as its advertisements bragged, that photography could "transform all Parisians into reporters, into archivists, into explorers of the Parisian sublime or commonplace."[13] Promotional materials promised that "even very simple" cameras—in the hands of amateurs—could produce valuable, archival quality images.[14] The contest realized earlier predictions that photographers would work as historians of the future.[15] More than just a byproduct of photo books (as Henriot wrote) or photojournalism (as Valéry predicted), history became photography's primary goal. Presumably the contest also turned thousands into avid consumers of the cameras, film, and developing services available at the FNAC. Nonetheless, during a period in which old photographs had become prized for the subjective gaze of their authors, how better to document a whole city than by taking advantage of camera-clad volunteers?

The Contest: Origins and Organization

Two differing accounts of the contest's origins make clear that its inspiration came not only from the destruction of Paris but also from the state of the photo collections at the Bibliothèque historique. Publicity materials about the contest

produced by the FNAC attributed the idea for "C'était Paris en 1970" to Claude Gourbeyre, then mayor of the 20th arrondissement. In an interview published in *Contact*, the FNAC's newsletter for members, Gourbeyre lamented that "the twentieth century's archives, all things otherwise equal, are thinner than those that contain the memory of previous centuries."[16] Photography was to blame. By pushing painters, engravers, and sketchers toward abstraction, the medium had ended the once vibrant and constant tradition of documenting the city. Instead of taking up the mantel of such artists to record diverse corners of Paris, both amateur and professional photographers had focused on well-known monuments and neighborhoods.[17] The photographic age had produced a paradox: there were more and more photos in the world but they documented less and less. Moreover, the rarity of drawings, engravings, prints, and paintings of Paris had made them precious and guaranteed their collection and preservation in museums, libraries, and archives. Despite small moments of interest in individual photographers or events such as the Liberation, these institutions had not made large-scale efforts to preserve the twentieth century's cheap and plentiful flood of photos.

From the beginning, then, the contest's aims were twofold: to produce "the *complete* photographic archive [of Paris]" and to ensure its preservation in a public historical institution.[18] Gourbeyre had thought to conduct this sort of contest exclusively in the 20th arrondissement until he found willing collaborators in FNAC cofounders Max Théret and André Essel and director of public relations André Gouillou who decided to expand the idea to the entire capital.

While the publicized and published account of the contest's inception highlights the paradoxical role of photography, it erases the part played by the Bibliothèque historique's director Henry de Surirey de Saint-Remy. In a note presumably intended for some high-ranking city official, de Surirey de Saint-Remy protested the public announcement in March that the "C'était Paris en 1970" photographs would be donated to the Archives de Paris.[19] He insisted that they had always been intended for the Bibliothèque historique, because he had given Gourbeyre the idea. Several years earlier, he had proposed that the historical society Le vieux Belleville organize something similar to document the 19th arrondissement.[20] The group never did, but de Surirey de Saint-Remy mentioned it to Gourbeyre when the mayor met with him to discuss possible cultural activities for the 20th. During the same meeting, the director described the contradictions of the past fifty years of Paris's visual archives: the very ones that Gourbeyre evoked in the *Contact* interview. The mayor presumably expressed his gratitude to Henry de Surirey de Saint-Remy by inviting him to join the contest's organizing committee.[21]

The director's version of events rings true. After all, how else would the mayor of the 20th arrondissement have such a fine-grained understanding of the challenges and riches of the Bibliothèque historique's archives? De Surirey

de Saint-Remy likely had early-twentieth-century amateur photo contests sponsored by the Commission municipale du Vieux Paris in mind during his conversation with Gourbeyre.[22] Thus, the Bibliothèque historique's investment in collecting photographs of Paris during moments of change did not just benefit from "C'était Paris en 1970." The contours of this history—sedimented in its twentieth-century collections—drove the contest's very existence.

As an ambitious and high-impact project, the contest also fit quite nicely into the FNAC's growing cultural agenda. The founders Max Théret and André Essel had started the Fédération nationale d'achats des cadres as a discount club in 1954. They launched a catalog selling photo materials shortly thereafter and from there rapidly transformed the FNAC into a public tastemaker.[23] They began exhibiting photographs in their showroom in 1956.[24] Eight years later, to celebrate the FNAC's ten-year anniversary, Théret and Essel organized the first of many amateur photo contests. It drew over five thousand submissions. The 330 award winners were projected as part of a musical spectacle at the Salle Pleyel in Paris that ran for multiple nights before 20,000 spectators.[25] That same year the FNAC launched its cultural events arm ALPHA, or Arts et loisirs pour l'homme d'aujourd'hui, which would bring numerous internationally renowned groups and performances to France.[26] In 1966, the FNAC's first permanent photo exhibition space opened. Throughout the 1960s *Contact* joined publications such as *Photo-France* in teaching readers about photographic materials and techniques. By 1977 alone the group could boast of having exhibited some 256 photographers in 25 galleries to over 10 million visitors—all free of charge.[27]

With its far-reaching and discounted, if not free, cultural services, the FNAC was already a major cultural force in 1970: the type of force that could take on a project with the scope of "C'était Paris en 1970." When Gourbeyre approached the FNAC with his idea, Essel later recounted, he realized "only the Fnac could carry [it] out."[28] While amateur photo clubs, and even the Société française de la photographie regularly sponsored amateur photo contests, no other group had the FNAC's members (200,000 in 1970), its relations with amateur organizations, a newsletter, and the capital needed to launch an operation on this scale. The contest would certainly bring in money for the FNAC, as it sold cameras, film, and developing services to participants, but that is no reason to dismiss the contest as a mere commercial enterprise. As the shrinking budget of the Bimillénaire had made clear, neither the city nor the state was willing to prioritize the preservation, dissemination, and celebration of Parisian history. Only a commercial organization could stage this sort of venture in 1970.

The very people who had played an oversized role in shaping the public historical imagination helped harness it to the task of documenting Paris in 1970, as the FNAC joined its organizational power and plain-old capital with the cultural capital of Parisian photography and history. The contest's organizing committee

boasted some of the most prominent names in Parisian history, among them Henry de Surirey de Saint-Remy and the Musée Carnavalet curator Jacques Wilhelm. Janine Alexandre-Debray, the municipal councilor who had served as deputy vice president of the Bimillénaire's executive committee, joined them, as did the historian Alain Decaux. Some of these figures, contest advertisements promised, would also help judge entrants' photographs. The ad that appeared in *Le Monde* in March named Yvan Christ, Chris Marker, Izis, and the amateur photographer turned artist Jacques-Henri Lartigue as jury members.[29] The chance to have experts review their work must have helped attract photographers to the project. Essel certainly hoped they would approach it as an opportunity to "improve their photographic technique."[30] For the historian then, the contest submissions offer traces of an unprecedented encounter: one between, on the one hand, contestants' aesthetic ideas and historical imaginations and, on the other, the very people shaping photography's place in history and art.

The contest's regulations accommodated both the desire to create an exhaustive archive and the perceived value of each photographer's perspective. Contestants could enter black-and-white prints, color slides, or both, which would be judged separately. Each participant was asked to submit three categories of pictures. The first called for "a report describing as completely as possible, and with an unlimited number of photographs, a sector of Paris corresponding to a square measuring 250 meters on each side."[31] Organizers divided the city into 1,755 such blocks and assigned seven or eight photographers to each by lottery (fig. 5.2). This mission prevented contestants from converging upon the Eiffel Tower or the Sacré Coeur. Early twentieth-century contests had addressed the same issue by asking participants to document specific monuments or types of architecture. Their regulations were consistent with then contemporary preservation approaches that focused on individual buildings. The square in "C'était Paris en 1970" responded to the designation of the sector as the new unit of historical preservation by the 1962 Malraux Law.[32] Authored by then minister of culture André Malraux, this new legislation took into account the fact that a building on its own might not be historically significant, but twenty such buildings were. The contest's organizers similarly understood that future historical significance would reside in the sum of a square's parts. Regulations thus asked contestants to "systematically cover all of the streets and all of the squares, all the monuments and all the buildings, and the green spaces and the cemeteries, and the ground and the underground, and what we are proud of and what we might be ashamed of, and all the Parisians as well, in their everyday lives."[33]

The last two categories offered greater geographic flexibility. Gourbeyre claimed that he had insisted on the inclusion of the second category: "two photos that endeavor to make known a curious or little-known aspect of Paris."[34] These submissions had to come from either the assigned square or one abutting it. The

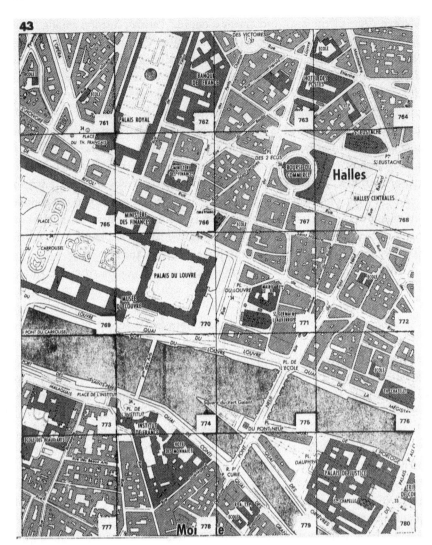

FIGURE 5.2 Contest squares 761–780. BHVP.

last category called for "a single photo, which can be taken anywhere in Paris, and that, for the contestant, will epitomize Paris during the month of May 1970."[35] These photos would go to the jury, whose members would select 110 winners distributed over six levels of prizes; they would share the 150,000 francs in award money. One might read these two categories as inclusions designed to motivate the amateur photographer by flattering his or her artistic aspirations, while the first category produced the real historical documentation of the city.[36] To do so, however, would ignore the value placed on the photographer's subjective

interpretation that had emerged over the previous two decades. Rather than seeing the amateur photographers as a necessary evil to be tolerated if one wanted to produce an archive of this size at this price, organizers were genuinely interested in creating an archive that explicitly included the plethora of perspectives through which participants saw the city—and its historical changes.

The contest may have made room for a multitude of perspectives, but it was quite fixed in its interpretation of the capital itself. "C'était Paris en 1970" presumed Paris intramuros. The maps published and distributed as part of the contest depict the city as an island in a sea of blank space. They strictly follow its boundaries, fixed in 1930, along the former site of the Thiers defensive wall and the limits of the Bois de Boulogne and the Bois de Vincennes. The photographers assigned to squares such as 6 (or, heaven forbid, square 1) must have wondered if they were supposed to document only the 20 square meters of "Paris" or extend their curiosity beyond it (fig. 5.3). This visual effacement of the surrounding suburbs echoes efforts made throughout the century by Parisian politicians as well as archivists and historians to define Paris in opposition to its suburbs. Limiting the contest to Paris, not the suburbs, likely stemmed from practical concerns about the scope of the project, but it also speaks to a certain dismissal of the historical value of the suburbs, even though they were changing just as quickly, if not more so, than Paris itself.

FIGURE 5.3 Contest squares 1–9. BHVP.

The Photographers and Their Photographs

Who were the participants in "C'était Paris en 1970"? Much about them is unknown, but they did leave some traces in the archive. They were first of all, perhaps, overly ambitious. According to the FNAC, of the 15,057 photographers who signed up, only 2,800 of them submitted completed packets by the deadline.[37] This even after the date was pushed back by fifteen days to make up for a spate of bad weather.[38] Second, despite the contest's rhetoric about calling on Parisians to produce an archive of the capital, only about half of the participants actually lived within the city limits. Many hailed from the surrounding suburbs, both close ones such as Issy-les-Moulineaux and Saint-Mandé, and those much farther away: Meudon-la-Forêt, Le Vézinet, Saint-Germain-en-Laye, Drancy, Le Bourget, Trappes, L'Isle-Adam, and Longjumeau to name just a few. A handful of participants signed up from towns and cities all over France, including Brécey (in Normandy), Lens, Chartres, Tours, and even Nice. The geographic scope of the participants attests to the national reach of the FNAC's marketing as well as a wide interest in both amateur photography and the history of the capital.

The participants in "C'était Paris en 1970" brought social as well as geographic diversity to the contest. Many gave addresses, as one might expect, in the wealthier arrondissements and suburbs (mainly to the west of Paris). But they also lived in the poorer areas of the 19th and the 20th as well as notoriously disadvantaged suburbs such as Sarcelles and Le Kremlin-Bicêtre. Of the approximately eighty photographers assigned to squares in the Marais, many had typically French names, for instance Gaston Berger or Chantal Hervé. Others—Pierre-Yves Ardja, Stanislas Sramski, Peter Drynda, Szwajeer—suggest the engagement of immigrants, their children, or even tourists in the project. In other senses, however, the contest participants were less diverse. They were, for the most part, young. Of the 14,016 people who had signed up as of April 16, two-thirds were younger than thirty.[39] They were also overwhelmingly—about 87 percent—male.[40]

In the end, this data tells us much less about the participants than their actual photographs do. But it might provide a less Paris-centric interpretation of the contest. For if we take seriously the idea that photographs document the encounter between the photographer and the photographed, then this seemingly ethnically and socially diverse group of people from all over France left something of themselves in their photos. The decision of Jean-Pierre Auger, who registered with an address in Châtenay-Malbry, a town just west of Sceaux, to photograph a building site in the Marais says just as much about his perspective as a resident of the suburbs as it does about the neighborhood itself. Alain Berruer, resident of Asnières, focused on artisans at work in the same neighborhood, while Bernard Pouzet, who lived on the rue Bourg Tibourg in the Marais itself, eschewed the

neighborhood's working-class activities in favor of wrought-iron architectural details. He took dozens of such photos (fig. 5.4). Each participant brought his or her own understanding of Paris's historical value to the project.

In some cases, these different perspectives aligned in striking ways. The five photographers documenting squares 951, 952, and 955 around the rising Front de Seine development in the 15th arrondissement submitted remarkably similar images. Three of them framed the grim scene of a car carcass moldering upside down in the front courtyard of a crumbling three-story building. All but one photographed a mail slot in an old wooden fence and the new high-rise emerging menacingly from behind it (fig. 5.5). Two photographers in the Marais produced almost perfectly twinned photographs of the angel-winged demon heads that serve as doorknockers on the Hôtel de Saint-Aignan, which now houses the Musée d'art et d'histoire du Judaïsme. Such photographs suggest that much of the documentation of the city during this contest was driven simply by what existed in the square.

Photographers also brought their own visions to the project, particularly in their interpretation of how to create "comprehensive coverage." One woman toured her assigned square before returning with her camera.[41] Another contestant started by studying the history of his, noting its oldest (built in 1781) and

FIGURE 5.4 Bernard Pouzet, submission to "C'était Paris en 1970," square 818. BHVP/ Roger-Viollet.

FIGURE 5.5 Anonymous, "rue Emile Zola," submission to "C'était Paris en 1970," square 955. BHVP/Roger-Viollet.

newest (built in 1957) architecture. He plotted its important buildings, which included the café-tabac, the bar-restaurant, the metro station, and the boulangerie, and photographed each one.[42] Other approaches are legible in the photographs themselves. Some participants approached the task haphazardly. They must have lacked the time, money, or motivation needed to produce exhaustive coverage and so submitted only a handful of photos. But many provided meticulous treatment of their assignments. They took generic street views, pictures of waterways, sidewalks, and alleyways. A few even ventured down into the metro. They photographed building façades and storefronts. Participants gained entrance to private courtyards and buildings. They stuck their cameras through the slots of the high wooden fences around construction sites. They photographed graffiti and posters. They closed in on countless architectural details. And they studied the people and animals of their assigned squares. Occasionally they happened upon an event—a strike or an accident—and photographed it as well.

Others conceived of the task as spatial and temporal. More than one produced a "day in the life" of the square. The submissions of Peter Drynda, one of the contestants photographing around the Square du Temple just north of the Marais, narrate a story. Each bears a number and a caption that follows from the previous image. On the back of the first photo, a banal shot of the rue Réaumur, he wrote: "It is 1pm. Arrived rue Réaumur. Leaving on the tour

of square 784." Captions of subsequent pictures describe the people and places he encountered and mark the passage of the hours. The last image, of the organ in the Eglise Sainte-Elisabeth-de-Hongrie, declares "the tour is over. It is 5pm." This photographer captured thus not the month of May but a mere four hours in the life of this sector. Another photographer, working in color, penned the captions to a series of photos of the flower market as a poem. Evelyne Gabriel, from the 6th arrondissement and assigned to a square in Ménilmontant, gave herself an art assignment, captioning her photos as illustrations of abstract ideas: "texture," "rhythm," "power," "charm," "serenity," "ambiance," "opposition," and "reality."

Some of these photographers worked with future historians in mind. Contestants commonly noted the subject of their photos, but some also inscribed them with the precise location from which the pictures were shot. A photographer who registered simply under the name Guedon, assigned to a square in the 19th arrondissement, worked for a potential future rephotography project. The contestant glued a small rendition of the square marked with both the camera position and the field of view comprised in the photograph to the back of each print (fig. 5.6). This effort betrays a meticulous attention to detail and an awareness of the potential value in knowing where each photo was taken. Catherine Le Pape, a resident of the 16th arrondissement who documented a section of Pigalle, similarly pasted detailed notes to the back of each of her 207 photographs. These indicate the square number, neighborhood, street (taken between such and such a place), date of the photo, format, lens, and focal length. She also numbered each print and stamped it with her name, address, and telephone number.

Despite organizers' hopes for the contest, in the end relying on amateurs produced an uneven documentation of Paris in May 1970. The FNAC reported that at least 150 squares received insufficient or no submissions.[43] Other squares ended up with hundreds taken by multiple photographers. Furthermore, although organizers insisted that the contest received "a hundred thousand good photos," the submissions reveal otherwise.[44] Some photographs are beautifully framed, their subjects fittingly selected, their development competently executed. Catherine Le Pape's photographs of sex shops in Pigalle reveal a droll sense of timing. Alice Aubert's photos of children in the Marais are some of the most compelling from the era—heirs to the portraits of young Parisians by Robert Doisneau and Henri Cartier-Bresson. Others are quite poor from both documentary and aesthetic points of view. They are over- or underexposed or badly framed. Some chop off the tops of buildings or the edges of architectural details. Others are out of focus. There are very few shots of the metro or even the interior of buildings among the contest photos. Those that do exist are often blurry. Many contestants processed their own film, and their entries also suffered from developing errors that produced too much or too little contrast. One contestant,

FIGURE 5.6 Guedon, submission to "C'était Paris en 1970," square 300. BHVP/ Roger-Viollet.

assigned to a square around the Hôtel de Ville, even unintentionally solarized two prints.

The vast majority of the contest photographs, however, are simply unremarkable rather than bad. Sometimes this is the photographer's fault. He or she crowded too much information into the frame or did not get close enough to workers or market sellers to create compelling central subjects. But the city and the contest itself were at fault in this as well. One street could come to resemble another, or nothing much happened in that particular square when the photographer visited it. Large parts of Paris were dirty and run down in 1970, and not every photographer could transform general disrepair and poverty into the picturesque. Sometimes a pile of construction debris just looks like rubbish. The

presence of so many of these unremarkable pictures in the archive suggests that
participants really believed in the potential documentary value of their work.
They opened the camera's shutter with the conviction that whatever etched itself
onto the film could one day be useful.

And yet out of this cacophony, patterns emerge. Some appear thanks to the
city itself. Contestants captured the homogeneity of Haussmannized Paris: its
boulevards and the trees that line them. The standardization of café furniture and
restaurant menus provides continuity across arrondissements. The same billboard
advertising Levi's appears in dozens of photographs, as does a poster for Buster
Keaton's *Steamboat Bill*. Other patterns emerge from participants' overlapping
senses of the city's history, ideas about how to tell it, and anxieties about its future.

Contest Controversy

The FNAC would attempt to turn "C'était Paris en 1970" into the photographic
event of the year. French radio promoted the contest. The company bought
advertising space in major newspapers to announce it. Later that fall more ads
promoted the exhibition of winning photographs held at Les Halles, which
opened on October 20 and ran through the end of December. The FNAC even
commissioned a song to spread the word: "C'était Paris en 1970," recorded by
Juliette Gréco. The track was a true product of its era with music by the jazz pi-
anist and composer Claude Bolling and lyrics by the prolific Pierre Delanoë.[45]
The woman who sang "This was Paris in 1970, a little bit of the year 2000, traces
of the year 1000" was herself the living embodiment of the postwar artistic com-
munity in Saint-Germain-des-Prés. There were few singers as indelibly linked to
the capital in 1970, but the choice of Gréco, whose popularity was then waning,
seems as nostalgic as some of the contest's photographs. Despite this hype—or
perhaps because of it—"C'était Paris en 1970" was not lauded as the important
operation that organizers had hoped for. Instead, it drew criticism from both
photographers and those invested in the preservation of Paris.

Since the nineteenth century, photo contests were common fixtures of the
evolving commercial and noncommercial landscape of amateur photography in
France and beyond. George Eastman's company began sponsoring competitions
for amateur photographers in 1897. Winners earned cash prizes and appeared
in advertisements.[46] Kodak thus seized on the idea that amateurs could produce
high-quality photographs to promote the sale of photographic materials. The
practice thrived within amateur photo clubs and societies on both sides of the
Atlantic. As photo magazines developed, they too offered competitions, with the
added bonus that the winners would see their photos in print. The Commissariat
général du tourisme sought to tap into this culture with its 1951 contest. These

groups helped create cultures of aesthetic aspiration and of participation in collective, competitive photographic enterprises among amateurs.

Historical institutions quickly realized the usefulness of amateur photographers. In England in the last decades of the nineteenth century, the Photographic Record and Survey Movement called upon camera-carrying volunteers "to make a permanent and publicly accessible record of England's visible past"—the architectural and living remnants of history.[47] The survey movement's organizers understood what the Commission municipale du Vieux Paris had realized decades earlier: amateur photo projects offered a cheap way of acquiring photographs—even if one had to pay out prize money. Comparatively few photographers participated in the Commission municipale's first contests: only 61 in 1905. And yet they had produced 1,100 photos that the panel of judges deemed good enough to enter the Musée Carnavalet's collections. The Commission spent a mere 1,000 francs to install the exhibition and to produce medals for its winners.[48] Each photo thus cost less than one franc, half the going rate professionals charged. Similarly, the organizers of "C'était Paris en 1970" estimated that if they hired professionals to take the 200,000 photographs they hoped to receive, it would cost the city over two billion francs.[49] Amateurs would work for free and pay for film, paper, and developing. The FNAC covered the costs of advertising and judging, leaving the city the task of cataloging and storing the submissions. Whereas photographers in the early twentieth-century contests sponsored by the Commission municipale du Vieux Paris retained ownership of their images, participants in "C'était Paris en 1970" signed theirs away in order to participate.[50]

The question of photographers' rights incited professional photographers to protest the FNAC contest. The FNAC launched its publicity campaign at the beginning of March 1970. By the end of the month, the Association nationale des journalistes, reporters, photographes, et cinéastes, the Association nationale des photographes publicitaires, and the Groupement des photographes illustrateurs all condemned "C'était Paris en 1970" as a violation of France's March 11, 1957, law protecting intellectual and artistic property.[51] Until 1957, photography's copyright had existed thanks to the application of a 1793 law, which, enacted some forty years before the invention of photography, did not mention the medium. The 1957 law revised copyright to include photographs, but only those of artistic or documentary nature.[52] This precision left the enforcement of photographic copyright open for interpretation. Concerns about potential precedents drove photographers' reactions to the threat of a large body of "documentary" photographs not subject to the 1957 law.

Their protest speaks to the fact that contemporaries understood photo archives of Paris as archives of images for publication—potential sources of profit—and not simply tools for the scholarly study of urban change. But even

more so, it suggests that these groups perceived amateur photography in general as a threat to the quite new and uncertain structures that safeguarded professional photographers' ownership of their work. If a cultural institution with the growing weight of the FNAC could oblige photographers to renounce their rights in order to participate, could others follow suit?

What began as a movement among professional photographers quickly changed the structure of the entire operation. Henri Cartier-Bresson withdrew from the jury, prompting one journalist's snide comment that he should have read the regulations before agreeing to serve.[53] The Fédération nationale des sociétés photographiques de France revoked its official participation.[54] Troubled by the negative press, the Prefect of Paris and the Prefect of Police rescinded their sponsorship in mid-April.[55]

The FNAC quickly rallied to defend "C'était Paris en 1970." The cooperative's lawyers studied the complaints and affirmed that the contest did not violate the 1957 law. Because it constituted "an offer of a voluntary contract [*contrat d'adhésion aléatoire*]," the competition fell under the regulation of gambling rather than intellectual and artistic property. The FNAC lawyer concluded, "the rescindment of rights to the prints, which is one of the contest's rules, cannot be called into question by those who choose to participate."[56] Documents shared with city officials—likely in the hopes of placating official patrons—promised that photographers would maintain ownership of the negatives of all submitted prints. Contest regulations encouraged photographers to keep copies of slides entered if they wished to sell or print them in the future. And André Essel personally assured participants that the FNAC "promised not to use the photographs for any commercial purpose."[57]

Regardless of these clarifications, "C'était Paris en 1970" still appeared to threaten professional photographers' relationship to the industry of photographic illustrations of Paris that had developed over the course of the twentieth century. They depended on the press and the market for reuse in magazines and books. Editors were no longer vieux Paris amateurs, such as Charles Eggimann, using their own personal photo collections to illustrate Parisian history books.[58] If publishers and the press could return to that model, using a freely accessible catalog of Paris created by amateur photographers, why would they purchase pictures from professionals again? Photographers had been fighting to add their work to copyright laws for decades and feared the contest might undermine their gains. Roland Bourigeaud, president of the Fédération nationale des sociétés photographiques de France, reminded readers of the magazine *Photo-Revue* that not respecting the 1957 law implied "not only financial losses from eventual reproduction rights, but also the suppression of the authors' names on any published or exhibited photographs."[59] Supporting the contest would go against the interests of photographers at large. After widely echoing the views

of professional photographers, the press turned its back on the contest, covering neither its launch on April 25 nor the subsequent exhibition.

Before they did so, however, members of the press accused the FNAC and the city of taking advantage of participants, as if amateur meant gullible. Ownership of the photos aside, with 14,016 photographers signed up by April 16, the FNAC certainly stood to profit from record film and photo developing (if not camera) sales during May 1970.[60] Accusations circulated in the press that the whole contest was simply an elaborate ruse to establish a comprehensive list of amateur photographers in the capital.[61] A journalist writing in the satirical newspaper *Le Canard enchaîné* admired the city's cleverness, "once again . . . to call upon the enthusiasm and generosity of suckers [*gogos*] . . . for the benefit of a private business."[62] One participant subsequently declared with pride: "I am one of these guys that the *Canard enchaîné* so kindly calls 'volunteer suckers.'"[63] The prize money did not drive him; instead he relished "the certainty . . . of participating in a project useful to a city that I love so much."[64] Interviewed forty years later, the participant Christian Vigne did not even recall a public scandal about rights.[65] He signed up for the contest "because [he] loved photography (this is still true) and Paris."[66]

The third major vein of criticism levied against "C'était Paris en 1970" responded to the very idea of photography as a reaction to the city's rapid transformation. Parisian opinion was divided over the value of the radical modernization of the 1950s and 1960s. To many it seemed necessary to bring Paris into the future, to build new and higher-quality housing, and to make way for a car-driven future.[67] Even amid the celebrations of the Bimillénaire, Parisians were not simply celebrating the city's preservation, but rather advocating for its renovation. In 1951, the president of the Touring Club de France declared, "the housing crisis has become at least as severe for cars as for city-dwellers themselves."[68] London, he explained, had put its bombed-out lots to good use as parking lots. Although he quickly insisted that Paris had luckily been saved, he suggested that solutions—read, parking lots—might be found just outside the city limits.[69] In turn, redevelopment boosters drew vehement critics. Yvan Christ, for example, repeatedly urged readers of the magazine *Arts* to "Denounce the vandals!" at work in the capital and throughout France.[70] His rephotography books offered up proof of all that had already been lost.

The 1970 contest's rhetoric acknowledged but downplayed these attacks. "We could be saddened [by the city's transformations]," the March 21 advertisement in *Le Monde* acknowledged. "But isn't it the defining characteristic of healthy cities to be at once rooted in the past and built for the future?"[71] Radical reconstruction, it promised, was a sign of Paris's postwar dynamism. In the March issue of *Contact*, Claude Gourbeyre reminded potential participants that "a city is not a museum to preserve but an urban space to modernize unceasingly in order

to allow men to live in their own eras."[72] Another announcement in *Le Monde* printed on March 28 cast photography as a militant act. It dubbed the contest "a great movement of collective defense" and compared it to the popular uprising of the 1944 Liberation.[73] Municipal officials' withdrawal from the contest would not be announced until ten days later, but one has to wonder whether the idea that the camera even needed to fight the bulldozer—just as much as the question over photographers' rights—contributed to their decision.

Was Paris really so helpless before this modernization? The municipal officials who headlined announcements for "C'était Paris en 1970"—Etienne de Vericourt (President of the Municipal Council), Maurice Grimaud (Prefect of Police), and Marcel Diebolt (Prefect of Paris)—were the very ones making the radical reconstruction of Paris possible.[74] By participating in the contest's organization, Paris's largely conservative municipal council, like Haussmann, admitted that contemporary urbanization meant the destruction of historic neighborhoods. The FNAC was notoriously left-leaning at the time. I, for one, want to believe that Max Théret, André Essel, and André Gouillou conceived of the contest, at least in part, as an effort to convince Parisians of city officials' attention to the importance of historic preservation—if only in pictorial form. Certainly, this must be what attracted Yvan Christ to the project. But he did not end up judging photos that summer. Christ may have not taken part for any number of reasons, but he also may have decided that participating in "C'était Paris en 1970" fell far short of his earlier calls to denounce those responsible for the city's destruction.

The most outspoken criticism of the contest came from the popular cartoonist Gébé. Then editor of the satirical magazine *Hara-kiri* (and future editor of *Charlie hebdo*), Gébé had already begun to tackle the ecological and human costs of contemporary life in 1970 with his series *L'an 01*, published in the left-leaning *Politique hebdo*.[75] In April, Gébé published a full-page spread in the magazine *Pilote* mocking city officials and FNAC directors for their affected helplessness (figs. 5.7 and 5.8).[76] The cartoon quotes and ridicules contest rhetoric. Gébé questioned the idea that modernization would benefit average Parisians by building much-needed housing rather than just office buildings. Tongue-in-cheek, he declared "in any case, we have nothing to do with it!" if parts of the capital had to be destroyed: "Paris must be photographed before it has its eye put out." In order to win, he suggested contestants follow demolition plans, moving in to capture them before they occurred (fig. 5.9). Better yet, demolishers could take part, camera in one hand, pickaxe in the other. Real estate developers were most likely to win. Gébé's rendition, with a camera mounted on his hat and pickaxes shooting from his eyes, has only to turn his head to document and destroy with just one look. The speculator's gaze, after all, was transforming the capital—so why should it not also constitute its photographic archive? Gébé predicted the dire consequences this laxity in the capital might have on the rest of the nation.

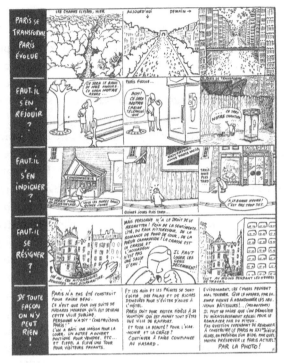

FIGURE 5.7 First page, Gébé, *Paris qu'on pioche*, 1970. ©Nicole Blondeaux.

His scene of shutterbugs in the French countryside snapping away at the site of future HLMs, "industrial zones," and polluted rivers (warning "pollution coming soon")—only to drop the camera with a shocked "ah! Too late!" at the sight of a water tower rising up over an old church—suggests that the contest was a clever ploy. It was designed to distract Parisians and the French from active engagement against the country's industrial and urban overdevelopment (fig. 5.10).

Organizers certainly overstated Parisians' helplessness in the face of what historians have described as dehumanizing urban change, but the effort to produce a massive photographic archive of a changing Paris did have value. Drawing on a long history of visual documentation of radical upheaval, from revolutions to urbanization, the contest would ensure that destroyed swaths of Paris lived on in the historical record. The participation of the leaders of Paris's historical institutions—the director of the Bibliothèque historique Henry de Surirey de Saint-Remy and Jacques Wilhelm, curator at the Musée Carnavalet—suggests the degree of continuity that the contest enjoyed with past projects of urban documentation. And the library benefited too: its photo collections were "as if by the wave of a magic wand, tripled, if not quadrupled."[77] The contest's advertisements certainly echoed the language of the Commission municipale du

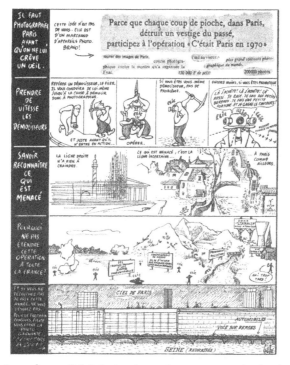

FIGURE 5.8 Second page, Gébé, *Paris qu'on pioche*, 1970. ©Nicole Blondeaux.

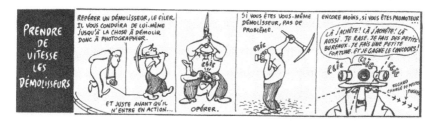

FIGURE 5.9 Detail, Gébé, *Paris qu'on pioche*, 1970. ©Nicole Blondeaux.

Vieux Paris when they lauded the value of "sav[ing] at least the image of that which is condemned or might be condemned to destruction."[78] Moreover, while historians often analyze public reaction to the destruction of the market pavilions at Les Halles as a marker of public discontent with the city's renovations, here are 100,000 documents that shed light on how Parisians and non-Parisians—who may never have signed a petition, written in to a newspaper, or held a protest sign—saw and understood the forces at work on the city.

FIGURE 5.10 Detail, Gébé, *Paris qu'on pioche*, 1970. ©Nicole Blondeaux.

Amateur Visions of Past, Present, and Future

In the autumn of 1970, Juliette Gréco sang in a breathy whisper of Paris that year: "what did it look like? Like whatever you wanted." And indeed from participants' photos it does seem that Paris in 1970 could look like whatever they wanted: run-down, brand new, modern, fun, poor, romantic, debauched, wholesome. Each contestant saw the city differently. Their photographs function, de Surirey de Saint-Remy explained, as documents of how thousands "saw, felt, and rendered their Paris."[79] But they also testify to the fact that these people did not actually see the city entirely, as Gréco promised, as whatever they wanted. Rather, their understanding of how their own photographs might serve as historical documents was already filtered through the lens of existing photographs. Their images testify to what the city looked like to them in 1970: these photos show what of it they imagined was historical and the influence of photography on their own historical imaginations. The images of Paris that populated the minds' eyes of participants helped them produce different visions of the city's history as they operated in some combination of three main modes: as archaeologists, as anthropologists or reporters, and as visionaries of the future. In the process, these amateur shots reveal a profound engagement with a changing Paris—and the possibility of photographing time itself.

The Photographer-Archaeologist

Contestants functioning in the first major mode trolled the city as vieux Paris history buffs might have nearly a century earlier. They looked for architectural details, old buildings, or picturesque scenes that already embodied the past, reproducing early-twentieth-century nostalgia for these traces of vieux Paris—or even of the more recent past. Henry de Surirey de Saint-Remy was right, then, when he wrote that the 1970 photographs "hint at a way of seeing and feeling that is altogether consistent with the standing tradition of the [library's] existing collections."[80] But he failed to note the direct link between these two collections: the "C'était

Paris en 1970" photographs looked that way, most likely, precisely because of the photographs there and elsewhere that had circulated widely in the general and illustrated press, books, exhibitions, and amateur photo magazines. Their submissions look like old photographs of Paris because old photographs of Paris had, by 1970, become clichés.

Participants channeled turn-of-the century photographers as they turned their lenses on architectural details such as staircase railings, door grills, fountains, pumps, and doorknockers (fig. 5.4). They often framed these fragments in such a way as to excise traces of the contemporary present. Others captured courtyards and alleyways that looked unchanged since Marville documented Paris or the same type of wooden handcarts that populated Atget's street scenes. In at least one case, a photographer (assigned to a square on the hill above Belleville and Ménilmontant) also mimicked turn-of-the-century processing techniques. Printing his photos of picturesque soon-to-be ruins in sepia tones he reproduced hues of nineteenth-century photography (fig. 5.11).

Others imagined pictures functioning as stand-alone history lessons. For participants assigned to the Marais, the timber-framed building at 3, rue Volta (which they thought the city's oldest) became an obligatory stop. They snapped it from up close and far away, taking care to note its exceptional status on the back of their prints. One participant assigned to a square in Montmartre added a short explanation to the back of an unremarkable view up the rue des Martyrs about the origin of the street's name. Evelyne Gabriel, the participant who approached the contest as an art photo assignment, discovered traces of the eighteenth-century past in her square. For the second category, she submitted a photo of the pavillon Carré de Baudouin, an eighteenth-century folly still standing in the 20th arrondissement. On its back, she romantically imagined the building brooding over lost time:

Its aristocratic brow
Still imposes itself on the neighborhood
Under its melancholy eye
History has come to hide
Young, it made great efforts
To be welcoming
Now, with its secrets
It dwells on its past.[81]

Such captions, more than teaching the future researcher about the history of the city, testify to participants' romantic sense of the accretion of time in the physical landscape of the city, which would not have been unfamiliar to turn-of-the-century history buffs.

FIGURE 5.11 Anonymous, submission to "C'était Paris en 1970," square 575. BHVP/ Roger-Viollet.

The amateur photographer-archaeologists also turned their lenses on Parisians as living traces of the past. They channeled the long tradition of *petits métiers* pictures as they photographed tradespeople—from pavers, peddlers, and painters to market sellers and knife sharpeners. Often their photographs offer tongue-in-cheek commentary on the work these people perform. The caption of François Colmez's photograph of the woman presiding over a public toilet on the rue Lamarck declares her, or perhaps even the toilet itself, "a monument of

public good." Others operated in a more romantic vein. One captured a woman in a polka-dotted dress, with a perfect high bun, deeming her evidence of "Paris in 1950 . . . not Paris in 1970." The attention here to outdated fashion seems both sweet and slightly dismissive. Other images bear the timelessness of contemporary photographs sold during the Bimillénaire de Paris. Photographs of street-sweepers, for example, replay not just a long tradition of the figure but also the usual pose in which they were caught: the same lone worker, set apart from the bustle of the city, wielding an old-fashioned twig-broom.

The backward-looking cast of so many of the photos taken during the contest—and reproduced both at the exhibition and in the later issue of *La galerie*—drew criticism. During an interview with Patrick d'Elme, editor of the special issue, the presenter on the televised regional news remarked of the contest: "all this seems a little like nostalgia."[82] And indeed it does. As historical documents of 1970, the photographs' utility varies by neighborhood. Those of the area cleared in the 1980s to create the Parc de Belleville, for example, ended up documenting the end of an era. But often, the objects that drew participants for their historical interest still exist precisely because they were already valued by historical preservationists. While they thus may not be especially precious as documents of the things they picture, these amateur images provide evidence for the influence of old photographs, sold to the public as both history and art.

The Photographer-Anthropologist

Despite the prevalence of the archaeologist's gaze, looking for surviving bits and pieces of the past, some of the most compelling photographs to come out of "C'était Paris en 1970" were those that imagined the historical value of the present. Contest regulations had reminded participants to document "all the Parisians . . . in their everyday lives," creating a veritable snapshot of the city as a whole. Organizers had hoped that instead of restaging preexisting pictures of Paris's past, contestants would capture what was particular to their moment. Publicity materials encouraged them to photograph "intimate Paris—hidden deep in a courtyard, or so mundane that one has a hard time imagining it one day becoming as precious as its equivalent under Napoléon or under Philippe IV."[83] Some managed this task more successfully than others. Photographing the here and now was harder than cataloging architectural details. It demanded keen observation of a place that the contestants might not know. It required them to forget their own awkwardness in order to observe others and to have the technical skill to snap pictures quickly. With varied degrees of success these 1970 photographers nonetheless turned their lens to their own civilization as anthropologists or reporters.

Participants turned this mode to a diversity of subjects and with different goals in mind. For the most part, they documented truly banal acts of Parisian life: walking, waiting for the bus, shopping for food, or chatting with the neighbors. They drew inspiration from press photography in which nothing much happened as well as from photo books such as Willy Ronis's *Belleville-Ménilmontant* that documented the minutia of everyday life. The contestant Bernard Duval submitted a nondescript photo of a metro entrance, a newsstand, a policeman, cars, and several pedestrians. He captioned it "life" as if to say that this, the banality of the everyday, is the stuff of life in Paris. Photographs of laundry hung out to dry and shared kisses demonstrate a voyeuristic attention to the forced intimacy of life in the city. In the Marais, one participant photographed a young couple emerging from the BHV department store carrying purchases from the rival La Samaritaine.

Some photographer-reporters focused in on the traces of commerce that colored everyday life in Paris. They photographed the glitzy marquees of the movie theaters that lined the Grands Boulevards and the posters for the American exhibition basketball team the Harlem Globetrotters plastered on the barriers around construction sites at the Front de Seine (fig. 5.12). They captured billboards advertising popular consumer goods of the 1970s: Levi's jeans, Sym trousers,

FIGURE 5.12 André Guillemenot, "The Big Movie Theaters of the boulevard des Italiens," submission to "C'était Paris en 1970," square 491. BHVP/Roger-Viollet.

Préfontaine wine, Milliat pasta, Charentes-Poitou butter, Mazda batteries, Chesterfield cigarettes, and Pur-O-Dor deodorizer (cannily touted on the side of public urinals). The participant M. Wegrzecki photographed a man in a sandwich board advertising a *self-service* restaurant near the Théâtre Antoine handing a flyer to a small black dog. Because he or she pasted a copy of the flyer to the back of the print, the material culture of the everyday entered the archive as an object and an image. The participants assigned to portions of the rue Saint-Denis photographed the exteriors of strip clubs. Catherine Le Pape turned her camera on the numerous strip clubs and sex shops in Pigalle. She photographed the neighborhood's neon signs by night. At one storefront, she captured an elderly man in a suit peering at the displays, while at another shop a cheerful young trio poses for the camera (fig. 5.13). Sex obviously sold in Paris in 1970.

Working within this mode, some of these photographic reporters recorded their own alienation from the values they saw at work in contemporary civilization. They captured this sentiment etched on to the city by posters and graffiti whose demands evoked the 1968 protests for labor and social reform. Political posters called people to march on May 10 against the American presence in Vietnam and protested the French presence in Chad (fig. 5.14). Participants focused in on the slogans scrawled on the bricks and stones of the capital: "Yes, we

FIGURE 5.13 Catherine Le Pape, submission to "C'était Paris en 1970," square 243. BHVP/Roger-Viollet.

FIGURE 5.14 Didier Boitreaud, submission to "C'était Paris en 1970," square 505. BHVP/Roger-Viollet.

will break the old world," "May 1970, long live the struggle," and "awakening to reality [*prise de conscience*]." At the Front de Seine development they converged on graffiti declaring "free [??] le dantec le bris." The intellectuals Jean-Pierre Le Dantec and Michel Le Bris had been arrested in 1970 for their affiliation with the Maoist newspaper *La cause du peuple*. Others documented social protests, from piles of rubbish left by a garbage collectors' strike to marchers in the street.

The numerous photographs of the homeless in the FNAC archive suggest both contestants' concern for structural inequalities and the tradition of such images in Parisian street photography. Alice Aubert, assigned to the Marais, produced a two-image photo story of a man sleeping beneath an advertisement for the tranquilizer Quintonine roused by the police (caption: "brotherhood") (fig. 5.15). The story is evidence of both Aubert's social consciousness and the types of images that might have appeared as a sort of repicturing sequence in her mind's eye as she walked the city streets. The first image, after all, bears remarkable resemblance to Brassaï's 1935 photo of a man in Marseille sleeping on the street just beneath an advertisement for food.

Others sought out the same passages and courtyards captured in the archaeological mode of the picturesque but framed them as social critique. Patrice Boussel, who succeeded de Henry de Surirey de Saint-Remy as director of the

FIGURE 5.15 Alice Aubert, "'Quintonine . . .' rue des Archives," submission to "C'était Paris en 1970," square 792. BHVP/Roger-Viollet.

Bibliothèque historique, later noted that contestants' photographs became social commentaries by "insisting on the squalid aspects of certain neighborhoods or the inhumanity of contemporary urbanism."[84] One pointedly captioned a photo of decrepit courtyard toilets: "This was still Paris in 1970." While documenting the same square in the 11th arrondissement, another photographer captured a young boy sitting on what looks like a bale of straw: "Paris: 1m² of green space per inhabitant" (fig. 5.16). Several photographers working all over the city took portraits of elderly Parisians leaning out of windows to watch activity on the street (fig. 5.17). They penned captions that expressed worry for the fate of this generation. Images such as these protested against the lack of indoor plumbing, parks, and gardens in working-class neighborhoods. They echo Gébé's skepticism about who benefited from reconstruction at the hands of real estate developers.

The disruption of reconstruction was also part of the everyday lives of many Parisians in 1970. Participants assigned to squares on the outskirts of the city by Bercy, traversed by the new ring highway, almost exclusively documented the construction site. But even those working in the center of the city, in areas affected by no major projects, captured teardowns and building projects. Wooden scaffolding and supports appear consistently in the submissions taken in the Marais. The geometry of the red and white barriers that prevented pedestrians

FIGURE 5.16 J.-C. Longeron, "Paris, 1 m^2 of Green Space per Inhabitant," submission to "C'était Paris en 1970," square 821. BHVP/Roger-Viollet.

from blundering into a hole in the ground dominates in other squares. Some found beauty in these forms. Evelyne Gabriel's close up for "renewal [*renouveau*]" focused on the spiral of a giant drill bit. In the Marais, Daniel Verchery played with the "geometric effect" of wooden building supports, photographing them head on and then from an angle in order to catch their shadows.

FIGURE 5.17 Anonymous, "The Elderly in Paris: Before the Expulsion (on the rue Payer whose buildings are destined to be demolished soon)," submission to "C'était Paris en 1970," square 955. BHVP/Roger-Viollet.

Others approached the construction sites with a more documentary lens. Two photographers assigned to square 491 behind the Opéra Garnier photographed the worksite there with its bulldozer and backhoe (fig. 5.18). On the backs of their photos, one quipped "in spite of everything, this is still a street" while the other

FIGURE 5.18 André Guillemenot, "Is the Opera Turning Its Back on the RER?," submission to "C'était Paris en 1970," square 491. BHVP/Roger-Viollet.

asked "Is the Opera turning its back on the RER?" Up in Ménilmontant and at the very edge of the 17th, participants photographed the empty lots abutting construction sites: depots for shells of automobiles, discarded furniture, and junk of all stripes. They documented the disruption, the mess, and the dirt of reconstruction in the city alongside its unevenness: how pleasant can new housing be if it abuts urban wasteland?

The most compelling of the photographs taken in the mode of the anthropologist or reporter do exactly what the editors of *Réalités* had looked for in 1951. They do not just bring Parisian architecture and streets to life by including human figures in them but turn these figures into allegories of contemporary civilization. A young boy and girl play hopscotch in the construction site beneath the new Bercy interchange. A schoolboy complete with knee socks and leather satchel walks indifferently past a series of posters for the Harlem Globetrotters (fig. 5.19). These figures embody French defiance in the face of both the disruptions of urbanization and the threat of American imperialism. Alice Aubert's portrait of curly-haired children in ankle socks playing on scaffolding or aiming pistols at the photographer from the ruined wall of a *hôtel particulier* provide hope that this new generation might successfully navigate the obstacles created by the present (fig. 5.20).

FIGURE 5.19 Jean-René Teichac, submission to "C'était Paris en 1970," square 955. BHVP/Roger-Viollet.

Another photographer working in the Marais captured a fashionably dressed wedding party coming out of the Eglise Saint-Merri (fig. 5.21). A pair of older women in aprons, shawls, metal-rimmed spectacles, and thick black stockings, their hair pulled back in buns, have stopped on the pavement to enjoy the spectacle. They stare, not judgmentally, taking in the joy of the event, but also standing apart from it—just barely connected to the scene by the floating white gauze of the bride's veil—a sort of peace flag proffered by the new generation to the old in Paris.

The Photographer-Futurist

As they looked for traces of the past or documented the present in May 1970, some participants could not help but project visions for the future into their photographs. Some, of course, did not see the future at all, or at least their photos betray no hint of it. Others let slip this perspective on the city in just one or two images, while for a handful of photographers what the future held in store seemed paramount. In a way, it is hard to separate out this mode from that of the photographer-anthropologist documenting the present, because you cannot, of course, take pictures of the future. But contestants did not have to look hard to

FIGURE 5.20 Alice Aubert, "The Little Girls of the rue Guillemites," submission to "C'était Paris en 1970," square 792. BHVP/Roger-Viollet.

find the "little bit of the year 2000" that Gréco sang about later that fall. Through careful framing and selection of subjects, as well as through the captions they scrawled on the backs of their photos, participants gave voice to enthusiasm and concerns about what the next years and decades held for Paris.

As they peered into the future through the landscape of Paris in 1970, among the first things that contestants saw were radically new architectural forms. Some

FIGURE 5.21 Anonymous, "Eglise Saint-Merri," submission to "C'était Paris en 1970," square 790. BHVP/Roger-Viollet.

of these, such as those in the panel displaying renovation plans for the Eglise Saint-Pierre du Gros Caillou captured by a photographer in the 7th arrondisse- ment, were as yet the dreams of architects. Others were already set in stone or, as it were, concrete. Paul Martaux, assigned to a square containing a section of the slaughterhouses at La Villette captured the new buildings emerging in the neighborhood. He photographed the globe-topped lampposts and repeated s- shapes of one such structure, so different from the staircases and framing trees around the nearby Canal Saint-Denis (fig. 5.22). Similar photos appear in most squares undergoing reconstruction. Other photos document towers: often, in addition to framing the buildings in full-sized portraits as Martaux did, photographers zoomed in to capture the new geometry of their façades (fig. 5.23). These photographs look the future squarely in the face, but their interpre- tation of it is unclear.

Other photographers developed a mode of framing the new architecture that leaves little doubt as to the future they foresaw. The renovation of nineteenth- century Paris had flattened "visual hierarch[ies]."[85] The clearing of the Parvis de Notre-Dame had rendered the building less grand, transforming it into just another element of the urban vista.[86] By 1970, buildings of ten, twelve, or even more stories that towered over those of previous generations similarly brought about new ways of picturing the city. While in some places contestants could get

FIGURE 5.22 Paul Martaux, submission to "C'était Paris en 1970," square 120. BHVP/ Roger-Viollet.

the distance they needed to photograph these buildings in their entirety, aligned with the plane of the camera's lens, others could not. The towers were simply too tall, the city's streets too narrow. So instead, they tilted their cameras back, filling the frame with repeating geometric patterns. Jean-René Teichac, for example, leaned back to capture a skyscraper looming over an archaeological fragment (the fence containing the letter slot) (fig. 5.24).

Such photos give these buildings, seemingly without end, a dizzying dominance over fragments of the old city. New construction seems even more menacing when framed as a dead end for old Paris. In a photograph taken near the Place des Fêtes, the new tower block may gleam with light, but it also blots out the sky, effectively burying the street below in concrete (fig. 5.25). Its off-kilter framing contributes to a sense of suffocation. By showing historic Paris trapped by modernization, these images warn against an inhumane architectural future.[87] They rearticulate Gébé's prediction of "Paris en 2001" reduced to walls of towers and expressways along the Seine (figs. 5.26 and 5.27).

Other photographers looked into the future and saw not what it would look like but what it would not. They familiarized themselves with plans for their assigned squares and made sure to document buildings and courtyards slated

FIGURE 5.23 Desir, "Modern Perspective," submission to "C'était Paris en 1970," square 952. BHVP/Roger-Viollet.

for destruction. André Brugger, for example, added the following caption to two photos of the boarded-up windows and debris-filled courtyards of the cité Canrobert in the 7th: "[the] end of an era, the cité Canrobert is going to disappear." Françoise Lefebvre produced a thirty-eight-image photo story about part of the future site of the Galaxie development in the 13th, billed at the time as the largest Parisian renovation project since Haussmannization.

FIGURE 5.24 Jean-René Teichac, submission to "C'était Paris en 1970," square 955. BHVP/Roger-Viollet.

Although she signed up with an address in Fresnes, Lefebvre assumed the perspective of one of the quarter's long-standing residents. Her story opens with the statement "my neighborhood is going to disappear," written on the back of a shot of a Galaxie billboard. Another clearly staged photo shows a young woman standing in the construction site reading the issue of *France Soir* that announced its groundbreaking (fig. 5.28). The subsequent photos trace the neighborhood's past, present, and future: streets, pedestrians, restaurant menus, posters, the traces of demolished buildings, cleared dirt-filled lots, and machinery become part of a story of the transformation of a lively, animated neighborhood into a construction site. Lefebvre's use of different times words and tenses in her captions turns photos from a single month into a much longer narrative of urban change.

For contestants working in a similar vein, people often seemed the most likely victims of modernization. The participant Christian Vigne remembered focusing

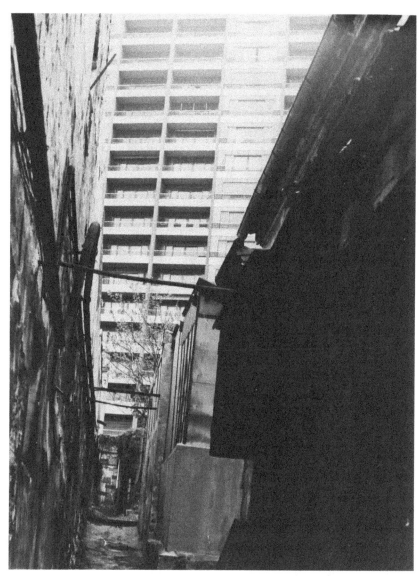

FIGURE 5.25 Anonymous, "Rue Pixérécourt," submission to "C'était Paris en 1970," square 565. BHVP/Roger-Viollet.

FIGURE 5.26 Detail, Gébé, *Paris qu'on pioche*, 1970. ©Nicole Blondeaux.

FIGURE 5.27 Anonymous, "New and Old Buildings of Paris, Citroën, rue de Ginoux," submission to "C'était Paris en 1970," square 952. BHVP/Roger-Viollet.

on "small Parisian workshops destined to disappear rapidly."[88] Françoise Lefebvre asked on the back of a photo depicting a poster protesting Galaxie: "But who lived here?" The photographs of elderly Parisians gazing down on the street mourn the passing of a generation and a way of life (fig. 5.17). They acknowledge that these faces would not be part of the landscape of future Paris. The editors of *La galerie* similarly interpreted one such photograph of a concierge. Its caption describes

FIGURE 5.28 Françoise Lefebvre, "Pentacost 1970," submission to "C'était Paris en 1970," square 1554. BHVP/Roger-Viollet.

how the photographer froze this figure who otherwise "tends to beat a retreat before the invasion of intercoms, mail boxes, double glass doors, and marble entry halls, in short, in front of the invasion of the modern, well-appointed building [*standing*]."[89]

Not every instance of photographers operating in this mode of "seer" interpreted the future negatively. For many in 1970, modernization was exciting.

Photographers celebrated the car's presence in the city, whether coming off the assembly line at the Citroën factories or squeezed into small parking spaces along its narrow streets (fig. 5.29). One contestant produced a striking Paris-by-night time-lapse of cars on the expressways along the Seine, which seems to

FIGURE 5.29 Jean-Michel Cisterne, "Quai de Javel, a 'DS' [pronounced in French, this sounds like goddess] Awaits You," submission to "C'était Paris en 1970," square 1178. BHVP/Roger-Viollet.

argue for the beauty inherent in the speed and flow of modern technologies. Their photos refute interpretations of Paris as a museum repository of images of its own past and as a construction site for sanitized and dehumanizing suburbs. This is a vibrant city innovating for the future. Such celebratory images, however, are far outstripped by those that saw something more menacing in what the future had in store.

As they documented Paris in May of 1970, participants responded to what exactly was in need of preservation—was it the recent or the distant past, or even the present? If the latter, was it life as it was lived or its residents' hopes and fears about what the future would look like? As they asked and answered such questions, contestants explored photography's temporal flexibility, its capacity to preserve multiple temporal moments. What form Paris would take in the coming years and decades deeply troubled some of the amateur photographers who took up cameras in the name of archiving the capital. They doubled the camera's objective power to document what lay before the lens with their own interpretations of the city hemmed in, choked off by new construction.

The Contest after May 1970

The contest ended where it had started, with an exhibition of the prizewinning photographs at the Baltard pavilions. Despite the press's ongoing boycott, in the fall of 1970, seventy thousand visitors came to Les Halles (where just two years earlier, they could have shopped for vegetables or poultry) to see photographs that crystalized all that was changing in Paris.[90] But while the FNAC celebrated the successful completion of the operation to preserve the capital, participants and the public questioned whether the contest had met its goals. Exhibition advertisements bragged that "the twenty arrondissements, the seventy-eight neighborhoods of the capital have been illustrated, gazed at, immortalized, in their richness or in their destitution, their brilliance or their banality, such as they were at least for a moment in the history of Paris."[91] The FNAC reported that it had received an impressive amount of praise from participants and nonparticipants alike.[92]

But many contestants charged that the contest—and in particular the prize committee—had lost sight of its ambition to document the particularities of Paris in May 1970. One participant criticized the jury for rewarding generic shots of the city. She lamented: "Paris in May 1970 seems to have been completely lost, for the images provided do not at all situate the spring of 1970."[93] Another photographer, who visited the exhibition twice, complained: "both times I came out profoundly disappointed!"[94] He too felt that the photos on display captured little of the moment. What must have been a highly stylized photo of the Eiffel Tower left him sputtering: "What will Parisians of the year 2070 think when they see a

deformed Eiffel Tower? They'll think that Parisians of 1970 did not know how to build straight."[95] Setting aside the fact that the tower was almost a century old at the time, the contest photos on display, he suggested, privileged artistic and aesthetic criteria and thus would not hold up as reliable historical documents.

The composition of the jury did privilege photography and its artistic merits over the city's history. No historian figured among the group that ended up judging submissions that summer. The artistic director for *Paris Match,* Jacques Bourgeas, sorted through photos, as did the designers Roger Tallon, who had devised the design of the new RER stations, the Corail trains, and the TGV (as well as innumerable postwar products), and Daniel Maurandy, responsible for the FNAC stores on the boulevard de Sébastopol at Châtelet and on the avenue de Wagram at Etoile. Alain Trappenard, the Directeur de l'action culturelle, de la jeunesse, et des sports, represented the city's administration on the panel, Théret and Gouillou the FNAC. The former *Paris Match* photographers Izis and Walter Carone (at the time also managing editor for the magazine *Photo*), fashion photographer Jean-Loup Seiff, and Jacques-Henri Lartigue worked alongside them. The president of the Société francaise de la photographie, Jean Prisette joined them.

The two first-prize winners in both the color and black-and-white categories reveal much about what both organizers and contestants expected from the mandate to produce a photo that best represented Paris in 1970 (figs. 5.30 and 5.31).

FIGURE 5.30 Belling, First prize, color category, "C'était Paris en 1970." BHVP/ Roger-Viollet.

FIGURE 5.31 Marc Robert, First prize, black-and-white category, "C'était Paris en 1970." BHVP/Roger-Viollet.

The color winner also portrayed an urban water feature: a detail of the horses of the Fontaine Carpeaux, just south of the Luxembourg gardens, rendered in muted greens and yellows. The black-and-white winner tightly framed the Fontaine des Fleuves, dedicated to river commerce and navigation, at the Place de la Concorde with the Hôtel Crillon in the background. Neither photo encapsulates the elements of change and continuity that make so many of the "C'était Paris en 1970" submissions compelling. Instead, both are technically

perfect (each water droplet is discretely frozen in midair), well composed, and completely generic. While the black-and-white winner obviously depicts Paris, the color photo could have been taken in any European city. The same participant who complained of the Eiffel Tower snipped: "a bronze horse head among sprays of water, is this really a photo epitomizing Paris?"[96] Without their captions, one would never know that either dated from 1970. At the same time, they get to the essence of the contest. The photos' generic and timeless depictions of place—and the fact that neither winning photo deals with the contemporary forces at work in Paris—embody the careful political neutrality of organizers' discourses and their insistence that despite modernization, the city's essential historic identity remained unthreatened.

These two prizewinning photos and the participation of Jacques-Henri Lartigue, France's most famous amateur photographer turned artist, in their selection speak to a fundamental disconnect between the contest's rhetoric and its jury's decisions.[97] Organizers had asked participants to create a photo archive that privileged documentation over art. The participants who wrote in to complain about the winning photographs had interpreted the contest as a documentary project, one that would serve future historians. They were disappointed when those who judged the photographs did so with aesthetic criteria in mind. For the FNAC, however, photography was necessarily both documentary and artistic.

The medium had not been so at the Bibliothèque historique, but the photo contest would spark a reevaluation of the importance of photography and its aesthetic potential within Paris's historical institutions, which ensured the contest photos would not resurface for almost forty years while also making that reappearance possible. Nonetheless, the contest photos were not immediately forgotten. Some were exhibited in the 1970s, notably at a show about contemporary French architecture that traveled to the USSR in 1974.[98] And researchers would occasionally consult them when they had questions about a building, street, or neighborhood. The contest submissions, however, were simply too recent to be interesting. More time needed to pass for them to be relevant for historians of Paris, and historians of photography would not interrogate amateur practices for at least another decade.[99]

The "C'était Paris en 1970" photos did give new life to photo collecting at the Bibliothèque historique. The FNAC had somewhat naively intended to classify and microfilm all of the photos before donating them.[100] After this proved impossible, the library appointed a full-time photo curator, Marie de Thézy, to deal with them. She cataloged a handful, whose cards entered the drawers devoted to the library's photo holdings. But she never made it through the 100,000 photos—and how could she have? Instead, she began to take stock of what else the Bibliothèque historique owned. Within ten years she had organized exhibitions of photos of street furniture as well as the work of the Séeberger

brothers, Charles Marville, and the Groupe des XV and begun a major research project about Marville.[101] She continued to buy more recent photos, often from well-known photographers, a practice the library had reinstituted in 1969.[102]

In the 1970s and 1980s, photography finally began to fit comfortably within the dual institutional mandate of history and art at both the Bibliothèque historique and the Musée Carnavalet. In the late 1970s, American PhD candidates in art history started frequenting both collections when Maria Morris Hambourg and Molly Nesbit began dissertation research on Eugène Atget.[103] The increased interest of researchers inspired the staff at the museum's Cabinet des estampes to reorganize photographs from the topography files into a separate photo collection. In 1978, the Musée Carnavalet held its first photo exhibition since the Liberation of Paris show in 1944–1945. Photographs and photography were undergoing similar revaluation in other institutions throughout France at the same time.[104] But in Paris it is paradoxically thanks to the photo contest, which itself sat so uncomfortably between history and art, that photographs began to enter the collections of these institutions again and became a regular part of their public programming.

This Was Photographic History in 1970

How then can we take stock of the "C'était Paris en 1970" photos? The pictures produced over the course of May 1970 gave rise to the central questions that drive this book. At the same time, by providing so much evidence about how people who were neither professional photographers nor historians imagined photographs might function as historical documents, they go a long way toward answering them. If Marcel Poëte had been alive in 1970, the contest submissions might very well have laid to rest his fears that photography, destined to document the city for generations to come, was too cold, too objective, too scientific of a medium. The sheer quantity of differing interpretations of Paris that these photographs open onto seem persuasive evidence of the fact that the camera can record the perspective behind it as much as the scene in front of it. Poëte might even have rejoiced at the fact that "C'était Paris en 1970" allowed the Bibliothèque historique to acquire photographs of otherwise little documented corners of the capital and in part compensate for the lack of photographic archives of twentieth-century Paris.

In retrospect, however, "C'était Paris en 1970" seems too little, too late, even at 100,000 pictures, somehow not enough. A month was too short of a time period: documenting it would not produce an archive of before and after images. By 1970, many of the most dramatic changes to the city were already well underway. To place these photographs in dialogue with Louis Chevalier's analysis, rather than showing Paris before its assassination, most often they show the murderers in the act or simply the scene of the crime. And compared to documentation

afforded by today's technologies, such as Google Street View, the contest's attempts at creating a comprehensive archive of the city during the month of May seem underwhelming.

At the same time there are too many photos. They endlessly catalog streets, buildings, or architectural details. But did they simply become part of a flood of banal images the likes of which Gourbeyre hoped the contest would stem in 1970? They did not. For even the most banal photographs provide insight into how their makers thought about photography's utility for history, even if the images reveal that those who shot them may not have thought about this question at all. Discussions of urban change in Paris so often focus on how politicians, architects, or technocrats see the city and how their visions are enacted in it. Everyday people enter into that story as subjects of relocation, protestors or both, but rarely as possessors of an image of what the city should look like. The contest provides access to intramuros Paris seen through the eyes of those who were not deciding its future. Its photos allow us to glimpse how certain contestants imagined the presence of the past and the passage of time in Paris. As they worked in the modes of photographer-archaeologists, photographer-anthropologists, and photographer-futurists they testified to the important role that previous photographs played in their own conception of the contest's project and to how they saw Paris even before they framed it through the viewfinder.

If the contest was too late in coming, it also could not have happened before 1970. The scale of its organizers' aspirations required that photography be available, and appealing, to a large population. But "C'était Paris en 1970" depended just as much on potential participants' notions of how photography might contribute to history as on their knowledge of and access to the medium. The public was receptive to its appeals to document the capital for posterity precisely because it already knew about the value of old photographs from exhibitions, photo books, and the general illustrated press as well as from magazines aimed at amateur photographers. They needed to have seen Charles Marville, Eugène Atget, or Louis Vert's photos in an exhibition, in newspaper coverage of one, or in books such as Louis Chéronnet's *Paris tel qu'il fût* or René Coursaget's *Dans les rues de Paris au temps des fiacres*. They needed to have walked by posters advertising Bimillénaire celebrations or attended its reenactments and performances. They needed to have leafed through Yvan Christ's rephotography books, the barricade photos of *La semaine héroïque*, or even André Warnod's *Les visages de Paris*. Or perhaps they simply absorbed a century of history in photographs alongside news and human-interest stories from the pages of *Paris Match*. All of these helped shape future participants' understandings of how photography might capture the past. They became familiar with the content as well as the style and forms of old pictures that shaped a set of visual clichés of Parisian history. Participants in

"C'était Paris en 1970" were heirs to the modes of seeing history in photographs as one-to-one copies of objects, snapshots of past time, and gateways to memory banks of historical pictures.

We might also think of "C'était Paris en 1970" as the starting point for two other histories: the first, of large-scale usually state-sponsored photographic documentation initiatives in France; the second, of the crowd-sourced digital photo projects that abound today. The contest marks the last time in France that a government body confided the creation of officially sanctioned documentation on this scale to amateurs. In its immediate aftermath, the contest inspired two other similar ventures, but neither drew the same level of participation. In May 1976, the magazine *Paris aux cent villages* worked with twenty independent camera and film shops to launch a competition with the same name, which received some three thousand photos, subsequently donated to the Bibliothèque historique.[105] Ten years later, the FNAC and city officials in Toulouse put together "C'était Toulouse en 1986." Only 750 people signed up; a mere 150 submitted photographs.[106] In the 1980s, however, the documentary impulse that drove efforts to produce a comprehensive photographic record of the city gave way to concerns for the aesthetic and artistic merits of such endeavors. Subsequent large-scale official projects, such as the 1984–1989 "Mission photographique de la DATAR" and the 2003–2008 "Mission France" organized by the French Ministry of Culture, hired professionals—twelve in the case of the DATAR and just one, Raymond Depardon, for the latter—and granted them artistic liberty in their documentation.[107] In light of this history, the original FNAC contest remains unique in that it called solely on amateurs and produced so extensive an archive.

From today's vantage point the competition also prefigures crowd-sourced photographic documentation projects to capture a place or a way of life. If time was speeding up in 1970, it is going full tilt now, and these operations often ask photographers to document a day, a minute, or even a single instant. The 2010 undertaking "A Moment in Time" organized by the *New York Times*, for example, asked participants all around the globe to take a picture on May 2, 2010, at 15:00 UTC.[108] Such projects have even returned full circle to Les Halles, which has again been renovated: a giant undulating wing now covers the shopping mall that had replaced the Baltard pavilions. In June 2014, SemPariSeine, the developer responsible for the project, asked both professional and amateur photographers to train their cameras and phones on this site for a contest entitled "My Life at Les Halles: A Look at the New Heart of Paris."[109] The winning photographs, selected from just fewer than seven hundred submissions, were displayed on the construction barriers at the site later that fall.[110] To think of "C'était Paris en 1970" as a crowd-sourced project reminds us that the world did not need digital photography and the Internet to imagine the value of collective portraits mass-produced by amateurs. But in this narrative, the FNAC contest remains unique, for while

subsequent projects have made photographs available online, their organizers rarely work to ensure the photographs' preservation. The preservation of "C'était Paris en 1970" in a public collection was integral to the undertaking from the very beginning, part and parcel of its conception as a complement to an already existing archive.

While this contest, then, certainly has a place in the lineage of mass photography projects, confided to both professionals and amateurs, its significance goes well beyond the history of photography. In pitching every photographer as a potential historian, it made every corner of Paris potentially historically significant. The organizers of "C'était Paris en 1970" did not come up with the idea that each and every Parisian stone held the past, but they certainly helped disseminate the idea that the city's history was irrevocably linked to photography. Those old stones in turn took on something of the photographic. It is this idea—of Paris as a museum city, as a place that, even as it halted the full-tilt modernization projects of the previous two decades, died somehow and became simply an image—that leads to a consideration of what exactly the history of photographs might have to do with the history of Paris as an image.

CONCLUSION

LOOKING BACK, LOOKING FORWARD:
THE VIDÉOTHÈQUE DE PARIS

In the early 1980s, new technologies for producing and reproducing images promised once again to fundamentally reshape the preservation and dissemination of the Parisian past. Echoing Marcel Poëte's 1925 declaration that photography had revolutionized the reproduction of Paris, municipal officials and scholars proclaimed video history's new frontier. Its tapes and VCRs could make nearly a century of film and television footage shot in the city available to viewers at the touch of a button. Computerized databases would make these images searchable, and the new cable network might even pipe them directly into French homes. At least this was the plan laid out for the Vidéothèque de Paris, which opened in 1988 in the underground shopping mall that replaced the markets at Les Halles.[1] "All of Paris, at your fingertips," a commercial promised—a technological utopia of municipal history.[2] It was to be a prestige institution in which the glories of the Parisian past lent cultural legitimacy to new machines and networks that, in turn, ensured city history pride of place in the landscape of the future.

From the beginning, the Vidéothèque curated public screenings and welcomed visitors to a consultation room, where they could explore its collections on their own. Some of its other plans, however, never saw the light of day. The Vidéothèque never collected anything close to a complete century's worth of footage. And it would not end up making its way onto television screens in living rooms across the nation—although the public could use the Minitel to search the catalog and reserve a high-tech viewing station. Both organizers and the press feted the latter as the *ne plus ultra* of modern technology. Here, in rolling chairs arranged in front of boxy computer screens and keyboards, the public would find all of the newest of the new on offer. Simple text commands allowed users to search the archive and select

something to watch. A three-armed robot then zipped along steel rails at speeds of two meters per second to find the corresponding videocassette in the stacks and insert it into the VCR hooked via cable to the user's screen. Any sound from the video came out of speakers located alongside the chair's headrest.

This set-up *did* make pictures of the past accessible in new ways. We should not, however, let the Vidéothèque's shiny metallic interior, its high-speed robot, or its networked viewing stations convince us that this institution was charting completely new territory. As much as we may be tempted to see in it the beginnings of the Internet, of video-sharing platforms, or of digital archives—such as the Institut national de l' audiovisuel's—that are now available online, the Vidéothèque serves us better as a way of reflecting on the past.[3] Indeed, an institution like the Vidéothèque was the predictable product of an image-centric approach to history more than a century in the making. As such, its creation illuminates the interwoven relationships between photography, history, and the city of Paris.

The history of the Vidéothèque demonstrates once again that pictures of Paris are not simply windows onto urban change; their production, preservation, and use are part and parcel of that history. To capture photos of Paris, to debate their historical merits, and to use new photos and reinterpret old ones was to define not just photography but also the city itself and, in particular, its relationship to the past. The Vidéothèque's rolling armchairs and zooming robot sat just meters below the former site of the Baltard pavilions, where participants in "C'était Paris en 1970" had picked up their square assignments. Both came into being thanks to the fact that the mandate to produce and collect pictures had been part of urban destruction, reconstruction, and trauma since Haussmannization. The photo contest was created in response to perceived shortcomings in how photographers had documented the city and how the Bibliothèque historique had preserved city pictures for the public—urgent problems in an era of rapid urban change.

The video archive, which was meant to take advantage of the rich traces left by moving-image cameras that no other institution was preserving, served, like the Musée Carnavalet a century earlier, to refute charges that attempts to bring the capital into the future had eviscerated it. The accusation in this case was that by removing the markets from Les Halles and destroying the Baltard pavilions, municipal officials had ripped out Paris's heart. The Vidéothèque could be sold as a sort of transplant, a nod to the importance of maintaining ties to the past, a project that injected history—as well as the possibility of memory, or a personal relationship to images of the past—back into the site of Les Halles. Photomechanically produced images captured urban change and thus offer evidence of it, but we also need to recognize the role they played in facilitating those very changes.

The Vidéothèque reminds us that photographs, as seemingly exact replicas of what had stood before the lens, have changed our relationship to the past. When

it first opened, the host of the midday news on France's second television channel asked the historian Georges Duby whether such an archive would make texts obsolete. Would historians even have to read documents anymore if they could simply watch the past unfold as it had happened? Duby replied no, of course not, but the question is a familiar one. For while other documents no doubt continued to be important, photographs did offer something new. The possibility of indexical images of the past was revolutionary, not because photography offered some essential truth about or seamless access to that which had been, but because people came to think that it did. In response to the possibility of photography, to the existence of photographs, people developed new ideas about how these and other pictures evoked the past, about what made an image a "document," about how the mind remembered the past, and about what the past looked like. If the organizers of the Vidéothèque could sell their institution as the site of "living memory" of the city, it was because a century of using photographs as historical documents had made it abundantly clear that such images, consumed in groups and alone, did shape how people imagined the past.

The Vidéothèque's history also drives home the fact that modes of seeing the past in seemingly self-evident images have their own history. People had to learn to read photographs, and how they understood them changed over time. Just as Marcel Poëte had lamented that photographs were too scientific, too cold to evoke the feel of the past as prints, sketches, or paintings had done, contemporaries worried that the Vidéothèque was collecting the wrong types of historical documents. A 1991 article in Le Monde reported that the institution was increasingly commissioning its own videos of Paris. This, like the decision to use amateurs in the 1970 contest, was in part a question of rights. The Vidéothèque would not have to pay licensing fees for its own productions.

But there was also another, more substantive reason. "Our celebrated era 'of the image,'" the article explained, "actually supplies fewer documents suitable for constituting a visual memory than before."[4] For the Vidéothèque's then-director, Véronique Cayla, this was a problem of speed: "the magic formula of the modern audiovisual world is always faster, always shorter."[5] Television stations favored rapid-fire images that often had no relationship to accompanying voice-overs. Yet historians have learned how to read these images, to appreciate their form not as a detriment to, but as an essential part of, the meaning they contain. They have done so much in the same way that over the course of the twentieth century, viewers had learned to understand old photographs as snapshots of lost time and to see recent images as pictures of the past. Historians continue to find many different pasts in the same photographs.

Most importantly, the Vidéothèque brings home just how important photography has been to ideas about what Parisian history should look like. For while describing the challenges of running an institution that preserved video, Cayla

seemed to thirst after a photographic ideal. Photographs are still. They can be consumed at one's leisure. They are captured instantaneously, but they exist afterward in long time. And one can choose to ignore any text that may accompany them. Indeed, Cayla's idea for the institution shared more with the world of images in books than those on television or in movie theaters. In a 1990 article, she described the Vidéothèque as a library, thus evoking the other half of its portmanteau name—the "thèque" in "bibliothèque." Its viewing stations, she wrote, afforded visitors "an individual, intentional, book-based approach: as with reading, the viewing takes place at each person's pace; the ability to pause, rewind, or fast-forward allows the viewer to *leaf through* a film."[6] This was a model of viewing based on the still page and on the photograph on it. For when most readers flip through books in search of the past, they are generally not after a footnote or a reference; they're often on the hunt for pictures, stopping to look and think when one catches their eye.

Since the mid-nineteenth century, historical innovation has often been tied to the creation of image collections, imagined for the future, from the topographic archive at the Musée Carnavalet to the photos of "C'était Paris en 1970" and the footage on offer at the Vidéothèque de Paris. But the story of how photography shaped history in Paris did not end within the walls of municipal historical institutions. Photography changed how people saw the city itself. Since the 1960s and Guy Debord's *The Society of the Spectacle*, people have almost instinctively described Paris as a city consumed as an image. For Debord this was a militant argument: one about the ravages of capitalism on the social world that used the idea of the spectacle to stand for the destruction of authentic social bonds. It both was and was not about actual images. For many scholars since, the idea of Paris reduced to an image has become a shorthand for these changes, but one that often takes the image more literally to mean picture-heavy mass culture and the pleasures on offer for the modern tourist. It has become a nostalgic argument, which supposes that an authentic Paris, an authentic society of real bonds, of actual relationships existed some decades ago, maybe even as far back as a century. Instead of a city that functions today, Paris has become a shell of its nineteenth-century past, a museum, where the past is on display but is no longer authentically lived.

We can say something more specific about what it meant for Paris to be consumed through and as images: this rhetorical idea may be strengthened by an investigation of the material. Over the course of a century, Paris did come to be consumed through and as images, and not just any images but photographs, and not just any photographs but photographs of the past. By the 1950s, the city had become so rammed full of pictures of its past that Parisians could not help but see them in the city. This had two important consequences. It meant that this way of seeing the past in the present would help justify the destruction of certain

parts of the city. After all, if Parisians' habits could be the living embodiment of urban history, one did not need to preserve an outdated physical shell in order to preserve the past.

But it also meant that photographs prevented people from actually seeing the city as it was. This was the case for Louis Chevalier who, in his study of how exactly he and his contemporaries had allowed Paris to be destroyed before their very eyes in the 1950s and 1960s, admitted that even as a historian of Paris, he had let this mode of perception, of constantly seeing pictures of the past overlain in his mind's eye temporarily blind him. "Perception itself is a matter of habit," he wrote, "Images from the past block the retina and mask images of the present. At first we do not see, or we see without actually seeing."[7] Two decades went by before he could shake these images from his vision and take stock of what had happened to the capital.

The modes of perception that Parisians had learned from photographs did not just prevent them from seeing but also allowed them to see selectively. For the production of the museum city, of the carefully preserved fragments of the past, set in the midst of chain stores, is itself an adaptation of the archaeological mode, so prevalent in the "C'était Paris en 1970" contest photos, in which mausoleum photos far outstrip those that look brightly into the future. This way of focusing on the fragments of the past was a form of resistance to the city's reconstruction, but it was also a learned behavior. Decades of photographs had taught contestants that to look at Paris was to see the past. If Paris has become a "museum city," a place that is only important because of its past glories, it is in part because people have mapped a mode of viewing that they learned within institutions onto its streets. In today's world of "green" cities, Paris seems once again to be leading innovation, but for many decades it was simply easier to filter the city through a mode of viewing that had both made the past more tangible and made the present easier to deal with.

The histories of how photos came to be available in contemporary historical collections and how their uses changed over nearly a century do not leave us mired in the past—or in a mode of mourning what Paris has become. Rather these policies continue to illuminate the issues that affect historical production and municipal policy today. Photographs are invading the world of historical inquiry and dissemination as never before. The digital projects that historians are increasingly developing too seem to depart from traditional textual scholarship by their implementation of images and/or maps. Historians have asked if the future of digital history is spatial history, but given that maps are also images, one might just as well ask: is the future of digital history visual history?[8] Publishers have realized that recycling old photographs in the public domain makes for a reliable revenue stream. The availability of photographs on the Internet has also allowed for new twists on older conventions. Rephotography, for example, is made that much

easier and more poignant by geolocalization techniques, the ability to embed old images in the new, and interactive features that allow users to switch between and compare new and old images.[9] This flood of old photographs has even produced a term for their disembodied digital consumption: "retronauting."[10]

In the early 2000s the city of Paris began digitizing and publishing the photographic collections of its museums and libraries on a new website, Paris en Images. A decade later, the specialized libraries of Paris, a network that includes the Bibliothèque historique, also began putting tens of thousands of pictures from its collections online. Like physical spaces before them—from the Musée Carnavalet and the Bibliothèque historique to the Vidéothèque de Paris—these virtual ones promise to preserve the changing city in the frozen moments of its past. Once again Parisian history in photographic form lies at the heart of projects designed both to use the latest technologies to define the city's contemporary identity and to build its present greatness on widely disseminated pictures of its past. These trends, which draw on the photograph's power to conjure the past materially and to live side by side with the present in the world outside the frame, seem unlikely to cease, and they make the study of collecting and consuming photographs as historical documents all the more timely.

NOTES

FM

1. Marcel Poëte, *Une vie de cité: Paris de sa naissance à nos jours*, Album (Paris: A. Picard, 1925), xiv. All translations, unless otherwise noted, are my own.

INTRODUCTION

1. The Bibliothèque historique de la Ville de Paris is often abbreviated as the BHVP, but for ease of reading, I will refer to it in the text as the "Bibliothèque historique."
2. My own research on the photos has inspired both a documentary about the contest on France Culture and the inclusion of several dozen photos in "Le Marais en héritage(s)," a 2015–2016 Musée Carnavalet exhibition: Perrine Kervran and Véronique Samouiloff, "Représenter la ville 2/4: 'C'était Paris en 1970,'" *La fabrique de l'histoire*, France Culture, February 24, 2015; Valérie Guillaume, ed., *Le Marais en héritage(s): Cinquante ans de sauvegarde, depuis la loi Malraux* (Paris: Paris musées, 2015).
3. There are many pictures of Paris in collections throughout the city, but most are incidental archives of Parisian history. The Bibliothèque nationale, for example, is France's copyright library; its photographs accordingly tell the history of the copyright deposition of photographs in print. The Préfecture de Police, the Pavillon de l'Arsenal, the Louvre, the Musée d'Orsay, the Société française de la photographie, and the Archives de Paris all hold photographs of the city, but again, each collection tells the history of different concerns that diverge from the self-conscious historicism of the Bibliothèque historique and the Musée Carnavalet's collections.
4. The documentary impulse is strong in France. Historically it has been activated by a sense of impending loss and by the need to preserve everything from buildings to the entire world. For more about the documentary impulse in general, see Gregg Mitman

and Kelley Wilder, eds., *Documenting the World* (Chicago: University of Chicago Press, 2016). For more about French projects, see M. Christine Boyer, "La Mission Héliographique: Architectural Photography, Collective Memory and the Patrimony of France, 1851," in *Picturing Place: Photography and the Geographical Imagination*, eds. Joan M. Schwartz and James R. Ryan (London: I.B. Tauris, 2003), 21–54; Edward Welch, "Portrait of a Nation: Depardon, France, Photography," *Journal of Romance Studies* 8, no. 1 (Spring 2008): 19–30; Paula Amad, *Counter-Archive: Film, the Everyday, and Albert Kahn's Archives de la Planète* (New York: Columbia University Press, 2010); Raphaële Bertho, *La Mission photographique de la DATAR: Un laboratoire du paysage contemporain* (Paris: La documentation française, 2013); Ari Blatt, "Détours en France: On the Road with Jean-Christophe Bailly and Raymond Depardon," *Contemporary French Civilization* 39, no. 2 (2014): 161–177.

5. A growing body of scholarship addresses the role of images in the imagination, whether historical, geographical, or cultural. For more, see Michael Ann Holly, *Past Looking: Historical Imagination and the Rhetoric of the Image* (Ithaca: Cornell University Press, 1996); Kate Flint, *The Victorians and the Visual Imagination* (Cambridge: Cambridge University Press, 2000); Gregory M. Pfitzer, *Picturing the Past: Illustrated Histories and the American Imagination, 1840–1900* (Washington, DC: Smithsonian Institution Press, 2002); Joan M. Schwartz and James R. Ryan, eds., *Picturing Place: Photography and the Geographical Imagination* (London: I.B. Tauris, 2003); Elizabeth Edwards, *The Camera as Historian: Amateur Photographers and Historical Imagination, 1885–1918* (Durham: Duke University Press, 2012).

6. This analysis builds on studies of photo book conventions in other contexts, including: Carol M. Armstrong, *Scenes in a Library: Reading the Photograph in the Book, 1843–1875* (Cambridge, MA: MIT Press, 1998); Patrizia Di Bello, Colette Wilson, and Shamoon Zamir, eds., *The Photobook: From Talbot to Ruscha and Beyond* (London: I.B. Tauris, 2012); John Mraz, "Picturing Mexico's Past: Photography and 'Historia Gráfica,'" *South Central Review* 21, no. 3 (Fall 2004): 24–45. Paris photo books most often figure in catalog-style compendiums: Hans-Michael Koetzle, *Eyes on Paris: Paris im Fotobuch, 1890 bis Heute* (Munich: Haus der Photographie, Deichtorhallen Hamburg, 2011); Martin Parr and Gerry Badger, *The Photobook: A History*, vols. 1–3 (London: Phaidon, 2004–2014).

7. This argument builds on a rich body of scholarship about the development of visual historical conventions in the nineteenth century. For more, see Richard Terdiman, *Present Past: Modernity and the Memory Crisis* (Ithaca, NY: Cornell University Press, 1993); Maurice Samuels, *The Spectacular Past: Popular History and the Novel in Nineteenth-Century France* (Ithaca: Cornell University Press, 2004).

8. Guy Debord, *La société du spectacle* (Paris: Buchet-Chastel, 1967). For a clear reading of Debord, see Martin Jay, "From the Empire of the Gaze to the Society of the Spectacle: Foucault and Debord," in *Downcast Eyes: The Denigration of Vision in Twentieth-Century French Thought*, ed. Martin Jay (Berkeley: University of California Press, 1993), 381–434.

9. He extrapolated from observations of Paris that urbanization worked to isolate individuals and destroy authentic social bonds. Postmodern theories of the city have placed this idea historically: David Harvey, *Paris, Capital of Modernity* (New York: Routledge, 2003); M. Christine Boyer, *The City of Collective Memory: Its Historical Imagery and Architectural Entertainments* (Cambridge, MA: MIT Press, 1994).

10. Rosemary Wakeman, *The Heroic City: Paris, 1945–1958* (Chicago: University of Chicago Press, 2009), 347.

11. T. J. Clark, *The Painting of Modern Life: Paris in the Art of Manet and His Followers*, Rev. ed (Princeton: Princeton University Press, 1999); Vanessa R. Schwartz, *Spectacular Realities: Early Mass Culture in Fin-de-Siècle Paris* (Berkeley: University of California Press, 1998); Naomi Schor, "'Cartes Postales': Representing Paris 1900," *Critical Inquiry* 18, no. 2 (Winter 1992): 188–244; Anne Friedberg, *Window Shopping: Cinema and the Postmodern* (Berkeley: University of California Press, 1993); Boyer, *The City of Collective Memory*.

12. Shelley Rice, *Parisian Views* (Cambridge, MA: MIT Press, 1997), 45.

13. Schwartz and Friedberg define *flânerie* as a viewing position. Scholars have also studied the *flâneur* as an actual figure, debating his or her class and gender identities: Keith Tester, ed., *The Flâneur* (London: Routledge, 1994); Aruna D'Souza and Tom McDonough, eds., *The Invisible Flâneuse? Gender, Public Space, and Visual Culture in Nineteenth-Century Paris* (Manchester: Manchester University Press, 2006). For more about the history of seeing, the following are useful: Donald Lowe, *History of Bourgeois Perception* (Chicago: University of Chicago Press, 1982); Jonathan Crary, *Techniques of the Observer: On Vision and Modernity in the Nineteenth Century* (Cambridge, MA: MIT Press, 1990).

14. This field was pioneered in France in the late 1970s and early 1980s at the Ecole des hautes études en sciences sociales by the historian Pierre Nora, who directed a collaborative project on French "sites of memory": Pierre Nora, ed., *Les lieux de mémoire*, 7 vols. (Paris: Gallimard, 1984–1992).

15. Nora writes, "Memory is rooted in the concrete: in space, gesture, image, object." Pierre Nora, "General Introduction: Between Memory and History," in *Realms of Memory: The Construction of the French Past*, ed. Pierre Nora, trans. Arthur Goldhammer, vol. 1, *Conflicts and Divisions* (New York: Columbia University Press, 1996), 3.

16. Examples of this occur in the literature about French "memory" of World War II. For an example of the "image" employed as a metaphor or shorthand for representations, see the essays in H. R. Kedward and Nancy Wood, eds., *The Liberation of France: Image and Event* (Oxford: Berg, 1995).

17. In *The Vichy Syndrome*, Henry Rousso credits the image's importance in the formation of collective memory but only analyzes the characters and plot of *The Sorrow and the Pity* (Marcel Ophüls, 1969) and *Night and Fog* (Alain Resnais, 1955).

Henry Rousso, *The Vichy Syndrome: History and Memory in France since 1944*, trans. Arthur Goldhammer (Cambridge, MA: Harvard University Press, 1991).

18. For more on the limits of memory as an analytic category, see Jay Winter, *Remembering War: The Great War between Memory and History in the Twentieth Century* (New Haven: Yale University Press, 2006).

19. Susan Sontag, "Looking at War," *New Yorker*, December 9, 2002, 87. For more about memory and images, see Scott McQuire, *Visions of Modernity: Representation, Memory, Time and Space in the Age of the Camera* (London: SAGE, 1998); Olga Shevchenko, ed., *Double Exposure: Memory and Photography* (New Brunswick: Transaction Publishers, 2014).

20. Theoretical writing about photography often dwells on this duality of the photograph, which can contain both what Roland Barthes defines as a *studium* (the historical details that one might study) and, every so often, a *punctum* (the intangible element that touches the soul of the viewer—but is different for everyone). Roland Barthes, *Camera Lucida: Reflections on Photography*, trans. Richard Howard (New York: Hill and Wang/Noonday Press, 1981), 26–27.

21. Eduardo Cadava explores photography's constitutive role in ideas about technology, memory, history, mimesis, allegory, and representation that span Benjamin's intellectual work: Eduardo Cadava, *Words of Light: Theses on the Photography of History* (Princeton: Princeton University Press, 1997).

22. Similar arguments have been made about film and history, see Rosenstone et al., "AHR Forum: History in Images/History in Words," *American Historical Review* 93, no. 5 (December 1988): 1173–1227; Marc Ferro, *Cinema and History*, trans. Naomi Greene (Detroit: Wayne State University Press, 1988); Vanessa R. Schwartz, "Film and History," in *The Sage Handbook of Film Studies*, eds. James Donald and Michael Renov (Los Angeles: SAGE, 2008), 199–215; Robert Burgoyne, *Film Nation: Hollywood Looks at U.S. History* (Minneapolis: University of Minnesota Press, 1997); Robert A. Rosenstone, *History on Film/Film on History* (Harlow: Longman/Pearson, 2006).

23. The French were not alone in theorizing photography's relationship to history. For an important consideration of how such ideas developed internationally and particularly in the context of the United States, see François Brunet, *La photographie: Histoire et contre-histoire* (Paris: Presses universitaires de France, 2017).

24. Margaret Cohen has written about how the places that André Breton's narrator visits in *Nadja* call on this imagination to evoke Paris's revolutionary past: Margaret Cohen, *Profane Illumination: Walter Benjamin and the Paris of Surrealist Revolution* (Berkeley: University of California Press, 1993).

25. Catherine E. Clark, "Capturing the Moment, Picturing History: Photographs of the Liberation of Paris," *American Historical Review* 121, no. 3 (June 2016): 824–860.

26. They were President of the Municipal Council Etienne de Vericourt, Police Prefect Maurice Grimaud, and Paris Prefect Marcel Diebolt. Michael Marrinan has written about the politics of picturing romantic Paris in the nineteenth century: Michael

Marrinan, *Romantic Paris: Histories of a Cultural Landscape, 1800–1850* (Stanford: Stanford University Press, 2009).

27. This is no coincidence. In his essay on Paris street photography, Julian Stallabrass writes, "The temporal frame of photography has often inclined towards melancholia, and in photography of Paris towards elegy." Julian Stallabrass, *Paris Pictured* (London: Royal Academy of Arts, 2002), n.p.

28. For more about Paris's status as "capital of the world," see Patrice L. R. Higonnet, *Paris: Capital of the World* (Cambridge, MA: Belknap Press of Harvard University Press, 2002); Harvey, *Paris, Capital of Modernity*.

29. Paris's twentieth-century decline coincided with the nation's. France's empire crumbled, and English became the twentieth century's lingua franca. Even as France experienced great economic prosperity in the period from 1948 to 1978 (dubbed "les trente glorieuses"), its global status was ebbing. French historians and journalists (largely on the political right) have been writing about this "decline" since the 1990s. For more, see Nicolas Baverez, *Les trente piteuses* (Paris: Flammarion, 1997); Nicolas Baverez, *La France qui tombe* (Paris: Perrin, 2003); Christian Saint-Etienne, *France, état d'urgence: Une stratégie pour demain* (Paris: Odile Jacob, 2013); Eric Zemmour, *Le suicide français* (Paris: Albin Michel, 2014). For analysis of this debate, see Perry Anderson, "Dégringolade," *London Review of Books*, September 2, 2004, 3–9; Walter Laqueur, *After the Fall: The End of the European Dream and the Decline of a Continent* (New York: Thomas Dunne, 2012).

30. Charles Rearick, *Paris Dreams, Paris Memories: The City and Its Mystique* (Stanford: Stanford University Press, 2011).

31. Such efforts include both broad studies and more specific investigations of gentrification and the idea of the "ville-musée": Ibid.; Anne Clerval, *Paris sans le peuple: La gentrification de la capitale* (Paris: La découverte, 2013); Boyer, *The City of Collective Memory*. The "museum city" has also become a commonplace in the press.

32. The social history of photographs is part of the history of Paris, in the same way that scholars have treated the history of other types of cultural production as urban history. For more about the history of Paris's cultural industries (including photography), see Hilary Ballon, *The Paris of Henri IV: Architecture and Urbanism* (Cambridge, MA: MIT Press, 1991); Marrinan, *Romantic Paris*; Clark, *The Painting of Modern Life*; Valerie Steele, *Paris Fashion: A Cultural History*, 2nd ed., rev. and updated (Oxford: Berg, 1998); Elizabeth Anne McCauley, *A.A.E. Disdéri and the Carte de Visite Portrait Photograph* (New Haven: Yale University Press, 1985); Marie de Thézy and Claude Nori, *La photographie humaniste: 1930–1960, histoire d'un mouvement en France* (Paris: Contrejour, 1992); Thomas Michael Gunther and Marie de Thézy, *Alliance Photo: Agence photographique 1934–1940* (Paris: Bibliothèque historique de la Ville de Paris, 1989); Elizabeth Anne McCauley, *Industrial Madness: Commercial Photography in Paris, 1848–1871* (New Haven: Yale University Press, 1994); Françoise Denoyelle, *La lumière de Paris*, 2 vols. (Paris: L'Harmattan, 1997); Françoise

Denoyelle, *La photographie d'actualité et de propagande sous le régime de Vichy* (Paris: CNRS éditions, 2003).

33. John Mraz describes these first two levels of meaning: John Mraz, *Photographing the Mexican Revolution: Commitments, Testimonies, Icons* (Austin: University of Texas Press, 2012), 8. For an in-depth discussion of my reinterpretation of Mraz, see Clark, "Capturing the Moment, Picturing History," 826–827.

34. For a good example of how the content of photos might be read alongside the context of their production, see Laura Wexler, *Tender Violence: Domestic Visions in an Age of U.S. Imperialism* (Chapel Hill: University of North Carolina Press, 2000).

35. A growing body of scholarship investigates the question of "what photographs do": W. J. T. Mitchell, *What Do Pictures Want? The Lives and Loves of Images* (Chicago: University of Chicago Press, 2005); Margaret Olin, *Touching Photographs* (Chicago: University of Chicago Press, 2012); Elspeth H. Brown and Thy Phu, eds., *Feeling Photography* (Durham: Duke University Press, 2014).

36. Clark, "Capturing the Moment, Picturing History," 826–827.

37. For more, see Hayden V. White, *Metahistory: The Historical Imagination in Nineteenth-Century Europe* (Baltimore: Johns Hopkins University Press, 1973); Anthony Grafton, *The Footnote: A Curious History* (Cambridge, MA: Harvard University Press, 1997); Daniel Rosenberg and Anthony Grafton, *Cartographies of Time: A History of the Timeline* (Princeton: Princeton Architectural Press, 2010). A similar attention to the conventions of the "accessories" of knowledge production drives Edward Tufte's work: Edward R. Tufte, *The Visual Display of Quantitative Information* (Cheshire: Graphics Press, 1983).

38. For studies of archives not just as sources but also as subjects, see Carolyn Steedman, *Dust: The Archive and Cultural History* (New Brunswick: Rutgers University Press, 2002); Antoinette M. Burton, ed., *Archive Stories: Facts, Fictions, and the Writing of History* (Durham: Duke University Press, 2005); Ann Laura Stoler, *Along the Archival Grain: Epistemic Anxieties and Colonial Common Sense* (Princeton: Princeton University Press, 2009); Astrid M. Eckert, *The Struggle for the Files: The Western Allies and the Return of German Archives after the Second World War*, trans. Dona Geyer (New York: Cambridge University Press, 2012); Arlette Farge, *The Allure of the Archives*, trans. Thomas Scott-Railton (New Haven: Yale University Press, 2013).

39. For more about the particularity of reading visual archives, see Elizabeth Edwards, *Raw Histories: Photographs, Anthropology and Museums* (Oxford: Berg, 2001); Costanza Caraffa, ed., *Photo Archives and the Photographic Memory of Art History* (Berlin: Deutscher Kunstverlag, 2011); Juliette Kristensen and Marquard Smith, eds., "The Archives Issue," special issue, *Journal of Visual Culture* 12, no. 3 (December 2013).

40. Because of the history of photography's place within art historical traditions, scholars have often privileged collections of photographic prints over the

ubiquitous photographs circulating in mass cultural forms. Prints are also usually easier to study.

41. The perception of the pace of historical change has its own history: Peter Fritzsche, *Stranded in the Present: Modern Time and the Melancholy of History* (Cambridge, MA: Harvard University Press, 2004).

42. The idea of the cliché shares with the term "icon" the idea of reproducibility but lacks the latter's power: Philip J. Ethington and Vanessa R. Schwartz, eds., "Urban Icons," special issue, *Urban History* 33, no. 1 (2006).

43. The term appears to have been used in French (1866) before English (1881): *Lexis: Dictionnaire de la langue française*, s.v. "cliché"; *OED Online*, s.v. "cliché," accessed November 14, 2016, http://www.oed.com/view/Entry/34264.

44. *OED Online*, s.v. "cliché"; *Dictionnaire de l'Académie française*, 9th ed., s.v. "cliché."

45. *Lexis*, s.v. "cliché."

46. The word "stereotype" has a similar history: it was first used to describe a metal plate cast from moveable type before denoting a fixed idea or impression. *OED Online*, s.v. "stereotype," accessed November 14, 2016, http://www.oed.com/view/Entry/34264.

47. Lynn Berger productively engages the multi-layered meaning of "cliché" and its journey from French into English to discuss amateur snapshots: Lynn Berger, "Snapshots, or: Visual Culture's Clichés," *Photographies* 4, no. 2 (2011): 175–190.

48. Art historical studies have traditionally privileged a single medium. This approach often considers photographs as original prints, rather than images that circulate in different media. This study borrows its broad medial lens from visual studies as well as from histories of the coexistence of, and dialogue between, new and old media. For examples of such approaches, see Stephen Bann, *Parallel Lines: Printmakers, Painters and Photographers in Nineteenth-Century France* (New Haven: Yale University Press, 2001); Marrinan, *Romantic Paris*; Thierry Gervais, "'Le plus grand des photographes de guerre': Jimmy Hare, photoreporter au tournant du XIXe et du XXe siècle," *Etudes photographiques*, no. 26 (November 2010): 10–49; Tom Gretton, "'Un Moyen Puissant de Vulgarisation Artistique': Reproducing Salon Pictures in Parisian Illustrated Weekly Magazines c.1860–c.1895: From Wood Engraving to the Half Tone Screen (and Back)," *Oxford Art Journal* 39, no. 2 (August 2016): 285–310. For more about the simultaneous use of new and old technologies, see David Thorburn and Henry Jenkins, eds., *Rethinking Media Change: The Aesthetics of Transition* (Cambridge, MA: MIT Press, 2003).

49. W. J. T. Mitchell, "Showing Seeing: A Critique of Visual Culture," *Journal of Visual Culture* 1, no. 2 (August 2002): 174.

50. Hayden White, "Historiography and Historiophoty," *American Historical Review* 93, no. 5 (December 1988): 1194.

51. Ibid., 1193.

52. John Mraz dislikes White's neologism. He has called it "unnecessarily complicated." He proposes "photohistory" instead; I would argue that the latter term lacks the methodological self-consciousness of White's. Mraz, "Picturing Mexico's Past," 41.

53. Histories of the uses of images as historical documents should take into account the uses of images on this much larger scale: Peter Burke, *Eyewitnessing: The Uses of Images as Historical Evidence* (London: Reaktion, 2001); Francis Haskell, *History and Its Images: Art and the Interpretation of the Past* (New Haven: Yale University Press, 1993).

54. Collectors and critics were also interested in the documentary, historical potential of film. In 1909, the banker Albert Kahn launched the Archives de la planète, to document the entire world in photos (mostly autochromes) and on film. At the same time, the Parisian municipal councilor and amateur historian Victor Perrot proposed an archive of the French capital on film. One could certainly reproduce my study with a focus on film and might come to many of the same conclusions. However, the efforts to archive and use film to historical ends never reached the scope and broad popular participation in this period as those focused on photography. For more about these two projects and Paris historical films, see Amad, *Counter-Archive*; Béatrice de Pastre, "Une archive dédiée à la pédagogie du cinéma," *1895: Bulletin de l'Association française de recherche sur l'histoire du cinéma*, no. 41 (2003): 177–186.

55. For more about the practice of rephotography, see Mark Klett ed., *Third Views, Second Sights: A Rephotographic Survey of the American West* (Santa Fe: Museum of New Mexico Press, 2004); Peter Sramek, *Piercing Time: Paris after Marville and Atget 1865–2012* (Bristol: Intellect, 2013). The term emerged from the 1977–1982 Rephotographic Survey Project that photographed—trying to replicate exact viewpoints and lighting conditions—the scenes of nineteenth-century photos of the American West. Photographer Mark Klett credits geologists' practice of "repeat photography" as inspiration: "Mark Klett, Rephotography, and the Story of Two San Franciscos: An Interview with Karin Breuer," in Mark Klett, *After the Ruins, 1906 and 2006: Rephotographing the San Francisco Earthquake and Fire* (Berkeley: University of California Press, 2006), 4. However, nongeological rephotography had begun a decade earlier in Paris.

56. The "visual turn" refers to a broad interest across the humanities, which developed in the 1980s and 1990s, in both the social work of pictures and the social construction of vision as objects of study. For more, see James Elkins, *Visual Studies: A Skeptical Introduction* (New York: Routledge, 2003); Nicholas Mirzoeff, *An Introduction to Visual Culture*, 2nd ed. (New York: Routledge, 2009).

CHAPTER I

1. Poëte, *Une vie de cité*, Album, xxi.
2. Ibid.

3. For more, see Ruth Fiori, *L'invention du vieux Paris: Naissance d'une conscience patrimoniale dans la capitale* (Wavre: Mardaga, 2012).

4. Similar groups formed in Berlin at the same time: Katja Zelljadt, "Capturing a City's Past," *Journal of Visual Culture* 9, no. 3 (December 2010): 425–438.

5. Quoted in: Lazare-Maurice Tisserand, *Histoire générale de Paris: Collection de documents fondée avec l'approbation de l'Empereur par M. le Baron Haussmann, sénateur, Préfet de la Seine, et publiée sous les auspices du Conseil municipal* (Paris: Imprimerie impériale, 1866), 17.

6. Tisserand, *Histoire générale de Paris*, 20. Haussmann, of course, often took credit for the ideas of others, and this idea was likely already circulating among those, including Charles Poisson, Charles Read, and Jules Gailhabaud, who subsequently worked on the project.

7. Charles Poisson, *Mémoire sur l'oeuvre historique de la Ville de Paris* (Paris: Imprimerie impériale, 1867), 16.

8. Andrew McClellan, *Inventing the Louvre: Art, Politics, and the Origins of the Modern Museum in Eighteenth-Century Paris* (Cambridge: Cambridge University Press, 1994).

9. For more about previous urban projects, see Ballon, *The Paris of Henri IV*; David P. Jordan, "Paris before Haussmann," in *Transforming Paris: The Life and Labors of Baron Haussmann* (Chicago: University of Chicago Press, 1996), 13–40; Nicholas Papayanis, *Planning Paris before Haussmann* (Baltimore: Johns Hopkins University Press, 2004).

10. For an overview of these physical and social changes, see David H. Pinkney, *Napoleon III and the Rebuilding of Paris* (Princeton: Princeton University Press, 1958); David Jordan, " 'The Implacable Axes of a Straight Line . . .'," in *Transforming Paris*, 185–210.

11. For histories of private financiers in Paris before and after 1871, see Helen M. Davies, *Emile and Isaac Pereire: Bankers, Socialists and Sephardic Jews in Nineteenth-Century France* (Manchester: Manchester University Press, 2015); Alexia Yates, *Selling Paris: Property and Commercial Culture in the Fin-de-Siècle Capital* (Cambridge, MA: Harvard University Press, 2015).

12. The historian Jean-Pierre Bernard has called the *Histoire générale de Paris* "the ideological justification, the moral front" for Haussmannization. Jean-Pierre A. Bernard, *Les deux Paris: Les représentations de Paris dans la seconde moitié du XIXe siècle* (Seyssel: Champ Vallon, 2001), 32. For a similar argument see: Peter Soppelsa, "How Haussmann's Hegemony Haunted the Early Third Republic," in *Is Paris Still the Capital of the Nineteenth Century? Essays on Art and Modernity, 1850–1900*, eds. Hollis Clayson and André Dombrowski (London: Routledge, 2016), 45.

13. Clark, *The Painting of Modern Life*, 54–55.

14. Georges-Eugène Haussmann, "Arrêté," March 16, 1866, VR 1, Archives de Paris.

15. Georges-Eugène Haussmann, "Rapport à l'empereur," in Tisserand, *Histoire générale de Paris*, 11.

16. Ibid., 10.

17. "Atelier des Travaux historiques: Situation au 31 décembre 1870," n.d., VR 1, Archives de Paris.

18. Ernest Lacan, "Note concernant le Service iconographique," 1871, VR 1, Archives de Paris.

19. Colin Jones, "Théodore Vacquer and the Archaeology of Modernity in Haussmann's Paris," *Transactions of the Royal Historical Society* 17 (2007): 157–183.

20. Poisson, *Mémoire sur l'oeuvre historique de la Ville de Paris*, 17. Haussmann had decided that "aside from written documents, we should collect material and tangible documents, in order to constitute in this way a *persuasive* history." Emphasis is in the original. There is a long history of using images as pedagogical tools for both the literate and illiterate: David Freedberg, *The Power of Images: Studies in the History and Theory of Response* (Chicago: University of Chicago Press, 1989); Barbara Maria Stafford, *Artful Science: Enlightenment Entertainment and the Eclipse of Visual Education* (Cambridge, MA: MIT Press, 1996).

21. Poisson, *Mémoire sur l'oeuvre historique de la Ville de Paris*, 18.

22. Ibid., 25–26.

23. Jean-Pierre Babelon, "Les relevés d'architecture du quartier des Halles avant les destructions de 1852–1854: Une source inédite sur l'iconographie parisienne entre le Louvre et l'Hôtel de Ville," *Gazette des beaux-arts* 2 (1967): 3. For more about Davioud's work see *Gabriel Davioud: Architecte (1824–1881): Mairies annexes des XVIe et XIXe arrondissements 1981–1982* (Paris: Délégation à l'action artistique, 1981).

24. Babelon, "Les relevés d'architecture du quartier des Halles avant les destructions de 1852–1854," 4–5.

25. Maria Deurbergue, "Féodor Hoffbauer (1839–1922), metteur en scène du Paris ancien," *Bulletin de la Société d'histoire de Paris et de l'Ile de France* (2012): 153. Deurbergue cites a manuscript held at the Bibliothèque historique that I have not been able to locate.

26. Jules Ferry, *Comptes fantastiques d'Haussmann* (Paris: Le chevalier, 1868).

27. Charles Read wrote to Charles Poisson, "All of our historical riches have gone down, as at sea, with our archives and our secular *état civil*, with our library and our collections of materials of all kinds!" Cited in: Camille Enlart, "Notice nécrologique sur Charles Read, Membre résidant de la Société national des antiquaires de France (1819–1898)," *Bulletin de la Société nationale des antiquaires de France* (1903): 73.

28. Ibid., 73–74.

29. Poisson, *Mémoire sur l'oeuvre historique de la Ville de Paris*, 28.

30. Charles Poisson, *Les donateurs du Musée historique de la Ville de Paris* (Paris: Imprimerie impériale, 1868), 17.

31. Peggy Rodriguez, "Jules Gailhabaud," *Dictionnaire critique des historiens de l'art* (Paris: Institut national de l'histoire de l'art, 2008), accessed October 4, 2016, http://www.inha.fr/fr/ressources/publications/publications-numeriques/dictionnaire-critique-des-historiens-de-l-art/gailhabaud-jules.html.

32. "Mise en vente d'objets ne devant pas faire partie des collections historiques de la Ville de Paris," September 3, 1874, 1AH 1, Musée Carnavalet.

33. Jules Cousin, "Biographie d'un musée et d'un homme," *La plume*, January 15, 1892, 32.

34. *Objets d'art et de curiosité éliminés du Musée municipal* (Paris: Imprimerie Pillet fils ainé, 1874), 11, 1AH 1, Musée Carnavalet.

35. The same objects "find themselves represented in more than one municipal museum of a major city, attesting to the value of the labor of the guilds." Paul Marmottan, *Le Musée Carnavalet [extrait du* Journal des beaux-arts, *mai 1886]* (Louvain: Typographie de Charles Peeters, 1886), 6. The Musée Alsacien in Strasbourg, which opened in 1907, still displays similar collections. It is the closest approximation to what the Carnavalet's rooms might have looked like if the original program had been maintained.

36. "Préfecture de la Seine: Travaux historiques et musée municipal, constitution du Service," June 18, 1871, VR 1, Archives de Paris.

37. Charles Pillet, "Vente à la requite de Monsieur F. Duval, Préfet de la Seine les 11, 12, 13, 14, 18, 19, et 20 janvier 1875," May 10, 1875, 1AH 1, Musée Carnavalet.

38. L'inspecteur des Beaux-arts de la ville de Paris, "Note: Relative à la demande adressée au Conseil municipal par Mme Veuve Claudel," November 29, 1906, VR 234, Archives de Paris.

39. Jules Gailhabaud, "A Monsieur Henri Chevreau, Sénateur et Préfet du départment de la Seine," March 6, 1870, 1AH 26, Musée Carnavalet.

40. For more about nation-centered efforts, see Astrid Swenson, *The Rise of Heritage: Preserving the Past in France, Germany and England, 1789–1914* (Cambridge: Cambridge University Press, 2013).

41. Erika Vause, "Getting Control of Things: The Musée Carnavalet and the Politics of Museal Media," *Chicago Art Journal* 16 (2006): 6.

42. Marrinan, *Romantic Paris*, 133–137. Francis Haskell credits the museum with spawning an interest in the details and otherness of the past: Haskell, *History and Its Images*, 249–250, 252.

43. Marrinan, *Romantic Paris*, 135.

44. Ibid., 137.

45. For more about the Musée Cluny, see Chapter Three of Elizabeth Emery and Laura Morowitz, *Consuming the Past: The Medieval Revival in Fin-de-Siècle France* (Aldershot: Ashgate, 2003), 61–84.

46. Anonymous, "Deux antiquaires," *Le Gaulois*, February 7, 1885, 1.

47. Ibid.

48. Ibid.

49. William R. Keylor, *Academy and Community: The Foundation of the French Historical Profession* (Cambridge, MA: Harvard University Press, 1975).

50. Ibid., 27.

51. Tom Stammers, "Collectors, Catholics, and the Commune: Heritage and Counterrevolution, 1860–1890," *French Historical Studies* 37, no. 1 (December 2014): 60. Stammers tracks this influence in the first decades of the Third Republic, but the work of Gailhabaud, Read, de Liesville, Cousin, and other suggests its earlier presence.

52. Cousin, "Biographie d'un musée et d'un homme," 32. The critic Paul Marmottan later praised the separation for protecting the library from future revolutions. Marmottan, *Le Musée Carnavalet*, 8.

53. Cousin, "Biographie d'un musée et d'un homme," 32

54. De Liesville was just one of a number of enthusiastic collectors, those "lone individuals" who, "when successive regimes shunned the painful reminders of the guillotine and civil war, [. . .] stored and sheltered the strange alluvium of the First Republic" as well as subsequent revolutions. Tom Stammers, "The Bric-a-Brac of the Old Regime: Collecting and Cultural History in Post-Revolutionary France," *French History* 22, no. 3 (2008): 297.

55. Faucou took over from Cousin in 1893 but died a few months later, forcing Cousin to come back from retirement. Quentin-Bauchart, conseiller municipal, "Rapport au nom de la 4e Commission, sur la réorganisation du service des Beaux-arts et des musées de la Ville de Paris," *Conseil municipal de Paris: Rapports et documents, année 1903*, no. 40 (Paris: Imprimerie municipale, 1904), 15.

56. Nineteenth-century curators commonly organized artifacts into pleasing ensembles: Alison Griffiths, *Wondrous Difference: Cinema, Anthropology, and Turn-of-the-Century Visual Culture* (New York: Columbia University Press, 2002).

57. More period rooms would follow, including Georges Fouquet's art nouveau jewelry shop designed by Alphonse Mucha, another turn-of-the-century room from the Café de Paris, 1925 murals from the ballroom at the Hôtel de Wendel, and the bedrooms of writers Marcel Proust, Anna de Noailles, and Paul Léautaud.

58. "Nouvelles diverses: Le musée de la Révolution," *Le Gaulois*, May 9, 1881, 3.

59. For more about the popularity of these entertainments and the modes of viewing they engendered, see Crary, *Techniques of the Observer*; Friedberg, *Window Shopping*; Schwartz, *Spectacular Realities*; and Stephen Pinson, *Speculating Daguerre: Art and Enterprise in the Work of L. J. M. Daguerre* (Chicago: University of Chicago Press, 2012).

60. For more about boulevard culture, see Schwartz, *Spectacular Realities*; Friedberg, *Window Shopping*; Gregory Shaya, "The Flâneur, the Badaud, and the Making of a Mass Public in France, circa 1860–1910," *American Historical Review* 109, no. 1 (2004): 41–77; and McCauley, *Industrial Madness*.

61. Marmottan, "Le Musée Carnavalet," 4.

62. Frederic Harrison, "The Municipal Museums of Paris," *The Fortnightly* 56 (September 1894): 464.

63. Marmottan, "Le Musée Carnavalet," 17.

64. Poisson, *Mémoire sur l'oeuvre historique de la Ville de Paris*, 25.

65. Harrison, "The Municipal Museums of Paris," 458.
66. Harrison suggested that London not implement "the wholesale demolition of old streets, the monotony of sundry new streets, the passion for a geometric plan, and the habit of renaming public places every few years, if possible so as to convey an insult to Conservatives and priests." Ibid.
67. Charles-Victor Langlois and Charles Seignobos, *Introduction aux études historiques* (Paris: Librairie Hachette, 1898), 44.
68. Ibid., 185–186. Emphasis is in the original.
69. Ibid., 45–47.
70. Marmottan, "Le Musée Carnavalet," 15.
71. Harrison, "The Municipal Museums of Paris," 465.
72. Poisson, *Mémoire sur l'oeuvre historique de la Ville de Paris*, 26.
73. "Commission des Beaux-arts: 54e séance, mardi 2 juillet 1861, procès verbal," July 2, 1861, VR 1, Archives de Paris.
74. "Commission des Beaux-arts: 78e séance, 10 juin 1864, Procés-verbal," June 10, 1864, VR 1, Archives de Paris.
75. Ibid.
76. "Commission des beaux-arts: 58e séance, jeudi 20 février 1862, procès-verbal," February 20, 1862, VR 1, Archives de Paris.
77. "Sous-commission des Travaux historiques: Séance du 31 janvier 1877, procès-verbal," January 31, 1877, VR 1, Archives de Paris.
78. According to Liza Daum, former director of the Bibliothèque historique's photo collection, photographers billed the library for 566 photos between 1885 and December 1889. Daum pulled her statistics from the library's *registres d'entrée* and kindly shared them with me. Many photos, however, likely entered the collections without documentation.
79. Paul Lacombe described bringing Cousin a photographic reproduction of a painting to include in the topography file: Paul Lacombe, *Jules Cousin 1830–1899: Souvenirs d'un ami par Paul Lacombe, Parisien* (Paris: Librairie Henri Leclerc, 1900), 20–21. "Photo study" collections gave scholars a broader range of sources, but their organization also limits the types of questions scholars could ask of them: Nina Lager Vestberg, "Ordering, Searching, Finding," *Journal of Visual Culture* 12, no. 3 (December 2013): 472–489.
80. Charles Sellier and Prosper Dorbec, *Guide explicatif du Musée Carnavalet . . .* (Paris: Librairie centrale des beaux-arts, 1903).
81. Forty years earlier, Charles Baudelaire, for instance, had explained that photography's true use was as "the servant of the arts and sciences." Charles Baudelaire, "The Salon of 1859," in *Photography in Print: Writings from 1816 to the Present*, ed. Vicki Goldberg, trans. Jonathan Mayne (Albuquerque: University of New Mexico Press, 1988), 125.
82. *Galignani's Illustrated Paris Guide for 1889* (Paris: The Galignani Library, 1889), 141.

83. *Paris et ses environs* (Leipzig: Karl Baedeker, 1903), 188.

84. Ethel E. Bicknell, *Paris and Her Treasures* (New York: Charles Scribner's Sons, 1912), 68.

85. Arsène Alexandre, "Carnavalet: Un critique d'art à Carnavalet," *Les annales "conferencia,"* October 1907, 464–466.

86. Jules Claretie, *La vie à Paris: 1898* (Paris: G. Charpentier et E. Fasquelle, 1899), 344.

87. Alexandre, "Carnavalet," 464.

88. Ibid.

89. Ibid.

90. " 'Today our museum has its clear place among those that are cited and taken as models.' " Cited in: Quentin-Bauchart, conseiller municipal, "Rapport sur la réorganisation du service des Beaux-arts et des musées de la Ville de Paris," 16.

91. Bicknell, *Paris and Her Treasures*, 68.

92. For more about Robida, see Philippe Brun, *Albert Robida (1848–1926): Sa vie, son oeuvre* (Paris: Promodis, 1984); Elizabeth Emery, "Protecting the Past: Albert Robida and the *Vieux Paris* exhibit at the 1900 World's Fair," *Journal of European Studies* 35, no. 1 (2005): 65–85; Daniel Compère, ed., *Albert Robida du passé au futur: Un auteur-illustrateur sous la IIIe République* (Amiens: Encrage, 2006).

93. Claretie, *La vie à Paris: 1898*, 181.

94. Georges Cain, *Coins de Paris* (Paris: E. Flammarion, 1910), 71.

95. Gaston Deschamps, "Georges Cain," *Le Temps*, March 6, 1919, 3.

96. Ibid. The de Goncourt brothers' admiration for the eighteenth century influenced the development of art nouveau in France: Debora Silverman, *Art Nouveau in Fin-de-Siècle France: Politics, Psychology, and Style* (Berkeley: University of California Press, 1989).

97. *Objets d'art et d'ameublement, tableaux, dessins anciens et modernes, gravures anciennes provenant de la collection de feu M. Georges Cain ancien conservateur du Musée Carnavalet: Première vente à Paris, Hôtel Drouot, les 9 et 10 mars 1939*, 1939; *Objets d'art et d'ameublement, objets de curiosité, objets d'art d'Extrême-Orient, provenant de la collection de feu M. Georges Cain ancien conservateur du Musée Carnavalet: Deuxième vente à Paris, Hôtel Drouot, du 18 au 20 mars 1939*, 1939.

98. There is no *catalogue raisonné* of Cain's work. Because his paintings were bought during his lifetime by individuals rather than the state, very few are on public display today. I've reconstructed his oeuvre here from works filed under the *dépôt légal* at the Bibliothèque nationale and documentation (including auction catalogs) held at the Musée d'Orsay.

99. "Georges Cain," in *Figures contemporaines tirées de l'Album Mariani*, vol. 2 (Paris: Librairie Henri Floury, 1896), n.p., Georges Cain, Dossiers biographiques Boutillier du Retail, Bibliothèque nationale de France.

100. For more about the troubadour style, see Beth S. Wright, *Painting and History during the French Restoration: Abandoned by the Past* (Cambridge: Cambridge University Press, 1997).

101. Silverman describes them as "resentful and bitter children of the nineteenth century." Silverman, *Art Nouveau in Fin-de-Siècle France*, 17.

102. "Georges Cain: Le buste de Marat aux piliers des Halles, Salon de 1880," *L'art contemporain*, n.d., n.p., SNR-3 Georges CAIN, Cabinet des estampes, Bibliothèque nationale de France.

103. "Georges Cain: Le bulletin de victoire," *Le panorama: Salon exposition de peinture des Champs-Elysées et du Champ de Mars 1895* (Paris: Ed. Baschet, n.d.), Dossier Georges Cain, Centre de documentation, Musée d'Orsay.

104. Like Cain, Hoffbauer has not been the focus of scholarly attention since his death in 1922. He does figure in dictionaries of nineteenth-century art: Gérald Schurr, *Les petits maîtres de la peinture*, vol. 7: *1820–1920* (Paris: Les éditions de l'amateur, 1989), 112.

105. Félix Narjoux and Eugène-Emmanuel Viollet-le-Duc, *Habitations modernes*, 2 vols. (Paris: Vve A. Morel, 1874–1875).

106. "Discours prononcés par M. Le Corbeiller, Vice-Président de la Commission et par M. le docteur Capitan, aux obsèques de M. J.-H. Hoffbauer," *Commission municipale du Vieux Paris: Procès-verbaux*, December 16, 1922, 130.

107. Fedor Hoffbauer, *Paris à travers les âges: Aspects successifs des monuments et quartiers historiques de Paris depuis le XIIIe siècle jusqu'à nos jours . . .*, 2 vols. (Paris: Firmin-Didot, 1875–1882).

108. Fedor Hoffbauer, *Livret explicatif du diorama de Paris à travers les âges, promenades historiques et archéologiques dans les différents quartiers de l'ancien Paris* (Mesnil: Imprimerie de Firmin-Didot, 1885).

109. Henri Thédenat and Fedor Hoffbauer, *Rome à travers les âges: Le forum romain et la voie sacrée, aspects successifs des monuments depuis le IVe siècle jusqu'à nos jours* (Paris: Plon-Nourrit, 1905).

110. Jules Cousin, "Préface," in *Paris à travers les âges*, vol. 1, ii.

111. Ibid.

112. Ibid., i–ii.

113. Cousin lamented the aesthetics of modern Paris but admitted that the new city was more pleasant to live in: Ibid., ii.

114. "Paris à travers les âges," *Le voleur illustré: Cabinet de lecture universel*, December 9, 1881, 776.

115. Ibid.

116. Victor Fournel, "Les oeuvres et les hommes: Courrier du théâtre, de la littérature et des arts," *Le Correspondant*, June 10, 1885, 928.

117. Ibid.

118. Ibid.

119. "Compte-rendu des séances: Assemblée générale tenue à la Bibliothèque nationale le 12 mai 1885," *Bulletin de la Société de l'histoire de Paris et de l'Ile-de-France: 12e année, 1885* (Paris: H. Champion, 1885), 69–70.

120. "Le 21 janvier," *Le voleur illustré: Cabinet de lecture universel*, January 28, 1886, 58.

121. Jules Roche, "Rapport . . . sur une demande de souscription présentée en faveur de l'ouvrage 'Paris à travers les âges,'" *Conseil municipal de Paris: Rapports,* no. 200, 1880, 3.

122. In 1903, Hoffbauer's painting of Paris in circa 1588 was on display in a "topographic room." Sellier and Dorbec, *Guide explicatif du Musée Carnavalet,* 76.

123. "Paris au Salon de 1899," *Bulletin de la Société de l'histoire de Paris et de l'Ile-de-France: 26e année* (Paris: H. Champion, 1899), 130.

124. Ibid.

125. Charles Sellier, "Note," January 10, 1906, VR 234, Archives de Paris.

126. Ibid.

127. "Compte rendu de la visite des toiles du diorama de J.-H. Hoffbauer 'Paris à travers les âges,' déposées à l'entrepôt Saint-Bernard—Décisions prises," *Commission municipale du Vieux Paris: Procès-verbaux,* January 26, 1924, 2.

128. For a detailed discussion of Poëte and his career, see Donatella Calabi, *Marcel Poëte et le Paris des années vingt: Aux origines de "l'histoire des villes"* (Paris: L'Harmattan, 1997).

129. For more about the school, see Yves-Marie Bercé, Olivier Guyotjeannin, and Marc Smith, eds., *L'école nationale des chartes: Histoire de l'école depuis 1821* (Thionville: Gérard Klopp, 1997); Lara Jennifer Moore, *Restoring Order: The Ecole des Chartes and the Organization of Archives and Libraries in France, 1820–1870* (Duluth: Litwin Books, 2008).

130. Marcel Poëte, "Le service de la Bibliothèque et des Travaux historiques de la ville de Paris: Rapport," in *Bulletin de la Bibliothèque et des Travaux historiques,* ed. Marcel Poëte, vol. 1 (Paris: Imprimerie nationale, 1906), xxi.

131. "Chronique: La deuxième exposition annuelle de la Bibliothèque et des Travaux historiques," in *Bulletin de la Bibliothèque et des Travaux historiques,* ed. Marcel Poëte, vol. 4 (Paris: Imprimerie nationale, 1909), xxviii.

132. "[Visitors]," 3574W 102, Archives de Paris. Reports in the library's bulletins offer significantly higher numbers. For example, the 1909 bulletin claimed that approximately 12,000 people had visited "Paris au temps des romantiques." Group visits, which may have been counted separately, or simple number fudging, may account for the disparity. "Chronique," xxix.

133. "Le vieux Paris en images," *La Liberté,* June 19, 1908, "Exposition: Paris au temps des romantiques," Actualités, BHVP; "Les images de Paris au temps des romantiques," *L'Action française,* June 25, 1908, "Exposition: Paris au temps des romantiques," Actualités, BHVP.

134. C. I. B., "Romantic Paris," *New-York Tribune,* August 16, 1908.

135. Arsène Alexandre, "L'hier et le demain de Paris," *Comoedia*, September 10, 1910. "Exposition: Les transformations de Paris sous le Second empire" Actualités, BHVP.

136. Marcel Poëte, *Les sources de l'histoire de Paris et les historiens de Paris: Leçon de réouverture du cours d'Introduction à l'histoire de Paris professé à la Bibliothèque de la Ville* (Paris: Editions de la Revue politique et littéraire [Revue bleue] et de la Revue scientifique, 1905), 5.

137. Ibid., 6.

138. Ibid., 9.

139. Ibid., 11.

140. Ibid., 13.

141. Etienne Charles, "Paris à Saint-Fargeau," *La Liberté*, June 4, 1907, "Exposition relative à la vie populaire à Paris," Actualités, BHVP.

142. "Statuts de la Société d'iconographie parisienne," *Société d'iconographie parisienne*, 1908, v.

143. "Procès-verbaux de séances: Séance du 30 mars 1908," *Société d'iconographie parisienne*, 1908, viii–ix.

144. "Société d'iconographie parisienne: Paris [séance du] 15 décembre 1929," n.d., Ms. 347, 4, Papiers Paul Jarry, Société d'iconographie parisienne, BHVP.

145. Albert Vuaflart, "Les peintres de l'inondation," *Société d'iconographie parisienne*, 1911, 81–82.

146. The Manhattan real estate developer I. N. Phelps Stokes also shunned photography. The six volumes of his *Iconography of Manhattan Island* (1928) contain only a handful of photographs. Max Page explains that for Stokes, photography "corrupted memory more than it preserved it." Max Page, *The Creative Destruction of Manhattan, 1900–1940* (Chicago: University of Chicago Press, 1999), 235–236.

147. Marcel Poëte, "L'image de Paris au temps des Romantiques (communication à la Société d'iconographie)," n.d., Ms. 144, 347, Papiers Marcel Poëte, BHVP.

148. Marcel Poëte, "L'image de Paris au temps des Romantiques (conférence à l'exposition de 1908)," n.d., Ms. 144, 368, Papiers Marcel Poëte.

149. Ibid.

150. Georges Cain, November 4, 1907, 3574W 73, Archives de Paris.

151. Marcel Poëte, *Une vie de cité: Paris de sa naissance à nos jours*, vol. 1, *La jeunesse: Des origines aux temps modernes* (Paris: A. Picard, 1924), v.

152. Molly Nesbit has charged Poëte with ignoring aspects of everyday life in Atget's photographs and rejecting any artistic interpretation of them, seeking only precise, clear details that would allow for what she terms "nonvisual" analysis of artifacts from the past: Molly Nesbit, *Atget's Seven Albums* (New Haven: Yale University Press, 1992), 68–71. But Poëte's efforts to collect photos of current events suggest a more expansive notion of the photographic document's utility.

153. The historian Jeffrey Jackson has exploited these collections: Jeffrey H. Jackson, *Paris under Water: How the City of Light Survived the Great Flood of 1910* (New York: Palgrave Macmillan, 2010); Jeffrey H. Jackson, "Envisioning Disaster in the 1910 Paris Flood," *Journal of Urban History* 37, no. 2 (March 2011): 176–207.

154. Henri Lavergne, "L'histoire de demain," *L'Aurore*, August 4, 1910, 1.

155. Ibid.

156. Marcel Poëte, "[Letter to Victor Perrot]," February 14, 1912, VP 048, Fonds Victor Perrot, Bibliothèque du film, Cinémathèque française, Paris.

157. Neither the film studios nor the Bibliothèque nationale, the great bastion of the *dépôt légal*, developed in order to preserve copies of all materials published in France, kept copies of French films.

158. "Rapport sur la conservation des films cinématographiques intéressant l'histoire de Paris et du département de la Seine présenté, au nom de la 3e Sous-Commission, par M. Victor Perrot [extrait du *Bulletin municipal officiel*]," *Le courrier cinématographique*, February 8, 1921, 34, VP 044, Fonds Victor Perrot.

159. Ibid.

160. Poëte, "[Letter to Victor Perrot]," February 22, [1912], VP 048, Fonds Victor Perrot. Later, Perrot would clarify that a paper print collection was the only safe way to constitute such an archive: "Rapport sur la conservation des films cinématographiques intéressant l'histoire de Paris et du département de la Seine présenté, au nom de la 3e Sous-Commission, par M. Victor Perrot," in *Le courrier cinématographique,* February 5, 1921, Fonds Victor Perrot.

161. For more about the Cinémathèque de la Ville de Paris, see de Pastre, "Une archive dédiée à la pédagogie du cinéma."

162. The photographs were exhibited at the library for the first time in 2014: André Gunthert, Emmanuelle Toulet, and Charles Lansiaux, *Paris 14–18: La guerre au quotidien* (Paris: Paris bibliothèques, 2014).

163. Lavergne, "L'histoire de demain."

164. Poëte, *Une vie de cité*, Album, xxi.

165. Ibid., xx.

166. For a description of this break in collecting, see Marie de Thézy, "Les photographies anciennes et modernes," in *Bulletin de la Bibliothèque et des Travaux historiques*, vol. 10: *Les collections photographiques de la Bibliothèque historique* (Paris: Mairie de Paris, 1986), 8.

167. "Projets de budgets et feuilles de compte: 1899–1909, 1910–1939," n.d., 3574W 7 & 8, Archives de Paris.

168. Françoise Reynaud credits the increasing numbers of illustrated publications that researchers had at their disposal and the development of new photographic archives, such as photo agencies, with making municipal photo archives obsolete. Françoise Reynaud, "Le Musée Carnavalet et la photographie," in *Portraits d'une capitale de Daguerre à William Klein: Collections photographiques du Musée Carnavalet* (Paris: Paris musées/Paris audiovisuel, 1992), 11–12.

CHAPTER 2

1. I define these as books that contain photographs as well as texts that narrate Parisian life and history. Historians have generally used this genre unselfconsciously, while art historians have almost entirely ignored it. Historians often turn to photohistories of Paris as primary or secondary sources, citing the texts without acknowledging their illustrations. Art historians pass over them in favor of artists' photo books, such as Brassaï's 1933 *Paris de Nuit* and André Kertész's 1934 *Paris vu par André Kertész*: Parr and Badger, *The Photobook*.

 Research for this chapter was conducted first in the collections of the Bibliothèque historique and the Bibliothèque nationale de France and then extended to include searches in libraries all over the United States via Worldcat. The latter provided a more comprehensive group of publications and a sense of their distribution. Like Margaret Cohen, who despaired of finding a coherent set of historical expectations operating in panoramic literature about Paris in the 1920s, I thought it might be impossible to identify common uses of photographs in these books. However, it quickly became apparent that each book repeated a very limited set of assumptions about the photograph's utility. Cohen, *Profane Illumination*, 82.

2. Lavergne, "L'histoire de demain."

3. For more about the rupture of the Great War, see Paul Fussell, *The Great War and Modern Memory*, new edition (New York: Oxford University Press, 2013); Modris Eksteins, *Rites of Spring: The Great War and the Birth of the Modern Age* (Boston: Houghton Mifflin, 1989); Mary Louise Roberts, *Civilization without Sexes: Reconstructing Gender in Postwar France, 1917–1927* (Chicago: University of Chicago Press, 1994). The historian Roxanne Panchasi has argued that the devastating sense of historical, cultural, and human loss after World War I gave rise to "a kind of cultural 'premourning,' a nostalgic longing for French values and cultural phenomena that *had not yet disappeared*." Roxanne Panchasi, *Future Tense: The Culture of Anticipation in France between the Wars* (Ithaca: Cornell University Press, 2009), 5. Emphasis is in the original.

4. For more about the political and financial crisis of interwar France, see Julian Jackson, *The Politics of Depression in France, 1932–1936* (Cambridge: Cambridge University Press, 1985).

5. Paris's intramuros population peaked at just shy of three million people in 1931. Its suburbs continued to grow: in 1936, they counted six million inhabitants. Evelyne Cohen, *Paris dans l'imaginaire national dans l'entre-deux-guerres* (Paris: Publications de la Sorbonne, 1999), 78, 75.

6. For more about Paris in these decades, see Norma Evenson, *Paris: A Century of Change, 1878–1978* (New Haven: Yale University Press, 1979); Tyler Edward Stovall, *The Rise of the Paris Red Belt* (Berkeley: University of California Press, 1990); Tyler Edward Stovall, *Paris Noir: African Americans in the City of Light* (Boston: Houghton Mifflin, 1996); Vicki Caron, *Uneasy Asylum: France and the*

Jewish Refugee Crisis, 1933–1942 (Stanford: Stanford University Press, 1999); Jeffrey H. Jackson, *Making Jazz French: Music and Modern Life in Interwar Paris* (Durham: Duke University Press, 2003); Clifford D. Rosenberg, *Policing Paris: The Origins of Modern Immigration Control between the Wars* (Ithaca: Cornell University Press, 2006); Jennifer Anne Boittin, *Colonial Metropolis: The Urban Grounds of Anti-Imperialism and Feminism in Interwar Paris* (Lincoln: University of Nebraska Press, 2010).

7. Poëte, *Une vie de cité*, Album, 526.

8. Cohen, *Paris dans l'imaginaire national dans l'entre-deux-guerres.*

9. Poëte, *Une vie de cité*, Album, 524.

10. André Beucler, "[Introduction]," *Photographie*, 1932, n.p.

11. Louis Chéronnet, "Pour un musée de la photographie," *Photographie*, 1933–1934, n.p.

12. Philippe Soupault, "Etat de la photographie," *Photographie*, 1931, n.p.

13. J. Bertrand, "Les livres d'étrennes," *Revue des deux mondes* 75, no. 30 (November 1905), 933.

14. Ibid.

15. For explanations of these processes, see Michel Frizot, "Photogravure," in *A New History of Photography*, ed. Michel Frizot (Köln: Könemann, 1998), 228; Sylvie Aubenas, "The Photograph in Print: Multiplication and Stability of the Image," in Frizot, *A New History of Photography*, 224–231.

16. For more about illustrations in the press, see Pierre Albert and Gilles Feyel, "Photography and the Media: Changes in the Illustrated Press," in Frizot, *A New History of Photography*, 358–369; Jason E. Hill and Vanessa R. Schwartz, eds., *Getting the Picture: The Visual Culture of the News* (London: Bloomsbury Academic, 2015); Thierry Gervais and Gaëlle Morel, *La fabrique de l'information visuelle: Photographies et magazines d'actualité* (Paris: Textuel, 2015).

17. Daniel Renoult, "Les nouvelles possibilités techniques: Le triomphe de la mécanique," in *Histoire de l'édition française*, 4 vols., eds. Roger Chartier and Henri-Jean Martin (Paris: Fayard, 1989–1991), vol. 4: *Le livre concurrencé 1900–1950*, 38.

18. Ibid.

19. Ibid., 41.

20. Offset would take over after World War II: Ibid., 42–43.

21. Marcel Poëte, *Les sources de l'histoire de Paris et les historiens de Paris*, 17.

22. Ibid., 16–17.

23. Samuels, *The Spectacular Past*, 66.

24. Between 1895 and 1914, he published eleven such books. See, for example: Armand Dayot, *L'invasion, le siège, la Commune, 1870–1871: D'après des peintures, gravures, photographies, sculptures, médailles, autographes, objets du temps . . .* (Paris: E. Flammarion, n.d.); Armand Dayot, *Histoire contemporaine par l'image: 1789–1872 d'après les documents du temps* (Paris: Flammarion, 1900).

25. For example: Georges Cain, *Promenades dans Paris: Ouvrage orné de 107 illustrations et de 18 plans anciens et modernes* (Paris: E. Flammarion, 1906); Georges Cain, *Le long des rues: Ouvrage orné de 124 illustrations et de plans anciens et modernes* (Paris: Ernest Flammarion, 1912).

26. *Coins de Paris* featured most of the text of *Croquis du vieux Paris* but without the limited edition prints. It would have been a much more affordable item. Cain, *Coins de Paris*, 50. This yearly production replaced Cain's engagement with the annual Salon cycle.

27. Translations include: Georges Cain, *Nooks and Corners of Old Paris*, trans. Frederick Lawton (London: E.G. Richards, 1907); Georges Cain, *Walks in Paris*, trans. Alfred Allinson (New York: Macmillan, 1909); Georges Cain, *The Byways of Paris*, trans. Louise Seymour Houghton (New York: Duffield, 1912). In the early 1910s, the publisher boasted of the following sales: *Coins de Paris* 11,000 copies sold; *Promenades dans Paris* (1906): 22,000; *Nouvelles promenades dans Paris* (1908): 14,000; *A travers Paris* (1909): 11,000; *Les pierres de Paris* (1910): 8,000; *Le long des rues* (1912): 7,000; *Environs de Paris, 1e série* (1911): 7,000; *Environs de Paris, 2e série* (1913): 6,000. Sales figures printed in: Georges Cain, *A travers Paris* (Paris: Ernest Flammarion, 1909), Getty Research Institute.

28. Cain, *Coins de Paris*, 51.

29. Ibid., 71, 213.

30. "This old place of debauchery" included the Tower of Found Children (where parents could abandon unwanted infants) and the low banks of the Seine in front of what is now the Parvis de Notre Dame. Ibid., 71–72.

31. "Hidden Paris That Casual Visitors Never Discover," *New York Times*, July 28, 1912.

32. He published in *La revue bleue, La vie urbaine, La gazette des beaux-arts*, and the publications of historical societies.

33. Marcel Poëte, *Une vie de cité*, vol. 2: *La cité de la Renaissance: Du milieu du XVe siècle à la fin du XVIe siècle* (Paris: A. Picard, 1927); Marcel Poëte, *Une vie de cité*, vol. 3: *La spiritualité de la cité classique, les origines de la cité moderne (XVI–XVIIe siècle)* (Paris: A. Picard, 1931). Poëte never wrote the proposed fourth volume.

34. Calabi, *Marcel Poëte et le Paris des années vingt*, 92n1.

35. Steven Melemis, "La cité et ses images: La collection iconographique de Marcel Poëte," *Les cahiers de la recherche architecturale et urbaine*, no. 29 Scènes en chantier (March 2014): 85–106.

36. Poëte, *Une vie de cité*, Album, xxi.

37. G. Lenotre, ed., *Le vieux Paris: Souvenirs et vieilles demeures*, vol. 1 (Paris: Ch. Eggimann, 1912), n.p. Molly Nesbit has characterized them less glamorously: "they only looked to see where the historical players had tread; if they could, they would have looked for finger prints." Nesbit, *Atget's Seven Albums*, 62.

38. G. Lenotre, *Notes et souvenirs: Recueillis et présentés par sa fille, Thérèse Lenotre* (Paris: Calmann-Lévy, 1940), 67.

39. George Eastman's Kodak, introduced in 1888, was the most famous of these: Colin Ford and Karl Steinorth, eds., *You Press the Button—We Do the Rest: The Birth of Snapshot Photography* (London: Dirk Nishen, 1988). The idea of the snapshot, or "l'instantanée," first surfaced in France in 1886, for more about it, see André Gunthert, "La conquête de l'instantané: Archéologie de l'imaginaire photographique en France, 1841–1895" (Thèse de doctorat en histoire de l'art, EHESS, 1999); Clément Chéroux, "Une généalogie des formes récréatives en photographie (1890–1940)" (Thèse de doctorat en histoire de l'art, Université Paris I, 2004).

40. Georges Cain, *Nouvelles promenades dans Paris* (Paris: Flammarion, 1908), 390, 401.

41. Ibid., 392.

42. Ibid., 396.

43. Ibid.

44. Even though Cain took many photos, they do not appear in this section on amateur photography.

45. Cain, *Nouvelles promenades dans Paris*, 400.

46. "2e sous-commission," *Commission municipale du Vieux Paris: Procès-verbaux*, June 2, 1898, 35.

47. André Paul Edouard Jean Barry, the Berthat frères, Pierre Emonts, Henri Godefroy, E. Gossin, and members of the Union photographique française all worked for the Commission. Nesbit, *Atget's Seven Albums*, 63.

48. G. Lenotre, ed., *Le vieux Paris: Souvenirs et vieilles demeures*, vols. 1–3 (Paris: Ch. Eggimann, 1912–1914).

49. Lenotre, *Le vieux Paris*, 1912, vol. 1, n.p.

50. Ibid.

51. Cain, *Nouvelles promenades dans Paris*, 389.

52. Ibid., 391–392.

53. For the Jardin des Plantes, Cain recommended Pierre Bernard, Louis Couailhac, Paul Gervais, and Emmanuel Le Maout, *Le Jardin des Plantes, description complète, historique et pittoresque du Muséum d'histoire naturelle, de la ménagerie, des serres, des galeries de minéralogie et d'anatomie et de la vallée suisse* (Paris: L. Curmer, 1842–1843). Cain, *Nouvelles promenades dans Paris*, 392.

54. Emphasis is in the original. Letter cited in: Lenotre, *Notes et souvenirs*, 46. Pierre Champion, *chartiste*, politician, and popular historian, testified to the same ability to see the past in its fragments: "inscriptions, [and] stones allow us to imagine the Parisian." Pierre Champion, *L'avènement de Paris: La vie de Paris au Moyen âge*, Notre vieux Paris (Paris: Calmann-Lévy, 1933), 12.

55. Georges Cain, "Saint-Lazare," in *Le vieux Paris: Souvenirs et vieilles demeures*, ed. G. Lenotre, vol. 3 (Paris: Ch. Eggimann, 1914), 8.

56. Alfred Tolmer, *Mise en Page: The Theory and Practice of Lay-Out* (London: The Studio, 1931), n.p. For more on the book, see Steven Heller, "First on Deco: A

Parisian Printer's Opus from the '30s Contains the Origins of a Design Staple," *Print Magazine*, May/June 2007, 88–93.

57. Pierre Lafitte, for example, brought a graphic sensibility honed in the publication of illustrated magazines to his books. Jean-Luc Buard, "Les paradoxes des publications Lafitte," *Le Rocambole: Bulletin des amis du roman populaire*, no. 10 (Spring 2000): 9. Hachette began including increasing numbers of illustrations during the Second Empire, when "the modernization of printing technologies and the triumph of photography made it necessary to give the image a more important place in book production." Jean-Yves Mollier, *Louis Hachette (1800–1864): Le fondateur d'un empire* (Paris: Fayard, 1999), 426.

58. Hubertus von Amelunxen, "Quand la photographie se fit lectrice: Le livre illustré par la photographie au XIXe siècle," *Romantisme* 15, no. 47 (1985): 89.

59. The Neurdein brothers had a "monopoly" on photographic reproductions at the Monuments historiques in the early twentieth century. Nesbit, *Atget's Seven Albums*, 23, 100. In *Rouen*, photographs are credited to Photo Giraudon, Cl. Archives photographiques–Paris, and Lévy and Neurdein. The latter was the Neurdein brother's firm after World War I: Robert Hénard, *Rouen* (Paris: Nilsson, 1925).

60. For more about Hachette, see also: Christine Haynes, *Lost Illusions: The Politics of Publishing in Nineteenth-Century France* (Cambridge, MA: Harvard University Press, 2010).

61. Ernest Granger, *Les races humaines*, Encyclopédie par l'image (Paris: Hachette, 1924), n.p.

62. Ibid.

63. The shift is apparent when comparing the following: Adolphe Joanne, *Paris illustré en 1870: Guide de l'étranger et du Parisien* (Paris: Hachette, 1870); Paul Joanne, *Paris-diamant* (Paris: Hachette, 1881); Paul Joanne, *Environs de Paris* (Paris: Hachette, 1907).

64. Huisman's dedication to new media would become greatly apparent in the 1930s, when he cofounded the Cannes Film Festival. Even prior to that, he was a graduate of the Ecoles des Chartes and so would have been versed in the value of images for historical study.

65. Volumes include: Georges Huisman, *De Saint Martin des champs aux Halles*, Pour connaître Paris (Paris: Hachette, 1925); Georges Lacour-Gayet, *Saint-Germain-des-Prés et la Coupole*, Pour connaître Paris (Paris: Hachette, 1924); Léon Gosset, *Jardins et promenades de Paris*, Pour connaître Paris (Paris: Hachette, 1929); Marcel Poëte, *La formation de Paris*, Pour connaître Paris (Paris: Hachette, 1926).

66. Arthaud relied on a handful of photographers. Claude Arthaud, interview with author, telephone, July 18, 2011.

67. Pierre Gauthiez, *Paris*, Les beaux pays (Grenoble: B. Arthaud, 1928).

68. Sylvia Gabriel (Photothèque Hachette), conversation with author, July 7, 2011.

69. Librairie Hachette, "Contract for Jean-Louis Vaudoyer for *Les musées*," n.d., Fonds Pierre Lafitte, Institut mémoires de l'édition contemporaine (IMEC).

70. The archive itself has survived, but very few documents about its functioning have been preserved. There are a few items scattered through the Hachette archive, currently managed by the IMEC. Most of these documents pertain to the archive's later decades.

71. Robert Grimoux, "Orientation professionnelle," *Vert luisant: Bulletin bimestriel d'information du Comité d'entreprise de la Librairie Hachette*, August 1958, 6.

72. These series were most likely separated after the 1957 expansion of French copyright law to cover photography.

73. Grimoux, "Orientation professionnelle," 8–9. At one point this library numbered in the thousands, but many of these volumes were thrown away after suffering water and mold damage in the 1990s.

74. Georges Huisman, *Pour comprendre les monuments de Paris* (Paris: Librairie Hachette, 1925) contained 600 photographs and cost 20 francs.

75. Books were cataloged according to size and entry number. ICONO books were shelved and numbered separately from the others. This system remained in place until the spring of 2010, when ICONO books were integrated into the others.

76. Rosemary Wakeman, "Nostalgic Modernism and the Invention of Paris in the Twentieth Century," *French Historical Studies* 27, no. 1 (2004): 117.

77. They "attempt[ed] to balance scientific urban planning with the historical and natural forms of the city." Ibid.

78. Georges Pillement, *Destruction de Paris* (Paris: Grasset, 1941), 11.

79. C. de Santeul, "A propos de photographie," *Bulletin de la Société française de photographie*, August 1924, 180.

80. Ibid, 181.

81. For more about *Vu*, see Michel Frizot and Cédric de Veigy, *Vu: The Story of a Magazine That Made an Era* (London: Thames & Hudson, 2009).

82. See, for example: "Laurel et Hardy travaillent pour 'Vu,'" *Vu*, November 27, 1935. The US magazine *PM* similarly taught readers about how photographs produced the news: Jason E. Hill, "De l'efficacité de l'artifice: *PM*, radiophoto et discours journalistique sur l'objectivité photographique," *Etudes photographiques*, no. 26 (November 2011): 50–85; Jason E. Hill, *Artist as Reporter: Weegee, Ad Reinhardt, and the* PM *News Picture* (Berkeley: University of California Press, 2018).

83. For more about Warnod, see *Hommage à André Warnod 1885–1960: Musée d'art moderne de la Ville de Paris* (Paris: Paris musées, 1985); Stanley Meisler, "André Warnod, the School of Paris, and the Jews," in *Shocking Paris: Soutine, Chagall and the Outsiders of Montparnasse* (New York: Palgrave Macmillan, 2015), 77–88.

84. "Communication de M. L. Tesson sur le Mont-Valérien et son histoire—Vœux de la commission," *Commission municipale du Vieux Paris: Procès-verbaux*, June 25, 1921, 131; Dominique-Jean-François Chéronnet, *Histoire de Montmartre, état*

physique de la butte, ses chroniques, son abbaye, sa chapelle du martyre, sa paroisse, son église et son calvaire, Clignancourt (Paris: Breteau et Pichery, 1843).

85. Eléonore Challine credits Chéronnet, of the interwar photo critics, with the most developed idea about photography's political potential. Eléonore Challine, "La critique photographique des années trente en France: Un échiquier politique?," *Revue française d'histoire des idées politiques* 39, no. 1 (2014): 37.

86. Chéronnet, "Pour un musée de la photographie." For more about similar projects, see Eléonore Challine, *Une histoire contrairiée: Le musée de photographie en France, 1839–1945* (Paris: Editions Macula, 2017).

87. "Les durs et les mous . . . Au tourisme," *Les Lettres françaises*, September 16, 1944, 2.

88. For more about these debates, see Rearick, "The Memory of a Certain Belle Epoque (1914–circa 1960): Or How the Turn-of-the-Century Lived on beyond Its Time," in *Paris Dreams, Paris Memories*, 44–81; Dominique Kalifa, *La véritable histoire de la Belle Epoque* (Paris: Fayard, 2017). Rearick discusses Warnod and Chéronnet's books without paying critical attention to their use of photographs.

89. Paul Morand, *1900* (Paris: Les éditions de France, 1931).

90. Fritzsche, *Stranded in the Present*.

91. André Warnod, *Visages de Paris* (Paris: Firmin-Didot et Cie, 1930), 332.

92. Ibid., 224.

93. Ibid., 324.

94. Ibid., 323, 324.

95. Louis Chéronnet, *A Paris . . . vers 1900*, Découverte du monde (Paris: Editions des Chroniques du jour, 1932), 7.

96. Ibid.

97. Beth Wright has argued that historical paintings "promised their audiences direct access to earlier times, an unmediated experience of the past. This feigned lack of mediation, of clarification, was achieved through meticulous illusionistic concrete components that denied the intervention of the artist's brush, and compositions that appeared to 'be' instead proclaiming their birth from the artist's brain." Wright, *Painting and History During the French Restoration*, 5.

98. It was published by Les éditions des Chroniques du jour, the publishing arm of the artistic revue by the same name, as part of a series "Découverte du monde" about contemporary art and culture. Chéronnet, A Paris . . . vers 1900, 9.

99. Ibid., 22.

100. Ibid., 9.

101. Chéronnet, "Pour un musée de la photographie," n.p.

102. Ibid., n.p.

103. Other similar projects also failed: Challine, *Une histoire contrairiée*.

104. Pierre Lièvre, "*A Paris vers 1900*, par Louis Chéronnet (Editions des Chroniques du Jour)," *La nouvelle revue française* 20, no. 228 (September 1932): 445.

105. Ibid.

106. Ibid.

107. Warnod, *Visages de Paris*, vi.

108. Ibid.

109. Ibid.

110. Ibid., v.

111. These are the same photos that Benjamin had hoped to use in his project about the Paris arcades: Cadava, *Words of Light*, xix.

112. Jean de Castellane, "Préface," in André Warnod, *Visages de Paris*, ii; Warnod, *Visages de Paris*, vi.

113. de Castellane, "Préface," ii.

114. "A travers le passé," *Le jardin des lettres*, no. 3 (January 1931): 10.

115. Warnod's book also used prints from the Musée Carnavalet's collection.

116. Chéronnet, "Pour un musée de la photographie," n.p. Obviously someone at Hachette agreed with Chéronnet.

117. For more about the production and circulation of such pictures, see McCauley, *A.A.E. Disdéri and the Carte de Visite Portrait Photograph*.

118. Georges Huisman, "*Visages de Paris*, par André Warnod," *La quinzaine critique des livres et des revues* 2, no. 24 (December 25, 1930): 818.

119. The best catalog of these books is: Hans-Michael Koetzle, *Eyes on Paris*. See also Patrick Deedes-Vincke, *Paris: The City and Its Photographers* (Boston: Little, Brown, 1992).

120. Sichel argues that they inherited forms from the surrealist novel and the flâneur's wanderings. Kim D. Sichel, "*Paris vu par André Kertész*: An Urban Diary," *History of Photography* 16, no. 2 (1992): 105.

121. Moshe Vorobeichic changed his name to Moshe Raviv after immigrating to Palestine. He is well known for two other 1931 photobooks: *Ein Ghetto im Osten-Wilna*, about the Vilnius ghetto, and *Ci-Contre: 110 photos de Moï Ver*. For more about his life and work see Andrea Nelson, "Reading Photobooks: Narrative Montage and the Construction of Modern Visual Literacy," (PhD diss., University of Minnesota, 2007), 254–256.

122. Warnod, *Visages de Paris*, vi.

123. Emile Henriot, "Photos de Paris," *Le Temps*, January 30, 1933.

124. Ibid.

125. Ibid.

126. It reviews the following: Lucien Dubech and Pierre d'Espezel, *Histoire de Paris* (Paris: Payot, 1926); Raymond Escholier, *Paris: Aquarelles de Nicolas Markovitch* (Paris: Editions Alpina, 1929); Gauthiez, *Paris*; Louis Hourticq, *Paris vu du ciel* (Paris: Henri Laurens, 1930); Huisman, *Pour comprendre les monuments de Paris*; Marcel Poëte, *Une vie de cité*, vol. 3; Warnod, *Visages de Paris*.

127. "Paris," *Le jardin des lettres*, March 1932, 5.

128. Ibid.

129. Paramount acquired the first book in 1932 and the latter in 1951. Both were subsequently donated to the library of the University of Southern California.

Filmmakers likely used these books, alongside photographs by the likes of the Séeberger brothers, to rebuild Paris in the studio and choose shooting locations.

130. Paul Valéry, "Discours du centenaire de la photographie," *Etudes photographiques*, no. 10 (November 2001): 93. I am grateful to François Brunet for bringing this speech to my attention.

CHAPTER 3

1. Jacques Wilhelm, *Visages de Paris: Anciens et modernes* (Paris: Les éditions du chêne, 1943), 5–6.
2. This chapter relies on the same methods as the previous one to identify a corpus of books published and circulated during this period. It also relies on prints of photos of the Liberation, which were collected at the time, as well as archives related to the photo-collecting and exhibition practices of the Musée Carnavalet during these years.
3. Marc Bloch, *Strange Defeat: A Statement of Evidence Written in 1940*, trans. Gerard Hopkins (New York: Oxford University Press, 1949); Philip Nord, *France 1940: Defending the Republic* (New Haven: Yale University Press, 2015).
4. Hanna Diamond, *Fleeing Hitler: France 1940* (New York: Oxford University Press, 2007).
5. Bertram M. Gordon, "Warfare and Tourism: Paris in World War II," *Annals of Tourism Research* 25, no. 3 (1998): 616–638. For more about France and Paris during World War II, see Eberhard Jäckel, *La France dans l'Europe de Hitler*, trans. Denise Meunier (Paris: Fayard, 1968); Gilles Perrault and Pierre Azéma, *Paris under the Occupation*, trans. Allison Carter and Maximilian Vos (New York: Vendome, 1989); Alan Riding, *And the Show Went On: Cultural Life in Nazi-Occupied Paris* (New York: Alfred A. Knopf, 2010); David Drake, *Paris at War, 1939–1944* (Cambridge, MA: Belknap Press of Harvard University Press, 2015).
6. Gordon, "Warfare and Tourism," 621.
7. For a detailed account see Matthew Cobb, *Eleven Days in August: The Liberation of Paris in 1944* (New York: Simon and Schuster, 2013).
8. Clark, "Capturing the Moment, Picturing History."
9. For more about war, revolution, and image, see John Milner, *Art, War and Revolution in France 1870–1871: Myth, Reportage and Reality* (New Haven: Yale University Press, 2000); S. Hollis Clayson, *Paris in Despair: Art and Everyday Life under Siege (1870–71)* (Chicago: University of Chicago Press, 2002); Laurence Bertrand Dorléac, *Art of the Defeat: France 1940–1944*, trans. Jane Marie Todd (Los Angeles: Getty Research Institute, 2008); Richard Taws, *The Politics of the Provisional: Art and Ephemera in Revolutionary France* (University Park: Pennsylvania State University Press, 2013); Katie Hornstein, *Picturing War in France, 1792–1856* (New Haven: Yale University Press, 2018).

10. While the Liberation brought at least slightly better living conditions for much of Europe, Paris actually fared worse after 1944. Rations, for example, were often more meager than during the previous four years. Wakeman, *The Heroic City*, 109–110.

11. For more about Hoffmann see Rudolf Herz, *Hoffmann und Hitler: Fotografie als Medium des Führer-Mythos* (Munich: Klinkhardt & Biermann, 1994).

12. Heinrich Hoffmann, ed., *Mit Hitler im Westen* (Berlin: Zeitgeschichte-Verlag, 1940).

13. Gordon, "Warfare and Tourism," 620. Images of Hitler's tour through the newly conquered city also circulated in newsreels.

14. For more about amateur photography during World War II, see Janina Struk, *Photographing the Holocaust: Interpretations of the Evidence* (London: I.B. Tauris, 2004); Georges Didi-Huberman, *Images in Spite of All: Four Photographs from Auschwitz*, trans. Shane B. Lillis (Chicago: University of Chicago Press, 2008); Frances Guerin, *Through Amateur Eyes: Film and Photography in Nazi Germany* (Minneapolis: University of Minnesota Press, 2012).

15. William L. Shirer, *Berlin Diary: The Journal of a Foreign Correspondent, 1934–1941* (New York: Alfred A. Knopf, 1941), 331.

16. Jean Eparvier, *A Paris sous la botte des Nazis* (Paris: Raymond Schall, 1944).

17. For more about photojournalism under Vichy, see Denoyelle, *La photographie d'actualité et de propagande sous le régime de Vichy.*

18. Claude Lévy and Henri Michel, "La presse autorisée de 1940 à 1944," in *Histoire générale de la presse française*, eds. Claude Bellanger et al., vol. 4, *De 1940 à 1958* (Paris: Presses universitaires de France, 1975), 43–44, 52, 59.

19. For more about these photos and the scandal they sparked in 2008, see Mary Louise Roberts, "Wartime Flânerie: The Zucca Controversy," *French Politics, Culture and Society* 27, no. 1 (2009): 102–110; Fabrice Virgili and Danièle Voldman, "Les Parisiens sous l'Occupation, une exposition controversée," ibid., 91–101.

20. "Ministère de la défense nationale et de la guerre: Réglementation des prises de vues photographiques dans la zone des armées," *Journal officiel de la République française: Lois et décrets* 72, no. 107 (April 28, 1940): 3101.

21. "Ministère de la défense nationale et de la guerre: Extension de la zone des armées," *Journal officiel de la République française: Lois et décrets* 72, no. 123 (May 17, 1940): 3650.

22. I looked through thousands of arrest records at the Archives de la Préfecture de Police in Paris for all of July 1942 without finding a single instance of an individual arrested for taking pictures.

23. For the case of a photographer who was arrested, see Gareth Syvret, "Photography in Jersey under German Occupation: The 1940 'Order Concerning Open-Air Photography' and Photography at the Société Jersiaise Museum," in *Photographs, Museums, Collections: Between Art and Information*, eds. Elizabeth Edwards and Christopher Morton (London: Bloomsbury Academic, 2015), 177–194.

24. For more about French publishing during this period, see Pascal Fouché, *L'édition française sous l'Occupation: 1940–1944*, 2 vols. (Paris: Bibliothèque de littérature française contemporaine de l'Université Paris 7, 1987).

25. Albert Schinz, "L'année littéraire mil-neuf cent quarante et une," *Modern Language Journal* 26, no. 4 (April 1942): 256.

26. Francis Carco, *Nostalgie de Paris* (Genève: Editions du milieu du monde, 1941); Elliot Paul, *The Last Time I Saw Paris* (New York: Random House, 1942).

27. Louis Chéronnet, *Paris tel qu'il fut: 104 photographies anciennes* (Paris: Editions Tel, 1943), 5.

28. For more about such efforts, see Isabelle Backouche, "Rénover un quartier parisien sous Vichy: 'Un Paris expérimental plus qu'une rêverie sur Paris,'" *Genèses*, no. 73 (2008): 115–142.

29. See, for example, Pillement, *Destruction de Paris*.

30. Chéronnet, *Paris tel qu'il fut*, 5.

31. Emmanuel Sougez, *Notre-Dame de Paris* (Paris: Editions Tel, 1941).

32. Paul Deschamps and Marc Foucault, *La cathédrale d'Amiens* (Paris: Editions Tel, 1942).

33. George Besson, *Matisse* (Paris: Braun, 1943); Jacques Mesnil, *Raphaël* (Paris: Braun, 1943).

34. For example: Doré Ogrizek et al., *Frankreich, Paris und provinzen* (Paris: Odé, 1943); Herbert de Bary and Erika Ruthenbeck, *Das verschleierte Bild von Paris: Pariser Bilderbogen* (Paris: Prisma, 1943); Hans Banger and Emmanuel Boudot-Lamotte, *Paris, Wanderung durch eine Stadt* (Paris: Verl. der Deutschen Arbeitsfront, 1942). The latter was published by the press of the official Nazi labor body.

35. Maurice van Moppès, *Images de Paris* (London: Hachette [distribution], 1940), n.p.

36. Historian Pascal Ory has described Robert Doisneau's Occupation photographs as strikingly empty: "It is just as a surrealist film from the 1920s, in which familiar objects and places magically disappear." Robert Doisneau and Pascal Ory, *Doisneau 40–44* (Paris: Hoëbeke, 2003), 13.

37. Pierre Mac Orlan, *Voyage dans Paris* (Paris: Les éditions de la nouvelle France, 1941), n.p.

38. Ibid.

39. Wilhelm, *Visages de Paris*, 6. The book's layout is credited to Jacques Fourastié, who also designed posters for films including Marcel Carné's *Les enfants du paradis* (1945), Maurice de Canonge's *Le dernier métro* (1945), and René Clément's *La bataille du rail* (1945).

40. Ibid., 5–6, 13.

41. Tolmer, *Mise en Page*, n.p.

42. Wilhelm, *Visages de Paris*, 13. Emphasis is added.

43. Edmond Dubois, *Vu pendant la Libération de Paris: Journal d'un témoin, illustré de 21 photographies* (Lausanne: Payot, 1944), 67.

44. For the interviews, see "Souvenirs et témoignages des photographes," in *Images de la Libération de Paris*, eds. Thomas Michael Gunther and Marie de Thézy (Paris: Paris musées, 1994), 133–143. Most of these photographers worked for the newly reorganized photo agency set up by the Comité de libération des reporters photographes de presse.

45. Roger Grenier, *A Box of Photographs*, trans. Alice Kaplan (Chicago: University of Chicago Press, 2013), 47–48.

46. Gunther and de Thézy, eds., *Images de la Libération de Paris*, 134.

47. Schall, however, would take many photographs after the Liberation that capture US soldiers in the same places and poses as the Germans.

48. Jean Baronnet, *Les Parisiens sous l'Occupation: Photographies en couleurs d'André Zucca* (Paris: Gallimard/Paris bibliothèques, 2008), 162–169.

49. He is wearing a US army helmet, but the French flag behind him suggests that he was Free French (who wore American helmets). He bears no other visible traits that would help identify him. Thanks to Matthew Cobb for confirming this.

50. Scholars often note the parallels between these two types of "shooting," see Jeannene M. Przyblyski, "Revolution at a Standstill: Photography and the Paris Commune of 1871," *Yale French Studies*, no. 101 (January 2001): 59.

51. Many well-known war photographs, from Roger Fenton's *The Valley of the Shadow of Death* to Robert Capa's *Falling Soldier*, were staged: Susan Sontag, *Regarding the Pain of Others* (New York: Picador, 2003); Errol Morris, "Crimean War Essay (Intentions of the Photographer)," in *Believing Is Seeing: Observations on the Mysteries of Photography* (New York: Penguin Press, 2011), 3–71.

52. Members of the Resistance had captured the Hôtel de Ville and the Préfecture de Police, but they did so as much to ensure that the largely Communist-led FFI would play a role in the new government negotiated with de Gaulle's Free French as to rout the Germans.

53. This photo was published on the cover of Georges Duhamel, *La semaine héroïque: 19–25 août 1944* (Paris: S.E.P.E., 1944).

54. Rapho, the agency that distributes this photo, provides the flipped version. Thank you to Jay Bute for pointing this out.

55. Robert Coiplet, "La bataille dans la rue," *Le Monde*, February 13, 1945, 2, paraphrasing Gustave-Jean Reybaz, *Le maquis Saint-Séverin: ou Comment fut libéré le quartier Saint-Michel* (Paris: Maison du livre français, 1945), 22. The historian Adrien Dansette judged that "to tell the truth, the most solid would not resist a single explosive shell." Adrien Dansette, *Histoire de la Libération de Paris* (Paris: Fayard, 1946), 269. Photo published in Dubois, *Vu pendant la Libération de Paris*, n.p.

56. Photo published in François Mauriac, *Paris libéré* (Paris: Flammarion, 1944), 62.

57. For a history of Parisian barricades since the sixteenth century, see Mark Traugott, "Barricades as Repertoire: Continuities and Discontinuities in the History of French Contention," *Social Science History* 17, no. 2 (1993): 309–323.

58. Robert Tombs, "La lutte finale des barricades: Spontanéité révolutionnaire et organisation militaire en mai 1871," in *La barricade: Actes du colloque organisé les 17, 18 et 19 mai 1995*, eds. Alain Corbin and Jean-Marie Mayeur (Paris: Publications de la Sorbonne, 1997), 357–365. Tombs argues that the last stand of the Communards nonetheless gave the barricade "a new mythical power" (364).

59. Lebel, who participated in the erection of barricades during May 1968, has since become a devotee of the form. He has collected and repurposed barricade images and objects in a series of exhibitions. His interest lies in the barricade as a spontaneous form of collective action, in its ephemerality and uselessness, and in how it nonetheless takes root "within the imaginary, therefore within the future." Jean-Jacques Lebel, "Art as Upheaval," interview conducted by Jean de Loisy, trans. David Curtis in Lebel, *Soulèvements* (Paris: Maison rouge, 2009), 211. Thanks to David Curtis for pointing out this overlap.

60. Dansette, *Histoire de la Libération de Paris*, 269–270.

61. *Le Parisien libéré*, October 14, 1944, 1.

62. Dansette, *Histoire de la Libération de Paris*, 268.

63. Ibid., 267.

64. Jacques de Lacretelle, "A la gloire de Paris," in *La Libération de Paris: 150 photographies* (Paris: Fasquelle, 1945), n.p. This argument contradicts Alain Corbin's judgment that "the barricade does not offer itself up as a spectacle to the flâneur or the gawker." Alain Corbin, "Préface," in Corbin and Mayeur, *La barricade*, 8. But Corbin only briefly addresses the 1944 barricades, which took the spectacle to extremes.

65. This map was published in: *Paris délivré par son peuple* (Paris: Editions Braun et Cie, 1944).

66. The barricade was also just across the river from the Ile de la Cité, where the FFI occupied key administrative buildings, so photographers would have passed in front of it as they traveled to and from the FFI headquarters.

67. For more about both of these traditions, see George Heard Hamilton, "The Iconographical Origins of Delacroix's 'Liberty Leading the People,'" in *Studies in Art and Literature for Belle da Costa Greene*, ed. Dorothy Miner (Princeton: Princeton University Press, 1954), 55–66; Przyblyski, "Revolution at a Standstill."

68. This photo was published in: Duhamel, *La semaine héroïque*, n.p.

69. Although Delacroix's painting had little immediate success, it has become an important touchstone for republican imagery in France: Nicos Hadjinicolaou, "'La Liberté guidant le peuple' de Delacroix devant son premier public," *Actes de la recherche en sciences sociales* 28, no. 1 (1979): 3–26; Marcia Pointon, *Naked Authority: The Body in Western Painting, 1830–1908* (Cambridge: Cambridge University Press, 1990), chap. 3.

70. This photo was exhibited at the Musée Carnavalet and published in Duhamel, *La semaine héroïque*, n.p.

71. Pierre Seghers, "Les visages de Paris," *Le Parisien libéré*, August 30, 1944, 2.

72. Suzanne Campaux, *La Libération de Paris (19–26 août 1944): Récits de combattants et de témoins réunis par S. Campaux* (Paris: Payot, 1945); Dansette, *Histoire de la Libération de Paris*.

73. Winners were to receive history books. "Un concours . . . pour l'histoire de la Libération de Paris, chaque Parisien doit témoigner," *Le Parisien libéré*, September 19, 1944, 2. The idea originated with Monique Cazeaux, librarian at the Bibliothèque de l'Arsenal, who recounted how she first thought to collect documents about the Liberation on the 21st, when the ceasefire was declared. She took the idea to Georges Bourgin, director of the Archives nationales, who recruited members from the city's other major historical institutions: the Musée Carnavalet, the Musée des traditions populaires, the Institut de France, and the Sorbonne. "Concours pour l'histoire de la Libération de Paris" (radio broadcast), October 4, 1944, Institute national de l'audiovisuel (INA), Paris. For more about the collection of documents in 1944 and 1945, see Alexandra Steinlight, "The Liberation of Paper: Destruction, Salvaging, and the Remaking of the Republican State," *French Historical Studies* 40, no. 2 (2017): 291–318.

74. "Un concours . . . pour l'histoire de la Libération de Paris," 2.

75. A. Metairie, "Un groupe d'historiens entreprend l'étude de la Libération de Paris," *Le Parisien libéré*, October 5, 1944, 1, 2. This committee would become the Comité nationale d'histoire de l'Occupation et de la Libération de la France in January 1945. "Pour l'histoire de la Libération de la France," *Le Monde*, January 10, 1945, 2. In 1951 it became the Comité d'histoire de la Seconde Guerre mondiale, before its 1982 transformation into the Institut d'histoire du temps présent (run for many years by Henry Rousso).

76. Georges Bourgin, "Histoire de l'Occupation et de la Libération," *Le Monde*, April 24, 1945, 4.

77. Ibid.

78. François Boucher, "Les musées d'histoire et leur rôle social," *La France municipale: Corporative et sociale*, July 4, 1941, Dossier Libération, Cabinet des estampes, Musée Carnavalet; François Boucher, "Les musées d'histoire et leur rôle social [suite]," *La France municipale: Corporative et sociale*, July 11, 1941, Ibid.

79. François Boucher, "[Letter to Monsieur Koscziusko]," February 2, 1945, Dossier Libération. He was of course, years behind the Bibliothèque historique, which had acquired contemporary photos 35 years earlier.

80. François Boucher, "Libération de Paris," n.d., 3, Dossier Libération.

81. Even though Adrien Dansette styled his account a "history," he reminded readers of the fallibility of the interviews he had collected. He asked, "does having spent one day tossed by waves mean one knows the sea and the mystery of its depths?" He also advised readers that the newspapers published during the Liberation were light on "correct information." Except for a handful of articles, the press contained "only effusions of leftist lyricism! Only reports dripping with literary heroism!" Dansette, *Histoire de la Libération de Paris*, 8, 257.

82. François Boucher, "Note à la presse," n.d., 1, Dossier Libération.

83. Ibid.

84. The private collector Charles Chadwyk-Healey estimates that there were over six thousand books about the war published between 1944 and 1946: a remarkable figure when one takes into account the scarcity of paper during those years. Thanks to Chadwyk-Healey's help Cambridge University Library has the most complete collection of these books.

85. Another 1,598 visitors attended the exhibition during its last two weeks. "Entrées de l'exposition de la Libération," Dossier Libération.

86. For more about this process, see Pieter Lagrou, *The Legacy of Nazi Occupation: Patriotic Memory and National Recovery in Western Europe, 1945–1965* (Cambridge: Cambridge University Press, 2000); Sarah Farmer, *Martyred Village: Commemorating the 1944 Massacre at Oradour-sur-Glane* (Berkeley: University of California Press, 1999); Alon Confino, "Remembering the Second World War, 1945–1965: Narratives of Victimhood and Genocide," *Cultural Analysis* 4 (2005): 47–75.

87. *L'âme des camps, exposition, album-souvenir* (Paris: Croix rouge française, Comité central d'assistance aux prisonniers de guerre en captivité, 1944); "Une exposition de la presse clandestine," *Le Parisien libéré*, September 29, 1944, 2.

88. For more about this exhibition, see Clark, "Capturing the Moment, Picturing History," 846–847.

89. "Des vérités nécessaires: En France et ailleurs . . . témoignage irrécusable," *Les Lettres françaises*, June 23, 1945, 2. Official documents report 487,270 visitors during its two-month Paris run. "Recettes d'entrée," Series F41, box 450, Archives nationales, Pierrefitte.

90. The following description is drawn from photographs of the exhibit's installation and inauguration, held in the Cabinet des estampes, and from Boucher "Note à la presse," 2.

91. Ibid.; Boucher, "Libération de Paris," 2.

92. Boucher, "Note à la presse," 2.

93. Ibid., 1.

94. Ibid.

95. Boucher, "Libération de Paris," 1.

96. This was not for a lack of images, which Boucher did collect.

97. "Au Musée Carnavalet: L' exposition 'Libération de Paris' retrace les heures glorieuses du mois d'août," *Le Parisien libéré*, November 11, 1944, 1.

98. The reviewer continued, "one feels true emotion before the few Parisian paving stones brought in as the symbol of the people's insurrection." Ibid.

99. Boucher, "Libération de Paris," 2.

100. "Dans Paris et dans les pays: Pavés de Paris à l'honneur," *Les Lettres françaises*, November 18, 1944, 2.

101. "Entrées de l'exposition de la Libération."

102. François Boucher, *La grande délivrance de Paris* (Paris: J. Haumont, 1945).

103. Rice became director of the US Information Library at the Paris embassy after the war: Howard C. Rice, "Post-Liberation Publishing in France: A Survey of Recent French Books," *French Review* 18, no. 6 (May 1945): 327–328.

104. My numbers come from research in the catalogs and collections of the Bibliothèque nationale de France, the Bibliothèque historique de la Ville de Paris, the Musée Carnavalet, the Bibliothèque administrative de la Ville de Paris, and other libraries available through WorldCat. One way to establish a list of Liberation books would have been to cull the published list of books entering the collections of the Bibliographie nationale, France's copyright library. Because the Bibliothèque nationale's holdings were so uneven in this area, the cross-referencing of various catalogs offered a more thorough overview.

105. Suzanne Campaux's collection of the accounts of the Liberation, for example, has just seventeen photos scattered over almost three hundred pages, while the only text in Jacques Kim, *La Libération de Paris: Les journées historiques de 19 août au 26 août 1944 vues par les photographes* (Paris: OPG, 1944) are the bilingual (French and English) captions to almost a hundred photos.

106. The 1946 edition of the pamphlet released by the police, for example, added photographs. Ferdinand Dupuy, *La Libération de Paris vue d'un commissariat de police* (Paris: Librairies-imprimeries réunies, 1946).

107. The September 1944 issue of the newspaper *France d'abord* cost 2 francs; an issue of *La Marseillaise* cost 3 francs; Georges Fronval, *Paris brise ses chaînes! Epopée des 20 arrondissements et de la banlieue dans les journées du 19 au 25 août 1944* (Paris: Editions et revues françaises, 1944) cost 10 francs; *Les barricades de Paris VII: La Libération* (Paris: A. Fleury, 1944) cost 12 francs; *L'insurrection de Paris* (Paris: France-éditions, 1944) cost 15 francs; Blanchot, *Libération de Paris* cost 300 francs; and *Paris libéré* cost 70 francs. Some were even free, as with the pamphlets and magazine articles produced by the Allied Information Service for distribution in France. These prices are in pre-1960 francs.

108. Dubois, *Vu pendant la Libération de Paris*; Kim, *La Libération de Paris*; Ferdinand Dupuy, *La Libération de Paris vue d'un commissariat de police*; Claude Roy, *Les yeux ouverts dans Paris insurgé* (Paris: R. Julliard, 1944).

109. Mauriac, *Paris libéré*, 4.

110. R. G., "A travers les rayons: Paris libéré," *Les Lettres françaises*, March 3, 1945, 3.

111. Marcel Flouret, "Préface," in *Paris, du 19 au 26 août 1944* (Paris: Imprimerie Draeger frères pour la Préfecture de la Seine, 1945), 9.

112. Louis Gratias, *Barricades: Suite de cent cinquante photographies groupées par André Papillon* (Paris: Editions occident, 1945), n.p.

113. "Propagande utile," *Les Lettres françaises*, August 18, 1945, 2.

114. For more about Vichy imagery, see Dominique Rossignol, *Histoire de la propagande en France de 1940 à 1944: L'utopie Pétain* (Paris: Presses universitaires de France, 1991).

115. Rice, "Post-Liberation Publishing in France," 328.

116. For more about the *Epuration* see Peter Novick, *The Resistance versus Vichy: The Purge of Collaborators in Liberated France* (New York: Columbia University Press, 1968). Similar struggles had occurred after World War I: Laird Boswell, "From Liberation to Purge Trials in the 'Mythic Provinces': The Reconfiguration of Identities in Alsace and Lorraine, 1918–1920," *French Historical Studies* 23, no. 1 (Winter 2000): 129–162.

117. A photograph of a barricade built in part out of a Morris column was published in the 1946 edition of Dupuy, *La Libération de Paris vue d'un commissariat de police*, 15.

118. Mauriac, *Paris libéré*, 5.

119. "Livres et documents," *Le Parisien libéré*, November 1, 1944, 2.

120. Dubois, *Vu pendant la Libération de Paris*, 70. Brett Bowles, "Jean Renoir's *Salut à la France*: Documentary Film Production, Distribution, and Reception in France, 1944–1945," *Historical Journal of Film, Radio, and Television* 26, no. 1 (2006): 64.

121. Coiplet, "La bataille dans la rue," 2. The book in question was: Reybaz, *Le maquis Saint-Séverin*.

122. For more about publishers during the Liberation and underground publishing during the Occupation, see Anne Simonin, *Les Editions de Minuit, 1942–1955: le devoir d'insoumission*, L'édition contemporaine (Paris: IMEC éd, 1994).

123. Draeger frères printed Pétain's speeches as well as also books and pamphlets for key Vichy entities, including the Secrétariat d'Etat à la Marine, the Secrétariat d'Etat à l'information et à la propagande, and the Bureau de documentation du Chef de l'Etat. Philippe Pétain, *La France nouvelle: Principes de la communauté, appels et messages, 17 juin 1940–17 juin 1941* (Montrouge: impr. Draeger frères, 1941); Robert Lallemant, *Marine nationale: 32 photos de Robert Lallemant* (Paris: [Draeger frères], 1942); *Travail, famille, patrie* (Paris, 1942); Philippe Pétain, *La France nouvelle: Appels et messages, 8 juillet 1941–17 juin 1943*, 2 vols. (Montrouge: impr. Draeger frères, 1943); Pétain, *Paroles du Maréchal* (Vichy: Bureau de documentation du Chef de l'Etat 1943).

124. Jean Louis Babelay, *Un an*, text by A. G. Leroux (Paris: Editions Raymond Schall, 1946); Eparvier, *A Paris sous la botte des Nazis*.

125. Lacretelle, *La Libération de Paris*; Pétain, *La France nouvelle* (1941). Flammarion, on the other hand, remained active during the war, but only published fiction.

126. Frieda Dettweiler and Johanna Müller, *Ein Tag in Versailles, Illustrierter Führer von Schloss, Museum, Park, und Trianons* (Paris: Braun, 1941); *Paris délivré par son peuple*. Other books published between 1944 and 1946 included accounts of the liberations of Marseille, Lyon, Mulhouse, and the Riviera.

127. Les Parisiens, "Le rond-point des lettres," *Le Parisien libéré*, September 19, 1944, 2.

128. "Des vérités nécessaires . . . ceux qui exagèrent," *Les Lettres françaises*, January 13, 1945, 2.

129. The literary scholar Douglas Alden claims that de Lacretelle "made no attempt—as so many of his contemporaries did—to get on the Resistance band wagon," but his preface to this book suggests otherwise. Alden, *Jacques de Lacretelle: An Intellectual Itinerary* (New Brunswick: Rutgers University Press, 1958), 246. For more about Brasillach, see Alice Kaplan, *The Collaborator: The Trial and Execution of Robert Brasillach* (Chicago: University of Chicago Press, 2000).

130. The pamphlet's introduction challenged: "Who said that the Paris Police was 'collaborationist'?" Dupuy, *La Libération de Paris vue d'un commissariat de police* (Paris: Librairies-imprimeries réunies, 1945), 30.

131. During the war these photographers sold pictures to Vichy-based publications including *La Semaine, L'Illustration, Paris-Midi*, and *Paris-Soir*. Schall, Jarnoux, Vals, and Papillon all received the Vichy accreditation necessary to cover official events: Denoyelle, *La photographie d'actualité et de propagande sous le régime de Vichy*, 402, 394, 404, 399.

132. Eparvier, *A Paris sous la botte des Nazis*, n.p.

133. Jean Galtier-Boissière, *Mon journal depuis la Libération* (Paris: La jeune parque, 1945), 112.

134. Ibid. André Zucca also took German-authorized photographs during the war; Roberts, "Wartime Flânerie."

135. Galtier-Boissière, *Mon journal depuis la Libération*, 112–113.

136. Jacques Duclos, *L'insurrection parisienne: 19–26 août 1944*, 2nd ed. (Paris: Editions du Parti communiste français, 1946).

137. Rice, "Post-Liberation Publishing in France," 329.

138. These colorful prints were very popular in France throughout the nineteenth century, but the term also came to mean any sort of simplistic or folk representation. Claude Morgan, "L' Allemagne et nous: Sus aux images d'Epinal," *Les Lettres françaises*, July 19, 1946, 1.

139. Georges Duhamel, *Tribulations de l'espérance* (Paris: Mercure de France, 1947); *L' âge de Caïn: Premier témoignage sur les dessous de la Libération de Paris* (Paris: Les éditions nouvelles, 1948); Paul Hénin, *Monsieur R. Nordling, consul de Suède, et son rôle pendant la Libération de Paris, août 1944* (Paris: Editions du foyer français, 1948); Bernard Malan, *Refaire la civilisation* (Paris: S.A.L., 1947); Henri Claude, *Le problème de la paix* (Paris: S.A.L., 1947); Claude Roy, *Clefs pour l' Amérique* (Paris: Gallimard, 1949).

140. Henri Grimal, *Derrière les barricades: Le peuple de Paris à la conquête de la liberté* (Paris: Bourrelier, 1948).

141. Duhamel, *La semaine héroïque*. The band is pasted inside the front cover of the copy held at the Bibliothèque nationale de France. When I talk about this material, people who grew up in France after the war often approach me to tell me they owned this very book.

142. André Tollet, "Le peuple de Paris," in *Paris, du 19 au 26 août 1944*, 35.

143. Rosemary Wakeman, for example, has argued that the populism of the Liberation shaped working-class culture in Paris through the 1950s. Wakeman, *The Heroic City*.
144. *Un micro dans la bataille de Paris, 20–26 août 1944* [audio disc] (Paris: Société de radioproductions, c. 1945).
145. *Les barricades de Paris VII*, n.p.

CHAPTER 4

1. Henriot, "Photos de Paris."
2. Willy Ronis and Pierre Mac Orlan, *Belleville-Ménilmontant* (Grenoble: Arthaud, 1954), n.p. Ronis did not like Mac Orlan's commentary. He later claimed it made him swear off publishing any further photo books for over two decades. What exactly offended him though, he did not say. Willy Ronis, *Sur le fil du hasard* (Paris: Contrejour, 1980), n.p.
3. Ronis and Mac Orlan, *Belleville-Ménilmontant*, n.p. Mac Orlan had been interested in photography as art since the 1930s, when he penned the preface to one of the first collection of Atget photographs: Eugène Atget and Pierre Mac Orlan, *Atget: Photographe de Paris* (Paris: Henri Jonquières, 1930).
4. Herman Lebovics, "Language Holds Everything Together," in *Mona Lisa's Escort: André Malraux and the Reinvention of French Culture* (Ithaca: Cornell University Press, 1999), 178–193; Marc Fumaroli, *Quand l'Europe parlait français* (Paris: Fallois, 2001).
5. Richard F. Kuisel, *Seducing the French: The Dilemma of Americanization* (Berkeley: University of California Press, 1993); Victoria De Grazia, *Irresistible Empire: America's Advance through Twentieth-Century Europe* (Cambridge, MA: Belknap Press of Harvard University Press, 2005).
6. Cited in Herbert R. Lottman, *The Left Bank: Writers, Artists, and Politics from the Popular Front to the Cold War* (Boston: Houghton Mifflin, 1982), 233–234.
7. Jean Fourastié, *Les trente glorieuses, ou, la révolution invisible de 1946 à 1975* (Paris: Fayard, 1979). For revisions of the idea of these years as "glorious," see Kristin Ross, *Fast Cars, Clean Bodies: Decolonization and the Reordering of French Culture* (Cambridge, MA: MIT Press, 1995); Céline Pessis, Sezin Topçu and Christophe Bonneuil, eds., *Une autre histoire des "Trente Glorieuses": Modernisation, contestations et pollutions dans la France d'après-guerre* (Paris: La Découverte, 2013).
8. Nuclear reactors, for example, would be written into a lineage of French monuments, while the Donzère-Mondragon dam on the Rhône inspired comparisons with Chartres, Notre-Dame, the Eiffel Tower, and the Place de la Concorde: Gabrielle Hecht, *The Radiance of France: Nuclear Power and National Identity after World War II* (Cambridge, MA: The MIT Press, 1998); Sara B. Pritchard, *Confluence: The Nature of Technology and the Remaking of the Rhône* (Cambridge, MA: Harvard University Press, 2011), 68.

9. Serge Guilbaut, *How New York Stole the Idea of Modern Art: Abstract Expressionism, Freedom, and the Cold War*, trans. Arthur Goldhammer (Chicago: University of Chicago Press, 1983).

10. For more about the use of Marshall Plan funds, see De Grazia, *Irresistible Empire*.

11. Wakeman, *The Heroic City*, 330.

12. The neighborhoods were "as such villages, still amidst the speed of the big city." Ronis and Mac Orlan, *Belleville-Ménilmontant*, n.p.

13. Vanessa R. Schwartz, "The Belle Epoque That Never Ended: Frenchness and the Can-Can Film of the 1950s," in *It's So French!: Hollywood, Paris, and the Making of Cosmopolitan Film Culture* (Chicago: University of Chicago Press, 2007); Rearick, *Paris Dreams, Paris Memories*; Kalifa, *La véritable histoire de la Belle Epoque*. "The alacrity with which post-war Parisians latched on to the notion of pre-war Paris as the glamorous cynosure of *la belle époque* [. . .] suggested that Paris was more willing to rest its claims to modernity on the past than on the future." Colin Jones, *Paris: The Biography of a City* (New York: Penguin, 2006), 384.

14. Janet Flanner (Genêt), *Paris Journal 1944–1965*, ed. William Shawn (New York: Atheneum, 1965), 63.

15. Becky Conekin, *"The Autobiography of a Nation": The 1951 Festival of Britain* (Manchester: Manchester University Press, 2003). There was a third major postwar European festival: the 1950 Holy Year's pilgrimage to Rome, which drew three million tourists. The historian Robert Ellwood has argued, "Probably no other Holy Year since the Middle Ages has had quite the political as well as spiritual significance of 1950." Robert S. Ellwood, *1950, Crossroads of American Religious Life* (Louisville: Westminster John Knox Press, 2000), 145, 144.

16. Raphael Samuel, *Theatres of Memory*, vol. 1, *Past and Present in Contemporary Culture* (New York: Verso, 1994), 55.

17. Kollar worked for *Harper's Bazaar* in the early 1950s, and even though it was never published, this photo was very likely taken with that publication in mind. This photo and the others discussed here are held at the Médiathèque de l'architecture et du patrimoine.

18. Jean Carlier, "Les Anglais fuyant leur 'Festival' pour notre 'Bimillénaire'" *Combat*, July 4, 1951, 1.

19. Historians of Paris have also viewed the Bimillénaire with some skepticism. Most gloss over it or discuss it merely within the context of American tourism. The Bimillénaire has received the most attention from historians as a promotional tool to attract American tourist dollars: Brian A. McKenzie, "Creating a Tourist's Paradise: The Marshall Plan and France, 1948 to 1952," *French Politics, Culture and Society* 21, no. 1 (Spring 2003): 35–54; Christopher Endy, *Cold War Holidays: American Tourism in France* (Chapel Hill: University of North Carolina Press, 2004), 108–109. For an interpretation of it as part of postwar public street festivals see Wakeman, *The Heroic City*, 34–36.

20. The state never gave the Bimillénaire the funding its organizers had hoped for: "Considérant que le comité municipal provisoire du Bimillénaire . . . ," n.d., 2ETP/6/8/00 11, Archives de la Chambre de commerce et de l'industrie de Paris, Archives de Paris.

21. "Conférence de presse du 20 mars 1951," 2ETP/6/8/00 11, Archives de la Chambre de commerce et de l'industrie de Paris.

22. "Le marché Saint-Germain-des-Prés s'éveille au son des farandoleurs," *JT 20H*, June 13, 1951, INA.

23. "A Montmartre: Can can 1880," *Les actualités françaises*, July 26, 1951, INA.

24. The invitation of every mayor of "Paris" caused a particular flurry in the American press. Some of the American cities even had to deputize mayors for the occasion: "Paris Hails U.S. 'Parisian'," *New York Times*, June 21, 1951, 4.

25. Jean Carlier, "Quatre Américains rêvaient de Paris: Invités pour le grand Bi, ils s'intéressent aux chinoiseries du 18e siècle et aux secrets de l'omelette," *Combat*, July 11, 1951, 1, 6; Jean Carlier, "Quatre Américains rêvaient de Paris: L'enseignement des universités américaines prépare à la vie, étudiants en télévision ou en journalisme y sont formés," *Combat*, July 12, 1951, 1.

26. He argued: "Rome is more majestic, Trier is older, Venice is more beautiful, Naples is more graceful, London is richer. What does Paris have then? The Revolution." Victor Hugo, "Introduction," in *Paris-Guide par les principaux écrivains et artistes de la France*, vol. 1 (Paris: Librairie internationale, 1867), xviii.

27. Emery, "Protecting the Past," 65.

28. Lenotre, *Le vieux Paris*, vol. 1, n.p.

29. Léon Gosset, *Tout Paris par l'image: Les sites, les monuments, tous les trésors de Paris avec 471 illustrations* (Paris: Hachette, 1937), 7.

30. Robert Bonfils, *200 vues de Paris: Guide des musées, églises, monuments, bibliothèques, curiosités, spectacles* (Paris: Larousse, 1930), v.

31. Paul Pierrot, "Service au feu d'artifice tiré aux Invalides le 8 juillet dernier," July 12, 1951, FC 2, Archives de la Préfecture de Police, Paris.

32. "400,000 spectateurs ont assisté au feu d'artifice du 'Grand Bi'," *Combat*, July 9, 1951, 8.

33. Jules Romains, "Introduction: Paris a deux mille ans," in *Portrait de Paris*, eds. Jules Romains et al. (Paris: Perrin, 1951), 8.

34. At the time Paul Haag was Prefect of the Seine. Roger Léonard held the post of Prefect of Police until April 1951, when Jean Baylot succeeded him.

35. For more about this split, see Philippe Nivet "Prépondérences et crises de gaullisme (1947–1965)," in *Le conseil municipal de Paris de 1944 à 1977* (Paris: Publications de la Sorbonne, 1994), 81–135.

36. "Comité du Bimillénaire [list of members]," n.d., 2ETP/6/8/00 11, Archives de la Chambre de commerce et de l'industrie de Paris.

37. For more about the Chamber of Commerce during this period, see Robert Frank, "Se moderniser face aux grandes mutations (1945–1970)," in *La chambre de commerce et*

d'industrie de Paris (1803–2003): Histoire d'une institution (Genève: Droz, 2003), 239–275.

38. Louis Aragon, "Victor Hugo par Aragon," *Les Lettres françaises*, June 28, 1951, 1.

39. Dossier "Fêtes du bi-millénaire de Paris: 14 décembre 1951," FC 2, Archives de la Préfecture de Police.

40. Maurice Chevalier, Francis Lopez, Albert Willemetz "Paris a ses 2.000 ans" (Polydor: 1951).

41. "[publicité] Au Printemps 2e mise en vente du Bimillénaire," *Le Parisien libéré*, July 2, 1951, 5; "Comité du Bimillénaire: Réunion du Comité exécutif du 30 janvier 1951," 2ETP/6/8/00 11, Archives de la Chambre de commerce et de l'industrie de Paris; "Comité du Bimillénaire: réunion du Comité exécutif du 22 janvier 1951," 2ETP/6/8/00 11, Archives de la Chambre de commerce et de l'industrie de Paris.

42. "Comité du Bimillénaire: réunion du Comité exécutif 30 janvier 1951," 2ETP/6/8/00 11, Archives de la Chambre de commerce et de l'industrie de Paris.

43. Jacques Fougerolle, "[letter to Jean Marin]," February 22, 1951, 2ETP/6/8/00 11, Archives de la Chambre de commerce et de l'industrie de Paris.

44. Marcelle Capron, "Sous le ciel de Paris et dans un cadre médiéval: Le 'Vray Mystère de la Passion," *Combat*, July 2, 1951, 2.

45. Marc Beigbeder, "Devant Notre-Dame: 'Le vray mystère de la passion' a manqué de passion dramatique," *Le Parisien libéré*, July 2, 1951, 2.

46. Ibid.

47. "Paris a-t-il dix mille ans? Nous avons reçu la lettre suivante," *Le Monde*, July 10, 1951. The vice president elaborated on the idea in: E. Gilbert, "À propos du bimillénaire de Paris," *Bulletin de la Société préhistorique française* 48, no. 7–8 (1951): 346–347.

48. "Paradoxes bimillénaires: Lutèce était (déjà) habitée par . . . des Parisiens!," *L'Aube magazine*, July 6, 1951, 1.

49. "De Paris à Saint-Denis," *Le Parisien libéré*, July 4, 1951, 6.

50. "Comité du Bimillénaire: Réunion du Comité exécutif du 4 décembre 1950," 2ETP/6/8/00 11, Archives de la Chambre de commerce et de l'industrie de Paris.

51. Fougerolle, "[letter to Jean Marin]."

52. For more about these, see "Comité du Bimillénaire: Réunion du 25 juillet 1950," 2ETP/6/8/00 11, Archives de la Chambre de commerce et de l'industrie de Paris; "Comité du Bi-millénaire: réunion du 6 octobre 1950," 2ETP/6/8/00 11, Archives de la Chambre de commerce et de l'industrie de Paris.

53. The filmed footage that does exist, produced for newsreels and television coverage, is usually less than thirty seconds long.

54. "Distribution des affiches concernant le Bimillénaire de Paris," n.d., 2ETP/1/2/63 24, Archives de la Chambre de commerce et de l'industrie de Paris.

55. The exhibition catalog: Roger Lecotté, *Archives historiques du compagnonnage* (Paris: Mémoires de la fédération folklorique d'Ile-de-France, 1956).

56. Louis Vert, "[letter to Max Terrier]," July 13, 1941, Dossier Expo (1941): Petits métiers, Cabinet des estampes, Musée Carnavalet.

57. Max Terrier, "[letter to Marcel Pouzin]," July 15, 1941, Dossier Expo (1941); Louis Vert, "[letter to Max Terrier]."

58. Max Terrier, "[letter to Georges Sirot]," July 15, 1941, Dossier Expo (1941).

59. Max Terrier, "Note à Monsieur le Préfet, secrétaire général de la Seine," July 31, 1941, Dossier Expo (1941).

60. Ibid.

61. "Au Musée Carnavalet," *La Croix*, November 29, 1941, 3, Dossier Expo (1941); "Une exposition de vieilles photographies au Musée Carnavalet," *Le Matin*, October 20, 1941, 4, Dossier Expo (1941).

62. José Bruyr, "Grâce à l'objectif d'E. Atget mille spectacles du Paris 1900 sont restés proches de nous!," *Tout et tout*, November 8, 1941, Dossier Expo (1941).

63. Ibid.

64. Ibid.

65. Chéronnet, *Paris tel qu'il fut*, 5.

66. Ibid.

67. Ibid.

68. "[review of *Paris tel qu'il fut*]," *La Gerbe*, July 22, 1943, Dossier biographique Boutillier du Retail: Louis Chéronnet, Bibliothèque nationale de France, Paris.

69. Christ also credited the influence of Achille Carlier's photographically illustrated archaeological journal *Pierres de France*. Yvan Christ, *Les métamorphoses de Paris, cent paysages parisiens photographiés autrefois par Atget, Bayard, Bisson, Daguerre ... [etc] et aujourd'hui par Janine Guillot et Charles Ciccione* (Paris: Balland, 1967), xx.

70. Louis Chéronnet, "Pour un musée de la photographie"; Louis Chéronnet, *Le petit musée de la curiosité photographique* (Paris: Tel, 1945).

71. The book was supposed to be the last of four, produced by Arts et métiers graphiques, that would trace life in Paris since the Middle Ages. This was the only one that saw the light of day. François Boucher, "La vie à Paris," in *La vie à Paris sous le Second Empire et la Troisième République*, ed. Jacques Wilhelm (Paris: Arts et métiers graphiques, 1948), n.p.

72. Jacques Wilhelm, *La vie à Paris sous le Second Empire et la Troisième République* (Paris: Arts et métiers graphiques, 1948), 10.

73. Ibid., 11.

74. René Coursaget and Georges Pillement, *Dans les rues de Paris au temps des fiacres* (Paris: Editions du Chêne, 1950).

75. In the late 1940s and early 1950s, the existence of archived images of the past similarly appealed to filmmakers who experimented with the possibilities and challenges of archival footage. Nicole Védrès's 1947 film *Paris 1900*, for instance, would bring this interest to bear on the turn-of-the-century capital: Paula Amad, "Film as the 'Skin of History': André Bazin and the Specter of the Archive and Death in Nicole Védrès's *Paris 1900* (1947)," *Representations* 130, no. 1 (Spring 2015): 84–118.

76. Norberto Angeletti and Alberto Oliva, *Magazines That Make History: Their Origins, Development, and Influence* (Gainesville: University Press of Florida, 2004), 192.

77. "La photo raconte déjà plus d'un siècle d'histoire," *Paris Match*, August 5, 1950, 37.

78. "La photo raconte déjà plus d'un siècle d'histoire," 37.

79. "Un siècle d'histoire en photos: La vie parisienne," *Paris Match*, September 2, 1950, 38–39; "Un siècle d'histoire en photo: La guerre de Crimée," *Paris Match*, August 19, 1950, 38–39; "Un siècle d'histoire en photo: Napoléon III et sa cour," *Paris Match*, August 26, 1950, 38–39.

80. "Un siècle d'histoire en photos: 1848–1853," *Paris Match*, August 12, 1950, 38–39.

81. Louis Chéronnet, *Paris tel qu'il fut: 104 photographies anciennes* (Paris: Editions Tel, 1951).

82. *Bimillénaire de la Ville de Paris: Exposition 'Paris,' peintures, gravures, cartes, livres, dessins et photographies illustrant le développement et l'esprit de Paris du 15 mars au 30 avril 1951 . . . Services culturelles de l' Ambassade de France . . . New York* (New York: [1951]).

83. "Yesterday's Paris: Plus Ça Change," *New York Times Magazine*, November 25, 1951, 64–65.

84. His photographs had been exhibited several times at MoMA, beginning in 1937. American cultural institutions, thanks to the efforts of curators such as Edward Steichen and Beaumont Newhall, were quicker to embrace art photography. Indeed, the same summer MoMA showed the work of four other French photographers: Robert Doisneau, Willy Ronis, Izis, and Brassaï.

85. Yvan Christ, *Saint-Germain-des-Prés 1900 vu par Atget* (Paris: Le comité de la quinzaine de Saint-Germain-des-Prés, 1951), 24.

86. Ibid., 27. This may have been a jab at René Coursaget, who had used Louis Vert's photos instead of Atget's in *Dans les rues de Paris au temps des fiacres*.

87. Ibid., 27, 24.

88. *Les grands créateurs de Paris et leurs oeuvres: juillet–octobre 1951* (Paris: Presses artistiques, 1951), n.p.

89. The absence of Bimillénaire participation in the anniversary may also have been part of the lack of national support for the Bimillénaire—both were held at state-run cultural institutions.

90. "La vie à Paris: Au Muséum d'histoire naturelle: Les conquêtes de la photographie," *Le Monde*, June 16, 1951; Robert Coiplet, "Cent douze ans de photographies," *Le Monde*, June 17, 1951.

91. "Nos echos . . . Centenaire de Daguerre," *Photo-France*, August–September 1951, 48. For more about whether or not this was a fair conclusion to draw, see Pinson, *Speculating Daguerre*.

92. Robert Coiplet, "Daguerre est mort le 10 juillet 1851 mais il n'avait pas inventé la photographie," *Le Monde*, July 9, 1951.

93. Ronis, *Sur le fil du hasard*, n.p.

94. For an introduction to postwar humanist photography in France, see Peter Edward Hamilton, "Representing the Social: France and Frenchness in Postwar Humanist Photography," in *Representation: Cultural Representations and Signifying Practices*, ed. Stuart Hall (London: SAGE, 1997), 75–150.

95. For this section, I surveyed coverage of the Bimillénaire in daily newspapers *Le Monde, Combat, L'Aube, Le Parisien libéré, New York Times, Times of London*, and weekly and monthly publications *Paris Match, Réalités, France-Illustration, le Monde illustré, Touring, Les Lettres françaises, Photo-France, National Geographic, Vogue, Revue de l'art belge, Coronet, Life, Gourmet, Holiday, House and Garden, Saturday Review, The Rotarian*, and *UN World*.

96. Eugene Kammerman, "Paris: Aetat. 2,000," *New York Times Magazine*, June 3, 1951, 24–25.

97. "Le Match de Paris vous offre le bouquet du bimillénaire," *Paris Match*, July 21, 1951, 33.

98. "Les nuits de Paris ont 2000 ans," *Paris Match*, July 28, 1951, 16–23.

99. "Paris after Dark," *Coronet*, September 1951, 69–84.

100. "A Salute to Paris on Her 2,000th Birthday," *Life*, July 30, 1951, 68–83.

101. Irving Penn, "Visages et métiers de Paris," *Vogue*, June 1951, 40–43.

102. Peter Hamilton, *Robert Doisneau: A Photographer's Life* (New York: Abbeville Press, 1995), 222–224.

103. Virginia Heckert and Anne Lacoste, *Irving Penn: Small Trades* (Los Angeles: J. Paul Getty Museum, 2009), 10. Heckert and Lacoste acknowledge that the Paris photos appeared in the issue of French *Vogue* dedicated to the 1951 celebrations but interpret them within the context of Penn's photographic training and subsequent production of small trade work.

104. "Images de Paris: Les sept aspects essentiels de la Cité," *Réalités*, June 1951, 54.

105. Ibid.

106. For books with aerial views, see *Paris vu en avion* (Paris: Aéro-photo, 1930); Hourticq, *Paris vu du ciel*; Roger Henrard, *Paris vu du ciel* (Paris: Armand Colin, 1952).

107. Albert Mousset, "Le passé prestigieux de Paris," *France-Illustration, le Monde illustré*, April 21, 1951, n.p.

108. Ibid.

109. "Nos echos . . . L'activité du Groupe des XV," *Photo-France*, May 1951, 54.

110. "Nos echos . . . Encore le Groupe des XV," *Photo-France*, February–March 1951, 47.

111. *Le reportage photographique*, trans. Simon Noireaud (Amsterdam: Editions "Time-Life," 1972), 68.

112. Jean Leroy, "Monographie, Izis," *Photo-Revue*, January 1977, 18.

113. Marcel Bovis, "Le rectangle et le Groupe des XV," in *Paris 1950 photographié par le Groupe des XV*, ed. Marie de Thézy (Paris: Direction des affaires culturelles, 1982), 8.

114. Jean-Louis Vaudoyer, "Peinture et photographie," *Photo-France*, July 1951, 11.

115. René Coursaget, "Imagiers de Paris des Limbourg au Groupe des XV," *Photo-France*, July 1951, 12–14.

116. The Groupe des XV organized in part in order to do so. The idea of the "decisive moment" arose at the same time and would serve the same purpose: Catherine E. Clark, "A Decisive Moment, France, 1932," in *Getting the Picture: The History*

and Visual Culture of the News, eds. Jason E. Hill and Vanessa R Schwartz (New York: Bloomsbury Academic, 2015), 55–58; Nadya Bair, "The Decisive Network: Producing Henri Cartier-Bresson at Mid-Century," *History of Photography* 40, no. 2 (April 2016): 146–166.

117. *Photo-France*, August–September 1951, 6.
118. "Nos echos . . . Une exposition de photographies de Paris sur le Liberté," *Photo-France*, August–September 1951, 48.
119. "Découverte de la France VIe Salon national," *Photo-France*, August–September 1951, 48.
120. "Le tourisme dans le monde: Concours de photographies, de films, de maquettes, d'affiches et de dépliants," *Le Monde*, June 21, 1951. This sum is in old francs, roughly equivalent to 626,400 2011 euros.
121. Lucien Lorelle, "Conseils," in *6e Salon national de la photographie* (Paris: Bibliothèque nationale, 1951), 17.
122. France also had a more trade-expo style event called the Salon de la photographie. Its twenty-second iteration had been held the previous March: "Le 22e Salon de la photographie s'est ouvert à la porte de Versailles," *Le Monde*, March 3, 1951.
123. R. C., "Le sixième Salon national de la photographie," *Le Monde*, October 6, 1951.
124. Yvan Christ, "Tourisme et photographie," in *6e Salon national de la photographie* (Paris: Bibliothèque nationale, 1951), 6.
125. Ibid.
126. I'm grateful to his daughter Elizabeth Wallace, who shared his scrapbook and photographs with me.
127. Henri Ingrand, "Le tourisme et la photographie," *Photo-France*, November 1951, 10.
128. "Paris after Dark," 69.
129. Jean Pastereau, "[Introduction]" in René-Jacques, *Paris la nuit: La ville lumière* (Paris: La bibliothèque des arts, 1964), 10.
130. Christ, *Les métamorphoses de Paris*. Peter Sramek has also noted Christ's innovation in this domain: Sramek, *Piercing Time*, 14.
131. Yvan Christ, *Les métamorphoses de la banlieue parisienne: Cent paysages photographiés autrefois par Atget, Bayard, Beissein, Daguerre . . . [etc] et aujourd'hui par Charles Ciccione* (Paris: Balland, 1969).
132. Yvan Christ, Michel Melot, and Charles Ciccione, *Les métamorphoses de la Normandie* (Paris: Balland, 1971); Yvan Christ, *Les métamorphoses de la Côte d'Azur* (Paris: Balland, 1971).
133. Yvan Christ, *Les nouvelles métamorphoses de Paris: Plus de cent paysages parisiens . . .* , 3 éd. revue, corrigée et augmentée (Paris: Balland, 1976).

CHAPTER 5

1. "Concours photo: Ils sont partis . . . ," *Contact: Journal d'information réservé aux adhérents de la Fnac*, June 1970, 2–3.

2. For more about the transformation of this site, see Norma Evenson, "The Assassination of Les Halles," *Journal of the Society of Architectural Historians* 32, no. 4 (December 1973): 308–315; Rosemary Wakeman, "Fascinating Les Halles," *French Politics, Culture and Society* 25, no. 2 (Summer 2007): 46–72; Meredith TenHoor, "Architecture and Biopolitics at les Halles," *French Politics, Culture and Society* 25, no. 2 (Summer 2007): 73–92.

3. Louis Chevalier, *The Assassination of Paris*, trans. David P. Jordan (Chicago: University of Chicago Press, 1994). I build on an interest in what art historians term "vernacular" or "snapshot" photography: Geoffrey Batchen, ed., "Vernacular Photographies [special section]," *History of Photography* 24, no. 3 (2000): 229–271; Geoffrey Batchen, "Snapshots: Art History and the Ethnographic Turn," *Photographies* 1, no. 2 (2008): 121–142; Berger, "Snapshots, or: Visual Culture's Clichés;" Catherine Zuromskis, *Snapshot Photography: The Lives of Images* (Cambridge, MA: MIT Press, 2013).

4. For scholarship about and contemporary criticism of these renovations, see Evenson, *Paris*; Chevalier, *The Assassination of Paris*; François Loyer, "Préface," in *La bataille de Paris: Des Halles à la Pyramide, chroniques d'urbanisme* (Paris: Gallimard, 1991), 7–30.

5. For more about the postwar development of Paris's suburbs, see Annie Fourcaut, Emmanuel Bellanger, and Mathieu Flonneau, *Paris-banlieues, conflits et solidarités: Historiographie, anthologie, chronologie, 1788–2006* (Paris: Créaphis éditions, 2007).

6. For more about cars and Paris, see Ross, *Fast Cars, Clean Bodies*; Mathieu Flonneau, *Paris et l'automobile: Un siècle de passions* (Paris: Hachette, 2005).

7. For more about debates around the zoning of Paris and how national interests pushed to relocate industrial production to the provinces, see the last chapter of Wakeman, *The Heroic City*.

8. André Fermigier, "Le troisième siège de Paris: Allez voir au Grand Palais les dominos de l'an 2000, c'est de votre vie qu'il s'agit (*Le Nouvel observateur*, 12 avril 1967)," in *La bataille de Paris: Des Halles à la Pyramide, chroniques d'urbanisme* (Paris: Gallimard, 1991), 32–33.

9. "Pour sauver Paris, qui meurt un peu tous les jours: La Fnac lance l'opération 'C'était Paris en 1970,'" advertisement in *Le Monde*, March 21, 1970.

10. Patrick d'Elme, ed., "C'était Paris en 1970," special issue, *La galerie: Arts, lettres, spectacles, modernité*, no. 107–108 (August–September 1971).

11. Photographers' participant numbers appear on the reverse side of most photos, although some bear no attribution. These numbers correspond to names and addresses noted on the library's copy of the master participant list.

12. When I first wrote about the contest, I assumed that participants assigned to these squares had not submitted photos. But now I wonder whether the FNAC might have held on to them for some reason and thus they never joined the rest of the photos at the Bibliothèque historique: Catherine E. Clark, "'C'était Paris en

1970': Histoire visuelle, photographie amateur et urbanisme," trans. Jean-François Allain, *Etudes photographiques*, no. 31 (Spring 2014): 94–95.

13. Since the first sales of George Eastman's Kodak in 1888, discourses about photography had highlighted its accessibility. The expense and technical skill involved, however, made photography a pastime of the wealthy until well into the twentieth century: Marin Dacos, "Le regard oblique," *Etudes photographiques*, no. 11 (May 2002): 44–67.

14. "Pour sauver Paris, qui meurt un peu tous les jours."

15. Henriot, "Photos de Paris"; Valéry, "Discours du centenaire de la photographie," 93.

16. "[Interview with] M. Claude Gourbeyre, maire du 20e arrondissement," *Contact: Journal d'information réservé aux adhérents de la Fnac*, March 1970, 9.

17. Ibid.

18. Ibid. Emphasis is in the original.

19. Henry de Surirey de Saint-Remy, "'C'était Paris en 1970': Note sur certaines conditions de l'organisation du concours appréciées du point de vue de la Bibliothèque historique," n.d., "C'était Paris en 1970" documents, BHVP.

20. Ibid.

21. Moreover, de Surirey de Saint-Remy would succeed in convincing the city and the FNAC that the Bibliothèque historique, rather than the Archives de Paris, should house the resulting photographs. The FNAC may have announced the inverse simply because the organizers did not understand the distinction between the two institutions. Ibid.

22. See, for example: "Organisation, par la Ville, d'expositions photographiques de sites choisis, soit à Paris, soit dans le département de la Seine," *Commission municipale du Vieux Paris: Procès-verbaux*, October 23, 1902, 225–226.

23. By the late 1980s, it had opened a chain of multimedia megastores, which competed with HMV and Virgin Megastores. For more about the FNAC, see Vincent Chabault, *La Fnac, entre commerce et culture: Parcours d'entreprise, parcours d'employés* (Paris: Presses universitaires de France, 2010); Jean-Louis Pétriat, *Les années Fnac: de 1954 . . . à après-demain* (Paris: Fayard, 1991).

24. Pétriat, *Les années Fnac*, 130.

25. Ibid., 101–102.

26. Ibid., 106–107.

27. Ibid., 133.

28. André Essel, "Les amateurs de photo témoignent pour l'avenir," *C'était Paris en 1970*, [1970], 3, "C'était Paris en 1970" documents.

29. "Pour sauver Paris, qui meurt un peu tous les jours."

30. André Essel, "Editorial: La Fnac, le design et le concours," *Contact: Journal d'information réservé aux adhérents de la Fnac*, May 1970, 3.

31. "Pour sauver Paris, qui meurt un peu tous les jours."

32. The Marais was one of the first districts targeted by the new law: Evenson, *Paris*, 315–323; Hannah Feldman, "Chapter 2: Façades; or, The Space of Silence,"

From a Nation Torn: Decolonizing Art and Representation in France, 1945–1962 (Chicago: University of Chicago Press, 2014); Guillaume, ed., *Le Marais en héritage(s)*.

33. "Pour sauver Paris, qui meurt un peu tous les jours."
34. "[Interview with] M. Claude Gourbeyre," 9; "Pour sauver Paris, qui meurt un peu tous les jours."
35. "Pour sauver Paris, qui meurt un peu tous les jours."
36. Clark, " 'C'était Paris en 1970,' " 93.
37. Numbers are from: "Concours photo: Ils sont partis . . . ," 2; Philippe Pons, "Le roman-photo de l'opération 'C'était Paris en 1970,' " "C'était Paris en 1970," special issue, 10. The actual number of contributors is likely higher because many continued to submit documentation after the deadline.
38. Pons, "Le roman-photo de l'opération 'C'était Paris en 1970,' " 8.
39. "Communiqué à la presse," April 17, 1970, "C'était Paris en 1970" documents. The real number of participants is probably lower since certain photographers likely signed up multiple times. Christian Vigne asked two friends to sign up so that he could document three squares. Christian Vigne, Interview with author, e-mail, May 8, 2010.
40. "Communiqué à la presse."
41. Renée Favard, "Impressions d'une lauréate," *C'était Paris en 1970*, [1970], 7, "C'était Paris en 1970" documents.
42. M. P. D., Viroflay, "Courrier: Un super-gogo bénévole," "C'était Paris en 1970," special issue, 186, 189.
43. "Cent mille bonnes photos: C'était Paris en 1970," *Contact: Journal d'information réservé aux adhérents de la Fnac*, October 1970, 16.
44. Ibid.
45. Written by Claude Bolling and Pierre Delanoë, sung by Juliette Gréco, "C'était Paris en 1970" (Philips, 1970).
46. Nancy Martha West, *Kodak and the Lens of Nostalgia* (Charlottesville: University Press of Virginia, 2000), 27.
47. Edwards, *The Camera as Historian*, 2.
48. A photographer by the name of Séeberger won first prize. "Compte rendu de l'exposition municipale de photographies documentaires et fixation du programme de l'an prochain," *Commission municipale du Vieux Paris: Procès-verbaux*, February 9, 1905, 19. Sums are in old francs.
49. "Pour sauver Paris, qui meurt un peu tous les jours." Figures are in new francs.
50. "Création d'expositions de photographies," *Commission municipale du Vieux Paris: Procès-verbaux*, January 15, 1903, 5.
51. B. G. A., "Des patronages officiels sont retirés à un concours de photographie sur 'Paris en 1970,' " *Le Monde*, April 11, 1970.
52. Molly Nesbit, "What Was an Author?" *Yale French Studies*, no. 73 (January 1987): 229–257.

53. "Le concours de la Fnac," *L'écho de la presse*, April 13, 1970, "C'était Paris en 1970" documents.

54. Letter from the society's president cited in: "On écrit au 'Canard,'" *Le Canard enchaîné*, April 22, 1970, 4.

55. "Quand les journalistes obligent le Préfet à respecter la loi," *Le journal des journalistes*, March–April 1970, "C'était Paris en 1970" documents. The Préfet de Paris subsequently denied photographers' requests for permission to photograph in cemeteries: Le Préfet de Paris, "Et la bonne volonté," "C'était Paris en 1970," special issue, 189–190.

56. A. Boccara, "Aff: Concours F.N.A.C.," April 23, 1970, 6, "C'était Paris en 1970" documents.

57. André Gouillou, "[letter]," April 15, 1970, "C'était Paris en 1970" documents.

58. Lenotre, *Le vieux Paris*, 1912, vol. 1, n.p.

59. V. R., "Président de la F.N.S.P.F. communique," *Photo-Revue*, July–August 1970, "C'était Paris en 1970" documents.

60. André Essel did concede that the contest was "indisputably promotional for photography, and consequently, for the FNAC." "On écrit au 'Canard.'"

61. André Essel, "Editorial: Défense d'agir," *Contact: Journal d'information réservé aux adhérents de la Fnac*, June 1970, 3.

62. "A photographier," *Le Canard enchaîné*, April 15, 1970, 2.

63. P. D., Viroflay, "Courrier: Un super-gogo bénévole," 186.

64. Ibid.

65. Vigne, Interview with author.

66. Ibid.

67. Chevalier, *The Assassination of Paris*.

68. Henry Gasquet, "Nous irons à Paris . . . en voiture," *Touring: Revue du Touring club de France*, April 1951, 88.

69. Ibid.

70. Yvan Christ, "Dénoncez les vandales!: Peut-on rénover les abords de Notre-Dame?," *Arts*, April 4, 1962, 11; Yvan Christ, "Dénoncez les vandales!: Encore des démolitions en Ile-de-France," *Arts*, April 28, 1962, 11; Yvan Christ, "Dénoncez les vandales!: Lyon: une chapelle jésuite transformée en chaufferie," *Arts*, June 6, 1962, 9.

71. "Pour sauver Paris, qui meurt un peu tous les jours."

72. "[Interview with] M. Claude Gourbeyre," 9.

73. "Paris mobilise tous les Parisiens qui ont un appareil photo," *Le Monde*, March 28, 1970.

74. "Pour sauver Paris, qui meurt un peu tous les jours."

75. This was later published as: Gébé, *L'an 01* (Paris: Editions du Square, 1972).

76. Gébé, "Paris qu'on pioche," *Pilote*, no. 549 (May 1970): 8–9.

77. Henry de Surirey de Saint-Remy, "Images de Paris confiées à Paris 1871–1971," "C'était Paris en 1970," special issue, 19.

78. "Paris mobilise tous les Parisiens qui ont un appareil photo."
79. de Surirey de Saint-Remy, "Images de Paris confiées à Paris 1871–1971," 19.
80. Ibid., 20.
81. Folder 576, "C'était Paris en 1970" photos, BHVP. "Son front aristocratique / s'impose encore dans le quartier / sous son œil mélancolique / l'histoire est venue se cacher / Jeune il s'est beaucoup démené / à se faire hospitalier / maintenant avec ses secrets / il se penche sur son passé."
82. "Emission du 16 juillet 1971," *Journal de Paris*, July 16, 1971, INA.
83. "Pour sauver Paris, qui meurt un peu tous les jours."
84. Patrice Boussel, "Paris, villages," "Paris aux cent villages [exposition, Paris, BHVP]," special issue, *Paris aux cent villages*, November 1976, n.p.
85. Rice, *Parisian Views*, 124.
86. Ibid., 125.
87. For more about these photographs as a protest of contemporary urbanism, see Clark, " 'C'était Paris en 1970.' "
88. Vigne, Interview with author.
89. "C'était Paris en 1970," special issue, 42.
90. Pons, "Le roman-photo de l'opération 'C'était Paris en 1970,'" 12.
91. Ibid., 13.
92. "Cent mille bonnes photos," 16.
93. Mlle C. G., Paris, "Courrier: Quels critères?," "C'était Paris en 1970," special issue, 190.
94. M. R. G., Issy-les-Moulineaux, "Courrier: Une tour Eiffel biscornue," "C'était Paris en 1970," special issue, 190.
95. Ibid.
96. M. R. G., Issy-les-Moulineaux, "Courrier: Une tour Eiffel biscornue," 190.
97. Lartigue had become an almost overnight sensation after the 1964 exhibition of his work at MoMA: Kevin Moore, *Jacques Henri Lartigue: The Invention of an Artist* (Princeton: Princeton University Press, 2004).
98. "Exposition d'architecture française contemporaine en l'U.R.S.S.," *L'architecture d'aujourd'hui*, February 1974, v, "C'était Paris en 1970" documents.
99. Anne McCauley, "En-dehors de l'art," *Etudes photographiques*, Colloque "Photographie, les nouveaux enjeux de l'histoire," no. 16 (May 2005): 50–73.
100. "Concours-photo: Le jury au travail," *Contact: Journal d'information réservé aux adhérents de la Fnac*, September 1970, 16.
101. Marie de Thézy, "Les photographies anciennes et modernes," 29; Marie de Thézy, *Marville, Paris* (Paris: Hazan, 1994).
102. Boussel, "Paris, villages," n.p.
103. Maria Morris, "Eugene Atget, 1857–1927: The Structure of the Work," (PhD diss., Columbia University, 1980); Margaret Spence Nesbit, "Atget's Seven Albums, in Practice," (PhD diss., Yale University, 1983).
104. The photo was increasingly valued as art and commodity. For more, see Stuart Alexander, "Photographic Institutions and Practices," in Frizot, *A New History*

of Photography, 694–707; Gaëlle Morel, *Le photoreportage d'auteur: L'institution culturelle de la photographie en France depuis les années 1970* (Paris: CNRS éditions, 2006).

105. "Grand concours photo: Paris aux cent villages," *Paris aux cent villages*, August 1976, 9; Boussel, "Paris, villages," n.p.

106. *C'était Toulouse en 1986 organisé par la Fnac et la ville de Toulouse* (Toulouse: La galerie municipale du Château d'eau, 1986), n.p.

107. Vincent Guigueno, "La France vue du sol: Une histoire de la Mission photographique de la DATAR (1983–1989)," *Etudes photographiques*, no. 18 (May 2006): 96–119; Welch, "Portrait of a Nation"; Blatt, "Détours en France"; Bertho, *La Mission photographique de la DATAR*.

108. Such "mass photography" projects in the Anglophone context bear striking similarities to the FNAC contest. For more about them, and in particular the 1987 *One Day for Life*, see Annebella Pollen, *Mass Photography: Collective Histories of Everyday Life* (London: I.B. Tauris, 2016).

109. "Concours photo: Ma vie des Halles," Wipplay, accessed November 12, 2016, http://www.wipplay.com/fr_FR/concours-photo/vie-halles#

110. "Les lauréats du concours photo 'Ma vie des Halles' s'exposent sur les palisades," accessed November 12, 2016, http://www.parisleshalles.fr/actualite-les-laureats-du-concours-photo-ma-vie-des-halles-s-exposent-sur-les-palissades-001779.

CONCLUSION

1. It was the brainchild of then-mayor Jacques Chirac and Pierre Emmanuel, a poet and member of the Académie française who had served as the first president of the Institut national de l'audiovisuel (INA), the television and radio archive started in 1975. For more about its origins, see Catherine E. Clark, "La Vidéothèque de Paris, Memory for the Future," *Contemporary French Civilization* 40, no. 1 (2015): 1–23.

2. Vidéothèque de Paris, *Archive de films sur Paris possibilité de les consulter*, 1988, INA, accessed May 8, 2014, http://www.ina.fr/video/PUB3784077065.

3. In 1998, the Vidéothèque's name was changed to the Forum des images. It is still at Les Halles, and since 2008 its Paris collections have been available in digital form. They are not, however, available online.

4. Jean-Michel Frodon, "Paris au doigt et à l'oeil," *Le Monde*, January 29, 1991.

5. Cayla is cited in: Ibid.

6. Véronique Cayla. "Une première mondiale, la Vidéothèque de Paris," *Dossiers de l'audiovisuel*, no. 30 (1990): 29.

7. Louis Chevalier, *L'assassinat de Paris* (Paris: Calmann-Lévy, 1977), 16.

8. In a 2004 conference presentation, William Thomas asked whether the future of digital history was spatial history. The presentation was formerly available online at: http://www.vcdh.virginia.edu/thomas.spatial.pdf. For more about images and

digital history, see Daniel J. Cohen et al., "Interchange: The Promise of Digital History," *Journal of American History* 95, no. 2 (September 2008): 442–451.

9. Interactive features include slide bars and fade transitions, while mobile applications allow users to bring these images with them to photographic sites.

10. Jonathan Jones, "'Retronauting': Why We Can't Stop Sharing Old Photographs," *Guardian*, April 13, 2014.

BIBLIOGRAPHY

PRIMARY SOURCES

Archives

Archives de Paris
 2ETP/1/2/63 24
 3574W
 Archives de la Chambre de commerce et de l'industrie de Paris—2ETP/6/8/00 11
 VR 1
 VR 234
Archives de la Préfecture de Police
 FC 2
Archives nationales
 F41
Bibliothèque du film, Cinémathèque française
 Fonds Victor Perrot
Bibliothèque historique de la Ville de Paris
 Actualités: Expositions de la Bibliothèque
 "C'était Paris en 1970": Photos and documents
 Papiers Marcel Poëte
 Papiers Paul Jarry
 Registres d'entrée du département des photographies
Bibliothèque nationale de France
 Dossiers biographiques Boutillier du Retail: Georges Cain, Louis Chéronnet
 Image collections: Georges Cain
Institut mémoires de l'édition contemporaine (IMEC)
 Fonds Hachette
 Fonds Pierre Lafitte

Institut national de l'audiovisuel (INA)

Les actualités françaises 1951

Journal de Paris 1970–1971

Journal télévisé 1951

Musée Carnavalet

Archives—1AH

Cabinet des estampes: Photos; Dossier Expo (1941): Petits métiers; Dossier Libération

Musée d'Orsay

Centre de documentation: Georges Cain, Fedor Hoffbauer

Private Collections

William Wallace Papers/Photos

Interviews

Christian Vigne

Claude Arthaud

Sylvie Gabriel

Periodicals

L'Aube

Bulletin de la Bibliothèque et des Travaux historiques

Le Canard enchaîné

Combat

Contact: Journal d'information réservé aux adhérents de la Fnac

Coronet

France-Illustration, le Monde illustré

Les Lettres françaises

Le Monde

National Geographic

New York Times

New York Times Magazine

Le Parisien libéré

Paris Match

Photo-France

Photographie

Réalités

Société d'iconographie parisienne

Times of London

Touring

Vogue (Paris)

Articles and Books

"2e sous-commission." *Commission municipale du Vieux Paris: Procès-verbaux*, June 2, 1898, 29–38.

"Le 21 janvier." *Le voleur illustré: Cabinet de lecture universel*, January 28, 1886, 55–58.

6e Salon national de la photographie. Paris: Bibliothèque nationale, 1951.

"A travers le passé." *Le jardin des lettres*, no. 3 (January 1931): 10–11.

L'âge de Caïn: Premier témoignage sur les dessous de la Libération de Paris. Paris: Les éditions nouvelles, 1948.

Alexandre, Arsène. "Carnavalet: Un critique d'art à Carnavalet." *Les annales "conferencia,"* October 1907, 464–466.

L'âme des camps, exposition, album-souvenir. Paris: Croix rouge française, Comité central d'assistance aux prisonniers de guerre en captivité, 1944.

Anonymous. "Deux antiquaires." *Le Gaulois*, February 7, 1885, 1.

Atget, Eugène, and Pierre Mac Orlan. *Atget: Photographe de Paris*. Paris: Henri Jonquières, 1930.

Babelay, Jean Louis. *Un an*. Text by A. G. Leroux. Paris: Editions Raymond Schall, 1946.

Banger, Hans, and Emmanuel Boudot-Lamotte. *Paris, Wanderung durch eine Stadt*. Paris: Verl. der Deutschen Arbeitsfront, 1942.

Les barricades de Paris VII: La Libération. Paris: A. Fleury, 1944.

Baudelaire, Charles. "The Salon of 1859." In *Photography in Print: Writings from 1816 to the Present*, edited by Vicki Goldberg, translated by Jonathan Mayne, 123–126. Albuquerque: University of New Mexico Press, 1988.

Bertrand. "Les livres d'étrennes." *Revue des deux mondes* 75, no. 30 (November 1905): 933–946.

Besson, George. *Matisse*. Paris: Braun, 1943.

Bicknell, Ethel E. *Paris and Her Treasures*. New York: Charles Scribner's Sons, 1912.

Bimillénaire de la Ville de Paris: Exposition "Paris," peintures, gravures, cartes, livres, dessins et photographies illustrant le développement et l'esprit de Paris du 15 mars au 30 avril 1951 . . . Services culturelles de l'Ambassade de France . . . New York. New York: [1951].

Bolling, Claude, and Pierre Delanoë. "C'était Paris en 1970." Sung by Juliette Gréco, Philips, 1970.

Bonfils, Robert. *200 vues de Paris: Guide des musées, églises, monuments, bibliothèques, curiosités, spectacles*. Paris: Larousse, 1930.

Boucher, François. *La grande délivrance de Paris*. Paris: J. Haumont, 1945.

Brassaï, *Paris de nuit*, with text by Paul Morand. Paris: Arts et métiers graphiques, 1934.

C. I. B. "Romantic Paris." *New-York Tribune*, August 16, 1908.

Cain, Georges. *The Byways of Paris*. Translated by Louise Seymour Houghton. New York: Duffield, 1912.

Cain, Georges. *Coins de Paris*. Paris: E. Flammarion, 1910.

Cain, Georges. *Le long des rues: Ouvrage orné de 124 illustrations et de plans anciens et modernes*. Paris: E. Flammarion, 1912.

Cain, Georges. *Nooks and Corners of Old Paris.* Translated by Frederick Lawton. London: E.G. Richards, 1907.

Cain, Georges. *Nouvelles promenades dans Paris.* Paris: Flammarion, 1908.

Cain, Georges. *Promenades dans Paris: Ouvrage orné de 107 illustrations et de 18 plans anciens et modernes.* Paris: E. Flammarion, 1906.

Cain, Georges. "Saint-Lazare." In Lenotre, *Le vieux Paris.* vol. 3, 5–26.

Cain, Georges. *A travers Paris.* Paris: Ernest Flammarion, 1909.

Cain, Georges. *Walks in Paris.* Translated by Alfred Allinson. New York: The Macmillan Company, 1909.

Campaux, Suzanne. *La Libération de Paris. (19–26 août 1944): Récits de combattants et de témoins réunis par S. Campaux.* Paris: Payot, 1945.

Carco, Francis. *Nostalgie de Paris.* Genève: Editions du milieu du monde, 1941.

Cayla, Véronique. "Une première mondiale, la Vidéothèque de Paris." *Dossiers de l'audiovisuel,* no. 30 (1990): 28–29.

C'était Toulouse en 1986 organisé par la Fnac et la ville de Toulouse. Toulouse: La galerie municipale du Château d'eau, 1986.

Champion, Pierre. *L'avènement de Paris: La vie de Paris au Moyen âge.* Notre vieux Paris. Paris: Calmann-Lévy, 1933.

Chéronnet, Dominique-Jean-François. *Histoire de Montmartre, état physique de la butte, ses chroniques, son abbaye, sa chapelle du martyre, sa paroisse, son église et son calvaire, Clignancourt.* Paris: Breteau et Pichery, 1843.

Chéronnet, Louis. *A Paris . . . vers 1900.* Découverte du monde. Paris: Editions des Chroniques du jour, 1932.

Chéronnet, Louis. *Paris tel qu'il fut: 104 photographies anciennes.* Paris: Editions Tel, 1943.

Chéronnet, Louis. *Paris tel qu'il fut: 104 photographies anciennes.* Paris: Editions Tel, 1951.

Chéronnet, Louis. *Le petit musée de la curiosité photographique.* Paris: Editions Tel, 1945.

Chevalier, Louis. *L'assassinat de Paris.* Paris: Calmann-Lévy, 1977.

Chevalier, Maurice, Francis Lopez, and Albert Willemetz. *Paris a ses 2.000 ans.* Polydor: 1951.

Christ, Yvan. "Dénoncez les vandales! Encore des démolitions en Ile-de-France." *Arts,* April 28, 1962, 11.

Christ, Yvan. "Dénoncez les vandales! Lyon: une chapelle jésuite transformée en chaufferie." *Arts,* June 6, 1962, 9.

Christ, Yvan. "Dénoncez les vandales! Peut-on rénover les abords de Notre-Dame?" *Arts,* April 4, 1962, 11.

Christ, Yvan. *Les métamorphoses de la banlieue parisienne: Cent paysages photographiés autrefois par Atget, Bayard, Beissein, Daguerre . . . [etc] et aujourd'hui par Charles Ciccione.* Paris: Balland, 1969.

Christ, Yvan. *Les métamorphoses de la Côte d'Azur.* Paris: Balland, 1971.

Christ, Yvan. *Les métamorphoses de Paris, cent paysages parisiens photographiés autrefois par Atget, Bayard, Bisson, Daguerre . . . [etc] et aujourd'hui par Janine Guillot et Charles Ciccione.* Paris: Balland, 1967.

Christ, Yvan. *Les nouvelles métamorphoses de Paris: Plus de cent paysages parisiens . . .*, 3 éd. revue, corrigée, et augmentée. Paris: Balland, 1976.

Christ, Yvan. *Saint-Germain-des-Prés 1900 vu par Atget*. Paris: Le comité de la quinzaine de Saint-Germain-des-Prés, 1951.

Christ, Yvan, Michel Melot, and Charles Ciccione. *Les métamorphoses de la Normandie*. Paris: Balland, 1971.

Claretie, Jules. *La vie à Paris: 1898*. Paris: G. Charpentier et E. Fasquelle, 1899.

Claude, Henri. *Le problème de la paix*. Paris: S.A.L., 1947.

"Communication de M. L. Tesson sur le Mont-Valérien et son histoire—Vœux de la commission." *Commission municipale du Vieux Paris: Procès-verbaux*, June 25, 1921, 129–132.

"Compte rendu de la visite des toiles du diorama de J.-H. Hoffbauer 'Paris à travers les âges,' déposées à l'entrepôt Saint-Bernard—Décisions prises." *Commission municipale du Vieux Paris: Procès-verbaux*, January 26, 1924, 2.

"Compte rendu de l'exposition municipale de photographies documentaires et fixation du programme de l'an prochain." *Commission municipale du Vieux Paris: Procès-verbaux*, February 9, 1905, 18–21.

"Compte-rendu des séances: Assemblée générale tenue à la Bibliothèque nationale le 12 mai 1885." *Bulletin de la Société de l'histoire de Paris et de l'Ile-de-France: 12e année, 1885*. Paris: H. Champion, 1885, 65–78.

"Concours photo: Ma vie des Halles." Wipplay. http://www.wipplay.com/fr_FR/concours-photo/vie-halles#. Accessed November 12, 2016.

Coursaget, René, and Georges Pillement, *Dans les rues de Paris au temps des fiacres*. Paris: Editions du Chêne, 1950.

Cousin, Jules. "Biographie d'un musée et d'un homme." *La plume*, January 15, 1892, 31–32.

"Création d'expositions de photographies." *Commission municipale du Vieux Paris: Procès-verbaux*, January 15, 1903, 4–6.

Dansette, Adrien. *Histoire de la Libération de Paris*. Paris: Fayard, 1946.

Dayot, Armand. *Histoire contemporaine par l'image: 1789–1872 d'après les documents du temps*. Paris: Flammarion, 1900.

Dayot, Armand. *L'invasion, le siège, la Commune, 1870–1871: D'après des peintures, gravures, photographies, sculptures, médailles, autographes, objets du temps. . . .* Paris, E. Flammarion, n.d.

de Bary, Herbert, and Erika Ruthenbeck. *Das verschleierte Bild von Paris: Pariser Bilderbogen*. Paris: Prisma, 1943.

d'Elme, Patrick, ed. "C'était Paris en 1970." Special issue, *La galerie: Arts, lettres, spectacles, modernité*, no. 107–108, August–September 1971.

de Santeul, C. "A propos de photographie." *Bulletin de la Société française de photographie*, August 1924, 180–183.

Deschamps, Gaston. "Georges Cain." *Le Temps*, March 6, 1919, 3.

Deschamps, Paul, and Marc Foucault. *La cathédrale d'Amiens*. Paris: Editions Tel, 1942.

Dettweiler, Frieda, and Johanna Müller. *Ein Tag in Versailles, Illustrierter Führer von Schloss, Museum, Park, und Trianons.* Paris: Braun, 1941.

"Discours prononcés par M. Le Corbeiller, Vice-Président de la Commission et par M. le docteur Capitan, aux obsèques de M. J.-H. Hoffbauer." *Commission municipale du Vieux Paris: Procès-verbaux,* December 16, 1922, 129–131.

Dubech, Lucien, and Pierre d'Espezel. *Histoire de Paris.* Paris: Payot, 1926.

Dubois, Edmond. *Vu pendant la Libération de Paris: Journal d'un témoin, illustré de 21 photographies.* Lausanne: Payot, 1944.

Duclos, Jacques. *L'insurrection parisienne: 19–26 août 1944,* 2nd ed. Paris: Editions du Parti communiste français, 1946.

Duhamel, Georges. *La semaine héroïque: 19–25 août 1944.* Paris: S.E.P.E., 1944.

Duhamel, Georges. *Tribulations de l'espérance.* Paris: Mercure de France, 1947.

Dupuy, Ferdinand. *La Libération de Paris vue d'un commissariat de police.* Paris: Librairies-imprimeries réunies, 1945.

Dupuy, Ferdinand. *La Libération de Paris vue d'un commissariat de police.* Paris: Librairies-imprimeries réunies, 1946.

Enlart, Camille. "Notice nécrologique sur Charles Read, Membre résidant de la Société nationale des antiquaires de France (1819–1898)." *Bulletin de la Société nationale des antiquaires de France,* 1903, 63–77.

Eparvier, Jean. *A Paris sous la botte des Nazis.* Paris: Raymond Schall, 1944.

Escholier, Raymond. *Paris: Aquarelles de Nicolas Markovitch.* Paris: Editions Alpina, 1929.

"Une exposition de vieilles photographies au Musée Carnavalet." *Le Matin,* October 20, 1941, 4.

Fermigier, André. *La bataille de Paris: Des Halles à la Pyramide, chroniques d'urbanisme.* Paris: Gallimard, 1991.

Ferry, Jules. *Comptes fantastiques d'Haussmann.* Paris: Le chevalier, 1868.

Flanner, Janet (Genêt). *Paris Journal 1944–1965.* Edited by William Shawn. New York: Atheneum, 1965.

Fournel, Victor. "Les oeuvres et les hommes: Courrier du théâtre, de la littérature et des arts." *Le Correspondant,* June 10, 1885, 924–956.

Frodon, Jean-Michel. "Paris au doigt et à l'oeil." *Le Monde,* January 29, 1991.

Fronval, Georges. *Paris brise ses chaînes! Epopée des 20 arrondissements et de la banlieue dans les journées du 19 au 25 août 1944.* Paris: Editions et revues françaises, 1944.

Galignani's Illustrated Paris Guide for 1889. Paris: The Galignani Library, 1889.

Galtier-Boissière, Jean. *Mon journal depuis la Libération.* Paris: La jeune parque, 1945.

Gauthiez, Pierre. *Paris.* Les beaux pays. Grenoble: B. Arthaud, 1928.

Gébé. *L'an 01.* Paris: Editions du Square, 1972.

Gébé. "Paris qu'on Pioche." *Pilote,* no. 549 (May 1970): 8–9.

Gilbert, E. "À propos du bimillénaire de Paris." *Bulletin de la Société préhistorique française* 48, no. 7–8 (1951): 346–347.

Gosset, Léon. *Jardins et promenades de Paris.* Pour connaître Paris. Paris: Hachette, 1929.

Gosset, Léon. *Tout Paris par l'image: Les sites, les monuments, tous les trésors de Paris avec 471 illustrations*. Paris: Hachette, 1937.

"Grand concours photo: Paris aux cent villages." *Paris aux cent villages*, August 1976, 9–12, 30.

Les grands créateurs de Paris et leurs oeuvres: Juillet–octobre 1951. Paris: Presses artistiques, 1951.

Granger, Ernest. *Les races humaines*. Encyclopédie par l'image. Paris: Hachette, 1924.

Gratias, Louis. *Barricades: Suite de cent cinquante photographies groupées par André Papillon*. Paris: Editions occident, 1945.

Grenier, Roger. *A Box of Photographs*. Translated by Alice Kaplan. Chicago: University of Chicago Press, 2013.

Grimal, Henri. *Derrière les barricades: Le peuple de Paris à la conquête de la liberté*. Paris: Bourrelier, 1948.

Grimoux, Robert. "Orientation professionnelle." *Vert luisant: Bulletin bimestriel d'information du Comité d'entreprise de la Librairie Hachette*, August 1958.

Harrison, Frederic. "The Municipal Museums of Paris." *The Fortnightly* 56 (September 1894): 458–467.

Hénard, Robert. *Rouen*. Paris: Nilsson, 1925.

Hénin, Paul. *Monsieur R. Nordling, consul de Suède, et son rôle pendant la Libération de Paris, août 1944*. Paris: Editions du foyer français, 1948.

Henrard, Roger. *Paris vu du ciel*. Paris: Armand Colin, 1952.

Henriot, Emile. "Photos de Paris." *Le Temps*, January 30, 1933.

Hoffbauer, Fedor. *Livret explicatif du diorama de Paris à travers les âges, promenades historiques et archéologiques dans les différents quartiers de l'ancien Paris*. Mesnil: Imprimerie de Firmin-Didot, 1885.

Hoffbauer, Fedor. *Paris à travers les âges: Aspects successifs des monuments et quartiers historiques de Paris depuis le XIIIe siècle jusqu'à nos jours. . . .* 2 vols. Paris: Firmin-Didot, 1875–1882.

Hoffmann, Heinrich, ed. *Mit Hitler im Westen*. Berlin: Zeitgeschichte-Verlag, 1940.

Hourticq, Louis. *Paris vu du ciel*. Paris: Henri Laurens, 1930.

Huisman, Georges. *De Saint Martin des champs aux Halles*. Pour connaître Paris. Paris: Hachette, 1925.

Huisman, Georges. *Pour comprendre les monuments de Paris*. Paris: Librairie Hachette, 1925.

Huisman, Georges. "Visages de Paris, par André Warnod." *La quinzaine critique des livres et des revues* 2, no. 24 (December 25, 1930): 818–819.

L'insurrection de Paris. Paris: France-éditions, 1944.

Joanne, Adolphe. *Paris illustré en 1870: Guide de l'étranger et du Parisien*. Paris: Hachette, 1870.

Joanne, Paul. *Environs de Paris*. Paris: Hachette, 1907.

Joanne, Paul. *Paris-diamant*. Paris: Hachette, 1881.

Kim, Jacques. *La Libération de Paris: Les journées historiques de 19 août au 26 août 1944 vues par les photographes*. Paris: OPG, 1944.

Lacombe, Paul. *Jules Cousin 1830–1899: Souvenirs d'un ami par Paul Lacombe, Parisien.* Paris: Librairie Henri Leclerc, 1900.

Lacour-Gayet, Georges. *Saint-Germain-des-Prés et la Coupole.* Pour connaître Paris. Paris: Hachette, 1924.

Lallemant, Robert. *Marine nationale: 32 photos de Robert Lallemant.* Paris: [Draeger frères], 1942.

Langlois, Charles-Victor, and Charles Seignobos. *Introduction aux études historiques.* Paris: Librairie Hachette, 1898.

"Les lauréats du concours photo 'Ma vie des Halles' s'exposent sur les palisades." http://www.parisleshalles.fr/actualite-les-laureats-du-concours-photo-ma-vie-des-halles-s-exposent-sur-les-palissades-001779. Accessed November 12, 2016.

Lavergne, Henri. "L'histoire de demain." *L'Aurore,* August 4, 1910, 1.

Lecotté, Roger. *Archives historiques du compagnonnage.* Paris: Mémoires de la fédération folklorique d'Ile-de-France, 1956.

Lenotre, G. *Notes et souvenirs: Recueillis et présentés par sa fille, Thérèse Lenotre.* Paris: Calmann-Lévy, 1940.

Lenotre, G., ed. *Le vieux Paris: Souvenirs et vieilles demeures.* Vols. 1–3. Paris: Ch. Eggimann, 1912–1914.

Leroy, Jean. "Monographie, Izis." *Photo-Revue,* January 1977, 12–27.

La Libération de Paris: 150 photographies. Paris: Fasquelle, 1945.

Lièvre, Pierre. "A Paris vers 1900, par Louis Chéronnet (Editions des Chroniques du Jour)." *La nouvelle revue française* 20, no. 228 (September 1932): 445–447.

Mac Orlan, Pierre. *Paris vu par André Kertész.* Paris: Librairie Plon, 1934.

Mac Orlan, Pierre. *Voyage dans Paris.* Paris: Les éditions de la nouvelle France, 1941.

Malan, Bernard. *Refaire la civilisation.* Paris: S.A.L., 1947.

Marmottan, Paul. *Le Musée Carnavalet [extrait du* Journal des beaux-arts, *mai 1886].* Louvain: Typographie de Charles Peeters, 1886.

Mauriac, François. *Paris libéré.* Paris: Flammarion, 1944.

Mesnil, Jacques. *Raphaël.* Paris: Braun, 1943.

Un micro dans la bataille de Paris, 20–26 août 1944 [audio disc]. Paris: Société de radioproductions, c. 1945.

"Ministère de la défense nationale et de la guerre: Extension de la zone des armées." *Journal officiel de la République française: Lois et décrets* 72, no. 123 (May 17, 1940): 3650.

"Ministère de la défense nationale et de la guerre: Réglementation des prises de vues photographiques dans la zone des armées." *Journal officiel de la République française: Lois et décrets* 72, no. 107 (April 28, 1940): 3101.

Moï Ver. *Paris: 80 photographies.* Paris: Editions Jeanne Walter, 1931.

Morand, Paul. *1900.* Paris: Les éditions de France, 1931.

Morris, Maria. "Eugene Atget, 1857–1927: The Structure of the Work." PhD diss., Columbia University, 1980.

Narjoux, Félix, and Eugène-Emmanuel Viollet-le-Duc. *Habitations modernes.* 2 vols. Paris: Vve A. Morel, 1874–1875.

Nesbit, Margaret Spence. "Atget's Seven Albums, in Practice." PhD diss., Yale University, 1983.

"Nouvelles diverses: Le musée de la Révolution." *Le Gaulois*, May 9, 1881, 3.

Objets d'art et d'ameublement, objets de curiosité, objets d'art d'Extrême-Orient, provenant de la collection de feu M. Georges Cain ancien conservateur du Musée Carnavalet: 2e vente à Paris, Hôtel Drouot, du 18 au 20 mars 1939. 1939.

Objets d'art et d'ameublement, tableaux, dessins anciens et modernes, gravures anciennes provenant de la collection de feu M. Georges Cain ancien conservateur du Musée Carnavalet: 1e vente à Paris, Hôtel Drouot, les 9 et 10 mars 1939, 1939.

Ogrizek, Doré, et al. *Frankreich, Paris und provinzen*. Paris: Odé, 1943.

"Organisation, par la Ville, d'expositions photographiques de sites choisis, soit à Paris, soit dans le département de la Seine." *Commission municipale du Vieux Paris: Procès-verbaux*, October 23, 1902, 225–226.

"Paris." *Le jardin des lettres*, March 1932, 5.

"Paris à travers les âges." *Le voleur illustré: Cabinet de lecture universel*, December 9, 1881, 776.

"Paris au Salon de 1899." *Bulletin de la Société de l'histoire de Paris et de l'Ile-de-France: 26e année*. Paris: H. Champion, 1899, 130–144.

"Paris aux cent villages [exposition, Paris, BHVP]." Special issue, *Paris aux cent villages*, November 1976.

Paris délivré par son peuple. Paris: Editions Braun et Cie, 1944.

Paris, du 19 au 26 août 1944. Paris: Imprimerie Draeger frères pour la Préfecture de la Seine, 1945.

Paris et ses environs. Leipzig: Karl Baedeker, 1903.

Paris-Guide par les principaux écrivains et artistes de la France, vol. 1. Paris: Librairie internationale, 1867.

Paris vu en avion. Paris: Aéro-photo, 1930.

Paul, Elliot. *The Last Time I Saw Paris*. New York: Random House, 1942.

Pétain, Philippe. *La France nouvelle: Appels et messages, 8 juillet 1941–17 juin 1943*. 2 vols. Montrouge: Impr. Draeger frères, 1943.

Pétain, Philippe. *La France nouvelle: Principes de la communauté, appels et messages, 17 juin 1940–17 juin 1941*. Montrouge: Impr. Draeger frères, 1941.

Pétain, Philippe. *Paroles du Maréchal*. Vichy: Bureau de documentation du Chef de l'Etat 1943.

Pillement, Georges. *Destruction de Paris*. Paris: Grasset, 1941.

Poëte, Marcel. *La formation de Paris*. Pour connaître Paris. Paris: Hachette, 1926.

Poëte, Marcel. *Les sources de l'histoire de Paris et les historiens de Paris: Leçon de réouverture du cours d'Introduction à l'histoire de Paris professé à la Bibliothèque de la Ville*. Paris: Editions de la Revue politique et littéraire (Revue bleue) et de la Revue scientifique, 1905.

Poëte, Marcel. *Une vie de cité*. 4 vols. Paris: A. Picard, 1924–1931.

Poisson, Charles. *Les donateurs du Musée historique de la Ville de Paris*. Paris: Imprimerie impériale, 1868.

Poisson, Charles. *Mémoire sur l'oeuvre historique de la Ville de Paris*. Paris: Imprimerie impériale, 1867.

Quentin-Bauchart, conseiller municipal. "Rapport au nom de la 4e Commission, sur la réorganisation du service des Beaux-arts et des musées de la ville de Paris." *Conseil municipal de Paris: Rapports et documents, année 1903*, no. 40. Paris: Imprimerie municipale, 1904: 1–233.

René-Jacques. *Paris la nuit: La ville lumière*. Paris: La bibliothèque des arts, 1964.

Le reportage photographique. Translated by Simon Noireaud. Amsterdam: Editions "Time-Life," 1972.

Reybaz, Gustave-Jean. *Le maquis Saint-Séverin: ou Comment fut libéré le quartier Saint-Michel*. Paris: Maison du livre français, 1945.

Rice, Howard C. "Post-Liberation Publishing in France: A Survey of Recent French Books." *French Review* 18, no. 6 (1945): 327–333.

Roche, Jules. "Rapport . . . sur une demande de souscription présentée en faveur de l'ouvrage 'Paris à travers les âges.'" *Conseil municipal de Paris: Rapports*, no. 200, 1880, 1–3.

Romains, Jules, et al. *Portrait de Paris*. Paris: Perrin, 1951.

Ronis, Willy. *Sur le fil du hasard*. Paris: Contrejour, 1980.

Ronis, Willy, and Pierre Mac Orlan. *Belleville-Ménilmontant*. Grenoble: Arthaud, 1954.

Roy, Claude. *Clefs pour l'Amérique*. Paris: Gallimard, 1949.

Roy, Claude. *Les yeux ouverts dans Paris insurgé*. Paris: R. Julliard, 1944.

Schinz, Albert. "L'année littéraire mil-neuf cent quarante et une." *Modern Language Journal* 26, no. 4 (1942): 256–265.

Sellier, Charles, and Prosper Dorbec. *Guide explicatif du Musée Carnavalet. . . .* Paris: Librairie centrale des beaux-arts, 1903.

Shirer, William L. *Berlin Diary: The Journal of a Foreign Correspondent, 1934–1941*. New York: Alfred A. Knopf, 1941.

Sougez, Emmanuel. *Notre-Dame de Paris*. Paris: Editions Tel, 1941.

Thédenat, Henri, and Fedor Hoffbauer. *Rome à travers les âges: Le forum romain et la voie sacrée, aspects successifs des monuments depuis le IVe siècle jusqu'à nos jours*. Paris: Plon-Nourrit, 1905.

Tisserand, Lazare-Maurice. *Histoire générale de Paris: Collection de documents fondée avec l'approbation de l'Empereur par M. le Baron Haussmann, sénateur, Préfet de la Seine, et publiée sous les auspices du Conseil municipal*. Paris: Imprimerie impériale, 1866.

Tolmer, Alfred. *Mise en Page: The Theory and Practice of Lay-Out*. London: The Studio, 1931.

Travail, famille, patrie. Paris, 1942.

Valéry, Paul. "Discours du centenaire de la photographie." *Etudes photographiques*, no. 10 (2001): 88–106.

Van Moppès, Maurice. *Images de Paris*. London: Hachette (distribution), 1940.

Vidéothèque de Paris. *Archive de films sur Paris possibilité de les consulter* [video]. 1988. http://www.ina.fr/video/PUB3784077065. Accessed May 8, 2014.

Warnod, André. *Visages de Paris*. Paris: Firmin-Didot et Cie, 1930.

Wilhelm, Jacques. *La vie à Paris sous le Second Empire et la Troisième République*. Paris: Arts et métiers graphiques, 1948.

Wilhelm, Jacques. *Visages de Paris: Anciens et modernes*. Paris: Editions du Chêne, 1943.

SECONDARY SOURCES

Albert, Pierre, and Gilles Feyel. "Photography and the Media: Changes in the Illustrated Press." In Frizot, *A New History of Photography*, 358–369.

Alden, Douglas. *Jacques de Lacretelle: An Intellectual Itinerary*. New Brunswick: Rutgers University Press, 1958.

Alexander, Stuart. "Photographic Institutions and Practices." In Frizot, *A New History of Photography*, 694–707.

Amad, Paula. *Counter-Archive: Film, the Everyday, and Albert Kahn's Archives de la Planète*. New York: Columbia University Press, 2010.

Amad, Paula. "Film as the 'Skin of History': André Bazin and the Specter of the Archive and Death in Nicole Védrès's *Paris 1900* (1947)." *Representations* 130, no. 1 (2015): 84–118.

Anderson, Perry. "Dégringolade." *London Review of Books*, September 2, 2004, 3–9.

Angeletti, Norberto, and Alberto Oliva. *Magazines That Make History: Their Origins, Development, and Influence*. Gainesville: University Press of Florida, 2004.

Armstrong, Carol M. *Scenes in a Library: Reading the Photograph in the Book, 1843–1875*. Cambridge, MA: MIT Press, 1998.

Aubenas, Sylvie. "The Photograph in Print: Multiplication and Stability of the Image." In Frizot, *A New History of Photography*, 224–231.

Babelon, Jean-Pierre. "Les relevés d'architecture du quartier des Halles avant les destructions de 1852–1854: Une source inédite sur l'iconographie parisienne entre le Louvre et l'Hôtel de Ville." *Gazette des beaux-arts*, 2, 1967, 1–90.

Backouche, Isabelle. "Rénover un quartier parisien sous Vichy: 'Un Paris expérimental plus qu'une rêverie sur Paris.'" *Genèses*, no. 73 (2008): 115–142.

Bair, Nadya. "The Decisive Network: Producing Henri Cartier-Bresson at Mid-Century." *History of Photography* 40, no. 2 (2016): 146–166.

Ballon, Hilary. *The Paris of Henri IV: Architecture and Urbanism*. Cambridge, MA: MIT Press, 1991.

Bann, Stephen. *Parallel Lines: Printmakers, Painters and Photographers in Nineteenth-Century France*. New Haven: Yale University Press, 2001.

Baronnet, Jean. *Les Parisiens sous l'Occupation: Photographies en couleurs d'André Zucca*. Paris: Gallimard/Paris bibliothèques, 2008.

Barthes, Roland. *Camera Lucida: Reflections on Photography*. Translated by Richard Howard. New York: Hill and Wang/Noonday Press, 1981.

Batchen, Geoffrey. "Snapshots: Art History and the Ethnographic Turn." *Photographies* 1, no. 2 (2008): 121–142.

Batchen, Geoffrey, ed. "Vernacular Photographies" [special section]. *History of Photography* 24, no. 3 (2000), 229–271.

Baverez, Nicolas. *La France qui tombe*. Paris: Perrin, 2003.

Baverez, Nicolas. *Les trente piteuses*. Paris: Flammarion, 1997.

Bercé, Yves-Marie, Olivier Guyotjeannin, and Marc Smith, eds. *L'Ecole nationale des chartes: Histoire de l'Ecole depuis 1821*. Thionville: Gérard Klopp, 1997.

Berger, Lynn. "Snapshots, or: Visual Culture's Clichés." *Photographies* 4, no. 2 (2011): 175–190.

Bernard, Jean-Pierre A. *Les deux Paris: Les représentations de Paris dans la seconde moitié du XIXe siècle*. Seyssel: Champ Vallon, 2001.

Bertho, Raphaële. *La Mission photographique de la DATAR: Un laboratoire du paysage contemporain*. Paris: La documentation française, 2013.

Blatt, Ari. "Détours en France: On the Road with Jean-Christophe Bailly and Raymond Depardon." *Contemporary French Civilization* 39, no. 2 (2014): 161–177.

Bloch, Marc. *Strange Defeat: A Statement of Evidence Written in 1940*. Translated by Gerard Hopkins. New York: Oxford University Press, 1949.

Boittin, Jennifer Anne. *Colonial Metropolis: The Urban Grounds of Anti-Imperialism and Feminism in Interwar Paris*. Lincoln: University of Nebraska Press, 2010.

Boswell, Laird. "From Liberation to Purge Trials in the 'Mythic Provinces': The Reconfiguration of Identities in Alsace and Lorraine, 1918–1920." *French Historical Studies* 23, no. 1 (2000): 129–162.

Bowles, Brett. "Jean Renoir's *Salut à la France*: Documentary Film Production, Distribution, and Reception in France, 1944–1945." *Historical Journal of Film, Radio, and Television* 26, no. 1 (2006): 57–86.

Boyer, M. Christine. *The City of Collective Memory: Its Historical Imagery and Architectural Entertainments*. Cambridge, MA: MIT Press, 1994.

Boyer, M. Christine. "La Mission Héliographique: Architectural Photography, Collective Memory and the Patrimony of France, 1851." In Schwartz and Ryan, *Picturing Place*, 21–54.

Brown, Elspeth H., and Thy Phu, eds. *Feeling Photography*. Durham: Duke University Press, 2014.

Brun, Philippe. *Albert Robida (1848–1926): Sa vie, son oeuvre*. Paris: Promodis, 1984.

Brunet, François. *La photographie: Histoire et contre-histoire*. Paris: Presses universitaires de France, 2017.

Brunet, François. *Photography and Literature*. London: Reaktion Books, 2009.

Buard, Jean-Luc. "Les paradoxes des publications Lafitte." *Le Rocambole: Bulletin des amis du roman populaire*, no. 10 (2000): 8–11.

Burgoyne, Robert. *Film Nation: Hollywood Looks at U.S. History*. Minneapolis: University of Minnesota Press, 1997.

Burke, Peter. *Eyewitnessing: The Uses of Images as Historical Evidence*. London: Reaktion, 2001.

Burton, Antoinette M., ed. *Archive Stories: Facts, Fictions, and the Writing of History*. Durham: Duke University Press, 2005.

Cadava, Eduardo. *Words of Light: Theses on the Photography of History*. Princeton: Princeton University Press, 1997.

Calabi, Donatella. *Marcel Poëte et le Paris des années vingt: Aux origines de "l'histoire des villes."* Paris: L'Harmattan, 1997.

Caraffa, Costanza, ed. *Photo Archives and the Photographic Memory of Art History*. Berlin: Deutscher Kunstverlag, 2011.

Caron, Vicki. *Uneasy Asylum: France and the Jewish Refugee Crisis, 1933–1942*. Stanford: Stanford University Press, 1999.

Chabault, Vincent. *La Fnac, entre commerce et culture: Parcours d'entreprise, parcours d'employés*. Paris: Presses universitaires de France, 2010.

Challine, Eléonore. "La critique photographique des années trente en France: Un échiquier politique?" *Revue française d'histoire des idées politiques* 39, no. 1 (2014): 27–39.

Challine, Eléonore. *Une histoire contrairiée: Le musée de photographie en France, 1839–1945*. Paris: Editions Macula, 2017.

Chéroux, Clément. "Une généalogie des formes récréatives en photographie (1890–1940)." Thèse de doctorat en histoire de l'art, Université Paris I, 2004.

Chevalier, Louis. *The Assassination of Paris*. Translated by David P. Jordan. Chicago: University of Chicago Press, 1994.

Clark, Catherine E. "Capturing the Moment, Picturing History: Photographs of the Liberation of Paris." *American Historical Review* 121, no. 3 (2016): 824–860.

Clark, Catherine E. "'C'était Paris en 1970': Histoire visuelle, photographie amateur et urbanisme." Translated by Jean-François Allain. *Etudes photographiques*, no. 31 (Spring 2014): 86–113.

Clark, Catherine E. "A Decisive Moment, France, 1932." In Hill and Schwartz, *Getting the Picture*, 55–58.

Clark, Catherine E. "La Vidéothèque de Paris, Memory for the Future." *Contemporary French Civilization* 40, no. 1 (2015): 1–23.

Clark, T. J. *The Painting of Modern Life: Paris in the Art of Manet and His Followers*. Rev. ed. Princeton: Princeton University Press, 1999.

Clayson, S. Hollis. *Paris in Despair: Art and Everyday Life Under Siege (1870–71)*. Chicago: University of Chicago Press, 2002.

Clerval, Anne. *Paris sans le peuple: La gentrification de la capitale*. Paris: La découverte, 2013.

Cobb, Matthew. *Eleven Days in August: The Liberation of Paris in 1944*. New York: Simon and Schuster, 2013.

Cohen, Daniel J., et al. "Interchange: The Promise of Digital History." *Journal of American History* 95, no. 2 (2008): 442–451.

Cohen, Evelyne. *Paris dans l'imaginaire national dans l'entre-deux-guerres*. Paris: Publications de la Sorbonne, 1999.

Cohen, Margaret. *Profane Illumination: Walter Benjamin and the Paris of the Surrealist Revolution*. Berkeley: University of California Press, 1993.

Compère, Daniel, ed. *Albert Robida du passé au futur: Un auteur-illustrateur sous la IIIe République*. Amiens: Encrage, 2006.

Conekin, Becky. *"The Autobiography of a Nation": The 1951 Festival of Britain*. Manchester: Manchester University Press, 2003.

Confino, Alon. "Remembering the Second World War, 1945–1965: Narratives of Victimhood and Genocide." *Cultural Analysis* 4 (2005): 47–75.

Corbin, Alain, and Jean-Marie Mayeur, eds. *La barricade: Actes du colloque organisé les 17, 18 et 19 mai 1995*. Paris: Publications de la Sorbonne, 1997.

Crary, Jonathan. *Techniques of the Observer: On Vision and Modernity in the Nineteenth Century*. Cambridge, MA: MIT Press, 1990.

Dacos, Marin. "Le regard oblique." *Etudes photographiques*, no. 11 (2002): 44–67.

Davies, Helen M. *Emile and Isaac Pereire: Bankers, Socialists and Sephardic Jews in Nineteenth-Century France*. Manchester: Manchester University Press, 2015.

Debord, Guy. *La société du spectacle*. Paris: Buchet-Chastel, 1967.

Deedes-Vincke, Patrick. *Paris: The City and Its Photographers*. Boston: Little, Brown, 1992.

De Grazia, Victoria. *Irresistible Empire: America's Advance through Twentieth-Century Europe*. Cambridge, MA: Belknap Press of Harvard University Press, 2005.

Denoyelle, Françoise. *La lumière de Paris*. 2 vols. Paris: L'Harmattan, 1997.

Denoyelle, Françoise. *La photographie d'actualité et de propagande sous le régime de Vichy*. Paris: CNRS éditions, 2003.

de Pastre, Béatrice. "Une archive dédiée à la pédagogie du cinéma." *1895: Bulletin de l'Association française de recherche sur l'histoire du cinéma*, no. 41 (2003): 177–186.

de Thézy, Marie. *Marville, Paris*. Paris: Hazan, 1994.

de Thézy, Marie. *Paris 1950 photographié par le Groupe des XV*. Paris: Direction des affaires culturelles, 1982.

de Thézy, Marie, and Claude Nori. *La photographie humaniste: 1930–1960, histoire d'un mouvement en France*. Paris: Contrejour, 1992.

Deurbergue, Maria. "Féodor Hoffbauer (1839–1922), metteur en scène du Paris ancien." *Bulletin de la société d'histoire de Paris et de l'Ile de France* (2012): 153–161.

Diamond, Hanna. *Fleeing Hitler: France 1940*. New York: Oxford University Press, 2007.

Di Bello, Patrizia, Colette Wilson, and Shamoon Zamir, eds. *The Photobook: From Talbot to Ruscha and Beyond*. London: I.B. Tauris, 2012.

Didi-Huberman, Georges. *Images in Spite of All: Four Photographs from Auschwitz*. Translated by Shane B. Lillis. Chicago: University of Chicago Press, 2008.

Doisneau, Robert, and Pascal Ory. *Doisneau 40–44*. Paris: Hoëbeke, 2003.

Dorléac, Laurence Bertrand. *Art of the Defeat: France 1940–1944*. Translated by Jane Marie Todd. Los Angeles: Getty Research Institute, 2008.

Drake, David. *Paris at War, 1939–1944*. Cambridge, MA: The Belknap Press of Harvard University Press, 2015.

D'Souza, Aruna, and Tom McDonough, eds. *The Invisible Flâneuse? Gender, Public Space, and Visual Culture in Nineteenth-Century Paris.* Manchester: Manchester University Press, 2006.

Eckert, Astrid M. *The Struggle for the Files: The Western Allies and the Return of German Archives after the Second World War.* Translated by Dona Geyer. New York: Cambridge University Press, 2012.

Edwards, Elizabeth. *The Camera as Historian: Amateur Photographers and Historical Imagination, 1885–1918.* Durham: Duke University Press, 2012.

Edwards, Elizabeth. *Raw Histories: Photographs, Anthropology and Museums.* Oxford: Berg, 2001.

Eksteins, Modris. *Rites of Spring: The Great War and the Birth of the Modern Age.* Boston: Houghton Mifflin, 1989.

Elkins, James. *Visual Studies: A Skeptical Introduction.* New York: Routledge, 2003.

Ellwood, Robert S. *1950, Crossroads of American Religious Life.* Louisville: Westminster John Knox Press, 2000.

Emery, Elizabeth. "Protecting the Past: Albert Robida and the *Vieux Paris* Exhibit at the 1900 World's Fair." *Journal of European Studies* 35, no. 1 (2005): 65–85.

Emery, Elizabeth, and Laura Morowitz. *Consuming the Past: The Medieval Revival in Fin-de-Siècle France.* Aldershot: Ashgate, 2003.

Endy, Christopher. *Cold War Holidays: American Tourism in France.* Chapel Hill: University of North Carolina Press, 2004.

Ethington, Philip J., and Vanessa R. Schwartz, eds. "Urban Icons." Special issue, *Urban History* 33, no. 1 (2006).

Evenson, Norma. "The Assassination of Les Halles." *Journal of the Society of Architectural Historians* 32, no. 4 (1973): 308–315.

Evenson, Norma. *Paris: A Century of Change, 1878–1978.* New Haven: Yale University Press, 1979.

Farge, Arlette. *The Allure of the Archives.* Translated by Thomas Scott-Railton. New Haven: Yale University Press, 2013.

Farmer, Sarah. *Martyred Village: Commemorating the 1944 Massacre at Oradour-sur-Glane.* Berkeley: University of California Press, 1999.

Feldman, Hannah. *From a Nation Torn: Decolonizing Art and Representation in France, 1945–1962.* Chicago: University of Chicago Press, 2014.

Ferguson, Priscilla Parkhurst, *Paris as Revolution: Writing the Nineteenth-Century City.* Berkeley: University of California Press, 1994.

Ferro, Marc. *Cinema and History.* Translated by Naomi Greene. Detroit: Wayne State University Press, 1988.

Fiori, Ruth. *L'invention du vieux Paris: Naissance d'une conscience patrimoniale dans la capitale.* Wavre: Mardaga, 2012.

Flint, Kate. *The Victorians and the Visual Imagination.* Cambridge: Cambridge University Press, 2000.

Flonneau, Mathieu. *Paris et l'automobile: Un siècle de passions.* Paris: Hachette, 2005.

Ford, Colin, and Karl Steinorth, eds. *You Press the Button—We Do the Rest: The Birth of Snapshot Photography*. London: Dirk Nishen, 1988.

Fouché, Pascal. *L'édition française sous l'Occupation: 1940–1944*. 2 vols. Paris: Bibliothèque de littérature française contemporaine de l'Université Paris 7, 1987.

Fourastié, Jean. *Les trente glorieuses, ou, La révolution invisible de 1946 à 1975*. Paris: Fayard, 1979.

Fourcaut, Annie, Emmanuel Bellanger, and Mathieu Flonneau. *Paris-banlieues, conflits et solidarités: Historiographie, anthologie, chronologie, 1788–2006*. Paris: Créaphis éditions, 2007.

Frank, Robert. *La chambre de commerce et d'industrie de Paris (1803–2003): Histoire d'une institution*. Genève: Droz, 2003.

Freedberg, David. *The Power of Images: Studies in the History and Theory of Response*. Chicago: University of Chicago Press, 1989.

Friedberg, Anne. *Window Shopping: Cinema and the Postmodern*. Berkeley: University of California Press, 1993.

Fritzsche, Peter. *Stranded in the Present: Modern Time and the Melancholy of History*. Cambridge, MA: Harvard University Press, 2004.

Frizot, Michel, ed. *A New History of Photography*. Köln: Könemann, 1998.

Frizot, Michel. "Photogravure." In Frizot, *A New History of Photography*, 228.

Frizot, Michel, and Cédric de Veigy. *Vu: The Story of a Magazine That Made an Era*. London: Thames & Hudson, 2009.

Fumaroli, Marc. *Quand l'Europe parlait français*. Paris: Fallois, 2001.

Fussell, Paul. *The Great War and Modern Memory*, new edition. New York: Oxford University Press, 2013.

Gabriel Davioud: Architecte (1824–1881): Mairies annexes des XVIe et XIXe arrondissements 1981–1982. Paris: Délégation à l'action artistique, 1981.

Gervais, Thierry. "'Le plus grand des photographes de guerre': Jimmy Hare, photoreporter au tournant du XIXe et du XXe siècle." *Etudes photographiques*, no. 26 (2010): 10–49.

Gervais, Thierry, and Gaëlle Morel. *La fabrique de l'information visuelle: Photographies et magazines d'actualité*. Paris: Textuel, 2015.

Gordon, Bertram M. "Warfare and Tourism: Paris in World War II." *Annals of Tourism Research* 25, no. 3 (1998): 616–638.

Grafton, Anthony. *The Footnote: A Curious History*. Cambridge, MA: Harvard University Press, 1997.

Gretton, Tom. "'Un Moyen Puissant de Vulgarisation Artistique': Reproducing Salon Pictures in Parisian Illustrated Weekly Magazines c.1860–c.1895: From Wood Engraving to the Half Tone Screen (and Back)." *Oxford Art Journal* 39, no. 2 (2016): 285–310.

Griffiths, Alison. *Wondrous Difference: Cinema, Anthropology, and Turn-of-the-Century Visual Culture*. New York: Columbia University Press, 2002.

Guerin, Frances. *Through Amateur Eyes: Film and Photography in Nazi Germany.* Minneapolis: University of Minnesota Press, 2012.

Guigueno, Vincent. "La France vue du sol: Une histoire de la Mission photographique de la DATAR (1983–1989)." *Etudes photographiques,* no. 18 (2006): 96–119.

Guilbaut, Serge. *How New York Stole the Idea of Modern Art: Abstract Expressionism, Freedom, and the Cold War.* Translated by Arthur Goldhammer. Chicago: University of Chicago Press, 1983.

Guillaume, Valérie, ed. *Le Marais en héritage(s): Cinquante ans de sauvegarde, depuis la loi Malraux.* Paris: Paris musées, 2015.

Gunther, Thomas Michael, and Marie de Thézy. *Alliance Photo: Agence photographique 1934–1940.* Paris: Bibliothèque historique de la Ville de Paris, 1989.

Gunther, Thomas Michael, and Marie de Thézy, eds. *Images de la Libération de Paris.* Paris: Paris musées, 1994.

Gunthert, André. "La conquête de l'instantané: Archéologie de l'imaginaire photographique en France, 1841–1895." Thèse de doctorat en histoire de l'art, EHESS, 1999.

Gunthert, André, Emmanuelle Toulet, and Charles Lansiaux. *Paris 14–18: La guerre au quotidien.* Paris: Paris bibliothèques, 2014.

Hadjinicolaou, Nicos. "'La Liberté guidant le peuple' de Delacroix devant son premier public." *Actes de la recherche en sciences sociales* 28, no. 1 (1979): 3–26.

Hamilton, George Heard. "The Iconographical Origins of Delacroix's 'Liberty Leading the People.'" In *Studies in Art and Literature for Belle da Costa Greene,* edited by Dorothy Miner, 55–66. Princeton: Princeton University Press, 1954.

Hamilton, Peter. "Representing the Social: France and Frenchness in Postwar Humanist Photography." In *Representation: Cultural Representations and Signifying Practices,* edited by Stuart Hall, 75–150. London: SAGE, 1997.

Hamilton, Peter. *Robert Doisneau: A Photographer's Life.* New York: Abbeville Press, 1995.

Harvey, David. *Paris, Capital of Modernity.* New York: Routledge, 2003.

Haskell, Francis. *History and Its Images: Art and the Interpretation of the Past.* New Haven: Yale University Press, 1993.

Haynes, Christine. *Lost Illusions: The Politics of Publishing in Nineteenth-Century France.* Cambridge, MA: Harvard University Press, 2010.

Hecht, Gabrielle. *The Radiance of France: Nuclear Power and National Identity after World War II.* Cambridge, MA: The MIT Press, 1998.

Heckert, Virginia, and Anne Lacoste. *Irving Penn: Small Trades.* Los Angeles: J. Paul Getty Museum, 2009.

Heller, Steven. "First on Deco: A Parisian Printer's Opus from the '30s Contains the Origins of a Design Staple." *Print Magazine,* May/June 2007, 88–93.

Herz, Rudolf. *Hoffmann und Hitler: Fotografie als Medium des Führer-Mythos.* Munich: Klinkhardt & Biermann, 1994.

Higonnet, Patrice L. R. *Paris: Capital of the World.* Cambridge, MA: Belknap Press of Harvard University Press, 2002.

Hill, Jason E. *Artist as Reporter: Weegee, Ad Reinhardt, and the* PM *News Picture.* Berkeley: University of California Press, 2018.

Hill, Jason E. "De l'efficacité de l'artifice: *PM*, radiophoto et discours journalistique sur l'objectivité photographique." *Etudes photographiques*, no. 26 (2011): 50–85.

Hill, Jason E., and Vanessa R. Schwartz, eds. *Getting the Picture: The Visual Culture of the News.* London: Bloomsbury Academic, 2015.

Holly, Michael Ann. *Past Looking: Historical Imagination and the Rhetoric of the Image.* Ithaca: Cornell University Press, 1996.

Hommage à André Warnod 1885–1960: Musée d'art moderne de la Ville de Paris. Paris: Paris musées, 1985.

Hornstein, Katie. *Picturing War in France, 1792–1856.* New Haven: Yale University Press, 2018.

Jäckel, Eberhard. *La France dans l'Europe de Hitler.* Translated by Denise Meunier. Paris: Fayard, 1968.

Jackson, Jeffrey H. "Envisioning Disaster in the 1910 Paris Flood." *Journal of Urban History* 37, no. 2 (2011): 176–207.

Jackson, Jeffrey H. *Making Jazz French: Music and Modern Life in Interwar Paris.* Durham: Duke University Press, 2003.

Jackson, Jeffrey H. *Paris under Water: How the City of Light Survived the Great Flood of 1910.* New York: Palgrave Macmillan, 2010.

Jackson, Julian. *The Politics of Depression in France, 1932–1936.* Cambridge: Cambridge University Press, 1985.

Jay, Martin. *Downcast Eyes: The Denigration of Vision in Twentieth-Century French Thought.* Berkeley: University of California Press, 1993.

Jones, Colin. *Paris: The Biography of a City.* New York: Penguin, 2006.

Jones, Colin. "Théodore Vacquer and the Archaeology of Modernity in Haussmann's Paris." *Transactions of the Royal Historical Society* 17 (2007): 157–183.

Jones, Jonathan. "'Retronauting': Why We Can't Stop Sharing Old Photographs." *Guardian*, April 13, 2014.

Jordan, David P. *Transforming Paris: The Life and Labors of Baron Haussmann.* Chicago: University of Chicago Press, 1996.

Kalifa, Dominique. *La véritable histoire de la Belle Epoque.* Paris: Fayard, 2017.

Kaplan, Alice. *The Collaborator: The Trial and Execution of Robert Brasillach.* Chicago: University of Chicago Press, 2000.

Kedward, H. R., and Nancy Wood, eds. *The Liberation of France: Image and Event.* Oxford: Berg Publishers, 1995.

Kervran, Perrine, and Véronique Samouiloff. "Représenter la ville 2/4: 'C'était Paris en 1970.'" *La fabrique de l'histoire.* France Culture, February 24, 2015.

Keylor, William R. *Academy and Community: The Foundation of the French Historical Profession.* Cambridge, MA: Harvard University Press, 1975.

Klett, Marc. *After the Ruins, 1906 and 2006: Rephotographing the San Francisco Earthquake and Fire.* Berkeley: University of California Press, 2006.

Klett, Mark, ed. *Third Views, Second Sights: A Rephotographic Survey of the American West*. Santa Fe: Museum of New Mexico Press, 2004.

Koetzle, Hans-Michael. *Eyes on Paris: Paris im Fotobuch, 1890 bis Heute*. Munich: Haus der Photographie, Deichtorhallen Hamburg, 2011.

Kristensen, Juliette, and Marquard Smith, eds. "The Archives Issue." Special issue, *Journal of Visual Culture* 12, no. 3 (2013).

Kuisel, Richard F. *Seducing the French: The Dilemma of Americanization*. Berkeley: University of California Press, 1993.

Lagrou, Pieter. *The Legacy of Nazi Occupation: Patriotic Memory and National Recovery in Western Europe, 1945–1965*. Cambridge, Cambridge University Press, 2000.

Laqueur, Walter. *After the Fall: The End of the European Dream and the Decline of a Continent*. New York: Thomas Dunne Books, 2012.

Lebel, Jean-Jacques. *Soulèvements*. Paris: Maison rouge, 2009.

Lebovics, Herman. *Mona Lisa's Escort: André Malraux and the Reinvention of French Culture*. Ithaca: Cornell University Press, 1999.

Lévy, Claude, and Henri Michel. "La presse autorisée de 1940 à 1944." In *Histoire générale de la presse française*, vol. 4: *De 1940 à 1958*, edited by Claude Bellanger, Jacques Godechot, Pierre Guiral, and Fernand Terrou, 7–93. Paris: Presses universitaires de France, 1975.

Lottman, Herbert R. *The Left Bank: Writers, Artists, and Politics from the Popular Front to the Cold War*. Boston: Houghton Mifflin, 1982.

Lowe, Donald. *History of Bourgeois Perception*. Chicago: University of Chicago Press, 1982.

Marrinan, Michael. *Romantic Paris: Histories of a Cultural Landscape, 1800–1850*. Stanford: Stanford University Press, 2009.

McCauley, Elizabeth Anne. *A.A.E. Disdéri and the Carte de Visite Portrait Photograph*. New Haven: Yale University Press, 1985.

McCauley, Elizabeth Anne. "En-dehors de l'art." *Etudes photographiques*, Colloque "Photographie, les nouveaux enjeux de l'histoire," no. 16 (2005): 50–73.

McCauley, Elizabeth Anne. *Industrial Madness: Commercial Photography in Paris, 1848–1871*. New Haven: Yale University Press, 1994.

McClellan, Andrew. *Inventing the Louvre: Art, Politics, and the Origins of the Modern Museum in Eighteenth-Century Paris*. Cambridge: Cambridge University Press, 1994.

McKenzie, Brian A. "Creating a Tourist's Paradise: The Marshall Plan and France, 1948 to 1952." *French Politics, Culture and Society* 21, no. 1 (2003): 35–54.

McQuire, Scott. *Visions of Modernity: Representation, Memory, Time and Space in the Age of the Camera*. London: SAGE, 1998.

Meisler, Stanley. *Shocking Paris: Soutine, Chagall and the Outsiders of Montparnasse*. New York: Palgrave Macmillan, 2015.

Melemis, Steven. "La cité et ses images: La collection iconographique de Marcel Poëte." *Les cahiers de la recherche architecturale et urbaine*, no. 29 Scènes en chantier (2014): 85–106.

Milner, John. *Art, War and Revolution in France 1870–1871: Myth, Reportage and Reality*. New Haven: Yale University Press, 2000.

Mirzoeff, Nicholas. *An Introduction to Visual Culture*. 2nd ed. New York: Routledge, 2009.

Mitchell, W. J. T. "Showing Seeing: A Critique of Visual Culture." *Journal of Visual Culture* 1, no. 2 (2002): 165–181.

Mitchell, W. J. T. *What Do Pictures Want?: The Lives and Loves of Images*. Chicago: University of Chicago Press, 2005.

Mitman, Gregg, and Kelley Wilder, eds. *Documenting the World*. Chicago: University of Chicago Press, 2016.

Mollier, Jean-Yves. *Louis Hachette (1800–1864): Le fondateur d'un empire*. Paris: Fayard, 1999.

Moore, Kevin. *Jacques Henri Lartigue: The Invention of an Artist*. Princeton: Princeton University Press, 2004.

Moore, Lara Jennifer. *Restoring Order: The Ecole des Chartes and the Organization of Archives and Libraries in France, 1820–1870*. Duluth: Litwin Books, 2008.

Morel, Gaëlle. *Le photoreportage d'auteur: L'institution culturelle de la photographie en France depuis les années 1970*. Paris: CNRS éditions, 2006.

Morris, Errol. *Believing Is Seeing: Observations on the Mysteries of Photography*. New York: Penguin Press, 2011.

Mraz, John. *Photographing the Mexican Revolution: Commitments, Testimonies, Icons*. Austin: University of Texas Press, 2012.

Mraz, John. "Picturing Mexico's Past: Photography and 'Historia Gráfica.'" *South Central Review* 21, no. 3 (2004): 24–45.

Nelson, Andrea. "Reading Photobooks: Narrative Montage and the Construction of Modern Visual Literacy." PhD diss., University of Minnesota, 2007.

Nesbit, Molly. *Atget's Seven Albums*. New Haven: Yale University Press, 1992.

Nesbit, Molly. "What Was an Author?" *Yale French Studies*, no. 73 (1987): 229–257.

Nivet, Philippe. *Le conseil municipal de Paris de 1944 à 1977*. Paris: Publications de la Sorbonne, 1994.

Nora, Pierre, ed. *Les lieux de mémoire*. 7 vols. Paris: Gallimard, 1984–1992.

Nora, Pierre, ed. *Realms of Memory: The Construction of the French Past*, vol. 1: *Conflicts and Divisions*. Translated by Arthur Goldhammer. New York: Columbia University Press, 1996.

Nord, Philip. *France 1940: Defending the Republic*. New Haven: Yale University Press, 2015.

Novick, Peter. *The Resistance versus Vichy: The Purge of Collaborators in Liberated France*. New York: Columbia University Press, 1968.

Olin, Margaret. *Touching Photographs*. Chicago: University of Chicago Press, 2012.

Page, Max. *The Creative Destruction of Manhattan, 1900–1940*. Chicago: University of Chicago Press, 1999.

Panchasi, Roxanne. *Future Tense: The Culture of Anticipation in France between the Wars*. Ithaca: Cornell University Press, 2009.

Papayanis, Nicholas. *Planning Paris before Haussmann*. Baltimore: Johns Hopkins University Press, 2004.

Paris libéré, photographié, exposé: Musée Carnavalet-Histoire de Paris, 11 juin 2014–8 février 2015. Paris: Paris musées, 2014.

Parr, Martin, and Gerry Badger. *The Photobook: A History*. Vols. 1–3. London: Phaidon, 2004–2014.

Perrault, Gilles, and Pierre Azéma. *Paris under the Occupation*. Translated by Allison Carter and Maximilian Vos. New York: Vendome, 1989.

Pessis, Céline, Sezin Topçu and Christophe Bonneuil, eds. *Une autre histoire des "Trente Glorieuses": Modernisation, contestations et pollutions dans la France d'après-guerre*. Paris: La découverte, 2013.

Pétriat, Jean-Louis. *Les années Fnac: de 1954 . . . à après-demain*. Paris: Fayard, 1991.

Pfitzer, Gregory M. *Picturing the Past: Illustrated Histories and the American Imagination, 1840–1900*. Washington, DC: Smithsonian Institution Press, 2002.

Pinkney, David H. *Napoleon III and the Rebuilding of Paris*. Princeton: Princeton University Press, 1958.

Pinson, Stephen. *Speculating Daguerre: Art and Enterprise in the Work of L. J. M. Daguerre*. Chicago: University of Chicago Press, 2012.

Pointon, Marcia. *Naked Authority: The Body in Western Painting, 1830–1908*. Cambridge: Cambridge University Press, 1990.

Pollen, Annebella. *Mass Photography: Collective Histories of Everyday Life*. London: I.B. Tauris, 2016.

Portraits d'une capitale de Daguerre à William Klein: Collections photographiques du Musée Carnavalet. Paris: Paris musées/Paris audiovisuel, 1992.

Pritchard, Sara B. *Confluence: The Nature of Technology and the Remaking of the Rhône*. Cambridge, MA: Harvard University Press, 2011.

Przyblyski, Jeannene M. "Revolution at a Standstill: Photography and the Paris Commune of 1871." *Yale French Studies*, no. 101 (2001): 54–78.

Rearick, Charles. *Paris Dreams, Paris Memories: The City and Its Mystique*. Stanford: Stanford University Press, 2011.

Renoult, Daniel. "Les nouvelles possibilités techniques: Le triomphe de la mécanique." In *Histoire de l'édition française*, vol. 4: *Le livre concurrencé 1900–1950*, edited by Roger Chartier and Henri-Jean Martin, 28–50. Paris: Fayard, 1989.

Rice, Shelley. *Parisian Views*. Cambridge, MA: MIT Press, 1997.

Riding, Alan. *And the Show Went On: Cultural Life in Nazi-Occupied Paris*. New York: Alfred A. Knopf, 2010.

Roberts, Mary Louise. *Civilization without Sexes: Reconstructing Gender in Postwar France, 1917–1927*. Chicago: University of Chicago Press, 1994.

Roberts, Mary Louise. "Wartime Flânerie: The Zucca Controversy." *French Politics, Culture and Society* 27, no. 1 (2009): 102–110.

Rodriguez, Peggy. "Jules Gailhabaud." *Dictionnaire critique des historiens de l'art*. Paris: Institut national de l'histoire de l'art, 2008. http://www.inha.fr/fr/ressources/

publications/publications-numeriques/dictionnaire-critique-des-historiens-de-l-art/gailhabaud-jules.html. Accessed October 4, 2016.

Rosenberg, Clifford D. *Policing Paris: The Origins of Modern Immigration Control between the Wars*. Ithaca: Cornell University Press, 2006.

Rosenberg, Daniel, and Anthony Grafton. *Cartographies of Time: A History of the Timeline*. Princeton: Princeton Architectural Press, 2010.

Rosenstone, Robert A. *History on Film/Film on History*. Harlow: Longman/Pearson, 2006.

Rosenstone, Robert A., David Herlihy, John E. O'Connor, Robert Brent Toplin, and Hayden White. "AHR Forum: History in Images/History in Words." *American Historical Review* 93, no. 5 (1988): 1173–1227.

Ross, Kristin. *Fast Cars, Clean Bodies: Decolonization and the Reordering of French Culture*. Cambridge, MA: MIT Press, 1995.

Rossignol, Dominique. *Histoire de la propagande en France de 1940 à 1944: L'utopie Pétain*. Paris: Presses universitaires de France, 1991.

Rousso, Henry. *The Vichy Syndrome: History and Memory in France since 1944*. Translated by Arthur Goldhammer. Cambridge, MA: Harvard University Press, 1991.

Saint-Etienne, Christian. *France, état d'urgence: Une stratégie pour demain*. Paris: Odile Jacob, 2013.

Samuel, Raphael. *Theatres of Memory*, vol. 1: *Past and Present in Contemporary Culture*. New York: Verso, 1994.

Samuels, Maurice. *The Spectacular Past: Popular History and the Novel in Nineteenth-Century France*. Ithaca: Cornell University Press, 2004.

Schor, Naomi. "'Cartes Postales': Representing Paris 1900." *Critical Inquiry* 18, no. 2 (1992): 188–244.

Schurr, Gérald. *Les petits maîtres de la peinture*, vol. 7: *1820–1920*. Paris: Les éditions de l'amateur, 1989.

Schwartz, Joan M., and James R. Ryan, eds. *Picturing Place: Photography and the Geographical Imagination*. London: I.B. Tauris, 2003.

Schwartz, Vanessa R. "Film and History." In *The Sage Handbook of Film Studies*, edited by James Donald and Michael Renov, 199–215. Los Angeles: SAGE, 2008.

Schwartz, Vanessa R. *It's So French!: Hollywood, Paris, and the Making of Cosmopolitan Film Culture*. Chicago: University of Chicago Press, 2007.

Schwartz, Vanessa R. *Spectacular Realities: Early Mass Culture in Fin-de-Siècle Paris*. Berkeley: University of California Press, 1998.

Schwartz, Vanessa R. "Walter Benjamin for Historians." *American Historical Review* 106, no. 5 (2001): 1721–1743.

Shaya, Gregory. "The Flâneur, the Badaud, and the Making of a Mass Public in France, Circa 1860–1910." *American Historical Review* 109, no. 1 (2004): 41–77.

Sherman, Daniel J. *The Construction of Memory in Interwar France*. Chicago: University of Chicago Press, 1999.

Sherman, Daniel J. *Worthy Monuments: Art Museums and the Politics of Culture in Nineteenth-Century France.* Cambridge, MA: Harvard University Press, 1989.

Shevchenko, Olga, ed. *Double Exposure: Memory and Photography.* New Brunswick: Transaction Publishers, 2014.

Sichel, Kim D. "*Paris Vu par André Kertész*: An Urban Diary." *History of Photography* 16, no. 2 (1992): 105–114.

Silverman, Debora. *Art Nouveau in Fin-de-Siècle France: Politics, Psychology, and Style.* Berkeley: University of California Press, 1989.

Silverman, Willa Z. *The New Bibliopolis: French Book Collectors and the Culture of Print, 1880–1914.* Toronto: University of Toronto Press, 2008.

Simonin, Anne. *Les Editions de Minuit, 1942–1955: le devoir d'insoumission*, L'édition contemporaine. Paris: IMEC éd, 1994.

Sontag, Susan. "Looking at War." *New Yorker*, December 9, 2002, 82–98.

Sontag, Susan. *Regarding the Pain of Others.* New York: Picador, 2003.

Soppelsa, Peter. "How Haussmann's Hegemony Haunted the Early Third Republic," in *Is Paris Still the Capital of the Nineteenth Century? Essays on Art and Modernity, 1850–1900*, eds. Hollis Clayson and André Dombrowski (London: Routledge, 2016), 35–51.

Sramek, Peter. *Piercing Time: Paris after Marville and Atget 1865–2012.* Bristol: Intellect, 2013.

Stafford, Barbara Maria. *Artful Science: Enlightenment Entertainment and the Eclipse of Visual Education.* Cambridge, MA: MIT Press, 1996.

Stallabrass, Julian. *Paris Pictured.* London: Royal Academy of Arts, 2002.

Stammers, Tom. "The Bric-a-brac of the Old Regime: Collecting and Cultural History in Post-Revolutionary France." *French History* 22, no. 3 (2008): 295–315.

Stammers, Tom. "Collectors, Catholics, and the Commune: Heritage and Counterrevolution, 1860–1890." *French Historical Studies* 37, no. 1 (2014): 53–87.

Steedman, Carolyn. *Dust: The Archive and Cultural History.* New Brunswick: Rutgers University Press, 2002.

Steele, Valerie. *Paris Fashion: A Cultural History.* 2nd ed., rev. and updated. Oxford: Berg, 1998.

Steinlight, Alexandra. "The Liberation of Paper: Destruction, Salvaging, and the Remaking of the Republican State." *French Historical Studies* 40, no. 2 (2017): 291–318.

Stoler, Ann Laura. *Along the Archival Grain: Epistemic Anxieties and Colonial Common Sense.* Princeton: Princeton University Press, 2009.

Stovall, Tyler Edward. *Paris Noir: African Americans in the City of Light.* Boston: Houghton Mifflin, 1996.

Stovall, Tyler Edward. *The Rise of the Paris Red Belt.* Berkeley: University of California Press, 1990.

Struk, Janina. *Photographing the Holocaust: Interpretations of the Evidence.* London: I.B. Tauris, 2004

Swenson, Astrid. *The Rise of Heritage: Preserving the Past in France, Germany and England, 1789–1914*. Cambridge: Cambridge University Press, 2013.

Syvret, Gareth. "Photography in Jersey under German Occupation: The 1940 'Order Concerning Open-Air Photography' and Photography at the Société Jersiaise Museum." In *Photographs, Museums, Collections: Between Art and Information*, edited by Elizabeth Edwards and Christopher Morton, 177–194. London: Bloomsbury Academic, 2015.

Taws, Richard. *The Politics of the Provisional: Art and Ephemera in Revolutionary France*. University Park: Pennsylvania State University Press, 2013.

TenHoor, Meredith. "Architecture and Biopolitics at les Halles." *French Politics, Culture and Society* 25, no. 2 (2007): 73–92.

Terdiman, Richard. *Present Past: Modernity and the Memory Crisis*. Ithaca: Cornell University Press, 1993.

Tester, Keith, ed. *The Flâneur*. London: Routledge, 1994.

Thorburn, David, and Henry Jenkins, eds. *Rethinking Media Change: The Aesthetics of Transition*. Cambridge, MA: MIT Press, 2003.

Tombs, Robert. "La lutte finale des barricades: Spontanéité révolutionnaire et organisation militaire en mai 1871." In Corbin and Mayeur, *La barricade*, 357–365.

Traugott, Mark. "Barricades as Repertoire: Continuities and Discontinuities in the History of French Contention." *Social Science History* 17, no. 2 (1993): 309–323.

Tufte, Edward R. *The Visual Display of Quantitative Information*. Cheshire: Graphics Press, 1983.

Vause, Erika. "Getting Control of Things: The Musée Carnavalet and the Politics of Museal Media." *Chicago Art Journal* 16 (2006): 3–17.

Vestberg, Nina Lager. "Ordering, Searching, Finding." *Journal of Visual Culture* 12, no. 3 (2013): 472–489.

Virgili, Fabrice, and Danièle Voldman, "Les Parisiens sous l'Occupation, une exposition controversée." *French Politics, Culture and Society* 27, no. 1 (2009): 91–101.

von Amelunxen, Hubertus. "Quand la photographie se fit lectrice: Le livre illustré par la photographie au XIXe siècle." *Romantisme* 15, no. 47 (1985): 85–96.

Wakeman, Rosemary. "Fascinating Les Halles." *French Politics, Culture and Society* 25, no. 2 (2007): 46–72.

Wakeman, Rosemary. *The Heroic City: Paris, 1945–1958*. Chicago: University of Chicago Press, 2009.

Wakeman, Rosemary. "Nostalgic Modernism and the Invention of Paris in the Twentieth Century." *French Historical Studies* 27, no. 1 (2004): 115–144.

Welch, Edward. "Portrait of a Nation: Depardon, France, Photography." *Journal of Romance Studies* 8, no. 1 (2008): 19–30.

West, Nancy Martha. *Kodak and the Lens of Nostalgia*. Charlottesville: University Press of Virginia, 2000.

Wexler, Laura. *Tender Violence: Domestic Visions in an Age of U.S. Imperialism*. Chapel Hill: University of North Carolina Press, 2000.

White, Hayden. "Historiography and Historiophoty." *American Historical Review* 93, no. 5 (1988): 1193–1199.

White, Hayden. *Metahistory: The Historical Imagination in Nineteenth-Century Europe.* Baltimore: Johns Hopkins University Press, 1973.

Winter, Jay. *Remembering War: The Great War between Memory and History in the Twentieth Century.* New Haven: Yale University Press, 2006.

Wright, Beth S. *Painting and History during the French Restoration: Abandoned by the Past.* Cambridge: Cambridge University Press, 1997.

Yates, Alexia. *Selling Paris: Property and Commercial Culture in the Fin-de-Siècle Capital.* Cambridge, MA: Harvard University Press, 2015.

Zelljadt, Katja. "Capturing a City's Past." *Journal of Visual Culture* 9, no. 3 (2010): 425–438.

Zemmour, Eric. *Le suicide français.* Paris: Albin Michel, 2014.

Zuromskis, Catherine. *Snapshot Photography: The Lives of Images.* Cambridge, MA: MIT Press, 2013.

INDEX

Note: Page numbers in *italics* indicate figures. Page numbers followed by n and a number indicate endnotes.

Auger, Jean-Pierre 174
Auradon, Pierre 156

barricades 99–104, *102, 103, 104, 105,
106, 107, 108, 109, 116,* 251n66
Barricades (Gratias) 114
Barthes, Roland 5
Bartholdi, Auguste 157
Baudelaire, Charles 233n81
Baylot, Jean 259n34
Beaurepaire, Edmond 54
de Beauvoir, Simone 126–7
Beigbeder, Marc 133
Belle Epoque, discourse on 127, 245n88
 See also Paris 1900 (prewar period)
Belleville-Ménilmontant
 (Ronis) 125, 190
Belling *208*
Benjamin, Walter 5
Berger, Gaston 174
Berger, Lynn 227n47
Berliner Illustrierte Zeitung
 (magazine) 69
Bernard, Jean-Pierre 229n12
Berruer, Alain 174
Beucler, André 52
Bibliothèque historique de la Ville de
 Paris (BHVP)
 collection of contemporary
 photos 252n79
 involvement in "C'était Paris en
 1970" 169–70, 210–11, 266n21
 photohistories at 68, 244n75
 under Poëte 39–44, 236n132
 split from Musée Carnavalet 28–9
Bimillénaire de Paris
 celebration of photographic history
 at 143, 144, 262n89
 cliché posters of 134–7, *135, 136,
 137, 138*
 depictions of Paris as modern
 during 145–7, *146, 147,* 150–5,
 152, 154

depictions of Parisian typologies
 during 147–50, *149, 150, 151*
filmed footage of 260n53
overview 127–30, 259n20, 259n24
politics of 131–3
rhetoric on 130–1
scholarship on 258n19
and tourism 155–9, 258n19
Boitreaud, Didier *192*
Bolling, Claude 179
Bonfils, Robert 130
Boucher, François 66, 106,
 107–9, 252n79
Bourgeas, Jacques 208
Bourgin, Georges 252n73
Bourigeaud, Roland 181
Boussel, Patrice 192–3
Bovis, Marcel 94, 153
Boyer, Christine 4
Brasillach, Robert 118
Brassaï 79, 192, 262n84
Braun, Adolphe 157
Briand, Béatrice 103–4, *105, 109,* 112
Brugger, André 201
Bruyr, José 139–40
Bureau des illustrations et
 photographie 67
 See also Hachette
Le buste de Marat aux piliers des Halles
 (Cain) 33

Cadava, Eduardo 224n21
Cain, Georges
 as Carnavalet curator 28, 29
 historical reconstructions by 30–3,
 31, 32, 34, 38
 lack of catalogue for works of 234n98
 as private collector 14, 23
 use of photography 54, 57, 58–9
 writings of 55–6, 241n26
Campaux, Suzanne 105, 254n105
Carco, Francis 79, 92
Carlier, Achille 261n69

Printed in the USA/Agawam, MA
April 11, 2019

701088.001